THE CREATIVE CRITIC

Writing as/about Practice

Edited by Katja Hilevaara and Emily Orley

Routledge
Taylor & Francis Group

LONDON AND NEW YORK

First published 2018
by Routledge
2 Park Square, Milton Park, Abingdon, Oxon, OX14 4RN

and by Routledge
711 Third Avenue, New York, NY 10017

Routledge is an imprint of the Taylor & Francis Group, an informa business

British Library Cataloguing-in-Publication Data
A catalogue record for this book is available from the British Library

Library of Congress Cataloging-in-Publication Data
Names: Orley, Emily, editor. | Hilevaara, Katja, editor.
Title: The creative critic : writing as/about practice /
 edited by Emily Orley and Katja Hilevaara.
Description: Abingdon, Oxon ; New York, NY : Routledge, 2018. |
 Includes bibliographical references.
Identifiers: LCCN 2017043028 | ISBN 9781138674820 (hardback) |
 ISBN 9781138674837 (pbk.) | ISBN 9781315561059 (ebook)
Subjects: LCSH: Criticism—Authorship. | Critical thinking. |
 Authorship. | Creative writing. | Academic writing.
Classification: LCC PE1479.C7 C74 2018 | DDC 808.06/68—dc23
LC record available at https://lccn.loc.gov/2017043028

ISBN: 978-1-138-67482-0 (hbk)
ISBN: 978-1-138-67483-7 (pbk)
ISBN: 978-1-315-56105-9 (ebk)

Typeset in Bembo
by Apex CoVantage, LLC

Visit the companion website: http://www.creativecritic.co.uk

THE CREATIVE CRITIC

As practitioner-researchers, how do we discuss and analyse our work without losing the creative drive that inspired us in the first place?

Built around a diverse selection of writings from leading researcher-practitioners and emerging artists in a variety of fields, *The Creative Critic: Writing as/about Practice* celebrates the extraordinary range of possibilities available when writing about one's own work and the work one is inspired by. It re-thinks the conventions of the scholarly output to propose that critical writing be understood as an integral part of the artistic process, and even as artwork in its own right.

Finding ways to make the intangible nature of much of our work 'count' under assessment has become increasingly important in the Academy and beyond. *The Creative Critic* offers an inspiring and useful sourcebook for students and practitioner-researchers navigating this area.

Please see the companion site to the book, http://www.creativecritic.co.uk, where some of the chapters have become unfixed from the page.

Katja Hilevaara is a collaborative artist, researcher and teacher who works in performance, installation and art-writing. Her research is concerned with (mis-) remembering, creative constraint and ideas surrounding maintenance, care and enchantment. She lectures at Goldsmiths, University of London, UK. www.katjahilevaara.com.

Emily Orley is a practitioner-researcher whose work includes performance, installation and art- (or place- or commemorative-) writing. She has been making work on her own and in collaboration for 17 years and currently lectures at the University of Roehampton, UK, in the Drama, Theatre and Performance Department. www.emilyorley.com.

CONTENTS

FIGURES

CONTRIBUTORS

Mojisola Adebayo is theatre artist: performer, playwright, director, producer and facilitator. Her practice spans 25 years, from Antarctica to Zimbabwe. Publications include *Mojisola Adebayo: Plays One* (Oberon), *48 Minutes for Palestine* (Methuen), *The Interrogation of Sandra Bland* (Oberon) and *The Theatre for Development Handbook* (Pan). She teaches Drama at Queen Mary University of London.

Iain Biggs RWA is an independent researcher, artist, curator and teacher interested in place, memory, identity and 'deep mapping'. An Honorary Research Fellow at the University of Dundee and Visiting Research Fellow at UWE, Bristol, he helps coordinate three arts research networks: PLaCE International, LAND2 and Mapping Spectral Traces.

Lucy Cash is an artist whose work spans moving image, installation, participatory event and writing. She likes to reveal the invisible within the visible, the extraordinary within the overlooked. She works in collaboration with others as well as by herself. Her work makes her as much as she makes it. www.lucycash.com.

Karen Christopher is a collaborative performance maker, performer and teacher. Her company, Haranczak/Navarre Performance Projects, is devoted to collaborative processes, listening for the unnoticed, the almost invisible, and the very quiet, paying attention as an act of social cooperation. She was a member of Goat Island for 20 years. www.karenchristopher.co.uk.

Emma Cocker is a writer-artist and Associate Professor in Fine Art at Nottingham Trent University. Her writing has been published in *Failure* (2010), *Drawing a Hypothesis: Figures of Thought* (2011), *Hyperdrawing: Beyond the Lines of Contemporary*

Art (2012), *Reading/Feeling* (2013), *On Not Knowing: How Artists Think* (2013), *The Yes of the No* (2016) and *Choreo-graphic Figures: Deviations from the Line* (2017).

Nicola Conibere is a choreographer and scholar. From August 2018 she will be a Senior Lecturer in Dance at Roehampton University, UK. Her research explores what choreographic practices offer to the politics of spectatorship and notions of publics, with a particular interest in theatricality and the generative potentials of bodies. She is currently undertaking research into embodied behaviours typically categorised as excessive, drawing on their qualities of inefficiency and wastefulness as choreographic propositions. Recent publications include performance writing and essays about dramaturgy, proximity, visibility and disability. Her choreography has been shown in theatres and galleries internationally. www.nicolaconibere.com.

Augusto Corrieri is an artist and writer. His work focuses on expanding notions of performance, to include non-human ecologies, processes and scales, as well as invisibility and in-articulation. His first book is called *In Place of a Show: What Happens Inside Theatres when Nothing is Happening*. He has made several performance works in the UK and across the rest of Europe, and is Lecturer in Theatre and Performance at the University of Sussex.

Diana Damian Martin is a performance writer, theorist and critic. Together with Mary Paterson and Maddy Costa she co-edits *Something Other*, and co-founded the Department of Feminist Conversations. She works as Lecturer, Performance Arts at Royal Central School of Speech and Drama.

Taru Elfving is a curator and writer focused on nurturing transdisciplinary and site-sensitive artistic investigations with a long-term commitment to the critical discourses on ecology and feminism. She holds a PhD from Visual Cultures, Goldsmiths University of London, and is currently Head of Programme at Frame Contemporary Art Finland in Helsinki.

Tim Etchells is an artist and a writer based in the UK whose work shifts between performance, visual art and fiction. He has worked in a wide variety of contexts, notably as the leader of the world-renowned Sheffield-based performance group Forced Entertainment. Exhibiting and presenting work in significant institutions all over the world, he is currently Professor of Performance and Writing at Lancaster University.

Ella Finer is an artist and researcher working with acoustic subjectivities in performance. Her current research project considers a 'politics of resonance': how female bodies acoustically disrupt, challenge or change the order of who is allowed to occupy – command – space. She is an Associate Lecturer in Theatre at Birkbeck, University of London, and Adjunct Professor of Performance Studies at Syracuse University, London.

Hélène Frichot is an Associate Professor and Docent in Critical Studies in Architecture, School of Architecture and the Built Environment, KTH, Stockholm, where she is the director of Critical Studies in Architecture. Her research examines the transdisciplinary field between architecture and philosophy. Recent publications include: *Architecture and Feminisms: Ecologies, Economies, Technologies*, co-edited with Gabrielsson and Runting (Routledge, 2017) and *How to Make Yourself a Feminist Design Power Tool* (AADR, 2016).

Maria Fusco is a Belfast-born writer working across fiction, criticism and theory, her work is translated into ten languages. Sole-authored works include: *Give Up Art: Collected Critical Writings* (LA/Vancouver: New Documents, 2017); *Legend of the Necessary Dreamer* (London: Vanguard Editions, 2017); *Master Rock* (Artangel & BBC Radio 4, 2015); *With A Bao A Qu Reading When Attitudes Become Form* (LA/Vancouver: New Documents, 2013); and *The Mechanical Copula* (Berlin/NY: Sternberg Press, 2011). She is current Reader in Interdisciplinary Writing, University of Edinburgh, and was Director of Art Writing at Goldsmiths, University of London. http://mariafusco.net.

Chris Goode is a writer and maker for theatre and performance. He is lead artist of Chris Goode & Company, director of the all-male ensemble Ponyboy Curtis, and an associate artist at the Royal Exchange Theatre, Manchester. He is the author of *The Forest and the Field* (Oberon).

Lin Hixson and Matthew Goulish co-founded *Every house has a door* in 2008. They received honorary doctorates from Dartington College of Arts, University of Plymouth, in 2007. They shared the United States Artists Ziporyn Fellowship in 2009, and a fellowship from the Foundation for Contemporary Art in 2014. Their collaborative writing has appeared in the anthologies *Small Acts of Repair – Performance, Ecology, and Goat Island*; *Live – Art and Performance*; and *Perform, Repeat, Record: Live Art in History*. They teach at The School of the Art Institute of Chicago.

Peter Jaeger is a Canadian writer based in London. He is the author of 11 books, including works of poetry, criticism, hybrid creative-critical research, and artist books. His most recent publications are *John Cage and Buddhist Ecopoetics* (2013), *540493390* (2014) and *A Field Guide to Lost Things* (2015). Jaeger is Professor of Poetics at Roehampton University.

Douglas Kearney has published six books, most recently, *Buck Studies* (Fence Books, 2016), which *BOMB* says: 'remaps the 20th century in a project that is both lyrical and epic, personal and historical'. *Publisher's Weekly* called Kearney's *Mess and Mess and* (Noemi Press, 2015) 'an extraordinary book'. He teaches at CalArts.

Joe Kelleher is Professor of Theatre and Performance at University of Roehampton in London. He is the author of *The Illuminated Theatre: Studies on the Suffering*

of Images (Routledge, 2015), *Theatre & Politics* (Palgrave Macmillan, 2009) and co-author with Romeo and Claudia Castellucci, Chiara Guidi and Nicholas Ridout of *The Theatre of Societas Raffaello Sanzio* (Routledge, 2007).

Kristen Kreider is a writer and artist whose research stems from an interest in the poetics of thought, its materialisation as form, and a concern with how artworks relate to the world. Books include *Poetics & Place: The Architecture of Sign, Subjects and Site* (I.B. Tauris, 2014) and, with Kreider + O'Leary, *Falling* (Copy Press, 2015) and *Field Poetics* (Ma Bibliotheque, 2018). She is currently Professor of Fine Art and Director of the PhD Programme at Goldsmiths College. http://www.kreider-oleary.net.

Johanna Linsley is an artist and researcher. Her work circulates around questions about text, performance, voice and listening. She is a member of the London-based performance collective I'm With You, and a founding partner of UnionDocs, a centre for documentary art in Brooklyn, New York.

Stephen Loo is Interdisciplinary Professor of Design and Art at the University of New South Wales, Sydney. He has published widely on architecture and design theory, biophilosophy, posthumanist ethics and experimental digital thinking. He is co-editor of *Deleuze and Architecture* (2012) and *Poetic Biopolitics* (2016) and is currently working on *Speculative Ethologies: philosophical strolls through A Picture Book of Invisible Worlds* with Dr Undine Sellbach. Stephen is a founding partner of award-winning architectural, interpretation and exhibition practice Mulloway Studio.

Tracy Mackenna is an artist and educator whose work plays with language, sculptural acts, creative critical writing and visual publishing. With the artist Edwin Janssen she is co-curator of The Museum of Loss and Renewal, a mobile discursive platform that creates space to explore wellbeing and sustainability through art. Tracy holds the Personal Chair of Contemporary Art Practice at DJCAD, University of Dundee and leads the Art, Society & Publics Masters course that she devised. www.tmolar.org.

Brigid McLeer is an Irish artist, writer, researcher and lecturer based in London. Her work has been exhibited and presented in the UK and internationally. She is currently working on a long-form art and activist project 'N scale' (*see n-scale.org*). Her new performance work 'The Triumph of Crowds', winner of the 2016 Leslie Scalapino Award for Performance Writers, was staged by theatre company 'the relationship' directed by Fiona Templeton at Downtown Art Company, New York in 2017.

Timothy Mathews is Emeritus Professor of French and Comparative Criticism at University College London. He is author of *Reading Apollinaire: Theories of Poetic Language; Literature, Art and the Pursuit of Decay in Twentieth-Century France*; and

Alberto Giacometti: The Art of Relation. He is co-editor of *Tradition, Translation and Trauma, the Classic and the Modern* and *Poetic Biopolitics.* He has translated and co-translated into English poetry by Michel Houellebecq, Luce Irigaray and Gérard Macé. He is member of the Academy of Europe and Officier dans l'Ordre des Palmes Académiques.

Richard Huw Morgan is half of good cop bad cop, an artistic collaboration with John Rowley since 1995, producing over 50 live performance works, and video and audio works including *Pitch* (since 2011 *Pitch/Illustration/Radio*) on Radio Cardiff. Morgan is Arts Council Wales 'Creative Wales Award' recipient (2006) for soundwork.

Hayley Newman is an artist with a passion for humour and fiction. She has made work in nightclubs, on trains, at marches and for concert halls and galleries. She tutors on the doctoral programme at the Slade School of Fine Art, UCL, where she is Reader of Fine Art.

James O'Leary is an architect and installation artist who has worked collaboratively with Kristen Kreider as Kreider + O'Leary since 2003 [http://kreider-oleary.net]. He is a current recipient of an AHRC TECHNE doctoral award to research transformational architectural approaches to the contested spaces of the 'interface areas' of Belfast, Northern Ireland [http://www.peacewall-archive.net]. He is currently a Senior Lecturer in Architecture & Innovative Technology at the Bartlett School of Architecture, University College London, where he is Programme Director for the MA Situated Practice programme [http://www.situated-practice.net].

Owen G. Parry (owko69) works across expanded performance cultures including live art, theatre, installation, moving image, sound and writing. He has staged and published works internationally on subjects including gay sex, trash, biopolitics, fandoms, online cultures and Yoko Ono. He lectures in Fine Art, Critical Studies at Goldsmiths and Central Saint Martins. http://owengparry.com/.

Mary Paterson is a writer and artist who works across text, visual art and performance. Her current research concerns the gestural and spoken languages of migration in British public life. Together with Diana Damian Martin and Maddy Costa she co-edits *Something Other*, and co-founded the Department of Feminist Conversations.

Mike Pearson is author of *Theatre/Archaeology* (2001), *In Comes I: Performance, Memory and Landscape* (2006); *Site-Specific Performance* (2010), *Mickery Theater: An Imperfect Archaeology* (2011) and *Marking Time: Performance, Archaeology and the City* (2013). As a director, his productions for National Theatre Wales include *The Persians* (2010), *Coriolan/us* (2012) and *Iliad* (2015).

Simon Piasecki is the Head of Drama, Dance and Performance Studies at Liverpool Hope University. He has enjoyed a career as an academic, a researcher, performer, artist and a writer, considering notions of belonging and landscape in socio-political and cultural contexts. His PhD studied 'cartographies' of Self and Other, considering belonging and place.

Jane Rendell is an architectural historian, art critic and writer-practitioner, who has introduced 'critical spatial practice' and 'site-writing' through her work, which crosses architecture, art, feminism, history and psychoanalysis. Her authored books include *The Architecture of Psychoanalysis* (2017), *Silver* (2016), *Site-Writing* (2010), *Art and Architecture* (2006) and *The Pursuit of Pleasure* (2002). Jane is Professor of Architecture and Art and Director of History and Theory at the Bartlett School of Architecture, where she also teaches on the new MA Situated Practice. www. janerendell.co.uk/.

Mitch Rose is a senior lecturer in the Department of Geography and Earth Sciences at Aberystwyth University. Email: mitch.rose@aber.ac.uk. His research interests are in cultural geography, cultural theory, landscape and material culture and the history and politics of the Middle East.

John Rowley is a theatre maker, performer and a visual artist. From 1990 to 1997 he was a core performer with Brith Gof. He is an associate performer with Forced Entertainment. He is co-artistic director of good cop bad cop. John is currently working on a commission for Walker Books.

Göze Saner is an actor, practitioner-researcher and a lecturer in Theatre and Performance at Goldsmiths, University of London. She studied philosophy at Bryn Mawr College and completed a practice-based PhD on archetype and performance at Royal Holloway, University of London. She trained and performed internationally with Bilsak Tiyatro Atölyesi, the Quick and the Dead, the New Winds, and with her company, cafila aeterna; most recently in *Göçmen Adımlar / Migrant Steps*, a community theatre project with groups of Turkish-speaking migrant women in the UK and Europe.

Undine Sellbach is a philosopher, writer and artist. She is Senior Lecturer in Philosophy at University of Dundee, UK. Her work explores life, matter, gender, instinct, ethics, ethology and performance. She is co-editor of *The Edinburgh Companion to Animal Studies* with Lynn Turner and Ron Broglio (2018), and is currently writing a book called *Speculative Ethologies: philosophical strolls through A Picture Book of Invisible Worlds*, with Stephen Loo. She is author of the children's book *The Floating Islands* (2006). Her creative work is documented at: undinefrancescasellbach.blogspot.com.

Rajni Shah has worked independently and with other artists since 1999 to create the conditions for performances, publications, conversations and gatherings

on and off-stage. At the time of publication key performance works include *The Awkward Position* (2003–4), *Mr Quiver* (2005–8), *small gifts* (2006–8), *Dinner with America* (2007–9), *Glorious* (2010–12), *Experiments in Listening* (2014–15), *Lying Fallow* (2014–15) and *Song* (2016). www.rajnishah.com.

P.A. Skantze directs theatre and performance, teaches theatre as urgent, aesthetic and political activism in Italy and London. With Matthew Fink she is co-founder of the performance group Four Second Decay, who work internationally. Her written practice includes the books *Stillness in Motion in the Seventeenth-Century Theatre* (Routledge, 2003) and *Itinerant Spectator/Itinerant Spectacle* (Punctum, 2013).

Phil Smith is a performance-maker, writer and ambulatory researcher. Associate Professor (Reader) at Plymouth University. Member of Wrights & Sites. His publications include *Anywhere* and *Walking, Stumbling, Limping, Falling* with Alyson Hallett (both 2017), *Walking's New Movement* (2015), *On Walking* and *Enchanted Things* (both 2014), *Counter-Tourism: The Handbook* (2012) and *Mythogeography* (2010).

Susannah Thompson is an art historian, critic and writer based in Glasgow. Her research focuses on writing by visual artists and the development of art writing and criticism since the 1960s. She is Head of Doctoral Studies at the Glasgow School of Art.

Louise Tondeur publishes creative work, as well as academic research on hair and queer reading, disability, and on creative pedagogy. Her work has appeared in, for instance, *Women: A Cultural Review*, *Textile*, *Writing Practice*, *Writing and Education* and *TEXT: Journal of Writing and Writing Courses*. Louise's short story collection, *Unusual Places*, comes out with Cultured Llama Press in 2018. She is working on her third novel.

Cathy Turner is an associate professor at the University of Exeter and a member of artists' collective, Wrights & Sites, whose work concerns place and space. Wrights & Sites' work includes a series of 'mis-guides' to walking, performances, curation and public art. Her monograph, *Dramaturgy and Architecture*, was published in 2015.

Salomé Voegelin is an artist and writer engaged in listening as a socio-political practice of sound. She is the author of *Listening to Noise and Silence: Towards a Philosophy of Sound Art* (Continuum, 2010) and *Sonic Possible Worlds: Hearing the Continuum of Sound* (Bloomsbury, 2014). As an artist she works collaboratively with David Mollin in a practice that engages words, things and sound, and focuses on invisible connections, transient behaviour and unseen rituals.

Joanne (or 'Bob' as most people know her) **Whalley** and **Lee Miller** completed the first joint practice-as-research PhD to be undertaken within a UK arts discipline in 2004. As part of that project they began to reflect upon the process of creative collaboration and knowledge production by drawing on the 'two-fold

thinking' of Deleuze and Guattari. These processes remain central to their ongoing work together. Alongside their creative practice, they both teach at Plymouth Conservatoire, part of the University of Plymouth. Their current research includes an exploration of affective exchange and the space in between audience and performer. Having spent too many years inside their heads, they have noticed they have bodies and, as a consequence, Bob is now an acupuncturist, and Lee teaches yoga.

G.D. White works in the Department of Drama, Theatre and Performance at the University of Roehampton. His plays include an adaptation of B.S. Johnson's *The Unfortunates* for BBC Radio 3 and he also researches on modern drama and law and performance. He rides an increasingly weary bike what seems like an increasingly long distance to work.

FOREWORD

L'avant-coup

Jane Rendell

L'avant-coup

So here, once again, we have two places, two epochs, and two processes. The conscious and the unconscious, the past and the present, the anticipatory event (*l'avant-coup*), and the retroactive attribution of new meaning (*l'apres-coup*). However, an analysis of the German term *Nachträglich* shows that it contains two ideas. On the one hand, the idea of coming at a later date and, on the other, the idea of a supplement. In other words, between two psychical events, I and II, the second is recognised as having a connection with the first, to which it now gives a fuller meaning that its initial, isolated, memory-trace suggested. So, retrospectively, II gives I a meaning that only existed in a state of virtuality, but which was by no means bound in advance to take this direction, among the other possibilities in a polysemic context. The progression of meaning involves, then, a return backwards in time which adds, retroactively, to the content it had initially, as well as a choice 'fixing' one of the various possibilities.[1]

II

16 July 2015, 12:29

Dear Jane,

I hope you are well. I am able to glean bits of your news from P.A.! I have spent the last few years having babies (two girls), but am now enjoying getting back into the swing of making and thinking.

I am putting together a book proposal at the moment, with a friend of mine (Katja Hilevaara) for an edited collection which brings together samples of creative

modes of critical enquiry. Much like the brilliant '-writing' event that you organised in 2010, we would like to ask a range of interesting people, mainly practitioners, to offer a piece of writing (which may include or consist of film, image, sound) that they have had fun producing but that also does some kind of critical work in itself. Really we would like to bring together a range of models of writing (in the loosest sense) by practitioners who are thinking about their own work or work that has inspired them. One of my main motivating forces has been my experience of giving a yearly talk to postgraduate students about using performative and other modes of creative writing in their theses and drawing together my own examples of work (by experts as well as recent graduates and emerging artists) to show as examples. Your *Site-Writing* book is at the top of my list – I have now recommended it to so many MA and PhD students that I'm getting predictable! During her PhD research (in the field of performance studies), Katja explored the criticality inherent in the act of responding creatively to a performance, and she too began to gather a prolific yet diffuse set of creative-critical writings across artistic and other disciplines. There does not seem to be a collection that offers a range of examples of such writings (in the way we'd like), so we want to put one together. We are in discussion with Routledge, who have shown interest. We are thinking of calling it something like 'The Creative Critic: writing as/about practice' but have made no decisions yet.

We were wondering, then, if you might make a contribution (however small) to the collection or perhaps (and I feel rather bold asking this) consider writing the foreword? You have inspired me in so many ways and your writing has been such an important, empowering part of my research journey that I would be honoured. We can send you the book proposal when I have finished putting the finishing touches to it, mainly firming up who the contributors are.

We would also like to ask your permission to approach several of the people from the '-writing' event that you ran to contribute to the collection? There was such a rich range of inspiring presentations that day (already five years ago) but it was very much your event and all the people there had a connection with you so I would not want you to feel I was poaching! We will, of course, acknowledge the event in the book.

Anyway, I hope you are enjoying the summer and having a break (of sorts) or at least getting to do the work you really want to do.

Sending warm wishes,
Emily (and Katja)

27 July 2015, 09:02

Dear Emily,

How lovely to hear from you!

I think about you often and wonder how you are, and I've had a little news through PA too.

Massive congratulations on becoming a double mother: two daughters – that's wonderful!

Your book project sounds excellent; such a volume is most definitely needed! I am rather over-committed right now, so nervous about saying yes to a chapter, but a foreword would be an honour.

And please feel free to contact the other authors from the *-writing* event . . . it would be great to get some of the geographers involved since there is often an unhelpful disciplinary split between place-writing and art-writing, and actually we have a lot to learn from each other especially regarding the different relation we have to our 'objects' of study.

Very best wishes, and I hope we meet in person again before too long!
Jane

<center>★</center>

But whatever I have said cheerfully and confidently to Emily in my email, I do feel a little nervous. A foreword? How to write into that border between the outside and the inside of the book? Perhaps I could write a kind of paratext?

Lovely of Emily to check with me that I don't mind her contacting the presenters from *-writing*, how typically thoughtful and considerate.

A kind of paranoia is often with me these days, as I have somehow become the oldest rather than the youngest at the conference, on the podium, in the book. I seem constantly anxious that my earlier work is getting lost. I've seen this kind of behaviour before in other older academics, feminists amongst them, and in the past found this need for recognition unappealing in its self-regard. It's not 'just' paranoia though; some of my best ideas have been purloined and remain out there on the internet in someone else's website uncited. I know too that this is not only my experience, that – 'seeing your work live on in others' – as the Guerrilla Girls liked to put it, is a condition of academic womanhood (and malehood too, but usually less often). And in general my work is treated with respect and referenced in a way that balances my own, sometimes obsessive, citation in my writing of those others who I come after.

So why this rather unpleasant need to hold on to what has gone before . . . Why worry about possession and authorship? (It must have something to do with the 'lost object', it usually does, I've found.)

Isn't writing something to share? Isn't that what I believe in? In writing together? Collectively?

Isn't writing something to let go? Is any word, or combination of them, really mine to possess in the first place? Didn't Mallarmé suggest that when we write, we are to cast our words adrift, off to sea in a bottle, for whoever may or may not come to find them?

When did I stop being the one who comes before, who is anxious to get noticed, and start to become the one who comes after, who expects to be recognised?

Maybe I can write a paratext embued with this kind of temporality . . . a writing before and a writing after?

Note

1 Green (2002: 36).

Reference

Green, André. 2002. *Time in Psychoanalysis: Some Contradictory Aspects*. Translated by Weller. London and New York: Free Association Books.

ACKNOWLEDGEMENTS

The editors would like to thank the contributors for their support and patience during the development of this publication. They would also like to thank the team at Routledge for their guidance and encouragement. A big thank you, too, to all those that advised, cajoled and loved them through the process, including the High Fidelity crew, and finally the heron that sat on a roof outside of Emily's window every day while we worked on the introduction and then disappeared.

AN INTRODUCTION IN FIVE ACTS[1]

Emily Orley and Katja Hilevaara

Setting the scene

The collection we are introducing here is for practitioner-researchers of all disciplines who find themselves working within the context of the Academy. It offers a range of possible ways of being a creative critic. Ways in which to write (about) your own practice, or one that inspires you, critically and creatively, so that it matters to others. Ways to seduce the reader into caring, ways to communicate beyond disciplinary boundaries and university walls.[2]

Dramatis personae

FOLDER 1

FOLDER 2

CONTRIBUTORS TO THIS VOLUME[3] Susannah Thompson, P.A. Skantze, Iain Biggs, Emma Cocker, G.D. White, Mike Pearson, Mojisola Adebayo, Nicola Conibere, Diana Damian Martin, Augusto Corrieri, Owen G. Parry, Joe Kelleher, Taru Elfving, Peter Jaeger, Undine Sellbach and Stephen Loo, Salomé Vogelin, Ella Finer, Hélène Frichot, Kristen Kreider and James O'Leary, Brigid McLeer, Cathy Turner, Phil Smith, Mary Paterson, Tim Etchells, Chris Goode, Hayley Newman, Mitch Rose, Maria Fusco, Simon Piasecki, Göze Saner, Lin Hixson and Matthew Goulish, Tracy Mackenna, Rajni Shah, Joanne 'Bob' Whalley and Lee Miller, Karen Christopher, Louise Tondeur, Johanna Linsley, Lucy Cash, Douglas Kearney and Timothy Mathews.

[We have taken the words they have contributed to this volume, often placing them wildly out of context here, for the purpose of our introduction.]

CHORUS OF THE INSPIRED AND
THE INSPIRING The chorus stands for and often cites all those (others) that
 have inspired us over the years. It is an ever-augmenting circle.[4]
STANDARDISATION DEMON

Act 1: an unfolding

*Two people, let's say they are women, [FOLDER 1 and FOLDER 2] enter the playing
space and lay a small folded handkerchief on the floor.*

FOLDER 1 Let's begin with the ideas of three people. Two philosophers and a
 physicist. Gilles Deleuze, Michel Serres and David Bohm.
FOLDER 2 Three men who multiply.
FOLDER 1 Michel Serres says that 'if you take a handkerchief and spread it out in
 order to iron it, you can see in it certain fixed distances and proximi-
 ties. If you sketch a circle in one area, you can mark out nearby points
 and measure far-off distances. Then take the same handkerchief and
 crumple it, by putting it in your pocket. Two distant points suddenly
 are close, even superimposed. If, further, you tear it in certain places,
 two points that were close can become very distant.'[5]
FOLDER 2 [*unfolds the handkerchief by one panel*] While unfolding, two points
 that were close can become very far away. (Although, can I make it
 very clear that I am not spreading this out to iron it, Michel Serres.)
FOLDER 1 [*folds it up again*] And while folding, we can bring far away points
 together.
FOLDER 2 David Bohm, in his controversial theory of the universe,[6] describes
 a new model of reality called the Implicate Order. Everything that
 is and will be in our cosmos, which is ever-evolving, is enfolded
 within his new order, as endless feedback cycles are created. Our
 manifest world [*FOLDER 2 claps her hands*], here, he calls the
 Explicate Order, but this is secondary and flows out of the law
 of the hidden, Implicate Order. In his words, Implicate Order 'is
 not to be understood solely in terms of a regular arrangement of
 objects (e.g. in rows) or as a regular arrangement of *events* (e.g. in
 a series). Rather, *a total order* is contained in some *implicit* sense,
 in each region of space and time. Now, the word "implicit" is
 based on the verb "to implicate". This means "to fold inward" (as
 multiplication means "folding many times"). So we may be led to
 explore the notion that in some sense each region contains a total
 structure "enfolded" within it.'[7] In other words, in principle, this
 small piece of folded material here, as a very crude example [*pick-
 ing up handkerchief*], as an individual element of the universe, could
 reveal detailed information about every other element of the uni-
 verse. [*She puts it back down on the floor.*]

FOLDER 1 Watch. [*She unfolds it, very slowly. It keeps opening out. She works in silence. The task seems never-ending.*]

MARY PATERSON [*aside*] It's funny because it's impossible.

FOLDER 2 The idea of folding (and unfolding) of course is also very important for Gilles Deleuze, as a philosophical concept but also as a practical means of understanding and developing connections between ideas and practices. In his book *The Fold*, for example, he highlights the interplay of the verbal and the visual as he discusses the Baroque sensibility in both Stephane Mallarmé's and Leibniz's works, and calls it 'a new kind of correspondence or mutual expression, an extr'expression, fold after fold', that is, *pli selon pli*.[8]

FOLDER 1 In Mallarmé's poem, 'Remémoration d'amis belges', he describes the city of Bruges emerging from the mist: 'That fold by fold the widowed stone unrobes itself.'[9]

FOLDER 2 Deleuze takes up Mallarmé's expression and folds it into a new theory of mutual expression –

FOLDER 1 Which he uses, in turn, to engage with Michaux's work, for example his anthology *Life in the Folds*, Boulez's composition *Pli Selon Pli: Un Portrait de Mallarmé* and Simon Hantaï's painting method, constructed from folding.[10]

FOLDER 2 As if folding begets more folding.

FOLDER 1 In Hantaï's words, you could fill the folded canvas without knowing where the edge was. You no longer knew where it stopped.[11]

FOLDER 2 In Brian Massumi's words, 'That seeping edge is where potential, actually, is found.'[12]

FOLDER 1 We could think about the act of folding as an endless feedback cycle.

FOLDER 2 In Deleuze's own words, 'the problem is not how to finish a fold, but how to continue it, make it go through the roof, take it to infinity.'[13]

FOLDER 1 [*still unfolding*] Let's continue then. In their book *On Folding: Towards a New Field of Interdisciplinary Research,* editors Michael Friedman and Wolfgang Schäffner approach and frame the idea within the discourse of codification. In her chapter therein, Karin Krauthausen describes a 'spatializing folding'. She talks about the multi-dimensionality of the practice of writing and reading being facilitated by the bound book, made up of folded sheets of paper. The physical action of folding those pages [*FOLDER 1 unfolds and unfolds, slightly out of breath*] both enables linear, codified reading, yet simultaneously disrupts its continuity. The reader can choose to fold backwards, forwards, interweave and extract, as the fold becomes a trickster between dimensions.[14]

FOLDER 2 Between dimensions, let's return to Massumi –

FOLDER 1 Fold back to?

FOLDER 2 He talks about a systematic openness, an open system. Incipient systems. Creative Contagion.[15]

FOLDER 1 Or contamination as Manuel Vason puts it.[16]

FOLDER 2 And continuing on, augmenting all the time, Massumi with Erin Manning writes 'Thought gathers in the work. It is the event of the work's unfolding.'[17]

FOLDER 1 The work everywhere, if we are lucky, if it is good, within academia and outside, continues after it has apparently finished.

FOLDER 2 It is folded into more work, different work, new work. Performance becomes film, music becomes recording, poetry becomes prose becomes criticism, words are folded or unfolded into more words, multiplied, elaborated.

FOLDER 1 And this is good as long as the folding keeps opening out. So long as there is always an unfolding.

FOLDER 2 The danger is when the unfoldings are expected to fit into existing moulds set out by notions of what the 'correct' scholarly outcome should look like.

FOLDER 1 The danger comes about when we forget the unfolding is a creative act as well as a critical one. We forget that embodiment and intuition are intellectual practices.

FOLDER 2 The key is to keep unfolding without losing the creative drive that inspired us in the first place. To insist that critical writing and thinking are crafted as artworks in their own right.[18]

FOLDER 1 So let's begin.

FOLDER 2 Let's continue.

Act 2: a multiplication

FOLDER 2 Deleuze says 'The multiple is not only what has many parts, but what is folded in many ways.'[19]

[*As FOLDER 1 unfolds, a number of people appear from the folds. It is the CHORUS OF THE INSPIRED AND THE INSPIRING*]

CHORUS OF THE INSPIRED AND THE INSPIRING We reiterate the words of Angelika Bammer and Ruth-Ellen Boetcher Joeres when they say: we believe in the potential of scholarly writing to make a difference. We take its challenge seriously. [*FOLDER 1 unfolds*] We appreciate the usefulness of established rules. But when those rules – the norms and conventions of our fields and disciplines – get in the way of the work our words can do, we have to act.[20]

[*FOLDER 1 continues unfolding*]

We repeat the words of Stephen Benson and Clare Connors: creative criticism, in short, is writing which seeks to do justice to what can happen – does happen; will happen; might or might not happen – when we are with an artwork. We can call that being-with an encounter.[21] And to have an encounter is to make a thing encountered. Creative criticism is the writing out of this

event, writing which endeavours in its own wordful stuff variously to register, and so to acknowledge, the event as a matter of language.[22]

We take on the words of Matthew Goulish when he says: if we can destabilize the boundaries between the critical and the creative, we may enrich them both, and discover a communal practice – one that relies on another for inspiration and energy, both critically and creatively.[23]

We call on Henk Borgdorff when he writes: concepts, thoughts and utterances 'assemble themselves' around the artwork, so that the artwork begins to speak.[24]

FOLDER 2 Karen Barad writes: 'It is through specific intra-actions that phenomena come to matter – in both senses of the word . . . Boundaries do not sit still.'[25]

[FOLDER 1 keeps unfolding. The space between her and FOLDER 2 keeps multiplying]

FOLDER 2 She writes, along with other materialist feminists: 'Feeling, desiring and experiencing are not singular characteristics or capacities of human consciousness. Matter feels, converses, suffers, desires, yearns and remembers.'[26]

CHORUS *[echoing Manning and Massumi]* Thought gathers in the work. It is the event of the work's unfolding.[27]

FOLDER 1 As we unfold, two points that were close can become very far away. And while new material is made visible, other material is folded over, made underside, lost to sight.

FOLDER 2 Let's fold over, for now –

FOLDER 1 The conventional format of the scholarly output and distanced objectivity of traditional academic writing.

FOLDER 2 Fold over, for now –

FOLDER 1 The idea that reflecting and critiquing are separate from the creative act. The idea that the theory comes in the dry writing afterwards, in the lacklustre (bit of the) talk, in the inaccessible analysis.

FOLDER 2 Fold over, for now –

FOLDER 1 The security of legitimating frameworks

FOLDER 1 Fold over, for now –

FOLDER 2 The authoritative, the dominant, the patriarchal, the binary, the ossified, the ritualised.

CHORUS *[singing]* In the words of Bammer and Boetcher Joeres, we have to expand our idea of scholarship.[28]

FOLDER 1 We have to question and destabilise the notion of what constitutes scholarship and to make space for the possible and that which is not yet known. There is a vulnerability in leaping forward into the unknown, but such leaps are full of potential, whether they end up in failure or a tentative grasping of something genuinely new.

FOLDER 2 We call for the legitimisation of artistic practice as a mode of think-
 ing, as a mode of research that draws its very strength from not
 knowing in advance.

FOLDER 1 Boundaries do not sit still.
 [*FOLDER 2 is miles away now, unfolding still. She is heard repeating
 ends of sentences like an echo.*]

CHORUS To quote Benson and Connors, let's celebrate a writing of open-
 ings in which there is room to move and air to breathe; writing
 which makes and maintain space for the possible.[29]

FOLDER 1 Let's embrace the arts practitioners with the academic hats on who
 are reflecting on and critiquing their own work and the work of
 those around them. Let's embrace those thinker-makers, maker-
 thinkers who find themselves standing in the still contested, yet
 enormously rich terrain of practice as research. The practitioner-
 researcher, the artistic-researcher,[30] the you (yes you) doing PaR,[31]
 you, doing research creation,[32] you, doing practice-led research,[33]
 art practice as research, performance as research.[34] Are you still feel-
 ing uneasy? Do you still feel as if your work comes under particu-
 larly heavy scrutiny?

CHORUS Let's call for Robin Nelson.[35] Robin Nelson?

FOLDER 1 He talks about artistic research as theory imbricated within practice.

CHORUS Robin Nelson!

FOLDER 1 He has coined the term 'complementary writing'.

CHORUS [*whispering*] Complementary!

FOLDER 1 To describe writings that work alongside practice, helping to artic-
 ulate the research inquiry and afford new insights.[36] Although he
 differentiates this kind of writing from practice, he does not suggest
 that they are mutually exclusive or that they need to be separated.

FOLDER 2 [*passing FOLDER 1 and the CHORUS holding a corner of the hand-
 kerchief*] This idea of complementarity of writing as artistic research
 and about artistic research is also echoed by Henk Borgdorff.

CHORUS Henk Borgdorff was among us. [*Calling*] Henk Borgdorff?

FOLDER 1 Where he suggests a 'third way' of writing about practice, one that
 does not interpret the artwork or reconstruct the artistic process,
 but involves an 'emulation or imitation of, or an allusion to, the
 non-conceptual content embodied in the art.'[37]

CHORUS The third way!

FOLDER 2 A writing-alongside.

CHORUS Simon Jones? Simon Jones! We were inspired by your 'The Cour-
 age of Complementarity' chapter.[38]

FOLDER 1 He says that the best writing-alongside 'becomes a kind of manual
 without a model, a means to no end, a history that speaks of the
 future, a manifesto'.[39]

FOLDER 2 Or what about a writing-*beside*?

CHORUS And now, Eve Kosofsky Sedgwick. [*Calling*] Eve Kosofsky Sedgwick?

FOLDER 2 She suggests a critical practice of positioning oneself 'beside' the artwork in question.[40] To adopt a position of besideness is to look for a new way 'round the topos of depth or hiddenness, typically followed by a drama of exposure, that has been such a staple of critical work of the past four decades.'[41] It means letting go of 'beneath', 'behind' and 'beyond', and challenging the traditional hierarchical and dualistic positions these entail, of tracing beginnings and analysing intentions.

FOLDER 1 She writes, 'Beside is an interesting preposition also because there's nothing very dualistic about it; a number of elements may lie alongside one another, though not an infinity of them. Beside permits a spacious agnosticism about several of the linear logics that enforce dualistic thinking: noncontradiction or the law of the excluded middle, cause versus effect, subject versus object.'[42]

CHORUS Eve Kosofsky Sedgwick! We are beside ourselves.

FOLDER 2 This idea is echoed by Irit Rogoff.

CHORUS [*whispering*] Irit Rogoff!

FOLDER 2 When she suggests that the practice of 'writing with' is a dehierarchization of the social relations governing the making of meaning in visual culture.[43] And it is also present in Jane Rendell's discussion –

CHORUS [*singing*] Jane Rendell! [*Calling*] Jane Rendell?

FOLDER 2 – of site-writing, a critical spatial practice that she developed which combines critical and creative writing modes, essay and text-based installation. She questions prepositional vocabulary in order to investigate how position informs relation, and so determines the terms of engagement between critic and artwork.[44] A shift in preposition –

CHORUS Shift. Under. Behind. On top. Beneath.

FOLDER 1 Alongside.

CHORUS To. To you.

FOLDER 2 A shift in preposition allows a different dynamic of power to be articulated, where, for example, the terms of domination and subjugation indicated by 'over' and 'under' can be replaced by the equivalence suggested by 'to' and 'with'. Rendell goes so far as to suggest removing prepositions entirely and simply writing the work under scrutiny (rather than writing about or to or with it) and in so doing aims to shift the relation between the critic and her object of study from one of mastery – the object under critique – or distance – writing about an object – to one of equivalence and analogy – writing as the object. The use of analogy – the desire to invent a writing that is somehow 'like' the artwork – allows a

certain creativity to intervene in the critical act as the critic comes to understand and interpret the work by remaking it on his/her own terms.[45]

FOLDER 1 The critic responds as artist, and so the artwork generates further creative and critical work.

NICOLA CONIBERE [*aside*] Same difference, doubling up differently.

FOLDER 2 The artwork does not stop there, at its encounter with its audience, but keeps moving, influencing, inspiring and infecting in different ways. The work continues.

GOULISH AND HIXSON The spell the performance cast in me never faded; the door that it opened never closed.

DIANA DAMIAN Thinking is revealed in texts that are not allowed to end, in the same way in which the performance, over its duration, unfolds in continuity.

OWEN PARRY Fandom comes into being through multiplicity, through a simultaneous affection, dissatisfaction and desire to transform existing narratives. It extends the work rather than capturing it.

FOLDER 2 As well as site-writing, there is an expansive range of other modes of hybrid and trans-disciplinary creative critical enquiry, fusing poetry, prose, theory and criticism, which continues to grow.

CHORUS [*singing*] Performative writing,[46] art writing,[47] new nature writing,[48] auto-ethnography,[49] fictocriticism,[50] anecdotal theory,[51] mytho and psychogeography,[52] as well as other forms of experimental, poetic and philosophical methods that cannot be so succinctly defined.[53]

G.D. WHITE [*aside*] . . . again, critical and creative, how do I work with, or between, or among, which could be the term, or trans, just trans, or inter, or intra, or perhaps con, or cum, criticalcumcreative, criticalitycumcreativity, creatcumcrit . . .

FOLDER 1 Each of these modes of writing investigate the transition between theory, criticism and practice in slightly different ways and in doing so open up exciting possibilities for the critic and ask whether critical thinking itself can be used to generate imaginative contexts.

SUSANNAH THOMPSON [*aside*] We will not be constrained by categorisation. We are the antithesis of Greenbergian medium-specificity. We are impure!

FOLDER 2 We could call these multiple forms of critical enquiry writings-beside.

CHORUS [*whispering*] Besideness-writings.

FOLDER 1 [*she calls from across the border*] You need to explain.

FOLDER 2 The act of writing beside an artwork is not about uncovering something other in the work but rather about allowing space and time to encounter it (whether it is your own creation or someone else's). This is not necessarily easy or comfortable.

FOLDER 1 [*again from afar*] As any child knows who's shared a bed with siblings . . . That's Kosofsky Sedgwick.[54]

FOLDER 2 Being, and indeed staying, beside a work (be it object or event) is a messy business. Such is our work.

FOLDER 1 And we fold to tidy. [*She keeps unfolding*]

FOLDER 2 Writing-beside involves, first and foremost, an attending to, a listening, a level of care.

FOLDER 1 A methodology that P.A. Skantze (drawing on the work of Sebald) calls a narrative of care.[55]

FOLDER 2 What Iain Biggs in his chapter here calls an act of noticing or one of 'notitia'.

IAIN BIGGS [*Aside*] A careful attention that is sustained, patient, subtly attuned to images and metaphors that tracks both hidden meanings and surface presentations.[56]

FOLDER 1 And this may take place across temporal and spatial planes.

ELLA FINER [*aside*] As everyday auditors we listen to multiple temporalities at once, whether we are conscious of our practice or not . . .

SALOMÉ VOGELIN We do not hear entities but relationships, the commingling of things that generate a sonic world, which we grasp not by inference, not by synthesizing various viewpoints, but by centring, decentring, and re-centring ourselves from moment to moment in the complex continuity of sound . . .

ELLA FINER Air recycles, and through doing so can touch other times.

FOLDER 1 Writing-beside might involve a remembering or returning to a particular object or experience, or a projection of what might be, could have been, around it. And inevitably, the listening calls forth a response, so an exchange or conversation ensues.

EMMA COCKER [*aside*] Conversational sparring enables a form of thinking and articulation beyond what is often conceivable on one's own; it is a means for drawing, forcing – even forging – language into being, a practice of *poesis* as much as of poetics.

P.A. SKANTZE Whoosh, let go, try
 Again, separate, regroup, listen and
 Speak, return to your refrains – try out new
 Verses, wander off, come back. Enter a
 Chorus you're not sure of, Concatenate,
 Agitate, Rest, Reverberate, Resound.

TRACY MACKENNA New dialogues release previously unknown forms emerging as connective mutations across a range of diverse registers.

PHIL SMITH Get inside as quickly as you can and use your time to find out what the elsewheres of this place are . . .

FOLDER 2 Indeed, each of the contributions in this volume can be seen as dialogues, some more explicit than others.

FOLDER 1 Simon Jones?

CHORUS Simon Jones! Come back!

FOLDER 1 – reminded me that David Bohm discusses the notion of dialogue, describing it as talking 'while suspending your opinions . . . Not trying to convince, but simply to understand . . . It is a kind of implicate order, where each one enfolds the whole consciousness.'[57]

FOLDER 2 Some dialogues occur between the practitioner and their own artistic and thinking process, some between the artist and a particular work (or event) of their own manufacturing, and some between the thinker and a work (or event) made by someone else.

RAJNI SHAH [*aside*] I hope that they will give you a glimpse of a certain way of working . . .

AUGUSTO CORRIERI . . . by steeping the self into itself, zooming into its processes, we might find that it is actually an open discursive space . . .

FOLDER 2 Each of the contributions here, in different ways, experiment with besideness, blurring the bifurcation implicit in Western thinking, reconfiguring or superseding (somehow) the conventional task of critical inquiry.

FOLDER 1 And of course Deleuze says 'The multiple is not only what has many parts, but what is folded in many ways.'[58]

FOLDER 2 You said that already.

FOLDER 1 I am folding.

Act 3: an explication

CHORUS Rigour!
 [*A cloaked figure appears. It is the Standardisation Demon.*]

DEMON I go by many names. One of my guises in the UK is Research Excellence Framework,[59] but I exist everywhere. I am loathed but really I am fighting for good work to be taken seriously.
 [*Folders 1 and 2 keep unfolding in silence. They are now oceans apart.*]
 Rigour is important here but it puts people off. In the REF guidelines, rigour is defined as 'intellectual coherence, methodological precision and analytical power; accuracy and depth of scholarship; awareness of and appropriate engagement with other relevant work.'[60]

CHORUS Break this down, Demon.

DEMON I will. 'Intellectual coherence': the work has to make sense conceptually, follow a path or series of paths, guide the reader through. 'Methodological precision': the work needs to be explicit about the methods in which it is engaging. 'Analytical power': a questioning, a breaking down, a finding a way around. 'Accuracy and depth of scholarship': the work needs to map a clear thinking-through

of its own intricacies. 'Awareness of and appropriate engagement with other relevant work': the work needs to be aware of where it comes in the world and who is around it, what came before and why it matters. As P.A. Skantze writes, it is a matter of 'taking care to think all the way through the complexities of what we are making, taking care to acknowledge what we might be excluding and why.'[61] It is not, as perhaps we assume it to be at first, restrictive or rigid,[62] but an attentive way of looking at and handling material.

FOLDER 1 [*looking up*] We might say, then, that rigorous scholarship is, like writing-beside, a matter of taking care. Or put another way: in taking care, writing-beside is a form of rigorous scholarship.

DEMON I am not blind, I see the growing sense of helplessness and cynicism within university arts and humanities communities everywhere. I, too, am disheartened by the current political environments worldwide and increased pressures to produce outputs and justify outcomes.[63] There is a sense of trepidation (in scholars themselves and in scholars assessing other scholars) in breaking existing moulds and challenging so-called legitimating models. But it is not the 'Academy' (whatever and whoever that really is) that is closed to new forms of criticism (ones that might not be immediately documented, rated, compared, and neatly archived) only we tend to assume that it still is.

[*With that the Demon turns into a sparrow and flies through an open window.*][64]

CHORUS Let us reinterpret and reconfigure the notion of rigorous scholarship. Let us look for it in new places. Places that are meticulous and playful, conscientious and experimental.

It is too easy to say that rigorous scholarship equates to 'good' academic writing, but it is not as simple as that. There are already many conflicting views on what constitutes 'good' and 'bad' writing,[65] and whether being clear is the same as being accessible is the same as being democratic is the same as being conformist.[66] Let's just say, for now, that 'good' writing is one that makes us think.[67]

FOLDER 1 [*momentarily begins re-folding the nonsensical and now enormous handkerchief, which surrounds everyone*] Rigour, if we think about it, might be as much about folding inwards. Not as an act of closing down but one of return. Returning, again and again. To check, verify, practise, rehearse, make sure, repeat, try again.

BRIGID MCLEER [*aside*] Each time I return the stories begin anew

GÖZE SANER Repetition by definition necessitates difference.

KREIDER AND O'LEARY All of this, or something similar, will happen again. The vortical logic will hold. The pattern will repeat, each time with a slight variation, each time leaving behind a wall.

TIM ETCHELLS The good news is that nothing lasts forever. Think of Rome. The Empire.

MOJISOLA ADEBAYO I don't want to marry a man! Not now, NOT EVER!

FOLDER 2 [*quoting Michel Serres*]Then take the same handkerchief and crumple it, by putting it in your pocket. Two distant points suddenly are close, even superimposed.

FOLDER 1 Rigour, if we think about it though, is as much about folding outwards.

 [*She continues unfolding. The chorus, one by one, disappear into the cosmic planes that the handkerchief now occupies. FOLDER 2 is light years away now.*]

Act 4: an implication

VOICES OFF We find ourselves in outer space

 [*Everyone is present but suspended as and between celestial bodies, amidst the vast unfolding. FOLDER 1 and 2 are still at work but nowhere to be seen. Slowly forms emerge, like constellations, satellite clusters.*]

MIKE PEARSON [*as voice only*] This is (Is this?) THEATRE after all?

KAREN CHRISTOPHER [*as voice only*] Often a train of thought starts with an image.

CHORUS [*as voices only*] We call on Hamlet in this most excellent canopy, the air, look you, this brave o — erhanging firmament, this majestical roof fretted with golden fire.[68]

FOLDER 2 [*as voice only*] Well, as Stephen Hawking says, to confine our attention to terrestrial matters would be to limit the human spirit.[69]

LOUISE TONDEUR [*as voice only*] This wasn't the sort of place for a person to hide or find anything at all.

FOLDER 1 [*as voice only*] Form is not a container for scholarly content: it is part of the scholarship.[70]

FOLDER 2 [*as voice only*] The contributors in this volume, while presenting different ways of writing beside, all take the aesthetics or form of the writing as seriously as its content. Their criticality is embedded, often, in the shape, style and tone of the writing itself.

FOLDER 1 [*as voice only*] Some of the writings appear more conventionally formatted than others but each of them challenge the orthodox ways that arguments are put together and analyses drawn out. Each of them open up a different range of creative possibilities.

FOLDER 2 [*as voice only*] Many aspire to polyphony, some with the use of columns, mirroring and doubling.

 [*Nicola Conibere, Diana Damian, Simon Piasecki enter the orbit.*][71]

FOLDER 1 [*as voice only*] And some with commentary in sidenotes and footnotes.

 [*Mojisola Adebayo and Mike Pearson also enter the orbit.*]

FOLDER 2 [*as voice only*] And some with the use of carefully built-up layers.
[*Tracy Mackenna and Lucy Cash now are pulled in.*]

LUCY CASH [*as voice only*] I am always drawn to looking at the deliberate pat-
terning and arrangement of bodies in space . . .

FOLDER 1 [*as voice only*] And some through scripts and imaginary dialogue.
[*Stephen Loo, Undine Sellbach, Johanna Linsley, G.D. White, Augusto Corrieri and Owen Parry navigate the gravitational pull.*]

LOO AND SELLBACH [*as voice only*] Each have distinct perceptions, orienta-
tions, appetites and inner worlds, related to their specific outside environments.

FOLDER 2 [*as voice only*] Some contributions include leaps in register and pitch,
or adopt specific tones and attitudes. There are those playing with the form of the manifesto.
[*P.A. Skantze and Susannah Thompson drift in to circle the Earth.*]

FOLDER 1 [*as voice only*] And those with the voice of the activist.
[*Iain Biggs, Mary Paterson and Phil Smith enter the orbit.*]

FOLDER 2 [*as voice only*] And those with dreamlike and evocative narratives,
fictional and real. Those with annotations in prose, commentaries in poetry.
[*Tim Etchells, Hayley Newman, Mitch Rose, Joe Kelleher, Chris Goode, Louise Tondeur and Taru Elfving are the next satellites to fall in with the gravitational pull.*]

CHRIS GOODE [*as voice only*] This, of course, is a fantasy, triggered partly by
experience – other projects, elsewhere – and partly by wish-
ful, or even wilful, thinking.

MITCH ROSE [*as voice only*] Stories make the world real by effacing the reality
that they purport to reflect.

HAYLEY NEWMAN [*as voice only*] The reverse journey takes seconds . . .

JOE KELLEHER [*as voice only*] The scene, already, displaces itself.

TIM ETCHELLS [*as voice only*] Night falls in the airport.

FOLDER 1 [*as voice only*] Others disrupt the linear movement of the text by
using fragments, quotations, spacing and visual imagery. They experiment with these as performative devices that interrupt the reader's process, reminding her of her own process of looking, reading and making sense.
[*Douglas Kearney, Kristen Kreider and James O'Leary, Cathy Turner, Brigid Mcleer, Joanne Whalley and Lee Miller, and Karen Christopher are drawn into orbit.*][72]

DOUGLAS KEARNEY [*as voice only*] FREEDOM FREEDOM CUT ME
LOOSE
[*FOLDER 1's body appears, a corner of the now infinite handkerchief in her hand.*]

FOLDER 1 So we have folded together, while we also unfold, this anthol-
ogy with which we hope to unsettle a number of conventions.

We have brought together a rich collection of short contributions, fragments in themselves, including a Foreword, an Afterword, and three Middlewords (forewords that come in the middle of the book, reflecting on the twelve or so chapters that come before them) to model the dynamic of a wider conversation.

FOLDER 2 [*as voice only*] A wider unfolding.

FOLDER 1 We asked each author here to frame their contribution with a sentence or two about how they situate their own writing. This was interpreted in different ways, sometimes included within the body of the text, sometimes placed as an epigraph, sometimes elaborated, sometimes not.

FOLDER 1 [*disappearing again*] We are all satellites now.

CATHY TURNER [*as voice only*] How does one dance a place into being?

JOHANNA LINSLEY [*as voice only*] I could literally disappear and I wouldn't mind.

TARU ELFVING [*as voice only*] Writing, like witnessing, is always for something. If not aimed at truth or disclosure, visibility or voice, what is it for? Situated, with care, its transversal potential may lie in how it calls for further encounters. Contagiously.

JOANNE WHALLEY and LEE MILLER [*as voice only*] We infect each other's images.

HÉLÈNE FRICHOT [*as voice only*] Writing is a world-historical delirium, which passes through peoples, places and things. It is a delirium that imagines a new people, a new Earth.

FOLDER 1 [*as voice only*] Some contributions spill off the pages.

FOLDER 2 [*as voice only*] Folds.

FOLDER 1 [*as voice only*] Folds of the book and into digital forms that can be found in the web companion,[73] moving from printed monochrome script and image to colour, movement and sound. The ever-expanding range of digital technologies at our disposal today offer alternative ways of responding, prompting changes in the ways that scholarly writing happens, opening up new processes of collaboration and experimentation. As text becomes unfixed from the page and other media gain equal weight, the act of writing as a means of inquiry and presentation becomes a choice.[74] There are other ways to communicate and respond.[75]

FOLDER 2 [*as voice only*] With this collection of samples, however, we were interested in the work of writing, on pages. Responding on paper, first and foremost –

SIMON PIASECKI [*as voice only*] The paper cannot be too porous –

FOLDER 2 [*as voice only*] – to artworks and processes, exploring how that translation from bodily experience (whether it be one of watching or making, or watching oneself making) to writing can and does occur.[76]

FOLDER 1 [*reappearing, still holding the handkerchief*] We were interested in 'techniques which embrace their own inventiveness'.

FOLDER 2 [*as voice only*] The insights offered by each chapter might apply to others and we hope they will. But their value is not to be found in their 'generalisability', rather they offer new paths forward.

CHORUS [*as voice only*] Rather than the sense of an ending the aspiration here is towards the possibility of an opening.[77]

[*The Earth's gravitational pull dissolves and the contributors float out of orbit and into the cosmos once again.*]

FOLDER 1 [*as her body disappears again*] If we unfold enough, we find openings.

Act 5

OFF-STAGE ECHO In Deleuze's own words, the problem is not how to finish a fold, but how to continue it, make it go through the roof, take it to infinity.[78]

[*A door in the roof opens.*]

Notes

1 Five in homage to ancient Greek, Elizabethan and Noh theatre, but also five because Pierre Boulez's composition *Pli selon pli: Portrait de Mallarmé* [Fold by Fold: Portrait of Mallarmé], which premiered in 1960 in Germany, was made up of five movements. The title is taken from a Mallarmé poem, in which the poet describes how a mist that covers the city of Bruges gradually disappears. Boulez described his work: 'So, fold by fold, as the five movements develop, a portrait of Mallarmé is revealed.' We hope that fold by fold, in five acts, our introduction here becomes apparent.

2 Bammer and Boetcher Joeres (2015: 21).

3 One of the many factors that inspired this collection was an event that Jane Rendell organised in June 2010 at the Bartlett School of Architecture called '-writing', bringing together a group of people to present their own creative modes of critical writing. Many of the contributors on that day find themselves here.

4 We are particularly indebted here to a range of books and journals that have argued for and brought together important collections of creative critical writing: Peg Rawes, Stephen Loo and Timothy Mathews (2016) *Poetic Biopolitics*; Angelika Bammer and Ruth-Ellen Boetcher Joeres (2015) *The Future of Scholarly Writing*; Ivan Callus and James Corby (2015–ongoing) *CounterText: A Journal for the Study of the Post-Literary*; Stephen Benson and Clare Connors (2014) *Creative Criticism*; Jackie Stacey and Janet Wolff (2013) *Writing Otherwise*; and Julia Lockheart and John Wood (2008–ongoing) *Journal of Writing in Creative Practice*.

5 Serres (1995a: 60). His assertion here is that time is more like the crumpled handkerchief than the ironed-out one. His readings of history, particularly scientific history, are based on this notion so that past, present and future discoveries are always intermingled and inform each other.

6 Controversial because it is/was alternative and did not adhere to the general understanding of quantum theory. Rather, he proposed that electrons are guided along paths by what he called the quantum potential. His cosmic view is based on the essential wholeness of nature and experience, where there are no independent elements of reality, rather everything is connected with everything else and always in process. His 'hidden variable'

theory so offended the scientific establishment that it was met with not only rejection but sheer silence, which was deeply distressing to Bohm. Although he went on to develop the theory further his work was always regarded as eccentric and nonconformist.
7 Bohm (1995: 188).
8 Deleuze (1993: 31).
9 Mallarmé (1979). Translation our own.
10 See also Charles J. Stivale's *Gilles Deleuze's ABCs: The Folds of Friendship* (2010).
11 Simon Hantaï, in conversation with Geneviève Bonnefoi (Bonnefoi 1973: 23–24; translation our own).
12 Massumi (2002: 43).
13 Deleuze (1993: 34).
14 Krauthausen (2016: 33). She draws on Derrida and Genette, but also references S. Burroughs and Brion Gysin, and their experimental work with folding found text. See for example, their *The Third Mind* (1978). See p. 42 of 'On Folding'.
15 Massumi (2002: 19).
16 Vason (2015).
17 Manning and Massumi (2014: 65).
18 See specifically, Jane Rendell, who writes that 'the use of analogy – the desire to invent a writing that is somehow "like" the artwork – allows a certain creativity to intervene in the critical act as the critic comes to understand and interpret the work by remaking it on his/her own terms' (2010: 7). The Chicago-based and now disbanded performance group Goat Island equally acknowledged the performative nature of documentation and created a series of works to be read and viewed alongside and after their performances, exploring the question 'How is a performance performed after it has actually been performed?' (n.p.). In a similar vein to Rendell's concept of Site-Writing, they sought to produce texts and films about their work 'that are artworks in their own right' (Goulish 2004–2005: n.p.).
19 Deleuze (1993: 3).
20 Bammer and Boetcher Joeres (2015: 26).
21 Benson and Connors (2014: 5).
22 Benson and Connors (2014: 5).
23 Goulish (2007: 211).
24 Borgdorff (2011: 58).
25 Barad (2009: 135).
26 Barad (2012: 59).
27 Manning and Massumi (2014: 65).
28 Bammer and Boetcher Joeres (2014: 65).
29 Benson and Connors (2014: 12).
30 The term used in continental Europe. See Freeman (2010); Borgdorff (2011) and Nelson (2013; especially Arlander, pp. 152–162; and Lesage, pp. 142–151).
31 The term Practice-as-Research is favoured in the UK and South Africa. For UK, see, for example, Nelson (2013), Kershaw and Nicholson (2011), McKenzie et al. (2010), Allegue et al. (2009) and Smith and Dean (2009). As for South Africa, see Veronica Baxter in Nelson (2013: 163–174); Hauptfleisch in Hunter and Riley (2009: 42–50).
32 The term used in Canada. See Kathleen Vaughan in Smith and Dean (2009: 166–186), and more generally the definition on the Canadian Social Sciences and Humanities Research Council website www.sshrc-crsh.gc.ca/funding-financement/programs-programmes/definitions-eng.aspx#a22 (accessed 20 September 2016).
33 The term used in Australia. See Julie Robson in Nelson (2013). She also defines it practice-based research, practice as research, studio research, artistic research (p. 130). See also Brad Haseman's call for 'performative research' in Haseman (2006); and Barrett and Bolt (2010).
34 Terms used more commonly in the United States, see Sullivan on visual arts research (2010 [2005]); Shannon Rose Riley in Nelson (2013); and Suzanne Little in Bendrups and Downes (Little 2011).

35 See especially Nelson (2013).
36 Nelson (2013: 36).
37 Borgdorff (2011: 58).
38 In Allegue *et al.* (2009).
39 Jones (2009: 26). Here Jones is differentiating it from the 'writing alongside' that Matthew Goulish (2000) describes in his *39 Microlectures in Proximity of Performance*, which can only ever draw attention to, point towards, or project away from. Jones evokes the analogy of the leper's window in the side of the Viennese cathedral that permitted the outcast a small glimpse of the holy event of transubstantiation. If we cannot experience an event but only know it through writing, it is doomed to failure.
40 Kosofsky Sedgwick (2003: 8) She is particularly looking at her response to art works of Judith Scott.
41 Kosofsky Sedgwick (2003: 8).
42 Kosofsky Sedgwick (2003: 8).
43 Rogoff (2008: 104).
44 She looks, for example, at the preposition 'to', discussing feminist philosopher Luce Irigaray's insertion of the term 'to' into 'I love you' producing 'I love to you' in order to stress reciprocity and mediation – the 'in-direction between us', and Michel Serres's focus on the transformational aspect of prepositions. See Luce Irigaray (2001) and Michel Serres (1995b). Rendell also references Irit Rogoff's (2008) discussion of the work of artist and film-maker Trinh T. Minh-ha, who draws attention to the significance assigned to the shift in use of prepositions (particularly from speaking 'about' to speaking 'to', see pp. 6–7 of *Site-Writing*). Important here too is Tim Mathews' chapter in *Poetic Biopolitics* where he discusses what he calls the 'optimism' of Luce Irigaray and Roland Barthes as they 'rebuild difference'. He shows how both writers do this by intervening in the rules of grammar, removing spaces and apostrophes and adding prepositions. See Timothy Mathews in Rawes *et al.* (2016).
45 Rendell (2010: 7). See also Michael Shreyach's chapter in Elkins and Newman (Shreyach 2008), where he writes 'some writers of criticism, that is, have the capacity to develop a mode of description that does more than just mirror its object. They instead produce an "equivalent" of it' (pp. 5–7).
46 See, for example, Della Pollock's chapter in Phelan and Lane (1998), Peggy Phelan's chapter in Heathfield (2004), Adrian Heathfield's chapter in Christie *et al.* (2006), and Ronald J. Pelias (2014).
47 For example, see David Carrier (1987), Yve Lomax (2005), Mieke Bal (2001), T.J. Clark (2006), Timothy Mathews (2013) and Kristen Kreider (2014).
48 See Jason Cowley (2008: 7–12). Examples include the work of Kathleen Jamie (2005, 2012) and Robert Macfarlane (2012, 2015).
49 For example, Ellis *et al.* (2011); Herrmann and Di Fate (2014); Adams *et al.* (2015); and Spry (2011).
50 For example, Fusco (2010, 2015, 2017); Muecke (2016); and Kerr and Nettlebeck (1998).
51 For example, Gallop (2002).
52 See Smith (2010) and Richardson (2015).
53 See, for example, Manning and Massumi (2014), and collections by Butt (2005), Benson and Connors (2014), Schad and Tearle (2011).
54 Kosofsky Sedgwick (2003: 8).
55 Skantze (2013: 8).
56 He draws on James Hillman's 'Archetypal Psychologies' here. See Watkins (2008).
57 Bohm quoted [enfolded] in Jones (2009: 27). Original reference: Bohm (1996: 118).
58 Deleuze (1993: 3).
59 The mechanism by which the quality of research produced by UK universities is evaluated.
60 REF (2012).
61 Skantze (2014: 250).

62 See Biggs and Buchler (2007). They write: 'An etymological approach may mislead us, since some have associated rigor with *rigor mortis*: a certain stiffness of intellectual attitude or worldview that is incompatible with change and the new' (p. 62).
63 See Hallock (2016).
64 In Greek mythology, the sparrow is associated with Aphrodite, the goddess of beauty, love and joy. We can only hope.
65 See, for example, Culler and Lamb (2003), which explores this debate. Other relatively recent books on the topic include Pinker (2014); Hayot (2014); Sword (2012); Strunk *et al.* (2007).
66 The editors of *The Future of Scholarly Writing*, Bammer and Boetcher Joeres, succinctly outline the 'good' versus 'bad' academic writing debate (2015: 14).
67 Bammer and Boetcher Joeres (2015: 14).
68 Shakespeare's *Hamlet* (Act 2, scene ii, 324).
69 From Hawking's Foreword to *The Physics of Star Trek* (Krauss and Hawking 2007: xiii).
70 Bammer and Boetcher Joeres (2015: 1).
71 Other great examples of texts using columns are Koestenbaum (2007); Spahr (1998); Derrida (1974); and before all of those, Cage (1961).
72 For useful discussions of the modular form or fragment as genre, see Elias (2004) and Jaeger (2014).
73 Please see the companion website to this book: http://www.creativecritic.co.uk.
74 Bammer and Boetcher Joeres discuss this in their introduction. They write: 'the emergence of new media and digital technologies confronts us with the obvious (but often ignored) fact that writing is not a given, but an option. The question then becomes why choose it?' (2015: 10).
75 *The Journal for Artistic Research* (*JAR*) and the associated documentary database Research Catalogue; and SenseLab, an international artistic network and the associated *Inflexions: A Journal for Research Creation* offer exciting examples of this kind of work. There is also Greg Ulmer's notion of the Mystory which, as a web-based research tool/form, prioritises a non-linear journey beginning with a sense of not-knowing in the maker and 'reader'. See Bammer and Boetcher Joeres (2015: 8).
76 Many of the contributors here, as well as experimenting with form and tone, also use the first-person, openly claiming responsibility for the way they attend to their own and other's work. They make their presence felt explicitly in the writing, pitching their own voice as a source of knowledge and form of evidence (Bammer and Boetcher Joeres 2015: 7), and challenging the now tired assumption of objectivity as a given in academic discourse. This does not mean that the writings lack critical distance, but that it is achieved through a sense of openness and generosity, rather than a detached perspective (if there is indeed such a thing). The first-person voice allows for a greater level of self-reflexivity, clarification and exploration, which all are undoubtedly important qualities in academic writing, but also challenges the official, dry and indifferent tone that has come to be associated with it. The different voices adopted in these chapters invite the reader to move beside the work (object, event) under investigation, compel us to listen, to respond, remind us of the necessary partiality of the subjective position. Not that using autobiographical writing in academic contexts is a not a new phenomenon, only that the contributions here highlight its validity.
77 Benson and Connors (2014: 12).
78 Deleuze (1993: 34).

References

Adams, Tony E., Stacy Holman Jones and Carolyn Ellis. 2015. *Autoethnography: Understanding Qualitative Research*. Oxford: Oxford University Press.
Allegue, Ludivine, Baz Kershaw, Simon Jones and Angela Piccini, eds. 2009. *Practice-as-Research in Performance and Screen*. Basingstoke: Palgrave Macmillan.

Bal, Mieke. 2001. *Louise Bourgeois' Spider: The Architecture of Art-Writing*. Chicago: University of Chicago Press.

Bammer, Angelika and Ruth-Ellen Boetcher Joeres, eds. 2015. *The Future of Scholarly Writing: Critical Interventions*. New York: Palgrave Macmillan.

Barad, Karen. 2009. 'Posthumanist performativity: Toward an understanding of how matter comes to matter' in *Material Feminisms*, 120–154, edited by Alaimo and Hekman. Bloomington: Indiana University Press.

Barad, Karen. 2012. Interview in *New Materialism: Interviews and Cartographies*, 48–70, edited by Dolphijn and Van der Tuin. Ann Arbor: Open Humanities Press.

Barrett, Estelle and Barbara Bolt, eds. 2010. *Practice as Research: Approaches to Creative Arts Enquiry*. London: I.B. Tauris & Co.

Benson, Stephen and Clare Connors, eds. 2014. *Creative Criticism: An Anthology and Guide*. Edinburgh: Edinburgh University Press.

Biggs, Michael A.R. and Daniela Buchler. 2007. 'Rigor and practice-based research'. *Design Issues* 23 (3): 62–69. Available at: http://uhra.herts.ac.uk/bitstream/handle/2299/4414/901029.pdf (accessed on 18 October 2016).

Bohm, David. 1995. *Wholeness and the Implicate Order*. London and New York: Routledge.

Bohm, David. 1996. *On Creativity*. London and New York: Routledge.

Bonnefoi, Geneviève. 1973. *Hantaï*. Montauban: Centre d'Art contemporain de l'Abbaye de Beaulieu.

Borgdorff, Henk. 2011. 'The production of knowledge in artistic research' in *The Routledge Companion to Research in the Arts*, 44–63, edited by Biggs and Karlsson. London and New York: Routledge.

Boulez, Pierre. 1957–1962. *Pli selon pli: Portrait de Mallarmé* [*Fold by Fold: Portrait of Mallarmé*]. Premiered in Cologne, 13 June 1960.

Burroughs, William S. and Brion Gysin. 1978. *The Third Mind*. New York: Viking Press.

Butt, Gavin, ed. 2005. *After Criticism: New Responses to Art and Criticism*. Malden, MA: Blackwell.

Cage, John. 1961. 'Where are we going? And what are we doing?' in *Silence: Lectures and Writings*, 194–259. Middletown: Wesleyan University Press.

Canadian Social Sciences and Humanities Research Council website www.sshrc-crsh.gc.ca/funding-financement/programs-programmes/definitions-eng.aspx#a22 (accessed 20 September 2016).

Carrier, David. 1987. *Artwriting*. Amherst: The University of Massachusetts Press.

Christie, Judie, Richard Gough and Daniel Watt, eds. 2006. *A Performance Cosmology: Testimony from the Future, Evidence of the Past*. London: Routledge.

Clark, T.J. 2006. *The Sight of Death: An Experiment in Art Writing*. New Haven: Yale University Press.

Cowley, Jason. 2008. 'Editors' letter: The new nature writing'. *Granta* 102: 7–12.

Culler, Jonathan and Kevin Lamb, eds. 2003. *Just Being Difficult? Academic Writing in the Public Arena*. Stanford: Stanford University Press.

Deleuze, Gilles. 1993. *The Fold: Leibniz and the Baroque*. Translated by Tom Conley. London: The Athlone Press.

Derrida, Jacques. 1974. *Glas*. Paris: Galilée.

Derrida, Jacques. 1982. 'Tympan' in *Margins of Philosophy*, ix–xxix. Translated by Alan Bass. Chicago: University of Chicago Press.

Elias, Camelia. 2004. *The Fragment: Towards a History and Poetics of a Performative Genre*. Bern: Peter Lang.

Ellis, Carolyn, Tony E. Adams and Arthur P. Bochner. 2011. 'Autoethnography: An overview'. *Forum: Qualitative Social Research* 12 (1): Art. 10.

Freeman, John. 2010. *Blood Sweat and Theory: Research Through Practice in Performance*. London: Libri Publishing.

Fusco, Maria. 2010. *The Mechanical Copula*. Berlin and New York: Sternberg Press.

Fusco, Maria. 2015. *Master Rock*. London: Artangel & Book Works.

Fusco, Maria. 2017. *Give Up Art: Collected Critical Writings*. Los Angeles and Vancouver: New Documents.

Gallop, Jane. 2002. *Anecdotal Theory*. Durham, NC: Duke University Press.

Goulish, Matthew. 2000. *39 Microlectures in Proximity of Performance*. London and New York: Routledge.

Goulish, Matthew. 2004–2005. *Reflections on the Process/Performance: A Reading Companion to Goat Island's 'When will the September roses bloom? Last night was only a comedy'*. Zagreb: Frakcija.

Goulish, Matthew. 2007. 'Creative response' in *Small Acts of Repair: Performance, Ecology and Goat Island*, edited by Bottoms and Goulish, 210–211. London and New York: Routledge.

Hallock, Thomas. 2016. 'A is for acronym: Teaching Hawthorne in a performance-based world'. *ESQ: A Journal of Nineteenth-Century American Literature and Culture* 62 (1): 116–121.

Haseman, Bradley C. 2006. 'A manifesto for performative research: Media International Australia incorporating culture and policy'. *Quarterly Journal of Media Research and Resources* 118: 98–106. Available at: http://eprints.qut.edu.au/3999/ (accessed 20 March 2017).

Hayot, Eric. 2014. *The Elements of Academic Style: Writing for the Humanities*. New York: Columbia University Press.

Herrmann, Andrew, F. and Kristen Di Fate, eds. 2014. 'The new ethnography: Goodall, Trujillo, and the necessity of storytelling'. *Storytelling, Self, Society: An Interdisciplinary Journal of Storytelling Studies* 10 (1): 299–306.

Hunter, Lynette and Shannon R. Riley. 2009. *Mapping Landscapes for Performance as Research: Scholarly Acts and Creative Cartographies*. New York: Palgrave Macmillan.

Irigaray, Luce. 2001. *To be Two*. Translated by Monique M. Rhodes and Marco F. Cocito-Monoc. New York and London: Routledge.

Jaeger, Peter. 2014. 'Modular form: A short introduction'. *Journal of Writing in Creative Practice* 7 (1): 3–8.

Jamie, Kathleen. 2005. *Findings*. London: Sort of Books.

Jamie, Kathleen. 2012. *Sightlines*. London: Sort of Books.

Jones, Simon. 2009. 'The courage of complementarity: Practice-as-research as a paradigm shift in performance studies' in *Practice-as-Research in Performance and Screen*, 19–32, edited by Allegue, Kershaw, Jones and Piccini. Basingstoke: Palgrave Macmillan.

Kerr, Heather and Amanda Nettlebeck. 1998. *The Space Between: Australian Women Writing Fictocriticism*. Nedlands: University of Western Australia Press.

Kershaw, Baz and Helen Nicholson, eds. 2011. *Research Methods in Theatre and Performance*. Edinburgh: Edinburgh University Press.

Kosofsky Sedgwick, Eve. 2003. *Touching Feeling: Affect, Pedagogy, Performativity*. Durham, NC: Duke University Press.

Koestenbaum, Wayne. 2007. *Hotel Theory*. Berkeley: Soft Skull Press.

Krauss, Lawrence and Stephen Hawking. 2007. *The Physics of Star Trek*. New York: Basic Books.

Krauthausen, Karin. 2016. 'Folding the narrative: The dimensionality of writing in French structuralism (1966–1972)' in *On Folding: Towards a New Field of Interdisciplinary Research*, 31–48, edited by Friedman and Schäffner. Berlin: Transcript Verlag.

Kreider, Kristen. 2014. *Poetics and Place: The Architecture of Sign, Subjects and Site.* London: I.B. Tauris.

Little, Suzanne. 2011. 'Practice and performance as research in the arts' in *Dunedin Soundings: Place and Performance*, 19–28, edited by Bendrups and Downes. Dunedin: Otago University Press.

Lockheart, Julia & John Wood. eds. 2008-ongoing. *Journal of Writing in Creative Practice.* Intellect.

Lomax, Yve. 2005. *Sounding the Event: Escapades in Dialogue and Matters of Art, Nature and Time.* London: I.B. Tauris.

Macfarlane, Robert. 2012. *The Old Ways: A Journey on Foot.* London and New York: Penguin Hamish Hamilton and Viking.

Macfarlane, Robert. 2015. *Landmarks.* London and New York: Penguin Hamish Hamilton and Viking.

McKenzie, Jon, Heike Roms and C.W.W.L. Wee, eds. 2010. *Contesting Performance: Emerging Sites of Research.* New York: Palgrave Macmillan.

Mallarmé, Stephane. 1979. 'Remémoration d'amis belges' in *Poésies*, 76. Paris: Gallimard-Poésie.

Manning, Erin and Brian Massumi. 2014. *Thought in the Act: Passages on the Ecology of Experience.* Minneapolis: University of Minnesota Press.

Massumi, Brian. 2002. *Parables of the Virtual: Movement, Affect, Sensation.* Durham, NC: Duke University Press.

Mathews, Timothy. 2013. *Alberto Giacometti: The Art of Relation.* London: I.B. Tauris.

Muecke, Stephen. 2016. *The Mother's Day Protest and Other Fictocritical Essays.* London: Rowman & Littlefield.

Nelson, Robin, ed. 2013. *Practice as Research in the Arts.* Basingstoke and New York: Palgrave Macmillan.

Pelias, Ronald. 2014. *Performance: An Alphabet of Performative Writing.* Walnut Creek: Left Coast Press.

Phelan, Peggy. 2004. 'On seeing the invisible' in *Live: Art and Performance*, 16–27, edited by Heathfield. London: Tate Publishing.

Pinker, Steven. 2014. *The Sense of Style: The Thinking Person's Guide to Writing in the 21st Century.* London: Allen Lane.

Pollock, Della. 1998. 'Performing writing' in *The Ends of Performance*, 73–103, edited by Phelan and Lane. New York: New York University Press.

Rawes, Peg, Stephen Loo and Timothy Mathews, eds. 2016. *Poetic Biopolitics: Practices of Relation in Architecture and the Arts.* London: I.B. Tauris.

REF 2012, Part 2D 'Main Panel D Criteria', p. 88. Available at: www.ref.ac.uk/media/ref/content/pub/panelcriteriaandworkingmethods/01_12_2D.pdf (accessed 12 October 2016).

Rendell, Jane. 2010. *Site-Writing: The Architecture of Art Criticism.* London: I.B. Tauris.

Richardson, Tina, ed. 2015. *Walking Inside Out: Contemporary British Psychogeography.* London: Rowman & Littlefield.

Rogoff, Irit. 2008. 'What is a theorist?' in *The State of Art Criticism*, 97–109, edited by Elkins and Newman. London and New York: Routledge.

Schad, John and Oliver Tearle, eds. 2011. *Crrritic! Sighs, Cries, Lies, Insults, Outbursts, Hoaxes, Disasters, Letters of Resignation and Various Other Noises Off in These the First and Last Days of Literary Criticism.* Brighton and Portland: Sussex Academic Press.

Serres, Michel. 1995a. *Conversations on Science, Culture, and Time* / Michel Serres with Bruno Latour. Translated from French by Roxanne Lapidus. Ann Arbor: The University of Michigan Press.

Serres, Michel. 1995b. *Angels, a Modern Myth*. London: Flammarion.

Shreyach, Michael. 2008. 'The recovery of criticism' in *The State of Art Criticism*, 3–25, edited by Elkins and Newman. London and New York: Routledge.

Skantze, P.A. 2013. *Itinerant Spectator/Itinerant Spectacle*. New York: Punctum Books.

Skantze, P.A. 2014. 'Shift epistemologies: Gap knowledge' in *MISperformance: Essays in Shifting Perspectives*, 245–254, edited by Blažević and Čale Feldman. Ljubljana: Maska.

Smith, Hazel and Roger T. Dean, eds. 2009. *Practice-Led Research, Research-Led Practice in the Creative Arts*. Edinburgh: Edinburgh University Press.

Smith, Phil. 2010. *Mythogeography: A Guide to Walking Sideways*. Axminster: Triarchy Press.

Spahr, Juliana. 1998. *Spiderwasp or Literary Criticism*. New York: Spectacular Books.

Spry, Tami. 2011. *Body, Paper, Stage: Writing and Performing Autoethnography*. Walnut Creek: Left Coast Press.

Stacey, Jackie and Janet Wolff, eds. 2013. *Writing Otherwise: Experiments in Cultural Criticism*. Manchester: Manchester University Press.

Stivale, Charles J. 2010. *Gilles Deleuze's ABCs: The Folds of Friendship*. Baltimore: Johns Hopkins University Press.

Strunk, William, E.B. White and Maira Kalman. 2007. *The Elements of Style Illustrated*. London: Penguin.

Sullivan, Graeme. 2010 [2005]. *Art Practice as Research: Inquiry in the Visual Arts*. Thousand Oaks and London: Sage.

Sword, Helen. 2012. *Stylish Academic Writing*. Cambridge, MA: Harvard University Press.

Vason, Manuel. 2015. *Double Exposures: Performance as Photography, Photography as Performance*. London: Intellect and Live Art Development Agency.

Watkins, Mary. 2008. '"Breaking the vessels": Archetypal psychology and the restoration of culture, community and ecology' in *Archetypal Psychologies: Reflections in Honor of James Hillman*, 414–437, edited by Marlin. New Orleans: Spring Publication Books.

Folding outwards 1

1

I AM FOR AN ART (WRITING)

Susannah Thompson

I first delivered this text in the context of a workshop on creative approaches to critical writing. The length of the paper necessitated brevity, so my argument had to be succinct. The result was manifesto-like oratory, all strident, impassioned and rhetorical. After the event, the written paper seemed flat and conventional in comparison, without the cadence and timbre of the piece 'as performed'. A re-editing and revision of the writing attempted to distil the key points from each section into the form of a classic art manifesto, modelled on – and in some cases directly appropriating from – Wyndham Lewis's Blast *(1914), Filippo Tommaso Marinetti's 'Futurist Manifesto' (1909 [2011]), Claes Oldenburg's 'I Am for an Art' (1961) and Oscar Wilde's 'The Critic as Artist' (1888 [1999]). The lack of qualifying statements to support or substantiate the arguments emphasises the playful, bold and irreverent tone of the piece. There are a few clunky, obvious puns and art in-jokes scattered throughout the text too, so while the overall points I try to express are serious, the manifesto itself (perhaps by necessity, in adopting a form with such historical baggage) is intended to be somewhat wry or tongue-in-cheek. It is my firm conviction that critical and creative writing need not be mutually exclusive endeavours, that criticality is often (whether deliberate or not) embedded in the form and style of writing as much as in its explicit 'content'. In my own writing I have often attempted to resist the hierarchies and taxonomies imposed by academia or disciplinary convention, writing across a range of often hybrid genres and forms which neither reject nor privilege the creative or critical but attempt to synthesize the two.*

I am for an art (writing) . . .

Down with Jonathan Richardson! I sit with Ernest and Gilbert in a library overlooking Green Park.

The critic may be an interpreter if she wishes, but our object is not to *explain* the work of art.

For the critic as artist, art writing *is* creative practice.

Art writing is not contingent or reliant upon the art to which it ostensibly 'responds'.

With Diderot, Baudelaire, Wilde and Pater, I am for an art writing for art writing's sake.

★

We're not special, and we're not new

Art writing is just one manifestation of 'creative critical writing'.

'Criticism in the expanded field' has bolted right over the fence, dragging an ever-increasing slew of terms and genres with it . . .

New Journalism, gonzo, faction,
ficto-criticism,
new nature writing,
site-writing, theory-fiction,
auto-theory,
aesthetic journalism,
anecdotal theory, object biography,
anti-memoir, critico-fiction . . .

We will not be constrained by categorization. We are the antithesis of Greenbergian medium-specificity. We are impure!

★

Don't choose your side

To those who proclaim the death of criticism . . .

To those who ask if more allusive, tangential, stylized, or creative forms of art writing replace evaluation, judgment, politics . . .

. . . I say: Must it be either / or?

We alter voice, mode and tone across our writing. We don't take sides in style or form.

To be oppositional is not to be critical. They are not synonymous.

Down with didacticism, paternalism, objectivity, critical distance!

Blast the explicit argument! Down with dogma! Long live wit!

Bless minor literature, ephemera, zines, small press, pamphleteering!

★

What even is it?

We are sculptural practices anchored by textual narrative.

We transgress borders between media and mode.

We exist as visual art practice, criticism, extra-literature.

We – artists, writers, historians, all – transgress our disciplines and conventions.
(Sometimes we maintain them.)

We meld anecdote and theory.

We foreground the subjective voice.

We speak our own argot, our own vernacular.

We revel in puns, polari, plagiarism.

★

Are you theory or practice?

Brickbats to academia! To slavish adherence to outmoded convention,
to the avoidance of personal pronoun.

Brickbats to the objective voice, to the deletion of adjectives!

Bouquets to art schools who embrace writing as a studio practice.
(We have taken less 'visual' forms into the fold – music, theatre, social science!)

Brickbats to the reductive equation with Concrete Poetry and text-based
Conceptual Art.
(Art writing can be all of these, none of these and more!)

Kick out those who insist on the estrangement of theory and practice, of 'creative'
and 'critical'. (They are NOT exclusive endeavours.)

Bring back critical writing that rejects its adjunct, parasitical status, that reflects, reciprocates with other forms of practice.

Writing in art schools should not = The Department of Dead Essays.

<div align="center">★</div>

The non-artist, cast adrift . . .

Art writers who don't define their work as art so often find themselves at sea. The tide is turning.

Behold the creative critic! We spurn the grain of tradition, vault taxonomies! We defy the 'output' imposed upon us!

Our criticality is embedded in form, voice, timbre. We have no need of the 'explanatory'.

We respect our audiences – we dumb UP!

Only shallow people do not judge by appearances . . .

Down with those who call art writing 'criticism lite'! Bad writing is bad writing, whatever its form.

To those who decry poetic and creative criticism, I say: form and style are essential vehicles through which judgment can be inferred.

Bless David Carrier! Style is crucial, for 'we cannot . . . extract an artwriter's argument from the text in which it is presented'.

To those who bemoan the fall of criticism into the 'merely descriptive', my challenge: read Dickens on Millais. Description can be devastating.

The poetic, the creative, the narrative, the fictional, the allusive are not new.

We are returning to the liberation of writing from 'service' to art.

With Baxandall, I am for an art writing in which 'most of the better things we can think or say about pictures stand in a slightly peripheral relation to the picture itself'.

I am for an art writing . . .

We will take a specific work of art as the departure point for
an autonomous piece of writing.

We will occupy a parallel or tangential relationship with the work.

We will be released from our contingency or reliance upon an art
work for its meaning.

We will allow both writing and art to operate separately, while offering
the hope of dialogue, reciprocity, poetry between the two.

I am for an art writing that understands its history, which sees criticism
as literature and literature as criticism.

I am for an art writing which is both.

With Baudelaire, I am for an art (writing) that is partial, passionate and political.

References

Lewis, Wyndham. 1914. *Blast: The Review of the Great English Vortex*. Issue 1. July.

Marinetti, Filippo T. 1909 [2011]. 'The Foundation and Manifesto of Futurism' in *100 Art-ists' Manifestos: From the Futurists to the Stuckists*, edited by Danchev. London and New York: Penguin.

Oldenburg, Claes. 1961. 'I Am for an Art' in *Environments, Situations and Spaces*. Exhibition Catalogue, Martha Jackson Gallery.

Wilde, Oscar. 1888 [1999]. 'The Critic as Artist' in *Intentions*. Cambridge: Proquest LLC.

2

LYRIC THEORY

P.A. Skantze

Three areas of research as a practitioner came together in the inspiration for creating what I call lyric theory: (a) composing the songs, words and music for a musical in which the New York Public Library saves New York City; (b) years of teaching and directing Shakespeare; (c) a research initiative called Voicing Revolutions which explores sound and resonance as theoretical investigative tools, voice in its specificities of race, gender, class and in its larger dimensions of communicative instrument, revolutions of vinyl on a turntable and of the citizenry in streets and classrooms.

We speak often of the desire for the interdisciplinary in our practice and research, and here in these lines I met the discipline on another plane, the discipline of counting syllables. Of course these lines while pentameter do not resemble a crafted poem; in fact part of the point of theory in pentameter is not to write theory as poetry but to have theory meet the lyrical, the demands of excising to fit the pentameter demands, the hope for a reader who can knot the line and turn the rope for the next tug towards the completed braid.

At least three questions remain in the interstices between lines, in the patter and the sound matter accentuating thinking as an acoustic corporeal practice. The matter of argument. I am worn down by the academic love of and demand for endless argument. What's your argument? How does that argument differ from other arguments? When is an argument a speck in the eye of the reader, a plank in the eye of the reviewer? One quality of practice is that it reveals: is revelation an argument?

The matter of occasional writing as a theorist. In the time of the scholar/practitioner, which is to say the time pressed down upon and squeezed by bureaucracies of nonsensical statistics or make-work email exchanges as proof of academic existence, much writing happens for an occasion, a conference, a collection, a festival. Does occasional writing constitute pursuing one's research in practice?

The matter of manifesto. Things are very bad right now. To say they are not is to close your eyes to the class warfare that is the education system in the UK and the US (and probably many other countries but these are the ones I know). Students not rich enough to be schooled in places where the traditions of learning are married to the traditions of ruling either in government or in business appear in classrooms so underprepared to think and read they should be listed as unaligned combatants. If what happens in the classroom is triage, then much of the writing and thinking I do as a practitioner ends up in the key of manifesto. Is a manifesto an argument? What are the occasions for a manifesto? How do we address each other thinking aloud, sounding out the thought while supporting the moment of clarity when we see how the system would love for us to make the state of affairs our fault? To speak of the constructed cynicism that is the Teaching Excellence Framework is to shout out, to remind each other not to drink the Kool-Aid that will leave us worrying about how to be ethical in a system that wants us to make work accessible so that the undertaught can become the worker bees for the overvalued. Thus my practice never strays far from the company of those writing about the state of where we are, who write too in a language of manifesto, whose manifestos analyse while they also encourage.

Lyric Theory

A Key to Lyric Theory Listening
Time and concision, undertaking pre-
cision, it won't all rhyme but short lines do
demand time not for the speaking but for
the tweaking of meaning and the gleaning

Take the aphorism: a short sharp shock
That elicits a long duree of paus-
èd thinking to decipher and explore
Bob Meister's 'debt is the tax we pay to
The private sector' dum da dum dum dumb
Live in that for a moment or let it
remind you of the last 'if you don't pay
this student loan bill we will garnish your
wages' letter and they don't mean with a
sprig of parsley or basil and certain-
ly not thyme. Pay or we will take the house,
the kid, the car, the cat, the beloved . . .
So these twelve syllables spoken by the
Meister creates twelve tone thinking, rever-
berating in time making time for time.
You will hear perhaps the pentameter
in this writing, a kind of sonic type-

writer where the end of each line demands
a flick of the oral wrist, push the carr-
Iage back to the next line and start again.

In their Lyric Theory Reader Prins &
Jackson write 'reading lyric, where lyric
is the object of interpretation
involves lyric reading . . . not as an ob-
ject of thought but as a mode of percep-
tion, an instrument of thinking', Oh yeah
It's not the meat, it's the method that makes
my baby want to shout. It's not the meat
it's the method that turns her inside out.
One instrument of thinking, a lyric
one, takes shape in the words of Guattari.
He describes a girl child in the scary
dark as she sings to give shape to the de-
territorialized world around her,
the night where monsters proliferate on
the side of the cosmos and the Im-ag
in-ary. Every one, Every group ev-
ery nation is thus equipped with a
basic range of incantatory re-
frains'. In the old TV cartoon Fat Al-
bert, one character, scrawny, vulnera-
ble crosses a dark bridge at night, he gets
from here to there safely because he has
his song . . . dum dum da dum da dum da dum.
Why can I still remember imitate-
ting this strategy, humming against the
coming storm or fist? Was I always se-
duced by sound? Or was it the combinat-
ion of fear of ridicule, of comfort
in rhythmic nonsense that made this motley
colored crew, motley in size, in shape, in
hue memorable, my sonic posse.

Bifo Berardi, he of the alli-
terative moniker, philosopher,
Italian writes, 'the refrain an obses-
sive ritual allows the in-di-vid-
ual' — Pause, digress, a definition:
Berardi must clarify indivi-
Du-al in an appositive [that hap-

py, come on get happy, grammatical
hip shift]. He defines individual
as 'that conscious organism in con-
tinuous variation' . . . Ahh, so that's
useful, a squirming lively thing that must
from time to time politically a-
lign its variation alongside oth-
ers respecting their continuous var-
iation. But still needing to get col-
lective work done — well more about align-
ment later. And back to the refrain sung
by the individual as a kind
of identity spelunking, accor-
ding to Berardi, to find identi-
fication points. Discovering the re-
frain she describes her territory and
represents himself to the surrounding
world. I self i-dent-I fy as a [fill
in the blank] or don't — but do we other
identify, filling in whose blank? What
blank? Tricky the blanks and the filling here.
Still what if our refrains were ways of bump-
Ing up against each other, exploring
Variation and solidity? El-
ias Krell speaking of transvocali-
ty recently at NYU re-I-
terated this living mix of fluid-
ity and place, of flexibility
and staying still, occupying. Time spent
standing for something with someone settled
between shifts, before the next continu-
ous or contin YOU US variation
Berardi names the individual.
Or 'dividual' a term Arun Ap-
padurai revisited at the breath
taking and breathgiving Cultures of Fi-
nance Group Conference. Let me digress again:
finance, please, not my cup of tea or fair-
trade coffee. But here's the thing, like Berar-
di's *Poetry and Finance* we cannot
escape the maw, the mouth of capital
gains And thus capital gaining on us,
but we can stick the rather incongru-
ously sturdy toothpick of poetry

into the maw while it stretches wide to
consume. Think of financial Creatures sud-
denly unable to chomp down on us,
the absurd joy of words 'reopening
the indefinite' As Berardi writes,
'an ironic act of exceeding the es-
tablished meaning of words'. That propped open
mouth wants to close in order to reduce
everything not just by violent crunching
but by 'been there, done that' deployed dismiss-
sal a drying up like the word 'whatev-
er' in response to a need for something
more than linguistic shrugging. The 'techno
-linguistic machine that is the finan-
cial web acting as a living organ-
ism – its mission to dry up the world'.
To dry up words, husks blown through the speakers.
Empty concision, without precision.

Rhythm Methods

D&G, not the designers but the
philosophers write of rhythm and re-
frain. How rhythm is the con-ca-ten-a-
tion between breathing and the surrounding
world. Refrain the only way to create
con-ca-ten-na-tion as cadence as con-
nective bumping – remember that dance? The
Bump? Or maybe in the pseudo nostal-
gia commercially induced by TV
The Bump has reappeared? Somehow this ev-
o-cation of rhythm and breathing mix-
es with my desire for a way to
think aloud together about . . . well to-
gether. So the dance the Bump comes to mind
It could be a political meta-
phor – how we form allegiances bod-i-
ly, strategically, testing where the
contact makes sense, doubles our sense, where we
find points of contact, indentifica-
tion points at the hip, the knee, the butt, thigh?
Sound, resonance comes not only in the
music accompanying our movements – Watch!
And listen can you do the silent Bump?
Who would want to, when you can laugh and groan?

The philosopher James Brown corrects our
collective action – 'get on the good foot'.
And maybe it's a white dance in a black
space, the black space that is JB's music
The white space that is a graceless if fun-
ny move of hip against thigh, butt against
shoulder. Yet this is part of the explor-
ation? The risk of whitishness, blackish-
ness, queerishness, transishness, straightishness,
finding the not always smooth contact points,
forgiving each other for the awkward-
nesses that occur when we acknowledge
continuous variation, when we
change our mind, our body, our pronoun(s)? All
of us need a few hospitable clues;
the unique resonance of voices poss-
ible because we bump up against points
of contact. Contact is not melding, it
holds its distance in respect of the var-
iation in answer to 'who we are'
that day, while it makes room for collective
plural singular action, voices raised.

It's tempting to dismiss this play as play
but it's practice: where in 'the e-con-o
my of loss vocality belongs to
the horizon of nonsense' as Ad-ri-
ana Cavarero explains and then
she dismantles the Platonic value
of speech as thought idea. Remember
Plato? The guy who gave us the acous-
tic brush-off In the 'intemperance of
the acoustic realm'? Instead what is real-
ly at issue in speech is a vocal-
ic relation between mouths and ears mak-
ing the uniqueness of the voices vi-
brate in their resonance . . . Or Holderlein,
the casual wonder in his phrase, 'since
we are a dialogue' but 'dia' ob-
scures the multiple in resonance, and
'logue' keeps us philosophically stacked
in incorporeal logos. Arendt,
Cixous, Cavarero fellow travellers
for the practice of refrains. Not, never

refraining from poetry or writing
as Cixous deams the medium of wri-
ting, the form that 'stops the least' . . . When you read
her writing again, after many years,
she still leaves you breathless, like the pop song
says. Here is an echo of Berardi's po-
etry as language of excess when he
urges us to employ its strategic
power: 'a reactivation . . . calling
for the de-automating of the word,
a process of reactivating sen-
suousness . . . the voice in the sphere of so-
cial communication, the infinite
game of interpretation'. Get on the
good foot – in the political and met-
rical realms. But listen up now people.
Doesn't that sound like Cixous? Claiming voice
'as in fact the name of a pleasure that
overflows language'. We need to teach phil-
osophers, scholars, the moves, like the Bump.
Bifo needs to do more than find Jean Luc
Nancy's thigh or Deleuze and Guattari's
butt because it is so shocking that the
generative circle of the voice, vo-
cality, writing about resonance
with the financialization of ev-
eryday life still sounds out a masculine
pitch. Believe! The pronoun here is 'he' when
push comes most assuredly to published
shove. So up against other hips Bifo!
Particularly Cavarero's your
compatriot in ideas and nation.

Still mashups remain a composer's task,
scholarly lyric, writing stanzas that
make of the rich works combined a refrain?
And the need is great. The urgency is
clear. The disentanglement of social
life from the ferocious domination
of mathematical exactitude is
a poetic task . . . an insolvent e-
nunciation in the face of symbol-
ic debt . . . Hear Berardi's portrait of now:
'the central project of Europe now-a-

days is the destruction of collective
intelligence, more prosaically,
the university, subjugation
of research to the narrow interests of
profit and competition'. How true dat.
Power, Arendt reminds us, is gener-
ated by interaction, lasts as long
as the time and space and the active re-
lation. It cannot be accumulate-
ed. Which I think explains its resonant
sweetness that we sit and think about what
we have said to one another, where the
last echo falls, the four seconds it takes
the vibration in our ears to disperse,
to decay between us. Whoosh, let go, try
again, separate, regroup, listen and
speak, return to your refrains – try out new
verses, wander off, come back. Enter a
Chorus you're not sure of, Concatenate
Agitate, Rest, Reverberate, Resound.
Sounding out a plurality in the
absolute local deemed by Cavarer-
ooooh as a condition where recipro-
cal speech 'signifies the sexed Uniqueness
of each speaker', a feminist perspec-
tive to trace speech back to its vocalic
roots extricating speech from the perverse
binary economy [one as dang-
erous to a trans revolution as
the tired heteronormative troughs
of he and she] that splits the vocalic
from the semantic and divides them in-
to two genders'. Two for the price of . . . two
in the service of the One — the One per-
cent who eat our confusion for breakfast
in Berardi's words 'when capitalism
has never been so close to its final
collapse but social solidarity
has never been so far from our daily
experience'. Shall we hum out loud? Stop
and chat, work against the time of no time,
time gone, time remaining, txt a refrain,
speak a nonsensical ditty, undo
the time of linguistic automation.

Charlie Chaplins all with our email wren-
ches and the rushing belt of fake emer-
gencies like quality assurance lang-
uage in teaching or the bogus interest
in student satisfaction when we can't
get no and nor should it be measured,
quantified with forms designed to pander.
Leave with Charlie, toss the tools and do the
funny walk and hum your refrain until
someone picks it up and adds a note, an
essential note, one you did not even
know you were missing, reverberating.

Leave, but leave and stay now as Fred Moten
and Stefano Harney suggest, part of
an abiding Undercommons where those
who work for the love of the work 'for those
moments beyond teaching – beyond rehears-
ing, beyond thinking aloud together
when you/us/we give away the unex-
pected beautiful phrase, make the unex-
pected beautiful rhyme or rhythm or
echo: unexpected, no one has asked,
beautiful, it will never come back'. Here —
wherever your work is — use poetry
to change it — it's easy all you have to
do is pucker up your lips and then bump.

References

Berardi, Franco (Bifo) 2012. *The Uprising: Poetry and Finance.* (Los Angeles: Semiotexte).

Cavarero, Adrianna (2005). *For More than One Voice: Towards a Philosophy of Vocal Expression.* (Stanford, CA: Stanford University Press).

Cixous, Helene (1992). *Coming to Writing and Other Essays.* (Cambridge, MA: Harvard University Press).

Cultures of Finance Group Conference 2016 https://ipk.nyu.edu/working-groups/cultures-of-finance

Krell, Elias, https://vassar.academia.edu/EliasKrell

Meister, Robert (2012). *After Evil: A Politics of Human Rights.* (New York: Columbia University).

Harney, Stefano and Fred Moten (2013). *The Undercommons: Fugitive Planning and Black Study.* (London: Minor Compositions).

Prins, Yopi and Virginia Jackson (2013). *The Lyric Theory Reader.* (Baltimore: Johns Hopkins Press).

3

NOTITIA, TRUST, AND 'CREATIVE RESEARCH'

Iain Biggs

Introduction

Categorical language, and the disciplinary mentality that underwrites it, arguably provide the greatest challenges facing creative research that needs to write honestly as/about practice. Why? Because once we engage with creativity's ambiguities and paradoxes we are forced to acknowledge that 'we are always both more and less than the categories that name and divide us'.[1] Ferdinand von Prondzynski, vice-chancellor of Robert Gordon University, offers another reason, suggesting that universities (as guardians of that language and mentality, and assumed to be prime generators of new knowledge in society) are now among its most reactionary and conservative institutions.[2] An archaic position he relates to a *realpolitik* that, unlike Higher Education's public rhetoric, remains deeply embedded in disciplinarity.[3]

I am caught up in a conversational practice located in a volatile professional space between 'artist', 'educator', 'writer', 'researcher', and 'activist'. This responds of necessity to synergies and tensions with other roles and responsibilities: centrally that of caring for my chronically ill daughter and partnering a carer, patient advocate, and creative activist. This situation informs my interest in the 'shift from Certainty to Trust'[4] regarding institutional activity, particularly in medical science and psychiatry, and reminds me that 'creative research' can also be heard as analogous to 'creative accounting'.

This chapter will suggest that the convergence of art and creative research foregrounds issues of trust when *notitia* is enacted as a 'careful attention that is sustained, patient, subtly attuned to images and metaphors' that tracks 'both hidden meanings and surface presentations'.[5] This supposes that *notitia* is common to what is most responsive in dialogical art, education, relational ethics and in conversation that is 'allowed to remain open so as to await the unforeseen whilst allowing ideas to converse with time itself without any foreclosed end set out in advance'.[6] *Notitia*

is further understood here as a form of listening that attempts 'to recover the neglected and perhaps deeper roots of what we call thinking'.[7] This is particularly relevant to issues of trust in relation to institutional power, given that 'we are the inhabitants of a culture hierarchized by a *logos* that knows how to speak but not to listen' – a culture of 'competing monologues' authorized by disciplinary, categorical thinking.[8] This validates creative conversation as a means to support 'apprenticeships in listening' since:

> If, as an art, conversation is the creation of worlds, we could say that to choose to have a conversation with someone is to admit them into the field where worlds are constructed. And this ultimately runs the risk of redefining not only the 'other' but us as well.[9]

Creative research as *notitia*

I refer here to two very different creative works centered on and by *notitia*. The first, the action *Edge and Shore: Acts of Doing*, involved the dancer Laila Diallo and the artist/maker Helen Carnac in an exercise in performative research into the dynamics of trust. Extracts from a text made in response to that action and related conversations are included here (italicized text) so as to ground the reader in trust as a performed or improvised event, a corporeal conversation.[10] The second work is *Voices from the Shadows*,[11] an hour-long ethnographically inflected film by Natalie Boulton and Josh Biggs. This consists of edited conversations with young

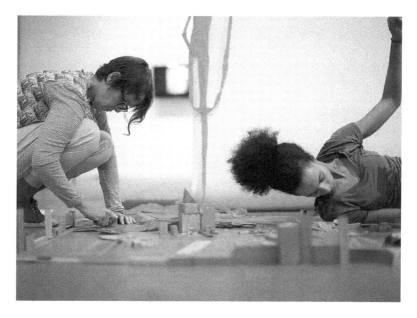

FIGURE 3.1 *Edge and Shore*. Photo Max McClure.

people suffering from chronic Myalgic Encephalomyelitis (ME) and their carers. The film links the two understandings of 'creative research' touched on above, since it is caught up in an ongoing controversy surrounding the *PACE Chronic Fatigue Syndrome Study* (hereafter *PACE*), a controversy that highlights issues of listening and trust.

Performing (and not performing) trust

They begin casually with hand-written words as if scoping a problem but become more focused as these are collected up. Each reads a word out loud in turn, an editing process during which Laila drops selected sheets onto the floor. The scale and tenor of the whole action then changes. A small table and assortment of wooden blocks becomes an intimate theatre for hands. Helen and Laila take turns to offer each other noisily constructed configurations of blocks. Helen's tend to the vertical, Laila's to the horizontal. Words have been replaced by permutations of blocks pushed back and forth. The proximity of each permutation to the table's edge becomes a question, focusing my attention more closely on their relationship. The pull and push crackles with an energy amplified by gesture, facial expression, and stance. Suddenly Laila changes the dynamic, using her blocks to map the space around her hand. Helen responds, building her own hand space into Laila's. I sense trust enacted.

My daughter, now in her mid-thirties, has suffered with ME since her early teens. Our family has responded to this through ME advocacy, including raising funds for and making *Voices from the Shadows* (*VftS*). This enables five ME patients and their carers to tell their stories, which are intercut with observations from Dr Nigel Speight, Prof. Leonard Jason, and Prof. Malcolm Hooper, three distinguished experts in the field. Premiered in 2011 at the Mill Valley film festival, this award-winning film has subsequently been shown at the Association for Chronic Fatigue Syndrome / Myalgic Encephalomyelitis conference, Ottawa (2011), Stanford University ME /CFS Symposium (2014), and in parliament buildings, cinemas, universities, and private homes. Recently, however, it has been claimed in a confidential letter to the British Medical Association that a doctor giving the parents of a child suffering from ME a DVD of *VftS* is acting unprofessionally because the film 'portrays professionals in a bad light'.[12] This complaint highlights the distance between forms of research as an extended act of *notitia* in which interpersonal trust plays a key role and conventional assumptions of 'certainty' assumed by both science professionals and institutional authority, an assumption now increasingly being defended through claims of professional defamation.

The claim that *VftS* portrays professionals in a bad light is at one level entirely accurate, since the participants recount actions in their own experience by professionals that amount, on occasion, to serious and sustained mistreatment that, in occasion, border on open sadism. That this testimony is then used to try to discredit professional individuals critical of such actions is consistent with long-standing attempts to deflect criticism of *PACE*, now shown to be both poor science and mired by the vested interests. Criticism of *PACE* intensified in December 2015 when independent experts – notably James C. Coyne, a

FIGURE 3.2 Still from Voices from the Shadows.

professor of psychology in both the USA and the Netherlands – were refused access by two universities to data claiming to support the trail.[13] The main justification for this refusal parallels that levelled at the film, that professional researchers were being subjected to a campaign to discredit the *PACE* study, causing them reputational damage.

This refusal has triggered the exposure of a larger set of issues. These include the three main investigators in *PACE* being involved in writing the protocol for a major review of their own trial,[14] and the complicity of respected journals in a wholesale validation of the inappropriate methodology on which it was based. Coyne has detailed wider social implications, noting that one of the paper's authors undertook paid work for a group attempting to deny social welfare payments to people with chronic physical illness, and has promoted the view that ME, regardless of its cause, is extended by a fear of exertion (despite that fact that this view has been scientifically discredited). The same author also provided testimony supporting forcing chronically sick ME patients to take more exercise and the revoking of individual ME patients' benefits.

Dr David Tuller has amplified this criticism, pointing up collusion between those promoting increasingly discredited research claims and those formulating social policy. He has shown that *PACE*, in addition to being 'fraught with indefensible methodological problems' and presenting 'claims of successful treatment and "recovery" . . . based on subjective outcomes', has, in promotion of its findings, hidden conflicts of interest where individuals' involvement in governmental imperatives to 'stem health and disability costs' related to ME are incompatible with the obligations of objective research.[15] Such criticism clearly extends the controversy from a specialist debate about scientific protocols to the political domain,

where there is growing complicity by scientists in ideologically driven social policy, a complicity aided and abetted by powerful media entities.[16]

Such political links return us to the question of *notitia* and public trust. That the two academic institutions denied access to research data in direct contravention of agreed conditions for the publication of their researcher's work – namely that authors are 'to make freely available any materials and information described in their publication that may be reasonably requested for the purpose of academic, non-commercial research'[17] – can be read in a variety of ways. As signalling a greater concern for their staff's sensibilities and reputations than for contractual obligations; as a reflection of an unthinking arrogance predicated on a presupposition of their own certain authority as institutions; or as an example of 'creative research practice', a calculated attempt to protect their ability to attract future funding in the face of increasingly detailed scientific criticism of the *PACE* study. To establish which, if any, of these readings is accurate will depend, I suggest, on a public and open conversation that can be seen to enact, or not enact, *notitia*. Clearly no such conversation will take place, since both the institutions and individuals involved have too much to lose. However, the controversy will no doubt continue, since at the time of writing it is extending to include discussion of the role of different medical journals in validating and promoting *PACE* as scientific research.

The makers of *Voices from the Shadows* set out to document:

> the devastating consequences that occur when patients are disbelieved and the illness is misunderstood. Severe and lasting relapse occurs when patients are given inappropriate psychological or behavioral management: management that ignores the reality of this physical illness and the severe relapse or exacerbation of symptoms that can be caused by increased physical or mental activity, over exposure to stimuli and by further infections.[18]

This required the film to make it clear that the belief in behavioural and psychological causes promoted by *PACE* (the orthodoxy still taught to British medical students and healthcare professionals) risks perpetuating the abuse it documents, particularly when ME has become chronic as the result of professional mismanagement. To claim that suggesting to parents of a child with ME that they view this film is an unprofessional and inappropriate act because it 'portrays professionals in a bad light' amounts, in my view, to a gross and self-serving distortion of an act of *notitia*. Fundamentally it constitutes a denial of the empathetic 'openness to one another' without which 'there is no genuine human relationship',[19] an openness necessary to any public performance of trust.

Laila now returns to her previous 'on the spot' sequence of movements. Helen meanwhile pins torn words and letters to a semi-transparent hanging screen that turns one corner of the room into a darker, store-like space. This action ambiguously insulates that area, since the words are repositioned, even destroyed, by her actions. There is a sense of persistence that, despite its inwardness, appears profoundly protective, as if a shelter is being prepared, although for whom and against what remains open.

FIGURE 3.3 *Edge and Shore.* Photo Max McClure.

The maintenance of trust

Listening as *notitia* needs to be seen for what it is, a basic professional requirement in both arts and science research properly understood. While *Edge and Shore*, read here as a condensed performance of trust, takes a very different form to *Voices from the Shadows*, both are predicated on and perform the centrality of the relationship between listening and trust. At a time when those involved in creative relational practices are increasingly arguing for the centrality of a conversational listening (e.g. Koh 2015; Bailey *et al.* 2014; Szewczyk 2009), it is important that writing as/ about creative research practice understands and acts responsively to the requirement to perform *notitia*.

Notes

1 Finn (1996: 156).
2 von Prondzynski (2008: n.p.).
3 von Prondzynski (2010: n.p.).
4 Latour (2013: 7).
5 Watkins (2008: 419).
6 O'Neill (2012: 12).
7 Fiumara (1995: 13).
8 Fiumara (1995: 85).
9 Szewczyk (2009: 2).

10 These are reworked from my 'Edge and Shore: Acts of Doing (surveying the edges of place and practice)' – notes towards a partial translation 26 July 2015, published online at: www.iainbiggs.co.uk/2015/07/edge-and-shore-acts-ofdoing-surveying-the-edges-of-place-and-practice-notes-towards-a-partial-translation/ [accessed 12 April 2017].

11 This can be viewed free at https://vimeo.com/ondemand/22513/108797012 using the promo code VOICES.

12 For reasons of confidentiality further details cannot be given here.

13 All material regarding the *PACE* controversy referenced here and not otherwise attributed is taken from either CO-CURE@LISTSERV.NODAK.EDU or http://blogs.plos.org/mindthebrain/author/jcyone/. Restrictions on the word length of this chapter make more detailed referencing impractical.

14 See http://niceguidelines.blogspot.co.uk/2015/12/principal-investigators-of-pace-and.html and http://onlinelibrary.wiley.com/doi/10.1002/14651858.CD011040/full [accessed 21 December 2015].

15 Tuller (2015: n.p.).

16 Monbiot (2003).

17 See http://journals.plos.org/ [accessed 13 April 2017].

18 See http://voicesfromtheshadowsfilm.co.uk [accessed 15 December 2015].

19 Fiumara (1995: 28).

References

Bailey, Jane, Ian Biggs and Dan Buzzo. 2014. 'Deep Mapping and Rural Connectivities' in *Countryside Connections: Older People, Community and Place in Rural Britain*, edited by Hagan Hennessy, Means and Burholt. Bristol: Policy Press.

Finn, Geraldine. 1996. *Why Althusser Killed His Wife: Essays on Discourse and Violence*. New Jersey: Humanities Press.

Fiumara, Gemma Corradi. 1995. *The Other Side of Language: A Philosophy of Listening*. London and New York: Routledge.

Koh, Jay. 2015. *Art-Led Participative Processes: Dialogue and Subjectivity within Performances in the Everyday*. Helsinki: Academy of Fine Arts, University of the Arts.

Latour, Bruno. 2013. *An Inquiry into Modes of Existence: An Anthropology of the Moderns*, translated by Catherine Porter. Cambridge, MA and London: Harvard University Press.

Monbiot, George. 2003. 'Invasion of the Entryists'. *Guardian*, 9 December. Available online: www.monbiot.com/2003/12/09/invasion-of-the-entryists/ [accessed 12 December 2015].

O'Neill, Paul. 2012. 'To Go Beyond – The Emergence of the Durational Commons' in *Surface Tension Supplement No 5: Beyond Utopia*, edited by Warren and Mosely. Berlin: Errant Bodies Press / Surface Tension Supplement no. 5.

Szewczyk, Monika. 2009. 'The Art of Conversation, Part 1'. *e-flux journal* 3. Available online: www.e-flux.com/journal/art-of-conversation-part-i/ [accessed 26 November 2014].

Tuller, David. 2015. 'TRIAL BY ERROR: The Troubling Case of the PACE Chronic Fatigue Syndrome Study', ME Association. Available online: www.meassociation.org.uk/2015/10/trial-by-error-the-troubling-case-of-the-pace-chronic-fatigue-syndrome-study-investigation-by-david-tuller-21-october-2015/ [accessed 13 November 2015].

von Prondzynski, Ferdinand. 2008. 'The Modern University: Corporate or Academic?' in *A University Blog: Diary of Life and Strategy Inside and Outside the University*. Available online: http://universitydiary.wordpress.com/2008/06/page/2 [accessed 13 October 2017].

von Prondzynski, Ferdinand. 2010. 'A Post-Disciplinary Academy?' in *A University Blog: Diary of Life and Strategy Inside and Outside the University*. Available online: http://universitydiary. wordpress.com/2010/14/a-post-disciplinary-academy/ [accessed 13 October 2017].

Watkins, Mary. 2008. '"Breaking the Vessels": Archetypal Psychology and the Restoration of Culture, Community and Ecology' in *Archetypal Psychologies: Reflections in Honor of James Hillman*, edited by Marlin. New Orleans: Spring Publication Books.

4

WRITING WITHOUT WRITING

Conversation-as-material

Emma Cocker

Conversation-as-material is a practice of 'writing without writing' that I have developed over a period of years through a series of artistic research collaborations: (1) Re— *(with Rachel Lois Clapham), (2)* The Italic I *(with Clare Thornton) and (3)* Choreo-graphic Figures: Deviations from the Line *(with Nikolaus Gansterer and Mariella Greil). Within this approach, conversation is conceived not only as a means for reflecting on practice, but also as a generative and productive practice in and of itself, both site and material for the construction of inter-subjective and immanent modes of linguistic 'sense-making'. For each of the above named collaborative projects, a 'sample' extract is presented in the form of an artists' page, alongside reflection on the evolution of the method itself.*

In order to progress we have to … just go with the idea.[147]

(T)his is (a) space which is generative and I don't quite know what that is (but) […]

if I have a hope for it … it is that something *not* known, or not previously known is somehow produced […] Ultimately it is a question of form […] *and* (of) an endeavour.[6]

(T)o build in spaces that are more speculative you have to build in spaces that are more speculative.

(B)etween proposition and response […] some sort of pattern of not knowing.[106]

Possibilities escalate in terms of what it is capable of and how different meanings are produced […] There is a definite play.

(S)omething is being diagrammed towards […] A gesture is drawn in advance of knowing what it enables.[7]

(T)he active spaces of the work are the places […] where I am not *quite* sure what is happening.[94]

It is ultimately speculative which isn't to say *not definite*. (They) are trying to say something, but not […] enough to *know* what they are saying.

The thing that is *not* being said […] is where the work comes from. (It) reveals itself in the shadow of what is being consciously produced.

(T)he points (where) a decision is made … to *do* something. It is (o)nly ever an accumulation of […] decisions.

(T)here is a repeating structure, but […] how do you have change within that?[31] (H)ow do you repeat *without* repeating (?)

(W)e are in the territory (between) what we have already done and the possibility of what … might be.[48]

(T)here is a blindness (;) a grasping or a groping.

Sample 1

Re—
A collaboration with
Rachel Lois Clapham.
Extract from perfor-
mance script.

Re— is a collaboration between myself, Emma Cocker and Rachel Lois Clapham that presses on two writers and two writing practices coming together, focusing on the tension between the visible / invisible, or public / private states of not knowing within the performed act of writing. *Re—* comprised a series of performance lectures, the 'scripts' for which we generated through conversation undertaken for reflecting together on the endeavour of writing-as-practice, the event of collaboration, the labour of making the work itself. The conversation was subsequently transcribed verbatim, attention paid to noting the peripheral and the incidental, those parts of conversation that could have gone unnoticed, that functioned as asides. The process of conversation-as-material involves the quest for a not-yet-known vocabulary emerging synchronous to the live circumstances that it seeks to articulate. Here, meaning does not exist prior to the event of utterance; rather it is co-produced through the dialogic process of conversation itself, moreover, is often only discernible in retrospect once the conversation has been transcribed, distilled. Transcribed conversation is compressed towards a vocabulary of poetic fragments, alongside the development of an emergent system of micro-gestures diagramming towards those parts of dialogic exchange that exist *beyond* words, affirmation of conversation's sensible, affective potentiality. Reassembled as a live performance reading – two practices sit side-by-side, their means restricted to broken fragments from earlier conversations and mute utterances of a finger pointing, nails pink; a spoken text of dislocated phrases; a diagram drawn; the space of breath. Within *Re—* reflection on the process of making does not come after the fact, but rather becomes folded into the material of the work itself. An attempt is made to trouble the normative chronology within practice, collapsing the distinction – perhaps even the perceived hierarchy – between preparation, performance, documentation and reflection.

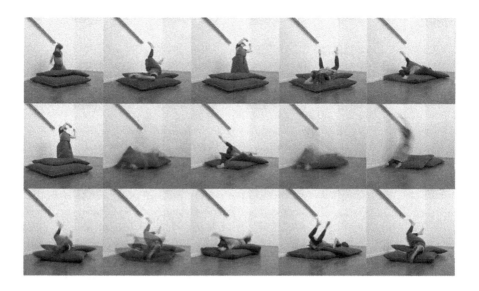

Folding of Attention
— a heightened subjectivity

Not disorientation but a shift in orientation.
Elemental transformation. Composition.
Composure. Compose. Fall into an
arrangement. Going inward. Turned
backward. Inverted. Inversion — to turn
or change; turn inside out, to fold. To turn
around on an axis; revolve — from *volvere*,
to roll or wind. Turn over, rolling on the
tongue; the release of language from itself.

Gravity/Levity
— striking the right balances

Hand striking the floor, marking time.
Push and pull; lag or drag. Tempering —
to calm, to modify its properties. Restraint
has positive force, a necessary tension.
Keeping form, one foot on the ground.
Anchoring, maintaining the equilibrium.
Retaining the lightness, bring to ground
without weight.

Breathless
— ventilating the idea

Decompress. Distill. Cooling down but
not towards resolution. Maybe it is useful
to bring in fermata, the inverted arc …
extended beyond normal duration. Beyond
sustaining a note. Considered pause, return
or realignment.

*To tune, to make tones available to
different keys. Temper. Temperate.
Temporal. Repeat the heating and cooling,
softening and solidifying of language.
Molten flex. Changes in temperature –
plunge to cool, desire to distill, regroup.
Melt it down again. Avoid the snap back
into brittle form.*

*Binaries mark out the pitch within
which to play, enables the curves
to happen, something to work
against. Goading us. Hot/cold.
Liquid/solid. Soft/hard. Doing/
thinking. Attending to the interval
– as an active space, against the
desires of habit.*

Sample 2

The Italic I
A collaboration with
Clare Thornton. Extract
from artists' publication.

The Italic I is a collaboration with Clare Thornton, for exploring the states of potential made possible through purposefully surrendering to the event of a repeated fall. Alongside performance and its documents, our enquiry has involved the construction of a poetic lexicon generated through the 'free-fall' of conversational exchange, for reflecting on the interior complexity of falling that its visual expression can only intimate towards. Together in conversation we seek to practise linguistic or even cognitive falls, searching for a language adequate to the task of articulating the experience of falling *through* falling. We ask: what happens if talking about practice is no longer an event of explication, but instead performed in the same key as doing? We aim towards a condition of exhaustion and elasticity in word and thought, stepping off or away from the stability of fixed subject positions towards the fluid process of co-production, intermingling of one another's word and thought. Akin to the body repeatedly falling, language can be generated from within fall-like circumstances, words pressured until they begin to arc and fold. Over and over, turned up and inside out, language can be rolled around in the mouth until it starts to yield or give. In the live-ness of conversation, words can often slip and spill into existence; thought conjured in the live event of its utterance, verbalised at the point of thinking leaning into the unknown. The specific rhythm of conversation produces a different shape and texture of textual articulation compared to that of conventional writing, a form of writing *without* writing. Significantly, its cadence or rhythmic pacing – its pitch and intonation, the tempo of speech – can often be of rising and falling, dipping and peaking. Excited acceleration. Hesitation. Deliberation. Syncopation. Abbreviation. Words dropped. Omissions. Repetitions. Sentence incompletion. Disregard for punctuation. Hurried utterance. Syllabic glides and slurs. By transcribing and distilling our conversation towards a working lexicon for reflecting on the arc of falling, our intent was to retain something of the original cadence, alongside the potential for slip or switch in tense, inflection, imperative or mood. We recognise it can be difficult to shape experience into words, language can sometimes seem too stiff or rigid, like the

The inherent movement
of the body
sets the line in motion.
Breathing into
the instable line.
Stretch of attention:
attempt to reach towards.
Between the line of
the drawn mark
and line of the body:
physical contact
without physical contact,
touching without touching.
A strange arc begins:
experience of exclusion,
sitting on the periphery.
Witnessing intensity:
following and leading,
reciprocity.
Attempted rapprochement.
More nuanced reach
through the extension
of affect into shadow.
Shadow: product of both
self and world,
an ambiguous 'I'.
Between the physicality
of a body, its environment
and the light:
a meeting point,
place of encounter.
Between the physical
and the virtual,
the corporeality of
the shadow:
bodily yet intangible,
ephemeral
yet still graspable.
A level of intention
at the limit
of the shadow.
Attention – field of immaterial
embodiment extended into space,
a milieu into which to operate.
Movement of a thought
and the movement of a body:
symbiotic intimacy.
Touch has contour,
creates a field of energy.
Wavering convergence.
Like air flows
or oceanic currents,
upwelling of wind,
downwelling of water.
Arising of liquids,
of emotion, building up
or gathering strength.
Downward movement
of fluid: of the sea,
the atmosphere,
depths of the earth.
Cartography of currents
and flows, surges and swellings,
deepening: the dynamic
of how things
emerge.

body it also needs to be stretched and flexed. Yet, for us, this perceived difficulty of 'putting into words' is transformed from problem into provocation. We ask: why would one not want to stretch, cultivate one's agility in speech as much as action, nurture one's endurance for working out with words? How might language be exercised akin to lungs and limbs? Conversational sparring enables a form of thinking and articulation beyond what is often conceivable on one's own; it is a means for drawing, forcing – even forging – language into being, a practice of *poesis* as much as of poetics.

Sample 3

Choreo-graphic Figures: Deviations from the Line A collaboration with Nikolaus Gansterer and Mariella Greil. Extract from a performance score.

1 Stern (2010).

Choreo-graphic Figures: Deviations from the Line is a collaborative artistic research project with artist Nikolaus Gansterer and choreographer Mariella Greil (working alongside invited interlocutors Alex Arteaga, Christine De Smedt and Lilia Mestre, and guest collaborators Werner Moebius and Jörg Piringer). Our shared research enquiry explores the dynamic movements of 'sense-making' within collaborative artistic practice, seeking to develop modes of performativity and notation (*choreo-graphic figures*) for making tangible this often hidden or undisclosed aspect of the creative process. Through live exploration we seek to give tangible articulation to the register of 'vitality forces'[1] and affects (which we call *figuring*) operating before, between and beneath the more readable gestures of artistic practice. We ask: *How do you attend to the thing that isn't visible? What other realms are there to find? Resonance. Reverberation. Tremulous vibration. It is sometimes hard to see the relatively imperceptible – this quivering edge when something is happening. Magnifying the minor. Starting to look nearer or closer. How we move when we move; there is tone and velocity and rhythm, like changes of state.* Our enquiry unfolds through the interweaving of different fields of shared practice: *Aesthetic Exploration*: designated period of time for working intensively together towards the embodied production of sensual knowledge, generated through live processes of artistic experimentation; *Practices of Attention*: sensory heightening and somatic hyper-sensitising for cultivating qualities of perceptual awareness and alertness, for practising readiness

Daniel Stern, *Forms of Vitality*, Oxford and New York: Oxford University Press, 2010.

2 Stern (2010: 122).

and receptivity; *Practices of Conversation*: conversation-as-material used for generating a form of embodied language emerging from the enmeshing of our different voices in live exchange, involving the production of an inter-subjective, *un*disciplinary language that is both subjective *and* impersonal. Within this project, conversation-as-material is used as the source from which to tentatively distil a working vocabulary for articulating aspects of enquiry (presented here as italicised text in addition to the artists' page). Moreover, as Daniel Stern reflects, unscripted, spontaneous speech is itself a vitality field, which requires physical as well as mental movement, where there is a kind of 'imprecise, messy, hit-and-miss work to find the "right words" to communicate what one wishes'.[2] *Almost like divination, the phrasing is coming, but you cannot grasp it: full of ellipses and swirls. Something in excess of what can be imagined. Seeking a language immanent to what we are doing. Naming the unnamable. Calling – more like an invocation. Precise vagueness. Babbling – wilderness, unrestrained.* Increasingly, the transcribed conversations have been used more explicitly within our process of artistic exploration itself, as both a textual script and a physical material with which to further experiment: conversation-as-material aerated through the performative 'ventilating of meaning' as a live event.

5

THE DISTRACTED CYCLIST

G.D. White

What kind of writing do I do? I write plays, and academic research, generally on very separate topics and using very different techniques. Sometimes the two overlap and coalesce, but it's hard to say what kind of writing that is until it happens. Sometimes a kind of documentary-drama. This time? It seems to be sort-of B.S. Johnson meets Alfred Jarry somewhere off the South Circular . . .

The CYCLIST pushes his bicycle along a pavement

THE CYCLIST: A simple brief, for a reflection on creative and critical practice. And if I reflect upon it *en route* . . .

The CYCLIST mounts the bicycle and heads off into the suburban traffic

> . . . in the process of travelling to and arriving at the place of work, some of the reflecting might get done in ways that it won't when sitting still. I can do it, find a frame for that practice, think about the ways of thinking about, and finding a form for, and shaping, practice, and making that shaping informed and rigorous. That's the keyword, isn't it, in both? How is being rigorous to be done, in the creative and the critical? So, is being rigorous being careful? Taking the road forking downhill here should mean being careful, it needs care, the brake is looser than it should be, it was meant to be tightened, this weekend, as ever, no good setting off on a journey without the tools in place, multitool in fact in bag, I could stop to reset the brake, pull the cable through a little farther, make this a little tighter, a little safer, a little . . . No, no need for safety, plunge on. But what if the safe thought is the thought which calls thinking back, rigorously, to the context and the influence, the pre-considered reflection on the instances and incidents . . .?

The CYCLIST narrowly avoids a collision

> . . . that could have been an incident, that was me not look-
> ing the right way, not consciously in the moment. If someone
> else was looking the right way they would correct me and alert
> me and show me what is naïve and what is foolhardy and what
> is simplistic and general, rigorously, don't step out there thank
> you! On my way past . . . thank you.

> The chlorine from the swimming pool, drifting into the street,
> always here, always a comfort, odd. But that's distraction, have
> I arrived at anything? Is this a rigorous way to go? It's the only
> way to go . . .

The CYCLIST enters a tunnel under a railway junction

> . . . into the foot tunnel, the two-way switch through the bar-
> rier without touching down with a foot, yes! The triumph of
> flowing with the bike out of the tunnel, triumph, well, yes,
> that's overstated, but why not? Flow is the current of inspired
> coordinated action, no thought, improvisation, who needs
> structure and precedence and form? Except this is form, even
> this, the practised pretence of non-form, of mimicking thought.
> How bloody modernist of you. Is this a stream of conscious-
> ness? Could I suggest that? 'I'll use a stream of consciousness
> technique', that has its rigour. I don't just mean it'll be words
> in a stream, it'll mimic in some way some version of the ways
> of speech . . . and thought. I mean, it'll be Joycean. In a lim-
> ited sense − well, in no sense really, that's an absurd compari-
> son. And it's not Dublin is it? It's a backroad in Streatham,
> small houses, streets down towards Lonesome, trapped by the
> railway line − the times I sat on those trains looking down at
> these streets, not imagining travelling through them day in day
> out . . . Where is this going? Pay attention; Attention! Is that
> Huxley? Huxley, *Island*, attention, utopia, think some uto-
> pian thoughts, how might that be useful? How might you put
> together a utopian picture of the critical and the creative? Is the
> critical ever utopian? Isn't it always comparative, explorative,
> testing, questioning, rigour undermining fixed conclusions and
> breaking up the ideal? Can you be utopian with rigour? Can
> you? One would seem to invalidate the other in fairly compre-
> hensive ways . . .

The CYCLIST encounters a headwind

> This headwind from the corner is going to be all along the
> flat lands now, right through, pushing against it, a mid-route

doldrum, although the doldrums don't have winds, that's the point, no progress, no headway, isn't that Braidotti? A theorised position, the old theorists of my old uni, critically embedded, often with each other, or the guy who asked the question at the graduate colloquium and then failed to finish it and had to stop, embarrassed, shamed, and then a couple of weeks later he was under a train, that's not the job of rigour, is it, to put someone under a train by its sheer intimidating bulk? Where's the play and the wit and the sense of possibilities? The balance of creative and – the garage there I love, a glimpse inside, grime everywhere and an old calendar Renoir by the door, but this other one is its *AA Book of the Road* opposite, everything in pristine over-alled splendour in between two of the terraced houses – there's rigour, if rigour is 'the cardinal virtues of traditional grocery', that's quotation, is that Joycean enough now? B.S. Johnson, or Bryan, quoting a hypothetical *Daily Telegraph* opinion, about the rigour of an establishment, and that garage, its rigour is mainte-nance always of ordered standards proven to be effective and to offer value for the customer, so does that work, is that the REF critical model now? The value shining through, financial and ethical, the two consistent and conflated . . .

The CYCLIST encounters a Rubbish Lorry

. . . this is the day for the bin lorry, switch to the cross street named after English seaside towns but who names them and is that a creative act? Is there anything playful in that moment down the planning department? Or is it generated by an algo-rithm? I can never spell rhythm, like the new car name what's that coming now, I wouldn't know if it hit me, but it's slow down mate, I'm out into the road to make you . . . Thank you. Who's that old guy on the bike? Isn't this the, or it's near here, where I turn up on StreetView, the old bloke on the bike like that end of term photo a student took of our class and I looked and thought who's the old bloke in the corner, oh, it's me . . . Distracted again – Attention! You're nearly halfway and this is not getting expressed in the ways that it needs to be, is it? They're not going to want this. The creative and the critical act, some kind of informed reflection. It's what I always say to the students writing plays what you want to say and the form in which you say it are the same thing and you won't see that now but you will as you cut and cut and cut away who was the guy? Gordon Lisk? Lish? I read in the paper, the one day a week it's a paper, who edited Carver, cut him to the bone and turned him into what he became and then Lisk says he's not interested in

people, or some such, that he might be autistic, is it then form that interests him, just as, if I'm a critic and I'm not, or I'm never writing as an critic of composition other than for my students and then as a guide and so when I'm looking for models I'm looking again and again at the same plays because they seem to answer the questions the students have, how to find forms, *A Number* and *Far Away*, *The Cherry Orchard* and *Party Time*, *Long Day's Journey Into Night* and *Blasted*, *The Playboy of the Western World*, and they answer those questions described, not read, the last time they were read or seen, I'm very taken with *Performance Art in Ireland*, a beautiful book, one I could lose myself in but somehow I'm glad to have never seen any of the Performance Art in it, to only have it there as an anthology, like that lecture the activist gave about the 60s/70s Dutch theatre company with the slides of the show about the rent strike and the political consciousness raiser and the kids show and the protests outside the theatre when the funding was cut and the new pieces working with community groups and the whole history could exist without the shows having existed so perfectly did they mesh with the moments of their conception and . . .

The CYCLIST crosses a busy road junction

. . . this is always hairy how do they get ambulances in and out of St George's when the traffic is so thick and they need to save lives and make sure *24 Hours in A and E* is on telly? That's rigour, the demands of an academic facility like a teaching hospital, rigour as definitions of life and death and the possibilities of stopping one from becoming the other, the possibilities which might change if the discoveries and processes and practices of research, their research practice, is rigorous enough to preclude error, just like my squeezing outside of the bollard along a stationary flow of traffic into the opposite carriageway . . . for just enough . . .

The CYCLIST squeezes past oncoming traffic

. . . time to pass without the oncoming car getting shirty and made it despite the loud blast on the horn, thank you, attention! It does cow me somehow, make me more child than adult, chastise, but brings me back now to thinking, again, critical and creative, how do I work with, or between, or among, which would be the term, about, or trans, just trans, or inter, or intra, or perhaps con, or cum, criticalcumcreative, criticalitycumcreativity, creatcumcrit, this is getting dubious and rubbish. Try again. Is criticality a spur to creativity or are these things the

same, the one and then the other or the forms intermerging —
is this research, me on a bike in the wind passing the car
showrooms — The time the salesman asked me — is this the
protocol of sales? — 'Who's the decision maker in your family?'
Could he have been any more by the book, the crib sheet, is that
being rigorous? Following the cues, the steps, ensuring that the
statement made is the logical conclusion of the research done
into the efficacy of many possible statements to many possible
customers at that kind of possible moment which leads to a stu-
pid outcome or . . . up the hill now and it's a long hill . . .
I wonder whether thinking and physical exertion . . .

The CYCLIST labours on a hill

. . . exist in an inverse relationship . . . efficacy of one . . . under-
cut by the . . . other, but . . . I'm trying . . . to get to work, and
. . . I'm trying . . . to get to the nub of the critical . . . but my crit-
ical is not everyone's and . . . I'm not particularly interested . . .
in my response to a play . . . or an article . . . or an idea and I'm
not really interested . . . in the appraisal of an artwork through
the frame of an idea, look how . . . this text is illuminated . . . by
that text . . . but I am very . . . interested in how . . . the impulses
to order . . . how impressions . . . and ideas . . . the fleeting . . .
and the systematically . . . and laboriously worked through . . . are
the same impulse in the critical . . . and in the creative, and in the
audiences . . . and the stories to be told . . . and how the sense of
resolutions . . . or revolutions . . . or deliberate . . . undercuttings . . .
or challengings . . . returns . . . and the . . . need to keep . . .
some shape and . . . structure . . . for the kids as . . . they step
out of . . . being kids and . . . for the students . . . who are
kids . . . and need to find ways . . . to step out . . . of being
kids . . . while still . . . being the kids . . . they were and need
to continue to be if they're going to . . . protect the things . . .
which make them . . . themselves and . . . the one thing . . .
I do in my . . . critique of . . . their work is take them . . . seri-
ously and take it . . . seriously . . . even if the . . . first thing . . .
they will find . . . once it leaves the safety harness . . . of this . . .
and (look, here we are . . . school kids streaming in their blaz-
ered public school privilege . . . in the wild . . . millionarism
of Wimbledon . . . no longer in the millenarianism of Tooting
Broadway . . . and Wolfie Smith down the hill) . . . and slips . . .

The CYCLIST gratefully reaches the top of the hill

. . . out into the world . . . What was I on to? They'll not get
taken seriously easily, so let's indulge them, in the face of every

move to reduce the possibility that there will even be time to take them seriously . . .

The CYCLIST rolls freely now

. . . that in the face of the post-60s slide away from the chance of experiment into the moment now – and there's a sixties garden, the one from the cover of *Unhalfbricking* and that was some serious experiment with form and tradition with the sleeve capturing family in age and youth – but it hid and covered something, whatever drove Sandy Denny and a voice I never liked when I was younger but I begin to see it, to hear it now and who knows where the time goes? This hill can be taken down and up the other side . . .

The CYCLIST picks up speed as he travels downhill

. . . without peddling unless someone gets in your way and . . .

Isn't that a bit like writing?

It can be a good thing to be distracted but when is distraction the place for inspiration . . . and when is it the man from Porlock come to tear attention away from higher things with the everyday, but then who says those are the higher things? Isn't that it, the mingled mix of forms and impulses the beginning and the end of all of it all?

The CYCLIST avoids a pedestrian

Watch it, Sunshine . . .

. . . Is that Eric Morecambe . . .?

The CYCLIST executes a perfect rolling dismount through the entrance to his place of work.

6

FOOTNOTING PERFORMANCE[1]

*Mike Pearson[2] with John Rowley[3] and
Richard Huw Morgan[4]*

D.O.A.[5] (written on 25 March 1995)[6]

1 The concept herein is to annotate, explicate, expand and gloss a performer's verbatim written mem-
 ory of the first few minutes of a theatre production, and to reconcile it with other accounts and
 documents (historical and contemporary, scholarly and creative) through the use of footnotes in the
 manner of editions of Greek and Latin texts or Shakespeare's plays; or as an 'analogue hypertext'. For
 footnoting model see Pearson (2013a).
2 Artistic director, Brith Gof 1981–1997; director of *D.O.A.*; complier of footnotes. Brith Gof was
 founded in 1981 in Aberystwyth by Pearson and Lis Hughes Jones: between 1990 and 1997, it was
 based in Chapter Arts Centre, Cardiff.
3 Performer with Welsh theatre company Brith Gof, 1990–1997; author of main text.
4 Performer with Brith Gof 1990–1997; source of a single sheet of numbered, hand-written personal
 notes that parallel Rowley's account – Morgan a. To provide orientation, he divides the ground plan
 into 25 squares labelled A–E on the horizontal axis and 1–5 downwards on the vertical; Morgan is X,
 Rowley is Y. Also a double-sided, typed A4 sheet of Brith Gof company notes of 'Alterations and
 developments since Mike's original document' – Morgan b. And a 16 minute 39 second rehearsal
 video – Morgan c. Morgan a and c are undated and unplaced in the creative process.
5 A performance created by Brith Gof in 1993. After the acronym 'Dead On Arrival'; or 'Death Of
 Arthur'; or in a Welsh coinage 'Dim Ond Angau' (trans. 'Only Death').
 'The four works of the Arturius Rex project – *D.O.A.* (1993), *Camlann* (1993), *Cusanu Esgyrn*
 (1994) and *Arturius Rex* (1994) – mirrored events in Yugoslavia following the death of Tito, and the
 ensuing internecine strife and the breakdown in social order, with the collapse of Roman rule and
 authority in Britain, and the exploits and demise of the semi-mythical King Arthur. Both precipitated
 a vacuum for internal chaos: factional fighting, the rise of warlords, invasion, the redrawing of the
 map, the creation of independent nations' (Pearson 2013b: 145). A fifth work, *Pen Urien*, remained
 unperformed.
6 *D.O.A.* was premiered in the backyard at Chapter, Cardiff, on 7 October 1993. Rowley's text was
 written almost 18 months after the first staging.

1.[7] The way is hard[8] – We (Richard and myself[9]) run[10] into the 'box',[11] via the only operational door.[12] We are carrying Dave[13] so the only means to open the door is to give it a sharp kick.[14] The audience[15] has obviously, by their reactions, not been prepared for this rupture.[16] In an instant they change from their state of cool curiosity, passivity to one of panic, confusion, fear (Of what? This is only theatre after all).[17] They are caught in some kind of crossfire, innocent bystanders, wondering what the fuck they have gotten themselves into, what's going to come through the door next – HOW CAN WE GET OUT OF THIS SITUATION? We are hyper-ventilating, sucking in the dust,[18] parched, feeling the weight of Dave. We are one minute into a performance of just over sixty minutes.[19] How are we going to get through all this? The audience (The Witnesses) have found what they hope to be a 'safe' place to view from. There are no safe places to view from here. They stick themselves to the wall space and when this is not possible

7 Section 1 of 17. See footnote 19.
8 The title of Plate 14 in Francisco Goya's series of etchings *The Disasters of War* (1967 [1863]). 'The title of each section will be spoken in Welsh, with key words chalked on the walls of the room. The only texts in this first half will be repetition of these titles. According to the tone of each individual section these repetitions are whispered, shouted, sung etc singly or obsessively' (Morgan b).
 'In Brith Gof's work the etchings were regarded as photographic moments' (Pearson 2006: 211); they were copied, emulated and elaborated to inspire physical action in the Arturius Rex project.
9 Rowley.
10 'Suddenly two men in filthy combat clothing rushed in . . .' (Pearson 2010: 74).
11 The setting was a roofless cube, 12 feet by 12 feet by 16 feet high, the scorched black wooden walls supported in a scaffolding frame. 'D.O.A. tracks the last few hours in the life of Arthur with his companions in the Black Chapel' (Brith Gof press release, 14 September 1993).
12 The door was the sole point of entry. When closed, it was flush with the wall. It is at A3 in Morgan b.
13 Dave Levett – performer with Brith Gof 1992–1994. Levett is Z in Morgan a.
 Morgan a: '1) X & Y enter, breathing heavily, carrying Z.'
 '. . . carrying disabled actor Dave Levett as the wounded Arthur, screaming and shaking in distress' (Pearson 2010: 74).
 'He will not use his chair in the performance . . .' (Brith Gof notes to performers – three single-sided A4 typed sheets by Mike Pearson, undated – Pearson 2013a).
14 '. . . the handleless door flies open and two men rush in carrying a third who is writhing and screaming . . .' (Pearson 2013b: 173).
15 '. . . fifteen spectators were enclosed with them . . .' (Pearson 2013b: 145).
 Morgan a: '2) Stop near door. At E5, X & Y look around at eye level.'
16 Gloss: 'rupture' – a term used in Brith Gof to denote a sudden, unexpected change in dramaturgical pattern or dynamic flow.
17 '. . . the scene is chaotic . . .' (Pearson 2013b: 173).
18 Gloss: 'sucking in the dust' – from the dried mud caking the performers' clothing.
 Morgan a: '3) X & Y move to B1, repeat 2.'
19 'Dramatic Structure. D.O.A is a performance of 70 minutes [*sic*] over which time it becomes increasingly less theatrical. There are two halves of approx. 30 minutes with a 5 min "interlude". In the first half, there are 17 sections of 2 minutes: three men in a room, one of whom is severely wounded.' 'This half will be extreme, loud, emotional, dynamic, unstable. It will be detailed, "acted", "dramatic". For the audience this should be an almost intolerable bellyful of theatre! And as the Arthur story will never be mentioned, it could resemble an incident in Bosnia.' 'The second half is increasingly cooler/less dramatic' (Morgan b).

they huddle in corners, jostling amongst friends (or possibly strangers), hiding as much exposed body as they can. Some let out small embarrassed laughs, some are open-mouthed (a sharp intake of breath). A few hold their hands up to their faces, and I remember that the large amounts of garlic eaten before the show are having an effect.[20] Without a signal the three of us shift into another space, causing the witnesses to scramble for new positions,[21] also now realising the amount of filth on our garments[22] and so try to keep out of direct contact with us, to save their own garments (HOW SHOULD ONE DRESS WHEN GOING TO THE THEATRE?). Richard breaks the silence by uttering, 'THE WAY IS HARD',[23] which are the first words he has spoken in a Brith Gof show (after three years of near-silence).[24] He then leaves Dave and myself. Over the duration of the project and subsequently, I am still not completely sure of his actions in these moments.[25] I am now holding Dave alone. Dave has CP[26] and is unable to help me with his weight – This is 'dead' weight, like manhandling a sack of potatoes.[27] I speak for the first time – 'THIS IS WHAT YOU WERE BORN FOR'[28] – Dave has been directed to stretch out,[29] to make himself as 'large' as possible and to struggle. He is unwieldy as I try and compensate for his shifting position and it feels, at this stage in the show that if there is going to be an accident,[30] this is the time when it will happen (we are about three or four minutes into the performance by now).

20 Smell played a significant role in creating the fetid atmosphere in *D.O.A.* Later, in the 'interlude' the performers would feed Levett with their fingers from opened tins of sild.

21 'The performers will need to brush past them, and perhaps fall against them, but are not directly addressed' (Morgan b).

22 Rowley and Morgan wore grubby boots, combat trousers, vests and army greatcoats, Levett a one-piece tank commander's overall.
 '. . . three grimy and frightened men in a frightening situation, wearing the distressed remnants of dirty and reeking uniforms . . .' (Pearson 2013b: 173).

23 Morgan a: '4) X,Y & Z move to B5, repeat 2. X delivers line 1.'
 It is Rowley himself who speaks this line in English in Morgan c.
 Morgan a: '5) X,Y & Z move to D5, repeat 2.'

24 Morgan had performed in *PAX* (1990–1991), *Los Angeles* (1992), *Ar y Treath – Patagonia Remics* (1992) and *Haearn* (1993).

25 In any physical sequence of duets amongst the three performers, one undertook solo actions.

26 CP – cerebral palsy. 'When he was born, he was not breathing. This caused damage to the motor functioning areas of his brain . . . He cannot stand unaided. Nevertheless, he generates tremendous pull and grip with his arms, and push with his legs' (Pearson and Shanks 2001: 16).

27 Crossed out in Rowley's original.

28 In fact, in English for the second time. Goya Plate 12.

29 '. . . he works with the actions his body wants to make. So pull can become embrace, hold, grip, fight, tear. And push becomes caress, reject, threaten. His work requires a force of enormous will, directly experienced by those of us who hold and touch him in performance, as he organises the effort and imagines his physical goal. Of course, he doesn't make conventional signs, rather a hovering net of gestural hint and suggestion. But we know what he means: we experience him "as experiencing/as expressing/as signing". Whilst it may be ambiguous in semiotic terms, it is fascinating and seductive' (Pearson and Shanks 2001: 17).

30 'I once dropped him. And he fell like a stone. Fortunately his body is tough. But he has no defence, no protective mechanism. To work with him is to know total responsibility' (Pearson and Shanks 2001: 20).

Richard has returned; the fear of dropping Dave has subsided. Richard has 'found' a bed[31] in the corner of the space and has positioned it, ready for us to place Dave upon it. As soon as Richard returns to help me with Dave, Dave then proceeds to writhe uncontrollably, screaming like an animal in the last throes of its life.[32] I catch people's eyes. They are obviously horrified, squinting, skin tight, teeth biting and grinding together. They pull back, like those repulsed but realise that there is nowhere to go. They feel helpless to act on any impulse they may have. This is (Is this?) THEATRE after all? We throw Dave onto the bed[33] which causes dust to fill the atmosphere and I am aware of some people a foot or so away coughing, stifled coughing. Stifled, I assume, so as to not draw any attention to themselves. Dave is thrashing about and screaming, sometimes in silence, sometimes voiced with saliva escaping and playing about his face.[34] Our bodies smother him, try to settle him,[35] also making sure that we are creating pictures for both sets of audience or witness. Those above (whom I have not yet mentioned and have not been aware of in performance terms) looking down over the edge of the 'box' by means of a built-in 'balcony'[36] and those who are in the box with us, on the same level. From our experience of performing *D.O.A.* we realise that you can never really assume where the audience will precisely be at any one time so must constantly be aware that the action images that you are creating are being opened up or directed to the positions where the audience have placed themselves.[37] Dave becomes passive on the bed. We release the positions in tension that we have been holding. It is quiet. You can feel the audience breathe for the first time since the performance started. A micro-second later – Richard 'DAU – YN RHESYMOL NEU'N

31 'In this space were a metal bedstead, a bucket and a standing audience of fifteen' (Pearson 2010: 74). The bed had a bare mattress and a single dirty white sheet.
 Morgan a: '7) X pulls Bed to floor from Wall. Y holds Z struggling.'
32 Morgan a: '8) X moves to Y. X & Y carry Z to bed.'
33 Morgan a: '9) X & Y place Z with Z's head at B2, legs at B3 on bed. Z begins to struggle more.'
34 'Occasionally, he can hitch a ride on the randomness, in a fury of physical abandon. At other times, he can achieve an awesome and terrible stillness. However, as we always joke, the one thing he can never do on stage is "die". A dance of impulses: intended, random and spasmodic' (Pearson and Shanks 2001: 17).
35 Morgan a: '10) X lifts Z's to A2½, Y lifts Z's legs to B2½, and hold down Z as Z struggles.'
 Morgan a: '11) X & Y restraining Z move up body to Arms and pull Z's arms out to A1 & A4 respectively.'
 Morgan a: '12) Holding Z's arms X & Y. X & Y look away from Z and let go of Z's arms. Z rolls from side to side on bed. Drawn to and repulsed by Z & Z's injuries. X & Y lunge towards Z as Z rolls to their side but stop short of contact, then turn away.
 Here Rowley wrote a single in chalk on the wall – "Reason".'
36 'Above them, forty others peered down over the wall from a scaffolding walkway' (Pearson 2010: 74).
37 'Performing primarily on the bed, two different perspectives were available. In the room his torments were experienced at an oblique angle, in close-up. For those above, he composed graphic, two-dimensional images within the frame of the bed' (Pearson 2010: 75).

AFRESYMOL . . . HYN SY'N DIGWYDD POB TRO'[38] – the break which announces the second section.[39] In a half breath we explode outwards, chewing the atmosphere with desperation[40] – 'THERE IS NO MORE TIME'[41] . . . Roughly five minutes have passed. Only another sixty to go . . .

John Rowley. Finished 15:49 on 25/03/1995.

Re-typed from the original (on thermal paper) without correction or addition on 08/03/2016.

References

Goya, Francisco. 1967 [1863]. *The Disasters of War*. Translated and edited by Philip Hofer. New York: Dover.

Pearson, Mike. 2006. *In Comes I: Performance, Memory and Landscape*. Exeter: University of Exeter Press.

Pearson, Mike. 2010. *Site-Specific Performance*. Basingstoke: Palgrave Macmillan.

Pearson, Mike. 2013a. 'One letter and 55 footnotes: The assassination of Llwyd ap Iwan by the outlaws Wilson and Evans'. *Parallax* 19 (4): 63–73.

Pearson, Mike. 2013b. *Marking Time: Performance, Archaeology and the City*. Exeter: University of Exeter Press.

Pearson, Mike and Michael Shanks. 2001. *Theatre/Archaeology*. London: Routledge.

Taylor, Ann-Marie. 1994. 'Out of the box rooms'. *Planet* 105: 70–76.

38 Trans: 'Two – With or without reason. This always happens.' See Goya Plates 2 and 8.
 'I hope the performance can be in "dog-Welsh"' (Pearson 2013a).
 'In *D.O.A.*, performers struggled to speak Welsh in a desperate attempt to convey the horrors of war, scrawling in chalk on the black walls . . .' (Pearson 2013b: 145).

39 The beginning of Section 2 of 17. 'Each section is full-bore and there are instantaneous changes from section to section which will be devised in great detail and each will have a theme: grief, resuscitation, arguing, praying, drinking, dancing . . .' (Pearson 2013a).
 Each of the 15 two-minute sections had a Goya title spoken at the beginning before the action commenced, as both heading and instruction. A series of physical interactions often resulting in tableaux; '. . . seeking in its overcharged (but highly disciplined) physicality, to create a kind of hyper-naturalism, and in its deliberate refusal of easily framed images, a challenge to television pictures of the Bosnian conflict' (Taylor 1994: 74).

40 Gloss: 'chewing the atmosphere with desperation' – the effect of gasping for breath in the dusty atmosphere.

41 Goya Plate 19.

7

AN EXTRACT FROM *ASARA AND THE SEA-MONSTRESS*

A play with theory

Mojisola Adebayo

Asara and the Sea-Monstress (*Asara*) is a play that tells the story of a left-handed girl on a quest for freedom and self-expression in the mythical right-handed West African Kingdom of Dexphoria. I developed *Asara* through workshops with children as writer-on-attachment at Birmingham REP theatre and Unicorn Theatre, London.[1] Act 1 of the play had a public rehearsed reading at Birmingham REP in 2012 and I later produced a full staged reading at Albany Theatre, London, in 2014 for an audience of children, parents, guardians and friends. In writing this play my aim was to find a way to discuss homophobia with children from four years old upwards (accompanied by adults), by using the idea of prejudice against left-handedness as a metaphor to explore minority sexualities, difference and discrimination, through a black queer lens. I set the play within a West African context and a black and accessible aesthetic, inclusively integrating a cast of British African-Caribbean actors many of whom are also LGBTQI+, D/deaf and disabled, interweaving re-interpreted folk tales and myths, music, movement, puppetry, British Sign Language and cartoon animation. Following positive feedback from children and adults who watched the staged readings, I plan to take the play into full production with workshops in 2019.[2]

As part of my research for the play, I engaged extensively with black, queer, socialist feminist and disability rights theories including the working of Sara Ahmed, Jack Halberstam, José Esteban Muñoz and Robert McCruer. When I wrote up the script as part of my practice-as-research doctoral thesis, I presented the play on the left-hand side of the page with a series of connected critical notes on the right, to reveal how the play and theories are in dialogue with each other and illuminate each other.[3] In this chapter I offer a short extract of the full text.[4] I play with the theory and theorise the play. This mode of presenting my research goes some way to challenging the hierarchy of critical over creative writing, which still negatively pervades British academia, exemplified in exercises such as the Research

Excellence Framework. Therefore, for me it is important that the play script comes first, on the left-hand side, and the critical notes are an accompaniment. These pages seek to reveal how reverse binaries privileging right before left, male, white and straight before female, black and queer, critical theory before theatre practice, are often played out. In this action I take up James Thompson's assertion that 'Theatre is the research method itself, not [just] the method to be researched'.[5] As Shakespeare's Hamlet says, 'the play's the thing'. My presentational choice was influenced by *Arden Shakespeare* commentaries where critical notes shed light on the play texts.[6] My notes are deliberately fragmentary and glued together through the dramaturgical structure and narrative of the play script itself. Although plays with critical commentaries are common for the study of Shakespeare, a critical commentary like this is unheard of in the world of children's theatre. However, it is important that adults working with and for children have resources to enable them to unpack the powerful homophobic and heteronormative messages that are being disseminated to children at an early age. My hope is that the full publication of the critical notes alongside the full play script will in the future prove useful for scholars and practitioners, including the team of artists taking *Asara* from page to stage, plus facilitators and teachers exploring the themes raised in post-show workshops and discussions. The play, however, should not be read as a mere demonstration of theories. My creative writing more often leads my critical thinking and choice of theoretical references. As Alyson Campbell and Steve Farrier discuss, performance can lead queer theory.[7] In the extract you are about to read, I am responding to the need that Kathryn Bond Stockton has identified: 'Instead of seeing fictions in need of theories' explanatory moves, I would show how theory (that strangely reified, ossified term) needs new fictions'.[8] *Asara* is an example of fiction that theory is in need of.

An extract from *Asara and the Sea-Monstress*
NB: Numbers correspond to critical commentary notes.

Asara's Birth

*ASARA's family home, a simple hut inside
a walled compound in the fictional West
African Kingdom of Dexphoria. PAPA dashes
on with the big fish in his arms. WITCHES X
and Y are coming out of the hut, carrying a
bowl and cloths, badly disguised as
midwives.*
PAPA *(in BSL and speech to WITCH X)*: Did
I miss it?
*(MAMA ASARA, sitting in bed with baby, calls
from inside).*

Critical commentary

1. Born fist first

Sara Ahmed frames her brilliant *Willful Subjects* with a Grimm Brothers fairy tale about a badly behaved child who dies but their arm keeps shooting up from the grave. She writes: 'The Grimm story can be read as part of a Protestant tradition that views the child's will as that which must be broken. The willful

MAMA: Where have you been?!

PAPA *(calling back)*: Catching dinner! *(Showing the fish to the 'midwives')*

WITCH Y: Your first-born has brought you luck it seems.

(PAPA goes in surprised and delighted. WITCHES X and Y hide outside, watching the action through a window. WITCH Z sits in the corner of the room with MAMA).

PAPA: Baby came early!

MAMA: You came late!

PAPA: I'm sorry.

MAMA: *(Softening)* Lucky those midwives were passing by.

(They smile tenderly at each other).

PAPA: Can I hold . . .

MAMA: Her.

PAPA: Daddy's girl! *(PAPA takes ASARA and gives MAMA the big wet fish. ASARA takes PAPA's finger).* She's a strong one! *(To the midwife)*

WITCH Y: She came out fist first *(showing her left hand).* **(1)**

MAMA: Like she couldn't wait to touch the world.

PAPA: Then we must call her 'Abirtha' − 'about one who's birth there is a story'.

WITCH X: Asara. **(2)**

PAPA: What's that?

MAMA: I suspect it means 'troublesome'.

WITCH Y: She certainly gave us some trouble.

MAMA: Asara, sounds pretty though don't you think?

PAPA: What about our tradition? We can't just pluck a name from the sky! *(ASARA starts to scream at his raised tone).* What shall I do?

MAMA: Sing her a lullaby.

PAPA: Me??

MAMA: Talk to her then, tell her a story.

PAPA: Which story?

WITCH Y: Think.

(A beat).

child . . . must be punished, and her punishment is necessary for the preservation of the familial and social order . . . The story could be "heard" as a command to the imagined child who reads the story: obey!'[9] Asara's left arm shoots not from the grave but from the cradle of her mother's body. A re-constructed queer / feminist shero is born. Ahmed considers that 'it might also be in feminist and queer fairy tales that wilfulness is embraced or reclaimed'.[10] Asara is such a willful subject, countering conformist warnings from Grimm tales of old. The play shall not be heard as the command 'obey' but as an encouragement to be whoever you want to be, not defined by family or social order but driven by your own will, your own desire, child.

2. What's in a name?

In Yoruba culture a name can be prophetic. (Mojisola means 'I wake up to wealth'. I sleep walk apparently ;-). In black lesbian literature too, naming is often significant.[11] The play is part of both my Yoruba and lesbian traditions. The name Asara comes from the Arabic word, 'asara', meaning 'to render difficult, arduous, troublesome'. The name for a left-handed person in Arabic is

PAPA: Now, be a good girl, not like naughty little Toshun, the beautiful girl named after the river, who returned to it as an ugly monster!

MAMA: Can't you tell her a nicer story?

(*PAPA walks with the baby and continues the story*).

PAPA: A long time ago there was a kind farmer with only one daughter, Toshun, which means 'the river gave me'. Her mother came from the tribe-on-the-other-bank but she died from malaria. So the farmer was soft on Toshun for she was all he had. He wanted her to marry a rich man so she could live in comfort and –

MAMA: – pay him a big fat dowry, exchange his daughter for a sack of money . . .

PAPA: He wanted her to be a *happy* wife. Many rich suitors came to woo but Toshun said . . . **(3)**

Toshun

Projected animation instantly takes us from the hut to the farmer's well-to-do house in the story. PAPA immediately plays FARMER and MAMA plays TOSHUN. TOSHUN has short hair. WITCH Z continues to interpret in BSL but now she is up on her feet, in role as a storyteller.

TOSHUN: NO! I DON'T WANT TO GET MARRIED!

FARMER: We've been through all this before –

TOSHUN: – I'm only 12 I want to play!

FARMER: Toshun you shall do as I say. You will marry and you will be gay with a frilly white dress and a shiny wedding ring –

TOSHUN: – but that silly stuff doesn't mean a thing –

FARMER: – on this family there will be no disgrace.

Stick a smile on that sulky face and meet the suitors I have arranged.

TOSHUN: I don't want to marry a man! Not now NOT *EVER!*

FARMER: Won't you just meet them Toshi, be nice for daddy.

an 'a'sar'.[12] So Asara is destined to be a trouble-maker. As Ahmed discusses,[13] reflecting on Judith Butler's *Gender Trouble*, a trouble-maker is someone who blocks (heteronormative) happiness. Asara is going to be and make people unhappy in this play. But her unhappy making will ultimately prove revolutionary.

3. Trafficking Toshun

The story of Toshun is the first Asara hears. It is Papa's warning against gender trouble. His calculation is: Happiness = father's desire + dowry + heterosexual marriage – dissent. As Jack Halberstam says, success 'equates too easily to specific forms of reproductive maturity combined with wealth accumulation'.[14]

Toshun is the transaction in what Carole Pateman calls the 'sexual contract' of marriage.[15] The scene you are about to read is a stage picture of Gayle Rubin's 1975 essay, 'The Traffic in Women: Notes on the Political Economy of Sex', where homosexuality is taboo, as it interferes with the trajectory of women being objects in a social transaction. Toshun will attempt to re-direct the traffic.

TOSHUN: Nice? All you care about is the bride price! Can't you see I am busy playing with my toys!

FARMER: Those toys are for boys and you're too old for playing games.

TOSHUN: Well you bought them for me so who's to blame?!

FARMER: Toshun for shame! You'll put me in the grave. You will learn to behave. You are spoilt. You want me dead like your mother? Then you'll feel guilt! *(TOSHUN cries. FARMER instantly regrets what he said).*

FARMER: Toshi . . . *(cuddling her).* Just do as I say and the tears will dry up like the stream in summer.

TOSHUN *(still really upset)*: But I don't want to meet the stupid suitors . . .

FARMER *(tenderly)*: They aren't stupid.

TOSHUN *(instantly recovering)*: How do you know?

FARMER: *(Stumped by this)* Well . . .

TOSHUN: You wouldn't want me to marry a fool would you . . . daddy dearest? . . .

FARMER: I only want you to have what's best.

TOSHUN: Well how about I set them a test?

FARMER: What kind of test?

TOSHUN: Nothing that my own clever father couldn't solve . . .

FARMER: Go on . . .

TOSHUN: The one who can fulfil my threefold task,
won't even have to get down on one knee to ask,
we will exchange our wedding bands and whoever he is – I promise you daddy – I will give him my hand –

FARMER: – in marriage! At last! Send in the first suitor! **(4)**

SUITOR *(entering)*: – get on with it!

TOSHUN: Stay locked in my father's barn, from sundown 'til sunrise –

SUITOR: – easy! –

4. Tales of the hunted

There is an African proverb, 'tales of the lion always glorify the hunter'. This, my feminist revision of the classic Yoruba folk-tale, *Abiola and the Three Tasks*,[16] is a tale of the lioness. In the original, Abiola wants to marry the best suitor and please her father. Many suitors fail the tasks until a handsome prince succeeds, pays the dowry and they live happily ever after. This is not Toshun's idea of happiness. With short hair and a love of 'boys' toys' Toshun has all the signifiers of a tom-boy lesbian. Toshun, a re-constructed hero, intervenes in a cycle of stories depicting violent male heroes, told to children from generation to generation, justifying male dominance.[17]

5. Feminist tests

Toshun sets three seemingly simple tests, all located in traditional female domains. The tests demonstrate women's unrecognised labour, often de-valued by capitalist societies. The first is the body, enduring pain and blood being sucked out of it, symbolising menstruation and childbirth. The second is food. Women sacrifice their burning tongues so that others can consume. Tamale says, 'Researching human sexuality without

TOSHUN: – NAKED –

SUITOR: – oh –

TOSHUN: – and don't move a muscle when the mosquitos bite!
I need man with his feet firmly on the ground.

SUITOR: Is that it?

TOSHUN: The morning after, you must eat my homemade hot pepper soup for breakfast, without blowing a single breath to cool your burning tongue. I need a man who can take the heat under pressure.

SUITOR: No problem!

TOSHUN: Lastly you must sing one song to the whole community from midday to midnight. I need a husband who can win the ear of the town, who is creative, skilled and most of all has stamina.

SUITOR: Bring it on! **(5)**

looking at gender is like cooking pepper soup without pepper'.[18] Soup and sexuality are stirred together in my story.
The third is community. Woman as carrier of his/ stories, artistry, culture itself. This too is hard work. All these aspects are taken for granted, but without a body, food, community there is no society, no humanity at all.

End of extract.

Notes

1 I am grateful to Carl Miller and Rosamunde Hutt who both encouraged me to write for children and to Caroline Jester who supported me as a dramaturg whilst I was on the EMERGE programme at Birmingham REP.

2 See www.mojisolaadebayo.co.uk and follow @adebayomojisola on Twitter for details of the full production.

3 Thanks to my PhD supervisor Dr Catherine Silverstone with Dr Caoimhe McAvinchey of Queen Mary University of London for their advice and guidance in this creative / critical experiment.

4 The original play is over 60 pages in length with over 75 critical notes. Thanks to Emily Orley and Katja Hilevaara for their help in editing.

5 Thompson (2003: 148).

6 From William Shakespeare's *Hamlet*, available online: www.goodreads.com/quotes/21250-the-play-s-the-thing-wherein-i-ll-catch-the-conscience-of [accessed 14 April 2017].

7 Campbell and Farrier (2015: 1–2).

8 Bond Stockton (2009: 25).

9 Ahmed (2014: 63).

10 Ahmed (2014: 237).

11 Rapi and Chowdhury (1998: 10–12).

12 McManus (2003: 35).

13 Ahmed (2014: 60).

14 Halberstam (2011: 2).

15 Ahmed (2014: 113).

16 Arnott (1971).

17 Hourihan (1997: 3).

18 Tamale (2011: 11).

References

Ahmed, Sara. 2014. *Willful Subjects*. Durham, NC and London: Duke University Press.

Arnott, Kathleen. 1971. *Auto and the Giant Killer and Other Nigerian Folk Tales*. Oxford: Oxford University Press.

Bond Stockton, Kathryn. 2009. *The Queer Child: Or Growing Sideways in the Twentieth Century*. Durham, NC and London: Duke University Press.

Butler, Judith. 2006. *Gender Trouble: Feminism and the Subversion of Identity*. London & New York: Routledge.

Campbell, Alyson and Stephen Farrier, eds. 2015. *Queer Dramaturgies: International Perspectives on Where Performance Leads Queer*. Basingstoke: Palgrave.

Halberstam, Jack. 2011. *The Queer Art of Failure*. Durham, NC and London: Duke University Press.

Hourihan, Margery. 1997. *Deconstructing the Hero: Literary Theory and Children's Literature*. London and New York: Routledge.

McManus, Chris. 2003. *Right Hand, Left Hand: The Origins of Asymmetry in Brains, Bodies, Atoms and Cultures*. London: Phoenix.

Rapi, Nina and Maya Chowdhury, eds. 1998. *Acts of Passion: Sexuality, Gender and Performance*. New York and London: Harrington Park Press.

Rubin, Gayle. 2014. 'The Traffic in Women: Notes on the Political Economy of Sex: 1975'. Available online: https://genderstudiesgroupdu.files.wordpress.com/2014/08/the-rraffic-in-women.pdf [accessed 14 April 2017].

Tamale, Sylvia, ed. 2011. *African Sexualities: A Reader*. Cape Town, Dakar, Nairobi and Oxford: Pambazuka Press.

Thompson, James. 2003. *Applied Drama: Bewilderment and Beyond*. Oxford: Peter Lang.

8

SAME DIFFERENCE

Nicola Conibere

This piece of writing elaborates some of the form and affects of the choreographic work it discusses, a piece called Count Two *(2010) by Nicola Conibere. In doing so it engages the potentials of retrospective critical reflection for extending the thinking at work in a live performance, whilst invoking some degree of embodied engagement with formal and expressive exploration. Perhaps, then, it will imply something of the affective experiences of knowledge that can only be accessed through the live event, and capture certain qualities of those experiences. Whilst the arrangement and expression of the text owes a debt to long histories of writing practices and authors including shaped and concrete poetry, the approach was one of organising words on a page a bit like bodies on a stage, an exercise that articulates the shared practices of choreographer and writer as putting things in relation.*

1.
These people are organising actions.
This performer walks, smiles and
opens their arms wide towards the
audience. And so does the next. And
the next. Like rolling waves of welcome
and presentation.
As each arrives they depart in order
to re-enter, this time lightly running,
smiling and waving a hand overhead.
One after the other.
Only to exit and return, one by one,
walking, looking around, seeing this
place, arriving here again.

They remain in view.

One.
These people are organising actions.
This performer walks, smiles &
opens wide arms to the audience.
And so does the next. And the next.
Like rolling waves of hosting and
presentation.
As each arrives they depart in order to
re-enter, this time jogging, smiling and
waving a hand overhead. One after the
other.
Only to depart and return, one by one,
walking, looking around, considering
this place, landing here again.

They remain in view.

This performer now draws their hands to their face in shock, or horror, or surprise.
And so does the next. And the next. Like a conveyor belt of stock expression.
As each relaxes they suddenly draw one palm to their chest and outstretch the other, their mouths ajar and eyes wide. One after the other.
They drop those forms, and one by one, thrust their necks forward, and drop their jaws, and gawp.

====================

They are performing *Count Two*, a piece that is reproduced next to itself. These three performers occupy one half of the stage, whilst three different performers inhabit the other. Stage-right and stage-left. Each group of three performs the material simultaneously. When one waves their arm, their counterpart on the opposite side waves their arm too. This does not generate an effect of mirroring but of almost direct duplication, a little like the words on this page.

This strategy of replication seeks to unsettle. It offers two consistent and equally demanding points of focus (as opposed to the many and changing points of focus that sometimes occur simultaneously in contemporary dance). Spectators might choose to focus on one trio, or neither, or move between the two. Either way, a choice is clearly being made, and so the fact of missing some detail might be more pronounced. *Count Two* seems to ensure that the marginal encounter is always present, that the rough edges

This performer now pulls their hands to their face in astonishment, or shock, or surprise.
And so does the next. And the next. Like a production line of standard expression.
As each relaxes they suddenly draw one palm to their sternum and outstretch the other, their mouths agape & eyes wide. One after another.
They drop those forms, and one by one, jut their necks forward, and drop their jaws, and gawp.

====================

They are performing *Count Two*, a piece that is replicated next to itself. These three performers occupy one side of the stage, whilst three different performers populate the other. Stage-left and stage-right. Each group of three performs the activities simultaneously. When one waves their arm, their counterpart on the other side waves their arm too. This does not generate an effect of mirroring but of almost direct duplication, a little like the words on this page.

This strategy of replication seeks to destabilise. It offers two consistent and evenly demanding points of focus (as opposed to the multiple, changing points of focus that sometimes occur concurrently in contemporary dance). Spectators might choose to watch one trio, or neither, or move between the two. Either way, a choice is clearly being made, and so the fact of missing some detail might be more pronounced. *Count Two* seems to ensure that the marginal aspect of the encounter is always present, that

of peripheral vision will imply the
shared form of the other side:
You see – they are the same.

Count Two's replication also means that
when the performers on stage-right
exit to stage-left, their offstage wing
runs down the centre, from downstage
to upstage. The middle of the stage on
which this work is performed exists at
the edge of each nucleus of activity.
Likewise the spine that runs between
these columns of text, generated
through the absence of marks that
indicate action-author-thinking, is a
void and a centre and an edge.

======================

These performers presented categories
of actions, of arrival and surprise, but
also of celebration, contemplation,
violence, sorrow, death and departure.
They re-organise some of these
movements:

This performer clutches their hands
to their chest and dies. Then this
performer draws their hands to their
face in surprise, before dropping to
their knees to weep.

And then this performer clutches their
hands to their chest and dies. Then this
performer draws their hands to their
face in surprise, before punching the
air in celebration.

When these performers move upstage
there's side-lights, and music, and
projection, and when they move
downstage there's worker lights, and
silence, and a bare backdrop. They
trigger these changes in theatrical

peripheral vision will imply the shared
form of the other side:
You see they're the same

Count Two's replication also means that
when the performers on stage-right
exit to stage-left, their offstage wing
runs down the centre, from downstage
to upstage. The middle of the space
on which this work is presented exists
at the edge of each nucleus of action.
Likewise the spine that stands between
these columns of words, created
through the lack of marks that indicate
action-author-thinking, is a negative
and a centre and an edge.

======================

These performers presented categories
of actions, of arrival and surprise, but
also of celebration, contemplation,
violence, sorrow, death and departure.
They re-organise some of these
movements:

This performer clutches their hands
to their chest and dies. Then this
performer draws their hands to their
face in shock, before dropping to their
knees to weep.

And then this performer grasps their
hands to their chest and dies. Then this
performer pulls their hands to their
face in shock, before punching the air
in celebration.

When these performers travel upstage
there's side-lights, and music, and
projection; and when they move
downstage there's worker lights, and
silence, and a bare backdrop. They
trigger these changes in the theatrical

framing when they cross into either of
these two zones.

The narratives are crass and implied.
The meanings the actions propose are
contingent on what's around them.
There are many meanings within reach
and they sometimes collide, but there's
plenty of room for manoeuvre; there is
wriggle room between definitions.

2.

These people are re-organising, away
from actions and into images. They
make rough tableaux of pictures
you may know. Like before, they
categorise, classifying by type; of
Renaissance and Romantic paintings,
of photo reportage and of Hollywood
symbols. This performer takes the form
of Venus, and these of The Raft of
the Medusa and these of Adam & Eve.
These performers are Charlie's Angels
and this one James Bond. And again,
they remix these groupings.

The images they present are saturated
with accumulated symbolism and
cultural associations. Their appearances
are so familiar they can seem
exhausted, overridden by acquired
rhetoric. In their treatment onstage
these paintings, photos and graphic
designs are deployed as signifying
gestures like the generic actions of the
previous section (although I seem to
recognise them more specifically).

If I attend to detail, there is some
breezy approximation at work in the
staging: these shapes the performers
create are only vaguely similar to

frame when they cross into either of
these two zones.

The narratives are crass and implied.
The meanings the actions invite are
contingent on what surrounds them.
There are many meanings within reach
and they might sometimes collide, but
there's lots of room for manoeuvre;
there is wiggle room amidst definitions.

Two.

These people are re-organising, away
from actions and into images. They
make coarse tableaux of pictures
you may know. Like earlier, they
categorise, classifying by type; of
Renaissance and Romantic paintings,
of photo reportage and of Hollywood
symbols. This performer takes the
form of Venus, and these of The
Raft of the Medusa and these of Adam
& Eve. These performers are Charlie's
Angels and this one James Bond. And
again, they rejig these groupings.

The depictions are saturated with
accumulated symbolism and cultural
associations. Their appearances are
so customary they can seem fatigued,
outweighed by acquired rhetoric.
In their treatment onstage these
paintings, photos and graphic designs
are employed as signifying gestures
like the generic actions of the former
section (although I seem to recognise
them more specifically).

If I look at detail, there is some
breezy approximation at work in the
staging: these shapes the performers
make are only loosely similar to the

the images listed here. But, they are sufficiently alike for recognition to occur. Sometimes this imprecision creates a kind of containment. When this performer places themselves in the stance of *Venus*, they are committed to that positioning yet do not embody the image in too determinate a way. Their estimation of the stance in the painting works with a consciously limited incarnation of its character. I read across the distance between this performer's gesture and its referent.

It is as if they are not quite convinced, these performers. Their enactment of the action is more of a gesture towards the action. They present their representation. This slightly restrained, or faintly hesitant embodiment foregrounds this action as the result of an instruction that has been followed. I read across the gap between the action and the instruction that led to it, between the identity of the person performing and the difference brought to that identity by being placed on stage and realising the actions of this piece.

These gaps produce multiplicity. It's into these gaps that I reach for the many and colliding meanings.

Tracy C Davis writes about a sympathetic brea h at work in theatricality as enabling a critical perspective, a kind of active dissociation "toward an episode in the public sphere, including but not limited to theatre".[1] She calls it a dédoublement. It's there when I see what makes the

images noted here. But, they are sufficiently alike for recognition to happen. Sometimes this haziness creates a kind of containment. When this performer places themselves in the posture of *Venus*, they are loyal to that positioning yet do not embody the image in too determinate a way. Their necessary estimation of the stance in the painting works with a consciously limited incarnation of its character. I read across the space between this performer's gesture and its referent.

It is as if they are not really convinced, these performers. Their presentation of the action is more of a gesture towards the action. They present their representation. This somewhat restrained, or faintly hesitant embodiment foregrounds the action as the effect of an instruction that has been followed. I read across the gap between the action and the instruction that led to it, between identity of the person performing and the difference brought to that identity by being placed on stage and realising the actions of this piece.

These gaps engender multiplicity. It's into these gaps that I reach for the multiple and colliding meanings.

Tracy C Davis writes about a sympathetic breach at work in theatricality as enabling a critical perspective, a kind of active dissociation "toward an episode in the public sphere, including but not limited to theatre".[2] She calls it a dédoublement. It's there when I see what makes the

lighting and sound and backdrop
change, when I see the instruction
behind the act, when I navigate the
multiple centres on the stage.

lighting and sound and backdrop
change, when I see the instruction
behind the act, when I navigate the
multiple centres on the stage.

3.

These These are
are doubling doubling up up
differently differently .
 closing closing
 gaps gaps and and
 new new ones ones.
 ,
briefly briefly. Like Like
 f l icc e r s.

Three.

 performers performers
 ,
 , again again
They They are are
some some opening
opening Creating
Creating new new centres centres,
 . itinerant
itinerant f l i kk e r s.

The The centre centre of of the the stage stage,, which which is is also
 also its its margin margin,, is is crossed crossed and and relocated
 relocated.. The The systems systems of of categorising categorising that that have
 have been been layered layered and and repeated repeated and and
 remixed remixed seem seem to to be be contingent contingent and
 and built built on on their their own own series series of of gaps
 gaps and and shifting shifting centres centres.. Peggy Peggy Phelan Phelan has
 has suggested suggested that that "" [a]s [a]s a a philosophical
 philosophical and and epistemological epistemological injunction
 injunction 'movement' 'movement' punctures punctures the the
 ideological ideological assumption assumption that that the the centre centre is is
 permanent permanent,, stable stable,, secure secure" "..[3]

This This performer performer dies
 This This performer performer dies.
 This This performer exits exits.
performer departs departs.

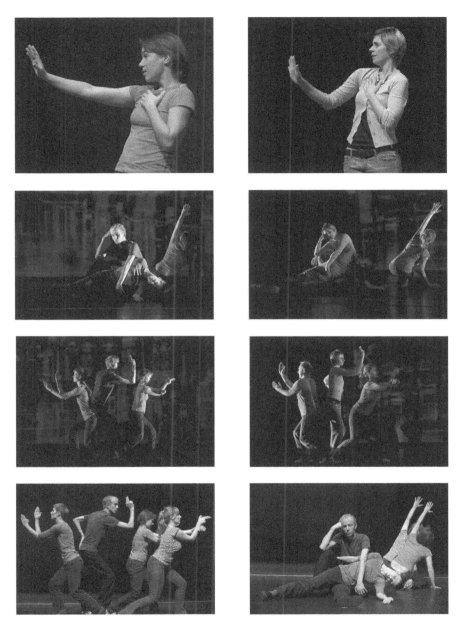

FIGURE 8.1 Photos by Guy Bell. Performers left to right: Steffi Sachsenmaier, Antje Hildebrandt, Tim Jeeves, Helka Kaski, Gerard Bell, Elena Koukoli.

Notes

1 Davis (2004: 145).
2 Davis (2004: 145).
3 Phelan (2011: 22).

References

Conibere, Nicola. 2010. *Count Two*. A choreographic work funded by Arts Council England and originally presented at Laban Theatre, London, UK.
Davis, Tracy C. 2004. 'Theatricality and Civil Society' in *Theatricality*, edited by Davis and Postlewait. Cambridge: Cambridge University Press.

9

CRITICAL GROUNDLESSNESS

Reflections on embodiment, virtuality and *Quizoola LIVE*

Diana Damian Martin

Dear Jurgen,

I am writing this in the midst of watching a twenty-four-hour performance by Forced Entertainment of their show *Quizoola*.[1] It's live-streamed you see, and it all made me think of you, as a close friend far away whom I haven't really spoken to much with lately.

And lately has been a bit of a long time, don't you think?

You see, the nice thing about twenty-four hours is that it has a natural poetics to it; it stretches over different temperatures and atmospheres and cycles, levels of light, levels of energy and the natural agitations of the city. My eyelids feel heavy though I've had some sleep; and breakfast, I had it at lunch, though I am not sure the physical perception of these things is quite accurate anymore.

Two columns: setting two different arguments and narratives in motion; working in parallel, but also independently; inter-related, but filled with textual noise. On the left, documents of a lived experience: criticism reflecting on a referent of focus: a live-streamed performance. On the right, a related argument, a broken-up, brief incursion into possible ways of viewing and grounding this mediated experience. This cross-pollination is as much referential, as it is contextual. I weave several methodological threads together: the conceptual ambition of performance writing,[3] the spatial awareness of site writing,[4] and an overt engagement with the mechanisms of theatre criticism, entrenched in Modernism, caught in the paradox of the cultural valuator in times of dismissed expertise (what happens when the performance is not re-viewed, it is being viewed). And situating these conversations is an interest in academic

And that's something I really like about this show; the set-up is evocative enough, on a formal level, but it's also so concerned with language and meaning that it really re-inscribes a certain faith in the aphoristic, in everyday dramaturgies, and in the meanings of fragmentation in general.

I should mention, there are others writing with me as well.[2] We have this rota system, based on the one the performers use as well, and there's also these strange parallels constructed by this, two systems in relationship to each other. I suppose there's something highly architectural about that and the structure of it all, makes me think of you.

My back pain has returned, maybe because the week feels so heavy on my shoulders, its narratives carried into this show. The performers, there's two of them at a time; sometimes they try and remember all the novels George Orwell wrote and at others they ask each other the same question several times; they speak of death and worst deaths and best ones, and occasionally something like Taylor Swift enters the conversation but leaves again, and they ask each other for a practical joke one might ask of someone when they come. Their voices mainly keep the same tone but energy levels really range; it's such a microcosm, this event, refracting all over.

And at the same time, these two people talking, the politics of it all, it reminds me of our walks through these

writing, its relationship to argumentative linearity, accrued authority and productive difficulty.

We read these texts horizontally, our eyes scattered across both. We are transported to another, mediated experience – twice mediated at that, passing from the physical space in which the performance occurs, to its digital representation and its critical response in that same realm; yet we also remain in the present. This disjointed experience is both aesthetic and embodied. Aesthetic, for the ways in which the critical text emerges in this virtual space, and embodied, for the ways in which it brings to mind, and also refracts the bodies of both performers and authors.

These characteristics of aestheticisation and embodiment offer a way of understanding how criticism might operate in the virtual realm; *Quizoola LIVE* provides a mode of thinking about criticism as an event, an unfolding process that creates, in its very architecture, a relationship between writing and performance that is politically nuanced, precarious and powerfully accidental. As an event for the ways in which it is marked by duration, and as process, for the ways in which the texts themselves disclose their coming into being, and their source.

I define criticism here as an analytical activity, one that is concerned with the constitution of discourse, encompassing a number of formal and contextual

cities we've both been familiar strangers in, and these timelines that have at times intertwined, and the journeys we've made together, and how I rarely check the time during these moments, but they're rare and they don't always happen when we'd like them to.

I don't know if I mentioned people can come in and out, but some of us, the writers, we're watching this as a live-stream so there's little engagement with that physical community there, and funny how timings make writing a letter to a good friend likely in the midst of this theatrical encounter, because it takes situations of otherness or slight strangeness to do this, sometimes. This is not a practical joke, and it's not serious but it's very heavy, I think.

It's important to tell that I still taste bitter coffee from my batch this morning, and I've had a croissant, and there's stuff everywhere in this studio, Gareth is in and out of sleep, but you can hear this on the TV from anywhere in our one room flat, but we're glad we managed to put this on the TV, because that feels meaningful.

[. . .]
– Diana.

The writing of and about performance implies some obvious parallels, so I will make them present here:

The referent and the writing.
The writer and the performance.
The writer and the subject.
The subject and the performers.
The connotation and the index.

variations. Just like *Quizoola LIVE*, which focused on the accumulation of meaning and collective authorship, the focus is not on the author of criticism as critic, but the production of meaning through the act of criticism.

Horizontalism, in the case of criticism, has been noted to refer to a different way of conceiving the relationship between writing and its referent.[5] The shift from cultural valuation to dramaturgical, analytical, subjective or formal exploration is not new, yet it designates an attitude in criticism towards re-thinking modernist values that seek a work's appearance[6] instead of its cultural legislation or legitimation. Yet what happens to this process of appearance when it is displaced in the digital realm, where this spatialisation of criticism is not as effective in unpacking the power relations at play?

In *Free Fall: A Thought Experiment on Vertical Perspective*, artist Hito Steyerl presents us with a fascinating proposition: that our aesthetic experience has shifted from one of horizontality to one of verticality. Steyerl makes her argument through an analysis of changes in representational politics, from '3D nose-dives, Google Maps and surveillance panoramas'[7] to the downfall of linear representation in visual culture, embedded in its claims for universal representation. Steyerl argues that there is political potential in this new paradigm of representation and mode of aesthetic experience.

In the society of surveillance, the rise of verticality presents us with a new ontological condition: a state

The site and the duration.
The fail and the pick-up.
The structure and the rota.
The emotion and its rejection.
The speculation and the fiction.
The distinction and the merging.

- Diana.

FIGURE 9.1

- Debbie.

FIGURE 9.2

- Johanna.

Diana and I

Tim Etchells and Mike Pearson
Romeo Castellucci and Bob Wilson
Zoolander and D'Angelo
Superman and King Lear

of groundlessness. To support this, Steyerl cites recent scholarship in philosophy that discusses this prevalent condition of groundlessness, referencing, amongst others, Oliver Marchart's study on the work of Nancy, Lefort, Badiou and Lacan. She concludes: 'if there is no stable ground available . . . the consequence must be a permanent, or at least intermittent state of free fall for subjects and objects alike'.[8]

But perhaps there is more to uncover here. If verticality is what gives us groundlessness, and if that groundlessness can be reconsidered from a precarious to a powerful vantage point, then we are looking at more than just a change in ways of seeing: it is a change in ways of being too. We speak often of precariousness as a condition of our contemporary existence; and what if this precariousness doesn't just manifest itself through labour[9] or collectivity,[10] but also through groundlessness? The critic then becomes the figure in free fall, but this also opens up her vantage point, and creates new ways in which meaning is constructed and emerges in relation to the referent.

What Steyerl argues is not just a representational, and aesthetic shift; it is a political one too. Verticality is increasingly replacing the homogenising, albeit communitarian politics of horizontality, yet it does not always do so on the basis of hierarchy, but on the basis of shifts in perspective. This focus on perspective brings the body back into discussions on visual culture and aesthetic experience. Falling, in this

Ron Athey and Martin O'Brien
Harvey Milk and Abu Bakr
Al-Baghdadi
Roger Federrer and Vaslav Nijinsky
Matthew Goulish and Adrian
Heathfield
Barack Obama and Jesus Christ
Gilles Deleuze and Oedipus

- Nik.

Anonymous invokes the dictionary; the
clowns shrug around self/body/happi-
ness; let's really hear everything really
for the first time; let's save a seat for
each other in this pretend room.

YOU: no I wouldn't like that
ME: baby voice / do you want to stop
HER EYES: she talks slowly because
it's true
YOU: you can find some space / at it
LIZARD: Spanish carousel (you can't
see it)
THAT BAND: I'll believe in anything
BROADBAND: tiny wind, tiny suck,
the anticipation of silence
SILENCE: star in the corner, every-
thing goes quiet
ME: finally Hamlet
NOT ME: finally the magician's
assistant
LAST NIGHT: a question of mirrors
HER: again belief and slow talk
HANNAH: imagine this on the page
and smearing
THEM: I'd share a life and you'd share
a life
SHE HAD TO: one burns and the
other freezes
WHY NOT: he turns this compulsion
towards binary into a meme

instance, is reliant on sensation – and
that sensation is one of the ways
through which verticality appears.
In this way, affect becomes politi-
cal, ways of seeing and being become
intertwined with different power
structures.

What is at stake in this proposition?
Steyerl provides an answer through
what she asks us to imagine: 'imagine
you are falling. But there is no ground

. . . Paradoxically, while you are fall-
ing, you will probably feel as if you
are floating – or not even moving at
all.' She adds: 'If there is no ground,
gravity might be low and you'll feel
weightless. Objects will stay suspended
if you let them go.'[11] This experience
might feel, Steyerl proposes, like stasis,
but that's deceptive. During the fall,
our sense of orientation is constantly
challenged; 'the lines of horizon shat-
ter, twirl around, and superimpose'.
So if we are falling, we don't neces-
sarily hit the ground, but exist in a
constant state of flux, which under-
mines our experience, and our way
of relating to other objects. If there is
no centre of gravity, verticality ceases
to become a problem of hierarchy: it
becomes a different mode of aesthetic
and political organisation.

In the virtual realm, groundlessness
opens up a way of understanding the
complexity of modes of meaning-
making between, in this instance,
performance and criticism. To feel in
fall, in constant movement, is what
emerges in this virtual realm between
critic(ism) and performance. Virtuality

SELF-CENSORSHIP: prediction: all three will all be white
ME: I wonder how Gareth Damian Martin pronounces 'z'
EMILY: It is as a Vesuvian face / Had let it's pleasure through –
SHE DOESN'T KNOW: she said what about worms / I'd like to dedicate this shame to trees
THE AVANT-GARDE: how embarrassing are these words in their fullness
YOU: as if punctuation could accelerate the burst
YOU IN MY HEAD: oh great lap dancing (oh great rationalising proximity)
US: we close our eyes to communicate stop
CHANGE: they stop (they are just getting started)
DID YOU HEAR A BELL: do you want to be a little baby / I'm ready for the drain

- Nisha

creates a parallel between the two, with a constant permutation of variables – the free-fall of meaning, and the moments when it clicks – like two streams that run side by side, where the interaction is molecular, and contingent on knowledge accumulated, or known correlations.

In its very form, and through its chronology and parallel with the unfolding performance, *Quizoola LIVE* makes the process of thinking visible, by nature unfinished and fractured. The process evidences the event, and it's slippery because of its collective, accumulated authorship, and the level of improvisation. But this opens it up to moments of real confrontation and productive interaction of meaning.

Thinking is revealed in texts that are not allowed to end, in the same way in which the performance, over its duration, unfolds in continuity. And when it all does end, when time marks that specific point, the criticism ceases to become; it remains and performs its own act of spectating.

Meaning occurs in moments of collision, as occasional as those of occlusion. This accumulated, collective voice discloses a multiplicity of vantage points, because everything is in motion. The text captures both the embodied and aesthetic dimension of this experience. *Quizoola LIVE* becomes, through this prism, an exercise in critical groundlessness.

Notes

1 *Quizoola LIVE* was a multi-authored, critical writing project I curated for *Exeunt Magazine*. The project consisted of a live publication written in parallel and in response to the live-stream of Forced Entertainment's 24-hour performance of *Quizoola*, taking place at the Millennium Gallery in Sheffield on 21 November 2014 from 23:45. The writers were given the following areas of formal exploration for their writing: the processes of witnessing, interrogation, appropriation and listening in; duration, repetition and rhetoric as modes of accessing critical writing; and the instruction as performative and textual strategy. http://quizoola.exeuntmagazine.com/ [accessed 12 April 2017].
2 John Boursnell, Laura Burns, Gareth Damian Martin, Mette Garfield, Debbie Guinnane, Johanna Linsley, Nisha Ramayya and Nik Wakefield.
3 See for example, Caroline Bergvall's Keynote address at the inaugural symposium on Performance Writing at Dartington College in 1996: www.carolinebergvall.com/content/text/BERGVALL-KEYNOTE.pdf [accessed 12 April 2017].
4 Site-Writing is an approach to, and form of criticism developed by Jane Rendell that considers 'the sites in which an artwork is constructed, exhibited and documented' (2010: 2). Site-Writing politicises the spatial dimension of criticism's sites of encounter, and foregrounds the positions a critic takes in her multiple relationships to the work.
5 Horwitz (2012).
6 Sontag (2009 [1964]).
7 Steyerl (2011).
8 Steyerl (2011).
9 Lorey (2014).
10 Butler (2015).
11 Steyerl (2011).

References

Butler, Judith. 2015. *Notes Toward a Performative Theory of Assembly*. Cambridge, MA: Harvard University Press.
Horwitz, Andy. 2012. 'Re-Framing the Critic for the 21st Century: Dramaturgy, Advocacy and Engagement', *Culturebot*. 5 September. Available online: www.culturebot.org/2012/09/13258/re-framing-the-critic-for-the-21st-century-dramaturgy-advocacy-and-engagement/ [accessed 12 April 2017].
Lorey, Isabell. 2014. *State of Insecurity: Government of the Precarious*. London: Verso.
Sontag, Susan. 2009 [1964]. *Against Interpretation and Other Essays*. London: Penguin.
Steyerl, Hito. 2011. 'In Free Fall: A Thought Experiment in Vertical Perspective', *E-Flux*. Available online: www.e-flux.com/journal/in-free-fall-a-thought-experiment-on-vertical-perspective [accessed 10 February 2012].
Rendell, Jane. 2010. *Site-Writing: The Architecture of Art Criticism*. London: I.B. Tauris.

10

A CONJURING ACT IN THE FORM OF AN INTERVIEW

Augusto Corrieri

Writing about one's own work seems to call for a rather inward-looking self-directed gaze. It is similar to the descriptive internal monologue through which we incessantly narrate everyday actions and thoughts back to ourselves. If this absorbed circularity appears debilitating – and it is – then a possible (if paradoxical) way out might be to fully embrace its centripetal force: by actively steeping the self into itself, and zooming into that process, we might find this limited thinking subject yielding to a rather open discursive field. Simply put, the self is really an ongoing symposium. Formed of emergent encounters and conflicting positions, this self-narrating self is always playing at becoming itself, through questions and disagreements. It is a kind of endlessly rehearsed self-formation, a fabrication, something 'made', devised, composed in the moment; less uncontrolled 'stream of consciousness', and more a series of shifting positions that can be made to dialogue on the page. This text, taken from a longer interview, is a three-way conversation between Augusto Corrieri (myself), Vincent Gambini (magician/performer) and a representative of the Rhubaba Gallery committee. Gambini and myself were in residence at Rhubaba Gallery in 2014, as part of the Edinburgh Art Festival.

RHUBABA GALLERY: Hello Vincent, hello Augusto.

VINCENT: Hello.

AUGUSTO: Hi.

RHUBABA GALLERY: You're both here at Rhubaba Gallery and Studios through-out the month of August, in different ways. Augusto, you're showing the two-screen video work *Diorama* (2013), in which we see an actor and a sheep in reversed settings: the animal on a theatre stage, and the human in a field. The two bodies execute the same actions.

And turning to you Vincent: you're in residency, working on what we could call . . . a deconstructed magic show?

VINCENT: That's right. I'll be developing the work throughout the month, with a few small showings along the way. There will be a more formal presentation

FIGURE 10.1 Shooting *Diorama*. Photo by Lucy Cash, 2013.

at the end, which I've called *This is not a magic show*. It won't really be a show, but rather a chance for me to reflect on magic and sleight of hand, through a kind of lecture-performance. It will be like a live essay, with demonstrations of magic, set in a theatre.

AUGUSTO: Sounds very much like a magic show, actually.

VINCENT: Yes, I guess. [*laughs*]

RHUBABA GALLERY: Part of the reason we were interested in bringing you both together for the month is that you share an interest in the theatre, and how the stage frames actions and expectations. Maybe you could say something about your relationship to the theatre or the stage.

AUGUSTO: Yes, the theatre is clearly at the centre of our interests, but we work with it in very different ways. Would you agree, Vincent?

VINCENT: Yes, there are many differences in the way we work.

AUGUSTO: For me, the theatre is always the starting point, and the point of arrival, it seems. I can never escape it, no matter how much I try. It's probably because I'm using theatrical means to enact my escape . . . so I always end up where I started: the red curtains, the stage, the wings, the seats, etc.

 I see the theatre as a device, a constructed situation, in which one person watches another. The Greek word *theatron* means 'the place of seeing', so theatre really is about being in a place, watching. And the way we watch is of course structured by conventions, which have to do with space, with archi-tecture, and with time: duration, modes of attention, etc. In the 20th century

a lot of effort went into bringing down theatre's walls, both literally and figuratively. And I am totally indebted to the avant-garde, to performance art, to deconstructive approaches, etc. It's all I know, in a sense . . . But I always work with the assumption that the theatrical situation, and its conventions, somehow returns: it is like a ghost of sorts, haunting the way we watch and make performance today.

RHUBABA GALLERY: We can leave the theatre, but the theatre won't leave us . . . right?

AUGUSTO: Yes! [*laughs*] And so, instead of trying to get rid of this artificial machinery, with all its trappings and outmoded functions, why not use it creatively, generatively? The example I often return to is John Cage's *4'33"* (1952), the famous 'silent' piece. The work was written for, and premiered in, a formal concert hall, the kind of space we might not associate with avant-garde music practices. Hence its apparent shock value: because the auditorium is a place for listening to *intentionally* produced sounds, i.e. to music. It was shocking at the time, and is still largely misunderstood, because Cage was seen to remove that sacrosanct intentionality. What is a theatre auditorium, if it is not filled with crafted meanings, with intentional human performances?

RHUBABA GALLERY: I guess the word 'auditorium' probably relates to hearing, right? So in fact Cage was using the auditorium precisely for what it was built: to hear, to listen. He adhered to the convention, but radically so.

AUGUSTO: And similarly, theatre is the place of seeing, and so that is what I explore: how we observe and perceive bodies, objects and phenomena. The theatrical frame bathes objects in a particular light; its imperative is: 'LOOK AT THIS, this is relevant, significant, it has been placed here for a reason', etc. So what if we continue employing the theatre as a device for heightening attention, but strip away, or somewhat diminish, the actions or the 'human drama'? I'm interested in paying attention to marginalised and unintentional entities, even non-human phenomena: sounds, for sure, but also currents of air, dust, or other life forms, such as non-human animals, insects, or plant matter, wood, metals . . .

RHUBABA GALLERY: Vincent, can we turn to you for a moment. What's your approach to theatre?

VINCENT: Listening to Augusto reminded me of just how much the magician's act is indebted to the theatre as a perceptual device. I am thinking in particular of the proscenium arch, theatre's architectural frame. One of the effects of this frame is that, just like in a painting, it produces a front and a back: there is a side that is given to see, and one that isn't. I don't just mean the wings at the sides: I mean that when you stand on stage facing the audience, for example, they can see your front, but they can't see your back. [*stands up to demonstrate*] And if I now turn to show you my back . . . you can't see my front. And so on.

It's a ridiculously simple premise, but I think it structures a lot of magic performances: the instant you show something, something else is hidden. It's a necessary compromise in the theatre, and magicians exploit it to the max.

RHUBABA GALLERY: There is always something behind what is presented, what is seen . . .

VINCENT: Essentially magic is the art of misdirection. And misdirection is not, as is often thought, about distracting spectators. It has more to do with sculpting the path of the audience's attention, sowing certain thought patterns and expectations. Like a film editor, you are responsible for choosing to highlight certain features and ideas over others: and only some of these choices have to do with outright concealment, many are simply about producing a certain logic, an idea.

AUGUSTO: So it's more a labour of the mind, than of the hands?

VINCENT: Yes . . . and no. I'm a sleight of hand magician, which means I'm a particular breed of, well, recluse! [*laughs*] I started doing magic when I was fourteen, and quickly it became my sole preoccupation. I practised magic all day, every day, year after year . . . In order to master complex sequences of sleight of hand, you have to enter a state of complete absorption, physically and mentally, where even the smallest movement or action is studied, rehearsed and naturalised. It is a very delicate kind of labour, and you can easily spend days simply rehearsing how to place a card on the table. Talk about an intentional, crafted performance! [*to Augusto*] I imagine John Cage hated magic tricks?

AUGUSTO: I don't know . . . but it sounds to me as though, as a teenager, you were using magic to ward off the 'real' world. You spent years mastering card and coin manipulation as a way to create a sense of order, or predictability . . . of holding life within a rehearsable parameter . . .

VINCENT: Absolutely. And it's interesting that magic, unlike performance art and the avant-garde perhaps, is about creating a quasi clockwork world, in which you control a mostly predictable outcome. Take for example a classic card trick, where the magician cuts to the four aces, one by one, from a shuffled pack of cards. Can you shuffle these? [*takes a deck of cards from his pocket, and hands over to Augusto for shuffling*]

Now watch carefully . . . [*Vincent holds the pack of cards in one hand, clicks his fingers, and the four aces jump out of the pack one at a time*].

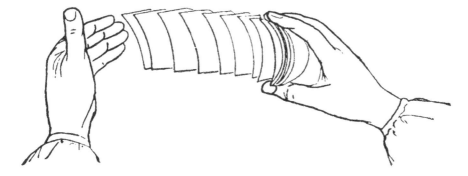

FIGURE 10.2 Sleight of hands with cards, reproduced from the classic book *Secrets of Conjuring and Magic, or How To Become a Wizard*, by Jean Eugene Robert-Houdin, 1868.

RHUBABA GALLERY: Wow . . .

AUGUSTO: What the . . .

VINCENT: It's important to point out that in this illusion the cards are really shuffled, there is genuine chaos and disorder, and the task is, within the chaos, to produce a kind of order . . . that is, the four aces. There is of course a mismatch between what the audience sees, and what is happening behind the wings, let's say. But the fact remains that I genuinely have to create this sense of order from chaos, it's not just a trick with an easy explanation . . .

AUGUSTO: I know you've said there's chaos, but I get an impression of unfailing precision and order. It makes me think of a little toy theatre . . . a miniature stage, where things come and go; cards appear and disappear, according to precise modes and timings.

VINCENT: There is a contradiction at play here. On the one hand the magician is in control of what happens; for example he (it's still mostly a male figure) will click his fingers, and a coin will suddenly appear out of nowhere. This is the conjuror as wizard, able to bend the laws of matter to his will, etc. On the other hand, mastery and control are very limited perspectives of the magician's craft; in fact, when I'm practising sleight of hand with cards, I often have the impression that I'm simply doing what the cards allow, or invite, the hands to do. It is the cards, their shape and size, grain and texture that dictate what can happen. I am entirely dependent on the particular properties of the objects. And these properties have to be discovered through trial and error, you can't dream them up in advance, independently of the objects . . . This way of thinking isn't so common. The majority of magicians enjoy the impression of mastery . . . It is probably not a coincidence that, historically, the figure of the modern magician – the white, male, bourgeois entertainer dressed elegantly in top hat and tails – appears at the height of industrial capitalism, affirming rational mastery over the elements (that is, natural resources). The dream that capitalism could allow for endless growth and production was perfectly mirrored by the stage magician, endlessly producing objects out of thin air . . .

RHUBABA: Vincent it is interesting to hear you talk about the training process as being engaged with ideas of the body. Augusto . . . you've worked in dance contexts, can you relate to this kind of experience?

AUGUSTO: Well, yes. But I never trained much as a dancer. In fact, my only real training was when I practised magic throughout my teenage years, just like Vincent.

RHUBABA GALLERY: Oh yes. We haven't talked about this. You're the magician here. Tell us about Vincent Gambini then. He is, really, just a fictional character?

AUGUSTO: The name Vincent Gambini comes from a Hollywood film, *My Cousin Vinny* (1992), with Joe Pesci in the role of Gambini. In the movie, which I watched a lot in my early teens, we see Gambini perform a simple but impressive card trick, ironically enough during a scene in which he's trying to win someone's trust.

Anyway, when you invited me to work on a magic performance here at Rhubaba I realised that I didn't want to use my own name.

RHUBABA GALLERY: Why not?

AUGUSTO: To give the project some space, and to protect it from myself somewhat. You see, in the performances and the writing I've been developing over the last decade, I have consciously been using strategies that are, let's say ideologically, totally opposed to magic and illusion. I think of Yvonne Rainer's 'No to spectacle', for example.[1] For a long time magic has been the no-go area, the temptation to avoid, the 'bad' performing art I need to emancipate myself from. It's all I did as a teenager, but that was a good while ago: I stopped practising magic around 2000, and I haven't been tempted to go back . . . until now, perhaps. So the Vincent Gambini pseudonym helps to create a separation: if Augusto cannot do magic so easily, then perhaps Vincent can.

RHUBABA GALLERY: It seems you have an awkward relation to magic.

AUGUSTO: I was 18 or 19 years old when I turned my back on magic and moved to theatre and performance art. That was 14 years ago. The challenge for me is to revisit without regression. I still really appreciate magic and deception, but almost as a guilty pleasure.

RHUBABA GALLERY: You feel you ought to always work within 'serious' or culturally sanctioned art forms?

AUGUSTO: I wonder . . . Magic's lack of 'seriousness' is oddly attractive to me, its lowly status presents an opportunity to do something novel. But it remains deeply flawed in my eyes: not just because of, say, the near-total lack of female

FIGURE 10.3 Joe Pesci as Vincent Gambini in *My Cousin Vinny* (1992).

magicians, but because in essence magic consists in doing something that the audience will not understand; talk about an un-emancipated spectator! Who knows, there might be ways round it. Perhaps Gambini will find a way of addressing this unbalance, by making explicit how the work is constructed, whilst not giving any secrets away . . . That would be a victory both for the performer, who would no longer need to hide, as well as for the spectators, who would become partners in crime, as opposed to its victims. And eventually I might not need Gambini to give myself permission to perform magic. He might disappear . . . as he did just now, in this interview.

Note

1 In Goldberg (1996: 141).

Reference

Goldberg, Roselee. 1996. *Performance Art: From Futurism to the Present*. London: Thames & Hudson.

11

YOKO ONO FANFICTION

owko69 (Owen G. Parry)

I would say that this writing is fanfiction, and that the writers and readers of this book constitute a fandom: a performance fandom. Or what if we re-imagine it as so? I want to deliberately draw relations between the amateur practice of writing fanfiction and the unpaid labour of critical writing because I think as affective inter-textual practices produced around a desired subject – in this case performance – they are related. The idea that fan works are solely subordinate or derivative works is reductive. As a form of archontic literature (via Derrida) or minor literature (via Deleuze and Guattari) these texts expand and transform an extant archive, at best through subversive, desiring intervention. I hope this is useful in considering where you might place my contribution in the book. I'm ultimately a fan of fans. Fans are my inspiration . . .

Prompt 1: Not very much happens in this performance at the Serpentine Gallery *Manifesto Marathon*. Or, the one in which everyone blames John Lennon for brainwashing Yoko and breaking up the fluxus movement.
Tags: #YokoOno #onocode #performance #art #fanfic #artworld #AU #manifesto #marathon #pregnantjohn #FanRiot

Yoko kept us waiting at the Serpentine Gallery outdoor pavilion in Hyde Park for almost an hour. We were all held in this temporary structure designed by the Canadian architect Frank Gehry, where the Manifesto Marathon was taking place over the course of a prematurely cold autumn weekend. Gallery stewards handed us little souvenir torches they called 'Onochord' with the initials Y.O engraved on them and informed us to wait for further instruction.

After much anticipation and checking the time on our phones, a diamond-shaped light appeared in the sky over nearby Knightsbridge and we knew immediately it was Yoko. She was arriving by helicopter. The aircraft landed right next to the pavilion. A spotlight scanned the audience and landed on its door, which immediately swung open allowing Yoko to dismount in a Swarovski-encrusted top hat and her signature glasses. The curator limped over

FIGURE 11.1 owko69, 2013.

to the aircraft with a big German smile, and what appeared to be a wooden leg. He greeted Yoko and took her straight to the stage. Then, with no introduction, and by her own accord, Yoko took out her little Onochord, and using Onocode (a colloquial language not unlike Morse-code, but developed across a span of more than fifty years of conceptual art practice) she gave us the instruction we had all been waiting for:

> *I/ love/ you*
> *flash/ flash flash/ flash flash flash*

We didn't know if Yoko really meant it, or whether she just wanted us to tell her that we loved her back, which we did anyway:

> *flash/ flash/ flash/ flash/ I/ love/ you/ Yokey-poo.*

Then, just like that, Yoko hit play on the PA sound system and an unidentified drum and bass track began to thump through the speakers. I wasn't sure if it was a track from her

2008 'Yes, I'm a Witch' remix album, a remix of the outro or intro, or an entirely new track? It definitely resembled a snippet of a sound score she once used in her 1968 'Fly on my Bum' video – the one in which at 3.33 she walks into the frame wearing no. 7 American tan tights eating a stick of celery, and where John is continually stoned because this was pre The Beatles' 'White Album', and after John's second pregnancy. In any case, there were definitely no tan tights and no celery in this performance.

Yoko climbed off the stage and proceeded to dance amongst us in the audience for the duration of the four-minute track. Everyone in the pavilion was trying to dance next to Yoko, who was dancing wildly for someone in her eighties who had just literally flown in. When the track ended, Yoko got back onto the stage, told us she loved us again in Onocode (which we had all by now fully acquired), and waited for us to reciprocate, which we all did.

> *Yoko Infinity*
> *f/ash*

We all loved Yoko, and then she got back into the helicopter, and continued flashing at us through the window on this starry night. We all stood there and watched her fly away with tears in our eyes and the wind from the propellers in our hairs . . .

Prompt 2: All the artists are critics, and all the critics are fans: Or, the one in which fanfiction and performance art become synonymous modes through which to re-write and expand upon extant artworks and question the authority of the archive. **Tags**: #art #performance #fanfiction #RPF #OTP #rewriting #feminist #post-critical #Cagingham #Jenkins #Schneider #Linzy #Abramović #Brimfield #Deller #Whynot?

There has been little crossover between critical writing about performance and the amateur practice of fanfiction and real person fiction (RPF), despite an apparent overlap between the two in methodology and practice. The practice of re-writing (usually) popular media texts in fanfiction and re-enactment (usually) in performance histories are obvious points for comparison. Transformative acts of re-writing in fanfiction, of archiving and preservation in performance, collide in experimental approaches to its study and criticism. Performative writing/performance writing (Peggy Phelan), art writing (Maria Fusco) and conceptual writing (Kenneth Goldsmith) are exemplary of such modes. As artists, researchers, writers and teachers we constantly negotiate the shifts between roles and positions. Yet being a fan remains a constant (if sometimes secret and volatile) source of motivation across a field of creative and critical labour. As Chad Bennett writes, 'Fan activities, [are] often private and marked by isolation, secrecy, and shame'.[1] Being a fan is often considered something we grow out of. Definitions of fans as 'characterized, influenced, or prompted by excessive and mistaken enthusiasm' (*OED*) or as mindless consumers in Theodor Adorno's now outdated treatise on mass culture, have kept fans as pathologised figures across cultural history. With over-attachments and intense relationships with their subjects of fascination, fans are stereotyped as

'stalkers', 'crazies' and 'kooks'.[2] So, what can be gained from taking up the position of fan of performance? And what might be gained from conceiving of the field of enquiry around performance as a fandom?

In some respect performativity has already been addressed in the scholarly field of fan studies through discussions on fan fictions that re-interpret, re-configure and give new life to official texts. If 'fanfiction is a way of the culture repairing the damage done in a system where contemporary myths are owned by corporations instead of owned by the folk'[3] then this is often done by shifting power dynamics or character representations in the official text, by, for example, giving precedence to minorities, women, queers, and people of colour hitherto unsubstantiated in the official narrative. Or, indeed by expanding the timeline of a work; changing its mood or sensibility; or re-contextualising a work in an alternate universe (AU). Fan scholar Henry Jenkins claims that fan labour 'typically involves not simply fascination or adoration but also frustration and antagonism, and it is the combination of the two responses which motivates their active engagement'.[4] Fans of Harry Potter or boy band One Direction create transformative works including fanfictions, videos, illustrations, memes, and music using those official, usually commercially driven texts and narratives to create their very own versions, whether that be a 'curtain fic' (or domestic fic) in which an enamoured Snape and Harry go shopping for curtains; a hurt/comfort fic (or death fic) where one band member, Louis, cares for the other band member, Harry, who has a terminal illness; or a One Direction/Harry Potter crossover in which Harry Potter is a performance artist and Harry Styles an art critic who 'bodyswap' to help each other out of 'sticky' situations. There are infinite possibilities for re-working popular texts in fanfiction, but like much writing about art and performance, most of the writing focuses on relationships, especially between fictional characters or artists in RPF. The romance genre is thus the most popular, and includes specialist tropes such as 'shipping' (putting characters into relationships) and 'one true pairing' (OTP), a fan's favourite romantic pairing or 'ship'. Shipping becomes a method through which fans can re-imagine and create multiple different narratives out of the source material.

Artists' relationships have always been a point of fascination and curiosity for me. My very first encounter with performance art was through a piece of writing by Cynthia Carr titled 'A Great Wall' (1989). This document re-tells the story of Marina Abramović and Ulay's *The Lovers* (1988) – their final epic performance walking towards each other from either ends of the Great Wall of China, crossing treacherous landscapes and warzones, until finally, they meet somewhere in the middle and end their relationship. On reading this as a first-year undergrad in 2001, I remember feeling the breadth and scale of this performance – a relationship of dramatic proportions played out and made visible to audiences across a landmark visible from outer space. I remember Lois Weaver, the teacher who gave us that text to read. I remember Lois on another occasion introducing us to her life-long collaborator Peggy Shaw (the couple formed *Split Britches* with Deb Margolin in 1980), and her alter ego persona Tammy Whynot? – 'a Southern Baptist Country

and Western Singer turned Lesbian Feminist Performance Artist'. I remember not knowing what a performance artist was, never mind a Lesbian-Feminist one. I remember not worrying about the truth or facts of many of Lois/Tammy's stories or the texts she gave us to read as she had begun the class with an activity: 'Ask me anything you like, any question and I will endeavour to answer it', she said. 'If I can't, or don't want to answer it, I will make it up.' This was perhaps my first valuable lesson on the instability and potential transformation of performance, identity and the archive.

Across art history, artist pairings and collectives become sites for domestic or romantic subtext and spectator intervention, and fantasy becomes an opportunity for re-working the source material. I remember reading somewhere John Cage's commentary on his relationship with the minimalist choreographer Merce Cunningham: 'I do the cooking and Merce does the dishes', and how this somewhat insignificant insight into their domestic life opened up a myriad other relations to the artists and their respective oeuvres. I wrote a Cagingham fanfic all about it and about homonormativity and published it in *The New Inquiry*[5] and on fanfiction.net (owko69 2015b). There is an abundance of artist pairings across performance histories ripe for the picking: from Yoko Ono and John Lennon, to Björk and Mathew Barney. Notably, both these pairings ended up having extensive impact on each other's artistic work. But besides 'shipping' what are the more specific methods that relate fanfiction to performance and writing about performance?

In his now canonical *Textual Poachers* Henry Jenkins describes how fans use existing media texts like 'silly putty', moulding them into all kinds of new re-configurations. Everything is allowed in the expanding universes of fanfiction; however, RPF is definitely the most controversial because of the ethical implications of writing about real people. In her essay 'Fans of Feminism', Catherine Grant expands on Jenkins' *Textual Poachers* to specifically explore the re-writing of second-wave feminism in contemporary art practice. Discussing the artist as critic, historian and fan, Grant considers the instability or rather interchangeability of the fan as a sympathetic mode through which to read and make feminist art, and in particular feminist performance. I would like to extend Grant's observations here to think more specifically about *doing* and writing about performance.

Re-enactment has been given much attention in performance studies and visual cultures over the past decade or so with a number of books, exhibitions and performances dedicated to the subject. There are multiple examples of re-writing and re-enactment across performance histories that tend towards both extremes: from precise replications to the parodic and absurd. In her book *Performance Remains* (2011), Rebecca Schneider examines performance itself as archival turning to historical battle re-enactments as her example, an amateur activity where enthused groups convene to *cosplay* and re-stage those historic events through precise game-like structures. In Marina Abramović's *Seven Easy Pieces* (2005), the artist re-enacts the works of seven iconic performances (by predominantly white, cis men from the Western canon), transforming the works by inserting herself

into those extant, yet perhaps at the time insufficiently documented performance histories. In Jeremy Deller's *The Battle of Orgreave* (2001), the artist re-creates the events of the miners' strike at the northern British town of Orgreave during the Thatcherite era involving many participants present at the original 1984 protest. In a series of works titled *This is Performance Art* (2011) artist Mel Brimfield re-mixes canonical histories of performance art with skits from Saturday night popular television entertainment, where comedic TV personalities Morecambe and Wise are interchanged with artist duo Gilbert and George to create a parodic commentary on distinctions of value and authority across these disparate genres. In the video series *Conversations wit de Churen II – V* (2003–2006), Kalup Linzy creates video vignettes fuelled by American television soap operas such as *All My Children* and *The Days of Our Lives*, making pointed commentaries about race, class and sexuality through 'odd juxtapositions'. Linzy's work perhaps best exemplifies a mode of fannish investment, as one article points out: 'ripe for parody . . . Kalup Linzy . . . maintains an unexpected sincerity while emulating the daytime television drama'.[6] Shifting beyond precise replication or re-enactment, but also the critical cynicism of postmodern parody, Linzy's work expresses both a desire and affection for the TV series as it stands in its imperfection, as well as a desire to rework it. Linzy's unstable position bears a striking resemblance to the interchangeable fan figured in Grant's essay, and as Meyer and Tucker point out: 'while some fans certainly do position their acts as sites of resistance, others simply express a deep affection or desire for particular media texts'.[7] Renouncing the singular authority of a source text or identity, the fan's work thus becomes difficult to categorise. Beyond this fanfiction, fan cultures have become an inspiration in my broader artistic practice. *Fan Riot* (fanriot.tumblr.com, 2015) is an ongoing project, which includes an itinerant fan club series (four thus far at Artsadmin, Jerwood Space and Chisenhale Dance Space) with invited artists and fans, workshops, publications including a zine created by and for fans of Live Art (owko69 2015a), and a number of commissioned artworks and performances including *TYOTA: The Yoko Ono Tribute Akt* (2015).

Asserting oneself as fan means to assert a certain subjective relation that almost always beckons judgement. For too long critics like Jason Guriel, who wrote 'I Don't Care about Your Life: Why Critics Need to Stop Getting Personal in Their Essays' (2016), have sought to shut down personal relations, without acknowledging their always burgeoning presence, if only as a means of motivating and sustaining one's interest or critical practice. So, instead of concealing personal desire, what if we expose it and speed it up? Through fannish investment subjective relations become common relations. When accelerated to the point of abstraction and delusion, they also break to become multiple or transparent again – just like Ono's flash – which reminds me of Walter Benjamin's theory on memory figuring through a flash, or the 'means to seize hold of a memory as it flashes up'.[8] In Ono's performance and my fanfiction the flash not only seizes hold of a memory or transforms it, but also says:

You're imperfect / I love you

Fandom comes into being through this multiplicity, through a simultaneous affection, dissatisfaction and desire to transform and re-work existing narratives. It extends a work, rather than capturing it. It opens to the possibility of collective or common investment, embodiment and infinite remediation. So, on writing about performance, boy bands or conceptual artists we love or want to love, we take a stance as fan and invite others to do the same.

Notes

1 Bennett (2010: 18).
2 Jenkins (1992: 11).
3 Harmon (1997).
4 Jenkins (1992: 23).
5 Parry (2015).
6 Taft (2006).
7 Meyer and Tucker (2007: 115).
8 Benjamin (1940: Thesis VI).

References

Writing

Benjamin, Walter. 1940. 'On the Concept of History', translated by Redmond, in *Marxist Internet Archive*. Available online: www.marxists.org/reference/archive/benjamin/1940/history.htm [accessed 9 September 2016].

Bennett, Chad. 2010. 'Flaming the Fans: Shame and the Aesthetics of Queer Fandom in Todd Haynes's *Velvet Goldmine*', *Cinema Journal* 49 (2): 17–39.

Carr, Cynthia. 1993. 'A Great Wall', in *On Edge Performance at the End of the Twentieth Century*, 25–49. Middletown: Wesleyan University Press.

Grant, Catherine. 2011. 'Fans of Feminism: Re-Writing Histories of Second-Wave Feminism in Contemporary Art', *The Oxford Journal* 34 (2): 265–286.

Guriel, Jason. 2016. 'I Don't Care about Your Life: Why Critics Need to Stop Getting Personal in Their Essays', *The Walrus*, 14 April. Available online: https://thewalrus.ca/i-dont-care-about-your-life/ [accessed 9 Septemer 2016].

Harmon, Amy. 1997. 'In TV's Dull Summer Days Plots Take Wing on the Net', *New York Times*, 18 August. Available online: www.nytimes.com/1997/08/18/business/in-tv-s-dull-summer-days-plots-take-wing-on-the-net.html [accessed 9 September 2016].

Jenkins, Henry. 1992. *Textual Poachers: Television Fans & Participatory Culture*. New York: Routledge.

Meyer, M.D.E. and Tucker, M.H.L. 2007. 'Textual Poaching and Beyond: Fan Communities and Fandoms in the Age of the Internet', *The Review of Communication* 7 (1): 103–116.

owko69. 2015a. *Live!Art Fanzine*. Fan Riot Press (Live Art Development Agency DIY 12), 1, October.

owko69. 2015b. 'Cagingham and the Homonormcore', *fanfiction.net*, 13 September. Available online: www.fanfiction.net/s/11504141/1/Cagingham-and-the-Homonormcore [accessed 9 September 2016].

Parry, Owen G. 2015. 'Mpreg versus Homonormcore', *The New Inquiry* 43. Available online: http://thenewinquiry.com/essays/mpreg-versus-homonormcore/ [accessed 10 September 2016].

Schneider, Rebecca. 2011. *Performing Remains: Art and War in Times of Theatrical Re-enactment*. London and New York: Routledge.

Taft, Catherine. 2006. 'Kalup Linzy: LAXART', *Artforum*, 8 July. Available online: http://art forum.com/index.php?pn=picks&id=11450&view=print [accessed 9 September 2016].

Artworks and performance

Obrist, Hans Ulrich. 2008. *Manifesto Marathon*. Serpentine Gallery 18–19 October 2008. Available online: http://www.serpentinegalleries.org/exhibitions-events/manifesto-marathon [accessed 9 September 2016].

Parry, Owen G. 2015. 'The Yoko Ono Tribute Akt (Bunny)', in *Fan Riot a Performance Album*. Trinity Laban Conservatoire of Music and Dance, London, 28 February. Available online: www.youtube.com/watch?v=bD0u8hamrCE [accessed 9 September 2016].

Parry, Owen G. 2015–2016. *Fan Riot*. Project website available online: http://fanriot.tum blr.com/ [accessed 9 September 2016].

12

A FUGUE STATE OF THEATRE

On Simon Vincenzi's operationinfinity.org

Joe Kelleher

What follows is a written reflection on a piece of performance documentation, a website put together by the artist Simon Vincenzi and his collaborators, following Vincenzi's own multi-part theatre project *Operation Infinity* (2007–13). The scene of these reflections is the site's public launch at London's Toynbee Studios one evening in early 2016, a place where several performances in the project had been shown in previous years, and where, for the website launch, I had been invited by Simon to say a few words. The words below are not the words I said on that occasion. The scene, already, displaces itself. However, they seem appropriate to offer for this volume's collective reflection on creative critical practices, attempting as they do to touch on something that fascinates me in my understanding of such practices, and my own part therein. Most immediately, I point to the website as a critical practice arising out of the work itself, and in this instance doing so with no apparent lack of insidious intent. The creative, here, arrives at the critical with some acceleration. I am also, though, interested in ways that spectatorship – understood as a mode of socialised speech that feeds, and feeds upon, a privacy of vision – contributes to the displacement of the scene. Not through a helpless distancing, but rather a translation of what is 'infectious' in the work, however we might want to take that word, into spaces of thinking and feeling where the work itself – localised as it is in a theatre or a screen or the page of a book – may not go. But which we, the writers, readers and spectators, may have to suffer. I am curious, then, about the ways that the work 'looks out' from itself towards those other places, and curious too about the complicities that our words – my words – for all their critical attention, share with that same hungry look.

The critical documentation process was already intrinsic to – and prominent in – the work itself. For example, the perpetually rotating video camera during performances of *Luxuriant: Within the Reign of Anticipation* (2010), perched on its stack of technical whatnot, amongst the intermingled crowd of performers and spectators: relentless,

indifferent. Or the 'security' operation at any of the performances – the waiver form offered on entry to *The Crimes of Representation* (2007), according to which I should surrender 'all rights to my identity in perpetuity, and for the full period of copyright exist as naught'. Or the way every gesture, every twitch and flicker of the actors in the shows, seemed to do with some sort of image 'capture': the screen test auditions of the immersive *Luxuriant*, or the way that the performers in the more traditionally theatrical *The Infinite Pleasures of the Great Unknown* (2008) were only visible through live relay, filmed in infra-red and projected onto a screen that completely covered the front of the proscenium stage. As if a *process* of some sort – a recursive process of production and consumption: of image and appearance, of act and reaction and all the rest of it – were what the work were about, more than any imperative to generate a 'work' as such.

Or put it like this. As I say, the recording devices – whether hidden and off-stage, or right in the middle of things – were taking it all in from the start, as if what generates the record, the account, the critical reflection, were nothing less than the performances themselves, the theatre that happened. And which now, after the live, although still within its ambit, escapes itself, joins with other forms of itself, which both vanish and emerge from the 'black hole of attention at its core'.[1] At the core of the live, that is; amongst those 'small ecstasies of forgetting'[2] that at once puncture and sustain the theatrical fiction that the live is what we are dealing with at all.

The phrases, I realise, are a touch baroque, but the baroque – or some corroded post-digital emanation of the same – may be where we are in 2016 with Simon Vincenzi's *Operation Infinity*: a multi-part theatre project that has recently been realised as operationinfinity.org, 'a fugue state of theatre hosted on the internet'. And here am I on the main stage at Toynbee Hall (the London base of Vincenzi's producers, Artsadmin) with others who are attending the launch of the website, and able – just about, in the rather murky ambience – to see past the screen where pages of the site were being projected, towards the auditorium where many of us had witnessed episodes of the project, up to the conclusion of its theatrical phase with *King Real Against the Guidelines* in 2013. In that semi-darkness, and amongst the crushed, transparent plastic drinking cups indecorously but deliberately scattered about the stage floor where we were gathered, I was recalling those earlier episodes. Remembering, for instance, the detritus distributed about the stage area as we entered for *Infinite Pleasures* nearly a decade ago, plastic bottles and jars containing various dubious-looking liquids, performers (presumably) asleep (presumably) on camp-beds around the proscenium, papers being put through a shredder at the front of the stage (it turned out to be those waiver-forms . . . or was that at another show?). And an aching soundscape that wouldn't let up, with intermittent blaring sirens, signal alerts. And as I was remembering all of this, I was fishing in mind for a line of thought on the nature of used things, exhausted things, used up, but put to use anyway.[3] And I was recalling the performers in those shows – those virtual presences entrapped in the image space of *Infinite Pleasures*, or the choric personages of *King Real* approaching the stage edge, gesturing to infinity while

looking up to the monitors overhead, lip-synching a mangled text, part Shake-speare, part machine-coded back-translation of the same. It was like those figures – placed there in a kind of theatrical perpetuity – functioned as a form of insistence. But insisting on what?

Now, I take this insistence as a critical picking at the same programmatic indifference of image production and consumption that the work itself portrays, and from which it appears to borrow its own productive processes. That is to say, the ongoing processing of human material, of gesture and motion, of pose and presentation, into something that is worth 'showing'; but then immediately is chewed back into the theatre's representation machine, as the dancers in *Infinite Pleasures* are re-absorbed in any moment into the cinematic glimmer from which they press; or the *King Real* actors are pulled back, after every approach, into the backstage gloom from which they walk forwards again into momentary clarity. As if the problem the performances insist upon might be set out thus: how to transform the recursive transformation that representation enacts? How to un-process the exploitative process that underwrites this aesthetic economy? Or – aligning the fiction of critique to the singular fiction that governs the work, i.e. the figure of Dr Mabuse, the evil mastermind of several of Fritz Lang's films from the early and mid-twentieth century, who functions as a sort of host for the Operation as a whole – how to channel another sort of breath through the spirit of 'criminality' that *inspires* the whole deadly business? As if transformation, process, and inspiration were themselves the trouble in store. Or to say it as simply as I can, as if 'creative practice' should aspire to do otherwise than give itself up to the sort of murderous economies that govern this world, while knowing itself to be hardly immune to those economies, whether falling foul of their 'values', or falling out of the accounting of value altogether.

How, then, to appreciate the creative practice of the operationinfinity.org website in these sorts of critical terms? Where might a fugue state of theatre seek to lead us, if it leads anywhere at all? And how might we attempt to follow? It may not be straightforward. A 'fugue state', in psychological parlance, refers to a dissociative disorder, which can involve short-term amnesia, a loss of personal identity characteristics, and a tendency to wander, unplanned. That goes some way to giving a sense of the 'character' of the website, which refers to itself as an 'information retrieval initiative' in worryingly blank, bureaucratic terms, and which – in parts – carries a background sound as if a tape machine had been left running, with nothing on the spools, recording only silence (there are occasional clicks of what might be accidentally heard operator activity). The sources of this fugal theatre meanwhile appear to be from another decade: one clip of film shows a couple of figures, wrapped in what look like exposure bags, synching (or singing?) Marc Bolan's 'Life's a Gas', while young dancers scurry around frantically. It appears to be recorded through a lenticular lens, magnifying extravagantly and arbitrarily, although other actions have been 'documented' through the fixed and un-expectant stare of a CCTV camera. Frequently, but randomly, we come across the paraphernalia of theatre business – and security business: an 'industry bookings' form,

a trespass warning, a request to access my web-cam, an invitation to advertise on this site, a rapid-fire slide-show portfolio of performance stills, another rapid slide-show of what look like Google Map close-ups of east London, each punctuated by a literal black hole that doesn't simply mark the spot but obliterates it. Banner ads and announcements, gifs, curtains and logos, fly up or else throb in some corner of the screen passive-aggressively: 'Coming Soon', 'Now Showing', 'Join'. A real-time date counter, accurate to the second, captions a view into a foil-lined room where nothing at all appears to be happening, except perhaps for a live video camera that may be pointing straight at us, the viewers. The area onscreen where clips from the theatrical pieces appear is small, it could be a peep show; at one point, if we look long enough, we can discern a particular act of self-pleasuring contortion. We stay, or we move on. And as we do so things jerk, they shudder, they hiss with static or else fanfare flatulently. Of course it is all meticulously labelled, even if the material itself seems irretrievably self-forgetting in its fractured state. It is also rigorously attuned to the conceptual mechanics of the theatre it derives from: the enforced perspectives and ways of looking, and the insistently punctual and then dilated temporalities ('Now Showing', for two hours only, and *ad infinitum*). And attuned too to the kind of corporate-anonymous discursive position that the theatre project was always enacting, which belies any claim to authorship or signature, or indeed singularity of any sort (Vincenzi's name hardly appears on the website, except on a credits page labelled 'staff').

What I find in all this, as far as framing might go, is not so much a set of critical points or positions, but rather the intimation of a judgement, which – not unlike the ubiquitous cameras embedded in the live performances – is intrinsic to the operation, and at once impersonal, rigorous, specific, implacable. But a judgement that explains nothing, that decides nothing. Its own operations are dissociative, self-forgetting. Rather, it passes the critical decision onto ourselves, the viewers, the visitors. And, we in turn exit the site, where others will arrive, the final judgement falling – as it always does – with the last, the latest judge, the next visitor spectator; that being something akin to a 'rule' of the theatre, and – as long as the theatre lasts – an infinite operation. We are, at once, done with judgement and its structures of authority, appropriation and imposing morality; and at the same time – or at least as long as desire is still in play; in the form of fascination, distraction, irritation or curiosity, or whatever wandering motivation leads us to arrive here and to stay for a while – not done with judgement at all yet. The critical task comes down to me; just as – if you care for it – it comes down to you.

I am online, I am clicking through the site. I am looking at the documentation, and I am remembering a theatre, parts of which I first encountered nearly ten years ago. I reach for adjectives, labels of assessment, triggers for a report. I find this theatre difficult, un-smooth, relentless. A kind of somnolent and alert irritability; that is something I note. I find it also very funny (there are good jokes). I find it beautiful too; tender in ways, 'loving' if you will, more loving than pitying; but also pitying too. I invoked a peep show above, a somewhat private – and for sure old-fashioned – form of entertainment, of self-entertainment, to be enjoyed

privately, in public, at an affordable price. Something shows, or suffers itself to be shown, to be seen. For as long as the shutter is open. Although this is not a tease. Things are going on all the time. The system is performing background activity. I think of a series of close-ups, but not on individuals; rather, close-ups of crowd scenes. Any of the crowd scenes that ever were, on any stage or screen. What these close-ups do, I am thinking, is they refuse to 'humanise'. They give no names or faces, as if the task of this looking were to respect – this is what I scribble down – the indignity of it all. I need to consider this further.

Notes

1 See Daniel Sack's reflections on the theatricality of the baroque image in his *After Live* (2015: 160).
2 See Operationinfinity.org, landing page. All subsequent citations are from the website.
3 My own more detailed account of the project appears in *The Illuminated Theatre: Studies on the Suffering of Images* (Kelleher 2015: 89–99).

References

Kelleher, Joe. 2015. *The Illuminated Theatre: Studies on the Suffering of Images*. London and New York: Routledge.
Operationinfinity website available online: http://operationinfinity.org/ [accessed 1 May 2016].
Sack, Daniel. 2015. *After Live*. Ann Arbor: University of Michigan Press.

13

WRITING WITH FUNGI, CONTAGIOUS

Taru Elfving

Writing is an intimate part of my practice as curator and educator, offering a way of thinking aloud with artworks. This chapter builds on my recent exhibition and editorial collaborations with the artists Essi Kausalainen and Terike Haapoja.[1] The works discussed are part of their ongoing research and experiments with conceptual, embodied and collective approaches to challenge anthropocentrism. With co-resonant yet distinctly situated enquiries they urge on the feminist, decolonial methods developed in my writing in response to the ecological urgencies today.

The co-performer centres her posture, feet firmly planted onto a small square velvety mat rimmed with coarse frills. She closes her eyes, raises her hands at a slight angle, palms open downward. Her head moves slowly from side to side, her fingers flutter in the air lightly. Her movements appear to be driven by an interior motive. Yet now, as my fingers search for words on the keyboard, the impression of self-contained agency wavers. I remember her deep but effortless breathing, flowing in and out of her body in sync with her feet rooting themselves to the soft mat and the concrete floor beneath, while her hands rest in the air. The space is so thick with concentrated silence that the artist beneath the wooden trap door next to her feet can hear the breathing before emerging from the underworld.

Sharing space is sharing breath. It will never leave you untouched. It takes a lot of trust, the artist Essi Kausalainen emphasises. This bond of trust allows for the intensity of the performance between the co-performers, who had only met the day before. To move is to be moved, by and with others. Not simply within the given external parameters, but as breath suggests, inside out. There lies a risk and promise of contagion – embodied and emotional as much as of language and thought. 'Trust is transformative', as Isabelle Stengers argues.[2]

Kausalainen examines inter-species communication in her body of work, which 'performs relations contaminated by the (dangerous) intimacy of the organic and

inorganic bodies'.[3] She aims for the work to grow 'into systems that take the likeness' of a mycorrhiza, a symbiotic body of plant and fungi, while working with small gestures with her co-performers – in this case human, mineral, fabric, hair, floor, doorway, etc.

Looking for words now I find my feet searching for balance against the floor, my shoulders relax and my fingers stretch out to feel the cool air. Yet I begin to stumble on the dichotomies that persistently weave their way back into these sentences. Is writing necessarily an act of violence against the performance, reducing it to the hierarchical and linear modes of thought the artist has set out to undo? If writing itself is transformative, as Stengers further claims,[4] could it also follow a fungal logic, become contagious?

FIGURE 13.1 Essi Kausalainen. Untitled (Symbiosis). 2016. Performers Essi Kausalainen, Aurore Le Duc. Photo Taru Elfving.

Likeness

As many artists are taking on the urgent task of reimagining co-dependence, what could this mean for the viewing and speaking positions of the curator or the writer? Urged on by Felix Guattari's call for transversal thought,[5] I attempt to tackle the inseparable processes of subjective, social and ecological transformations in and through my interwoven practices.[6] With a commitment to feminist critical discourse on ecology, my curatorial work focuses on nurturing artistic investigations and transdisciplinary dialogue within specific sites while tracing resonances across diverse contexts – from islands to archipelagoes. These convergent paths lead to further thinking together in writing, as in the case of Kausalainen's performance here.[7]

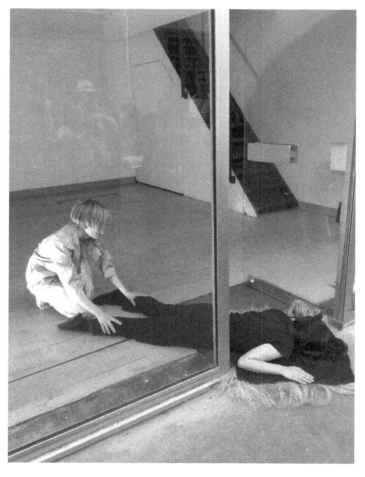

FIGURE 13.2 Essi Kausalainen. Untitled (Symbiosis). 2016. Performers Essi Kausalainen, Aurore Le Duc. Photo Taru Elfving.

'It is not only species that are becoming extinct but also the words, phrases, and gestures of human solidarity',[8] writes Guattari. The two performances I discuss here both stress the need to consider solidarity as integrally enmeshed also with affiliations and affinities beyond our species. This implies a persistent labour of decentring through the insufficient means of the languages, representations, and technologies at our disposal. The constantly re-situated sense of commonality they gesture towards resists fixed definitions and foundations, while in the encounters it unsettles the bounds of ourselves and of what we know.

How can I nurture these transformative encounters and transversality in writing? By 'taking their likeness', or 'performing relations', as Kausalainen suggests? In her work this means a likeness to something – mycorrhiza – that thoroughly challenges the logic of self-contained units and reproducibility. This resonates with Luce Irigaray's playful mimesis as a strategic jamming of the languages and operations of the order of the same.[9] Resemblance opens a space of mediation that allows for proximity yet insists on irreducible difference.[10] Yet how to assume such likeness?

Inequalities

To perform relations is an event of emergence in which the viewer – and the writer – participates. *History of Others: The Trial*, a re-enactment of a wolf poaching case, by Terike Haapoja and Laura Gustafsson, appropriates performatively legal procedures, while radically playing with the possibility of resemblance within them.[11] On entering a performance of *The Trial* I was directed to take a seat as a jury member and invited to use my judgement on the spot, based on the material given to us all during the event. Equal before the law. Or, trial and error.

The anxiety about how to perform merged with a concern about rights so easily compromised. Similar does not equal the same. Who can speak? Who is represented, by whom? Who can or will listen? I became painfully aware of how the information on the case is always partial and even somewhat irrelevant without knowledge of the legal structures that bind judgements. The work focuses on the notion of legal persons, the organising principle of who can be represented in court. While clearly demarcating the limits of law it appears, eventually, not to protect the rest from rampant exploitation. Rather it legitimises this lawlessness.

While placing faith in the promise of law, the work makes its deeply engrained anthropocentric logic uncomfortably felt. By getting the juridical system lay bare its grounding distinctions, the work gradually unravels them through the entwined histories of exclusion. It becomes evident that the expansion of rights through inclusion does not simply transform the law but questions its foundations. Positioning the viewer in such an impossible position of power, *The Trial* simultaneously initiates a series of subtle decentrings: of the functions of the legal apparatus, the significations within its language, the perspective of the viewer and, ultimately, the (hu)man as the measure of everything. Rather than solutions, the law only offers increasing complexity, in which the viewer (as witness) becomes implicated.

FIGURE 13.3 Terike Haapoja. *History of Others: The Trial.* Participatory court room performance. 2014. Performers Arttu Kurttila, Mirjami Heikkilä, Max Bremer. Photo Terike Haapoja.

Contagions

As a witness I found myself at *The Trial* in a space of impossibility, on the threshold between inside and outside, immediacy and distance. Yet this may be an opening for the emergence of communication.[12] Encounter is possible once understanding is requested and simultaneously denied as impossibility, argues Cathy Caruth in her writing about witnessing.[13] Similarity addresses like this, not through analogy but as a call.

The witness is partial and situated yet accountable. Critical practice may be thus considered in terms of empathy and affinity – as a dialogue that aims at 'witnessing, not at judging',[14] Rosi Braidotti argues. Empathy called for here can no longer be identificatory embrace nor altruism.[15] Rather it gestures towards compassion as contagion, as in Jean-Luc Nancy's thought.[16] Transformative to all the parties involved, empathy ruptures the aggressively guarded illusion of self-containment, not unlike the shared breath.

'The contaminated diversity of ecological relations takes center stage',[17] writes Anna Tsing on mycorrhiza, but might as well be referring to the performances. The works entangle my thought within the performed relations in divergent ways. Yet as I reconnect across temporal and spatial distance with 'fingery eyes',[18] to borrow Donna Haraway's visceral notion, resonant similarities in their trajectories become tangible.

Striving towards producing a likeness of the performances, my writing does not so much aim to return as to be moved on – with the gestures and words as well as the temperatures, weights, sounds, even subtle smells recollected. As viewing and

FIGRUE 13.4 Terike Haapoja. *History of Others: The Trial*. Participatory court room performance. 2014. Performers Arttu Kurttila, Mirjami Heikkilä, Max Bremer. Photo Terike Haapoja.

writing thus begin to feel their way, my sensibility shifts in its emphasis from making sense to responsiveness.[19] This implies disturbance on the embodied as much as symbolic bounds. To be touched by an image or a narrative does not necessarily mean identification or immersion in contrast to criticality and understanding. It can move me, not just to the verge of tears, but to the edges of myself, of what I know and of knowing itself.

Not-knowing

Assuming likeness and performing relations appear as modes of descriptive close-reading here, yet pushed beyond representation – from determination of meaning to contagious proximity. I no longer write about but with the works.[20] For the writer – as for the curator – this implies an active refusal of mastery and control.[21] It requires not-knowing, responding to the persistence of unknowability and holding onto the wonder that precedes attempts at understanding.[22] Furthermore, to know more has to do then with care rather than power – 'the unsettling obligation of curiosity'[23] that Haraway associates with nonmimetic caring.

The refusal to take part in the prevailing economies of knowledge production, whether interpretative or deconstructive, requires sensitivity to 'feel the smoke' of witch-hunts past and present, as Stengers argues.[24] It means withholding judgement – not avoiding taking a stance but rather being accountable and attentive for where one stands: the complex interdependencies with their entangled histories and futures that form the ground under my feet and thought.

Writing, like witnessing, is always for something.[25] If not aimed at truth or closure, visibility or voice, what is it for? Situated, with care, its transversal potential may lie in how it calls for further encounters. Contagiously.

Notes

1 Curatorial project *Beyond Telepathy* (2016–) with Kausalainen and co-edited publication *Altern Ecologies* (2016) with Haapoja.
2 Stengers (2016: 11).
3 Kausalainen (2016).
4 Stengers (2016: 21).
5 Guattari (2008: 29).
6 Feminist challenges to nature–culture dichotomy form the ground of my practice, in particular Irigaray (1985a) and Butler (1997) on irreducible difference and performativity, and the critique of anthropocentrism by Haraway (1991) and Braidotti (2013).
7 The archipelago or fungal logic of my site-sensitive and situated curatorial methodology may be compared to that of Anna Tsing in her research onto mycorrhiza with a focus on patches and their global resonances. See Tsing's discussion of site-specificity (2015: 221). On archipelago logic, see, for example, Elfving (2016).
8 Guattari (2008: 29).
9 Irigaray (1985b: 76–78). With mimesis Irigaray intervenes in the reproduction of the logic of the same and reveals how it erases difference through the exclusion of both matter and the feminine from the oppositions that supposedly define them.
10 On resemblance and proximity: Irigaray (1996: 109–119; 2002: 15–53); Butler (1993: 45).
11 The performance *History of Others: The Trial* took place at the Consistory Hall of the University of Helsinki as part of Baltic Circle Festival 13–15 November 2014.
12 On the impossibility in witnessing: Agamben (1999: 33–35, 39); Felman and Laub (1992: 232). See also Agamben's argument that language is born in and as testimony (1999: 38).
13 Caruth (1996: 41).
14 Braidotti (2006: 206). Braidotti refers to Haraway's rethinking of the figure of the modest witness, the neutral observer in science (Haraway 1997: 270–271).
15 On witnessing in terms of empathy and unsettlement: Miller and Tougaw (2002: 6); LaCapra (2001: 40–42); Bal (1999: xii).
16 Nancy (2000: xiii).
17 Tsing (2015: 43).
18 Haraway (2008: 5–6).
19 Irigaray stresses the outward and toward reach of speaking and listening, and the touch of words, over the exchange of messages (1996: 109–119; 2002: 15–53).
20 More on this methodology in Elfving (2009). See also Irit Rogoff (1998: 26).
21 See, for example, Trinh Minh-ha (1991: 193, 198).
22 Irigaray calls for wonder, a mode of encountering something for the first time, as a guarantee of irreducible difference (1993: 12–13, 72–82).
23 Haraway (2008: 36, 301).
24 Stengers (2016: 17–18).
25 On situated practices as always for some worlds, or some ways of living and dying, see, for example, Haraway (1997: 37; 2008: 88; 2016: 55).

References

Agamben, Giorgio. 1999. *Remnants of Auschwitz: The Witness and the Archive*. New York: Zone Books.
Bal, Mieke. 1999. 'Introduction'. In *Acts of Memory: Cultural Recall in the Present*, edited by Bal, Crewe & Spitzer. Hanover and London: University Press of New England.

Braidotti, Rosi. 2006. *Transpositions: On Nomadic Ethics*. Cambridge: Polity Press.

Braidotti, Rosi. 2013. *The Posthuman*. Cambridge: Polity Press.

Butler, Judith. 1993. *Bodies that Matter: On the Discursive Limits of 'Sex'*. New York and London: Routledge.

Butler, Judith. 1997. *Excitable Speech: A Politics of the Performative*. New York and London: Routledge.

Caruth, Cathy. 1996. *Unclaimed Experience: Trauma, Narrative, and History*. Baltimore and London: Johns Hopkins University Press.

Elfving, Taru. 2009. *Thinking Aloud: On the Address of the Viewer*. London: University of London, unpublished PhD thesis.

Elfving, Taru. 2016. 'Archipelago Logic: Notes On and Beyond a Dysfunctional Exhibition'. In *Contemporary Art Archipelago CAA*, edited by Björk, Elfving & Petronella. Turku: CAA. https://issuu.com/contemporaryartarchipelagocaa/docs/.

Elfving, Taru & Haapoja, Terike. 2016. *Altern Ecologies: Emergent Perspectives on the Ecological Threshold at the 55th Venice Biennale*. Helsinki: Frame Contemporary Art Finland.

Felman, Shoshana & Laub, Dori, 1992. *Testimony: Crises of Witnessing in Literature, Psychoanalysis, and History*. New York and London: Routledge.

Guattari, Felix. 2008. *The Three Ecologies*. London: Continuum.

Haraway, Donna. 1991. *Simians, Cyborgs and Women: The Reinvention of Nature*. London: Free Association.

Haraway, Donna. 1997. *Modest_Witness@Second_Millennium.FemaleMan©_Meets_OncoMouse™*. New York and London: Routledge.

Haraway, Donna. 2008. *When Species Meet*. Minneapolis: University of Minnesota Press.

Haraway, Donna. 2016. *Staying with the Trouble: Making Kin in the Chthulucene*. Durham, NC and London: Duke University Press.

Irigaray, Luce. 1985a. *Speculum of the Other Woman*. Ithaca: Cornell University Press.

Irigaray, Luce. 1985b. *This Sex Which Is Not One*. Ithaca: Cornell University Press.

Irigaray, Luce. 1993. *An Ethics of Sexual Difference*. London: Athlone Press.

Irigaray, Luce. 1996. *I Love to You: Sketch of a Possible Felicity in History*. New York and London: Routledge.

Irigaray, Luce. 2002. *The Way of Love*. London and New York: Continuum.

Kausalainen, Essi. 2016. Quotes from Kausalainen's artist statement on her performance *Untitled (Symbiosis)* for the exhibition *Beyond Telepathy I* in the gallery The Window in Paris, 3–6 May 2016.

LaCapra, Dominick. 2001. *Writing History, Writing Trauma*. Baltimore and London: Johns Hopkins University Press.

Miller, Nancy K. & Tougaw, James, 2002. *Extremities: Trauma, Testimony, and Community*. Urbana and Chicago: University of Illinois Press.

Minh-ha, Trinh. 1991. *When the Moon Waxes Red*. New York and London: Routledge.

Nancy, Jean-Luc. 2000. *Being Singular Plural*. Stanford: Stanford University Press.

Rogoff, Irit. 1998. 'Studying Visual Culture'. In *The Visual Culture Reader*, edited by Mirzoeff. London and New York: Routledge.

Stengers, Isabelle. 2016. 'The Challenge of Ontological Politics', a keynote paper presented at *The Insistence of the Possible: Symposium with Isabelle Stengers*. Goldsmiths University of London, 18–19 May 2016, unpublished.

Tsing, Anna. 2015. *The Mushroom at the End of the World: On the Possibility of Life in Capitalist Ruins*. Princeton: Princeton University Press.

MIDDLEWORD ONE

What kind of writing do we do?

Peter Jaeger

At present you need to live the question.

(Rainer Maria Rilke)

'Middleword one: what kind of writing do we do?' has been sourced from the chapters in this section. Most (but not all) of it has been re-written slightly, to shape each sentence into an inquiry—a series of questions, rather than a definitive set of answers, observations, or commentary. Grammatical subject positions have also been changed from 'I' and 'you' into 'we', in order to pluralize that subject position, and to underscore the collective nature of this inquiry.

Position (where): what kind of writing do we do?

What kind of writing do we do? Is it necessarily true that the lack of qualifying statements to support or substantiate the arguments emphasize the playful, bold and irreverent tone of the piece? Is it a kind of endlessly rehearsed self-formation, a fabrication, something made, devised, composed in the moment; less uncontrolled stream of consciousness, and more a series of shifting positions that can be activated and made to dialogue on the page? Is sharing space also sharing breath? How might you put together a utopian picture of the critical and the creative? Is writing necessarily an act of violence against the performance, reducing it back to the hierarchical and linear modes of thinking it set out to undo? #Whynot? Does the pull and push crackle with an energy amplified by gesture, facial expression, and stance? Or was that at another show? What even is it? How can we perform the centrality of the relationship between listening and trust? By insisting on what? Is this all relevant to issues of trust in relation to institutional power? Should we

again return to the example of John Cage's *4'33"* (1952), the famous *silent* piece? Is that being rigorous? And just how are we formed of emergent encounters and conflicting positions? What is a theatre auditorium, if it is not filled with crafted meanings, with intentional human performances? How do we address each other thinking aloud, sounding out the thought while supporting the moment of clarity when we see how the system would love for us to make the state of affairs our fault? Can we discuss homophobia and discrimination more widely? Who remains in view? In this trick, are the cards really shuffled, and is there genuine chaos and disorder? And what are the more specific methods that relate fiction to performance and writing about performance? Do fans now use existing media texts like silly putty, moulding them into all kinds of new re-configurations? Can you? Can we reflect on magic and sleight of hand through a kind of lecture-performance? Are we the inhabitants of a culture hierarchized by a logos that knows how to speak but not to listen—a culture of competing monologues authorized by disciplinary, categorical thinking? Why can we still remember imitating this strategy, humming against the coming storm or fist? Is that also part of the exploration? Is there such a space of impossibility, on the threshold between inside and outside, immediacy and distance? What is a production line of standard expression? Are all artists critics, and all critics fans? Are you theory or practice? Can you be utopian with rigour? How are we going to get through all this? Where might a fugue state of theatre seek to lead us, if it leads anywhere at all? What are the occasions for a manifesto? And what happens to this process of appearance when it is displaced in the digital realm, where this spatialization of criticism is not as effective in unpacking the power relations at play? Is this a stream of consciousness? In a mid-route doldrum, although the doldrums don't have winds, that's the point, no progress, no headway, isn't that Braidotti? How might that be useful? Can we seek to practise linguistic or even cognitive falls, searching for a language adequate to the task of articulating the experience of falling through falling? Shall we hum out loud? When is an argument a speck in the eye of the reader, a plank in the eye of the reviewer? Did we always work with the assumption that theatrical situations and conventions somehow return? What is a position? How can we transcribe conversation, compressing it towards a vocabulary of poetic fragments, and alongside the development of an emergent system of micro-gestures? Will it be like a live essay, with demonstrations of magic, set in a theatre? Why would we try to seek a language immanent to what we are doing? Can we hope to engage the potentials of retrospective critical reflection for extending the thinking at work in a live performance, whilst invoking some degree of embodied engagement with formal and expressive exploration? Is there anything playful in that moment down at the planning department? Why do gaps produce multiplicity? When shall we focus more on the tension between the visible / invisible, or between the public / private states of not knowing, within the performed act of writing? What terms can refer to different ways of conceiving the relationship between writing and its referent? Does interpersonal trust play a key role? Is unscripted, spontaneous speech itself a vitality field, which requires physical as well as mental movement, and where there

occurs a kind of imprecise, messy, hit-and-miss work to find the right words to communicate what one wishes? Doesn't that sound like Cixous? Isn't it always comparative, explorative, testing, questioning—rigour undermining fixed conclusions and breaking up the ideal? How can we resist the hierarchies and taxonomies imposed by academia or disciplinary convention, writing across a range of often hybrid genres and forms, which neither reject nor privilege the creative or critical but attempt to synthesize the two? Is that the REF critical model now? Will that never leave us untouched? We're nearly halfway and this is not getting expressed in the ways that it needs to be, is it? Who would want it to, when you can laugh and groan? Or is it generated by an algorithm? Why not quest for a not-yet-known vocabulary emerging synchronous to the live circumstances that it seeks to articulate? What blank? Or maybe this is an opening for the emergence of communication? Isn't that it, the mingled mix of forms and impulses? Who now pulls their hands to their face in astonishment, or shock, or surprise? What if our refrains are ways of bumping up against each other, exploring variation and solidity? As many artists are taking on the urgent task of reimagining co-dependence, what could this task mean for the viewing and speaking positions of the curator or the writer? If writing itself is transformative, could it also follow a fungal logic, become contagious? How can one make the intimation of a judgement, which—not unlike the ubiquitous cameras embedded in live performance—is intrinsic to the operation, and at once impersonal, rigorous, specific, implacable? Where are the play and the wit and the sense of possibilities? To those who ask if more allusive, tangential, stylized, or creative forms of art writing replace evaluation, judgement, politics . . . we say: must it be either / or? Does this self-narrating self always play at becoming itself through questions? How should one dress when going to the theatre? And so, instead of trying to get rid of this artificial machinery, with all its trappings and outmoded functions, why not use it creatively, generatively? How does that argument differ from other arguments? Who senses trust enacted, and why? What strategies can we use to further enable patients and their caregivers to tell their stories? Is this a rigorous way to go? Who really reaches into gaps for many and colliding meanings? How can feminist and queer fairy tales and willfulness be embraced or reclaimed? What are we on to? One quality of practice is that it reveals: is revelation an argument? Who could pay attention? How could we un-process the exploitative process that underwrites our aesthetic economy? When will we tentatively distil a common working vocabulary for articulating aspects of our enquiry? Or is that distillation even desirable? How, then, to appreciate creative practice in these sorts of critical terms? Isn't that a bit like writing? Could we suggest that? What would we call a form of listening that attempts to recover the neglected and perhaps deeper roots of what we call thinking? This is (Is this?) theatre after all? Naming the unnamable? The triumph of flowing with the bike out of the tunnel, triumph, well, yes, that's overstated, but why not? Where is this going? Does meaning exist prior to the event of utterance or is it produced through the dialogic process of conversation itself? And can we historicize that thought? Why do categorical language and the disciplinary mentality that underwrites it

arguably provide the greatest challenges facing creative research that needs to write honestly as/about practice? What kind of position might that writing entail? We can leave the theatre, but the theatre won't leave us . . . right? How does page layout contribute to putting the play and theories in conversation with each other? What strategies are, let's say ideologically, totally opposed to magic and illusion? Who hears? Can one make pointed commentaries about race, class and sexuality through odd juxtapositions? Is a manifesto an argument? What does the affective experiences of knowledge that can only be accessed through the live event imply for writing? Was it shocking at the time, and is it still largely misunderstood? Flow is the current of inspired coordinated action, no thought, improvisation—who needs structure and precedence and form? What happens if talking about practice is no longer an event of explication, but instead performed in the same key as doing? Were we always seduced by sound? Who laughs? Does the refusal to take part in the prevailing economies of knowledge production, whether interpretative or deconstructive, require sensitivity to feel the smoke of witch-hunts past and present? Remember Plato? How can we get out of this situation? What requires not knowing, but responds to the persistence of unknowability? Are you caught up in a conversational practice located in a volatile professional space among such categories as artist, educator, writer, researcher, activist? Does everyone stumble on the dichotomies that persistently weave their way back into these sentences? When do columns set different arguments and narratives in motion? Have we arrived at anything? How can conversation-as-material be used for generating a form of embodied language that emerges from the enmeshing of our different voices in live exchange, involving the production of an inter-subjective, interdisciplinary language that is both subjective and impersonal? And how might we attempt to follow? Are we urged on enough by transversal thought? Is trust transformative? How might we attempt to tackle the inseparable processes of subjective, social and ecological transformations in and through our interwoven practices? Does occasional writing constitute pursuing one's research in practice? How to transform the recursive transformation that representation enacts? Who knows where the time goes? Is that Joycean enough now? As artists, researchers, writers and teachers, how do we constantly negotiate the shifts between roles and positions? It can be a good thing to be distracted but when is distraction the place for inspiration? What's your argument?

Folding outwards 2

14

THE BLIND & DEAF HIGHWAY WOMAN

Undine Sellbach and Stephen Loo

USHERS 1 and 2 [ASIDE]: We are speculative ethologists. Our method is to infest familiar sites of spectacle, adventure and learning – the picture palace, the lecture hall, the open road – with small creatures of instinct.

> *The audience files into the lecture hall. It is dark like a cinema.*
> *At the front there is a screen. On one side of the screen there*
> *is a glass box of buttered popcorn, on the other a lectern.*

> *The USHERS exchange tickets for paper boxes*
> *of warm coconut water.*

USHER 1:
Keep your coconut water with you, warm and close to your person.

USHER 2:
On your stomach, inside a sleeve, under your arm, in the palm of a hand, against a leg, on your lap . . .

> *When everyone is seated* [USHERS move to the
> lectern] *the performance starts.*

> *The words 'THE BLIND & DEAF HIGHWAY*
> *WOMAN' flicker and appear on screen.*

USHER 1:
Working in the 1930s, the biologist Jakob von Uexküll proposed that animals are not machines but 'machine operators'.[1] Each have distinct perceptions, orientations, appetites and inner worlds, related to their specific outside environments.

USHER 2:
Uexküll's favorite example is the tick.

USHER 1:
How is a tick a machine operator?

USHER 2:
A tick, after mating, climbs up a shrub. Deaf and 'eyeless' she is drawn by her photosensitive skin, and hangs on the tip of a twig, waiting for a mammal to pass beneath her.[2]

[USHERS 1 & 2 are silent for a few minutes]

USHER 1:
Over this period, which may be almost her entire life span, nothing affects her.

The USHERS wait silently for a longer period still. Some in the Audience shift about in their seats.

USHER 2:
The tick, smelling butyric acid, which is a chemical emitted by all mammals in their sweat, falls.

USHER 1:
Oh no!

The Audience, drifting off now, starts to take notice.

USHER 2:
If she lands on a mammal, her tactile organs take over. Searching for a warm hairless spot, she bores into the mammal's skin, drinking its blood.

USHER 1:
Mmmmm. The taste of the blood is unimportant. Laboratory tests show a tick will drink from an artificial membrane containing any liquid at 37 degrees.

USHER 2:
Ladies and gentlemen, as we can see, a tick's life is reduced to three stimuli, each anticipate an action and unfold in a particular order.

On the screen, a diagram appears. [USHER 1 demonstrates the cycle on the screen]

USHER 1:
It seems that the tick's world is 'constricted and transformed into an impoverished structure'.[3]

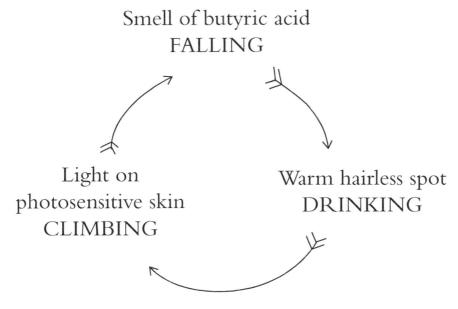

FIGURE 14.1 Umwelt cycle of the tick.

USHER 2:
But for Uexküll, actively not perceiving certain stimuli, while interpreting others as significant in a distinct temporal unfolding, is precisely what distinguishes the tick as a living being from a machine.

USHER 1:
A tick actively interprets her environment, neglecting some differences, amplifying others, while a machine only reacts according to physical laws.

USHER 2:
Most famously, Uexküll imagines the tick contributing a distinct melody to a vast *symphony of nature*, where all living things are musically, but also structurally, attuned like different orchestral instruments.

USHER 1:
[USHER 2 whistles a small tune] The symphony of nature allows for the intensification of relations between all things in the environmental milieu, which Uexküll calls the *Umwelt*.

USHER 2:

What is less considered, however, is the improvised, playful, pantomime dimension of Uexküll's biology.

USHER 1:

The original English translation, now superseded by more neutral wording, casts the tick as a Blind and Deaf Highway Woman. Uexküll invites his readers to ventriloquize her *Umwelt*, using makeshift objects, sensations and words from their own.

USHER 2:

The tick in turn, conjures we humans as 'undifferentiated' mammals.[4]

The Audience look quizzical.

USHER 1:

The conventional scientist uses his concepts 'as a means of analysis', but does not 'encounter' them in real life . . .[5]

USHER 2:

. . . but the tick meets her concepts as *living abstractions*.

The Audience continue to look quizzical.
The USHERS get slightly worried.

USHER 1:

Alright. To consider the strange concepts, subjects and modes of address that Uexküll's biology opens up, why don't we act out the tick's *Umwelt* cycle together!

The USHERS move to the front of the screen, shut
their eyes and signal to the audience to follow.

USHER 2:

The Umwelt of the tick begins with a burst of light felt by the skin. [A hot white light flashes from the screen] The feel of light on the skin signals the action: *climbing.* [USHER 1 starts climbing]

Some Audience members, especially those clustered directly under
the screen, follow the instructions — legs on chairs, arms flailing,
fingers folding, lids feeling, chins reaching . . .

USHER 1:

The second affect is smell, the odour of butyric acid acts as a signal. Now, the word 'butter' is an etymological cousin of 'butyric'. Butyric acid smells like rancid butter.

Eyeless, USHER 2 opens the box by the screen, and puts
a piece of buttered popcorn in each ear. USHER 1 follows suit.

USHER 2:
As Uexküll writes: 'The odour of butyric acid, acts on the tick as a signal to leave her watchtower and hurl herself downwards'.[6]

[USHER 1 falls], USHER 2, in a remarkable feat of un-sensing, continues to move about the room, popping popcorn in audiences' ears. Audience members, whose organs for sound and smell are set close together, sense the butter and start falling.

USHER 2:
[Eyes shut, ears plugged, nostrils tweaked in an effort to stay upright and distribute popcorn] As Uexküll points out, most ticks do not complete their Umwelt cycle . . .

The room is filling with ticks, suspended between affects – waiting to feel light and start climbing, or to smell the signal for falling.

USHER 1:
[. . . still falling] But if a tick is lucky, she lands on a passing mammal, and hitches a ride. [USHER 1 lands on a mammal]

USHER 2:
An artificial membrane, with liquid at 37 degrees is the signal for Boring & Drinking. [USHER 1 gropes for a box of coconut water, tucked inside his sleeve]

USHER 1:
The coconut water should now be warm and close to your person.

USHER 2:
[Falling at last, to the muffled smell of butter in her ears] On your stomach, inside a sleeve, under your arm, in the palm of a hand, against a leg, in your lap . . .

USHER 1:
On finding the membrane, all a tick needs to do is operate its stinger (suitable for boring into the skin of any mammal) and drink.

USHER 2:
You need to get the straw into the drink and drink!

USHERS 1 and 2 and Audience:
[in unison] And the tick, in her sound-less, sight-less, taste-less comportment . . . conjures an undifferentiated mammal.

The screen flashes, chairs topple, popcorn spoils, and straws snap and . . .
. . . The HIGHWAY WOMAN *enters the room!*

Notes

1 Uexküll (2010: 45).
2 Uexküll (2010: 44).
3 Uexküll (2010: 51).
4 Uexküll (2010: 179).
5 Uexküll (2010: 179).
6 Uexküll (1957: 7).

References

Uexküll, Jakob von. 2010. *A Foray into the Worlds of Animals and Humans with a Theory of Meaning*, translated by O'Neil. Minneapolis: University of Minnesota Press.

Uexküll, Jakob von. 1957, 'A Stroll Through the Worlds of Animals and Men: A Picture Book of Invisible Worlds' in *Instinctive Behaviour: The Development of a Modern Concept*, edited and translated by Schiller. New York: International Universities Press.

15

WRITING ABOUT THE SOUND OF UNICORNS

Salomé Voegelin

I write the quiet performance of words and thoughts into a text that is a transcript for you to perform aloud or silently; the text is thus a soundscape, an acoustic field of study, whose interpretation happens in its performance – contingent and unreliable.

First voice: how do you know how to listen out for something you do not know?

First action: listen to a mushroom and a bicycle

The name of unicorns

> So it is said that though we have all found out that there are no unicorns, of course there *might* have been unicorns. Under certain circumstances there would have been unicorns. And this is an example of something I think is not the case . . . I think that even if archaeologists or geologists were to discover tomorrow some fossils conclusively showing the existence of animals in the past satisfying everything we know about unicorns from the myth of the unicorn, that would not show that there were unicorns.[1]

In *Naming and Necessity*, Saul Kripke explains that this thing found by the archaeologists or geologists, despite matching all the traits of the thing we call unicorn, is not a unicorn, because that name 'unicorn' has already been given to something else: to the mystical beast that we know as a unicorn from fables, images and songs, and that thus exists in that name within the context of those representations, making it impossible for the fossils found in the woods to belong to a unicorn even if it looked exactly like its description in the fables. Any similarity would be coincidental rather than real, and thus would not warrant to give the fossilized animal the same name.

His reasoning why there cannot have been animals we can call unicorns moves the philosophy of language away from a descriptive theory of reference, where

a chair is a chair because it obeys the logic of its description, toward a process of naming as calling. The unicorn we speak of is real as the mystical beast that has been named so. It does not have to be validated in flesh and bone, and were such bones to be found they would be something else, they could not retrospectively climb into the name, which is the designation we have given it within the context of its reality. The bones we find now will demand their own name and designation.

Kripke's theory of language outlines, against a Kantian background, a realist philosophy that does not describe or structure the world with words but that names, as in baptizes, the objects and subjects in the world, which then remain named so in all counterfactual situations, even if their description, what they are doing and look like, and their valuation, what we think of them, change. Even if the chair changes its form, its purpose, and loses a leg say, it remains a chair.

His language does not represent an object or subject but names it through 'rigid designators' whose reference remains and is unchangeable even though everything else about the object or subject might change. In this regard, his realist philosophy of language, arrived at through a renewal of Aristotle, turns Immanuel Kant's philosophy on its head and demands complete reconsideration of the relationship between words as names and the object, subject named.

In Kant's idealist philosophy of language the description and pre-existing criteria 'justify' the name, and thus if the description does not fit anymore, in a counterfactual situation, what was named B once is not B anymore. In Kripke's realist philosophy of language, by contrast, the thing is named B and remains B in whatever counterfactual situation we encounter it. That does not mean that things around thing B have not changed, or indeed that B has not changed, however, whatever might have happened, thing B is still thing B.

That is why the fabled beast that is named unicorn within the myth remains that unicorn, and the bones found in the woods cannot all of a sudden become those of that unicorn also, but have to be given a new name: we could call it 'unicorn2'; it cannot however be called 'unicorn'.

Second voice: how do you write about something you have heard but do not know its source or have no name for?

A gothic curiosity

Kripke's naming, his baptism of things rather than discovering, structuring, and ordering them according to an etymological and ontological trajectory and truth, might, as Richard Rorty suggests, seem 'merely a Gothic curiosity, the last enchantment of the Middle Ages', appearing as a naïve view that considers the essence, or what Aristotle terms the soul of the things, the way things are in themselves, their immanence, which is understood by contemporary philosophy of language as an unreflective view. However, Rorty goes on to elaborate the radical challenge Kripke articulates for the language of philosophy, robbing it of its status

of first philosophy by guiding us ironically via a 'Gothic' metaphysics, toward a pragmatic consideration of the world, rather than its language.[2]

Thus, rather than representing an unreflective view, Kripke's naming understands the fallacy of habits and conventions and seeks to interrupt the path of normativity by renewing the relationship between perception and designation, urging us to see the rationale of reflection and of articulation and opening it to a different engagement and process, where language can grasp the as yet ungraspable rather than reduce perception to what we have words, criteria and references for; and where things once designated can change their shape and lose their form without losing their identity.

Kripke's designators are rigid but they do not restrict. Rather, and seemingly paradoxically, the gothic curiosity of his realism, the focus on the way things are, rather than rely on description, similarities and differences, means the named can be a much more fluid object or subject, contextually determined rather than in relation to a preexisting register. The named is certain to be who he is – a unicorn, a chair, a human – but there are many variants of how it can be so without ceasing to be itself.

The gothic curiosity of naming refuses the category of perception and of description and makes us see and hear beyond language, into the soul of things, and that demands we re-engage language as the coincidence rather than the description of the things' existence.

Second action: shout

YOU ARE ACTUALLY A BABY DEER AND I'M NOT GOING TO LET THAT GET IN THE WAY OF OUR POTENTIAL FUTURE RELATIONSHIP

> There is seriously an island in the South Pacific that is entirely covered in fragments of human teeth and all of these teeth are from people whose parents took them from underneath their children's pillows. Spoiler alert the tooth fairy is parents. Anyway the teeth are in fragments because I have walked over every inch of this island looking for a secret code that was placed there by the Incas that was placed there by Tibetan monks that was placed there by George Clooney's hidden twin that was placed there by an animate meteor with a bad childhood who now places secret codes on tooth-islands. This secret code will let me into a room in a broom closet at the pentagon and I know after I duck all the security lasers and put lead sand in my pockets until I weigh exactly 203.4 pounds and use my hidden Clooney twin retinal replicating glasses I can gain access to this pentagon-room where they are doing top secret research on the unpredictable physiological effects of your hair-smell. I read about this on WikiLeaks and I need to get in this room because you left your phone at my apartment I want to make sure you have your phone.[3]

Third voice: what do you hear?

Third action: go into the woods at night and listen to a bat

Fourth voice: what do you not hear?

The sound of unicorns

Sound radicalizes Kripke and challenges him to name the experience of the ephemeral and passing. By not offering him a stable object or subject to name, his designation is stretched into a naming of the possible and the possible impossible, the invisible and the inaudible – suggesting a phenomenological logic of language, not as contradiction but as challenge to both philosophical enquiries, and as an extension of each.

Sound is not an entity, or it is only then an entity when it exists within a Kantian scheme of language, as b flat, as c sharp, the sound of a lorry, or a chair, a loud sound, a quiet sound and so on. Sound as sound, as the thing in itself, as an acousmatic timespace thing, challenges Kripke to name the ephemeral and temporal and adds a phenomenological demand to his mathematical logic by bringing him phenomena that function not as objects or subjects, as entities, but as the temporal connections between objects and subjects as things thinging, contingently, which might remain inaudible even.

We do not hear entities but relationships, the commingling of things that generate a sonic world, which we grasp not by inference nor by synthesizing various viewpoints, but by centering, decentering, and recentering ourselves from moment to moment in the complex continuity of sound, that we name not to make a proposition nor to represent it or to testify to the veracity of its description but to grant another listener access to the heard and invite her to inhabit its sonic possible world and even its sonic possible impossible world, to name his own sounds and to consider her un-sounds and what remains unheard.

Sound's temporality means that the baptized thing cannot be held, the name is not only contextual but also contingent, not a designator but a portal, granting entrance to an experience that will have to be renamed continually. How will Kripke designate this invisible but nevertheless present sound that is the soul of the visible – its mobility, dynamic, and agency – but does not offer him a form, an entity, and does not work as a source, but is the commingling of all there is building a world not with objects and subjects stacked against and on top of each other, but as the honeyed fabric of a timespace place?

In relation to sound, language cannot, as in Kantian idealism, represent or describe, but it can also not adopt a straightforward Kripkian designation. It is not language, not what we say about something, but sound, that is generative, that is the world creating predicate; and its truth is not corresponding, nor positivist because it is what it sounds itself and 'what belongs to it absolutely'.[4]

A sonic philosophy of language does not describe nor name, but grants access to its actions through the experience of its ephemeral audibility and inaudibility,

out of which words come tenuously and in great doubt about their capability to communicate the heard but that try nevertheless, practising a phenomenological rather than an analytical philosophy of language. Listening engenders a phenomenological naming that knows neither an a priori nor necessity, but performs a non-ontological and non-etymological trial to grasp and communicate what it is we hear and accepts failures and misunderstandings as its most likely outcome.

Fifth voice: what are you ignoring?

Fourth action: whisper

A whisper is a sibilant thing
Sliding from the throat
Straight to the ear
an intimate thing
I'd say to a sister.
A whisper provides
An access into
boundless caverns
echoing myself.
A whisperbreaks
Narcissus' reflection
of himself.
A whisper
Is Echo's words.
This time they are heard.[5]

Sixth voice: what do you not want to hear?

Fifth action: listen to the last Kauai O'o A'a, at the British Library Sound Archive, recording, 56 sec.

The O'o A'a is a songbird from the Hawaiian island of Kauai. After many years of persistent habitat destruction and pressure from invasive species, the once thriving population had shrunk to just a single pair. In 1982, the female was lost when the island was ravished during Hurricane Iwa, leaving behind her male partner. It is his solitary voice that can be heard in this poignant recording made by John Sincock in 1983 and archived at the British Library. Singing from an old nest site of theirs, our lone O'o A'a is calling for his mate who would never respond. His song was heard for the last time in 1985 and the last sighting was in 1987. Finally, in 2000, the species was declared extinct.[6]

Writing the possible impossible

No fossils can be found in the woods that might or might not belong to a sound from a mythical fable or a time long gone. The sonic memory exists not in bones and stones but in its material trigger and the thick duration it carves in the present, and the future it prophesies. The audible holds the past without being named by it, and the inaudible sounds the future without yet designating what that might be.

The sound of the unicorn is the inaudible possible impossible. It cannot be called, and yet it triggers an imagination. It sounds at the critical edge of audibility hinting at an inexhaustible depth of inaudibility beneath and behind everything we hear, to sound what we might possibly hear also, but what remains, for now, inaudible – impossible. But to have the possibility of rigid designation, of naming, if not yet the name, means the inaudible has a place to sound from eventually, and grants us access to that which sounds already but we cannot yet hear.

Seventh voice: what do you write?

Notes

1 Kripke (1981: 24).
2 Rorty (1980: 2, 4).
3 Angel (2012).
4 Ronen (2006: 1).
5 Fayad (2001).
6 Tipp (n.d.).

References

Angel, Moss. 2012. *Untoward Magazine* 2(12), October 22. Available online: https://untowardmag.com/you-are-actually-a-baby-deer-and-im-not-going-to-let-that-get-in-the-way-of-our-potential-future-ec2874ba654 [accessed 30 January 2018].

Fayad, Mona. 2001. 'Whisper' in *The Poetry of Arab Women: A Contemporary Anthology* edited by Nathalie Handal. New York: Interlink Books.

Kripke, Saul. 1981. *Naming and Necessity*. Oxford: Blackwell.

Ronen, Ruth. 2006. 'Possible Worlds beyond the Truth Principle' in *Fabula, La Recherche en Littérature (Atelier)*. April 6, online journal, p. 1 [accessed August 9, 2013].

Rorty, Richard. 1980. 'Kripke versus Kant'. *London Review of Books* 2(17): 2, 4.

Tipp, Cheryl. n.d. Curator, Wildlife and Environmental Sounds, British Sound Archive, internal document for press team.

Woods, Russ. 2014. *Wolf Doctors*. Chicago: Artifice Books.

16

FAR STRETCH – LISTENING TO SOUND HAPPENING

Ella Finer

As everyday auditors (or what Don Ihde calls 'ordinary listeners') we listen to multiple temporalities at once, whether we are conscious of our practice or not. Not only might our auditory memory pattern other times and other sounds into what we are hearing now, but we are also continuously hearing sounds that have physically travelled long distances, travelling as well over long periods of time. From the faraway to the intimately close, our sound worlds are always overlaying times and spaces.

At the time of first composing these thoughts I wrote . . .

Listening now I can hear the sound of a plane like a heavy backdrop behind distant cars, close cars, a clock ticking, a noisy insect, these letters typing, my own breathing. And hearing the plane I think of the time when the air filled with glass from a volcanic ash cloud and planes were grounded and the sky was strangely loud in its unusual quietness. I remember my mother's voice on the phone from Berlin, one of many people stilled in transit, while listening to the sound of a soundless sky and thinking it is not a small world, after all.

And now. Listening *now* I hear go-karts, traffic, thumping feet, the higher pitches of a washing machiiiiiiiiiiiiiiiiiiiiiiiiiiiiiiiiine. London City Airport's thunderous traffic reminds me of the soundless sky and again I am transported.

Experiences of listening will never be as neat as a composed paragraph of sequential sensations. The sonic world makes its own punctuation and rarely bound by rules. While this might go without saying, or *writing*, immeasurable layers of sound happen all at once and there is always more than meets the (selective) ear, the (editing) body, the (too slow) scribing hand. Yet, descriptions of close listening often augment texts attending to sound in various forms because how else can we account for listening in text – through the medium of our hands typing or holding a pen? How can a writer communicate some sense of the strange simultaneous subtlety/density of the sonic environment she is or was in? Daniela Cascella's project

on 'Writing Sound' follows a method of writing-as-sounding, as she describes in her recent book wanting 'words to follow the untidy movements in listening, to be mud and magma',[1] while David Toop continually asks his reader to question the tricky relationship of sound and writing: 'The description of a sound, or the visual depiction of a sound, pulls sound into the world of things, the world of text. For writers this is a difficult and sometimes painful contradiction. When words describe sounds, do we think we hear those sounds?'[2]

What follows, through my thinking about how we listen in ever-expanding and contracting proximities to sonic material, is my own reckoning with how to write (about) sound. I began above concentrating on the sounds I am surrounded by now (which of course always holds the 'then' and the 'what will be') to expose a method which is implicit throughout this writing: ways of reading/perceiving the layers of live sound overlapped again with associated sounds, played back in memory. Listening constellates the sound of times, spaces and contexts, marking similarities and significant differences in the act, and this attentive listening to the complexity of correlating times is key to this method I am working with here, a method which relies on keeping faith in the absence of fact, of feeling the trace elements of something in the air, on the air, of listening to the materiality of vibrations and hearing imagination as information.

The motion of air, as Gina Bloom, Stephen Connor, Karla Mazzio and P.A. Skantze all acknowledge in vitally distinct ways, exists in mutual relation with the performance of sound. As Connor writes:

> Air is the body of sound, in the sense that it is the occasion, medium or theatre of sound. But sound is equally the body of air – air gathered into form, given itinerary, intensity and intent.[3]

The itinerary, intensity and intent of sound as the motion of air is key for helping us think of sound travelling over long distances to reach ears, however far away they may be or however unaware they may be that they are hearing something. For Connor writes that air, being 'neither on the side of the subject nor of the object' has no 'single form of being, manifesting itself in a multitude, and never less than a multitude, of traces and effects'.[4] And with this he suggests that air as breath once inhaled and exhaled and returned to the air will manifest itself in many other sites of elemental motion, for example in 'the hiss of a tire' or in 'the vortex of leaves on a street corner'.[5]

Air recycles, and through doing so can touch other times.

My practising with this methodology in my own work with sound has led me to theorise (in other places/papers/articles) the continuous performance of sound even in the absence of any nearby auditor, so that regardless of the presence of ears in the wake of its immediate happening, sound continues to perform. So let me then propose that the sounds taking place without witness do vibrate on, travelling through time and space and perhaps even through a part of the soundscape I just took a moment to listen again to in writing, and you took a moment to read.

When a tree falls in the forest and there is no one there to hear it, it does make a sound.

As cultural historian Hillel Schwartz writes in his recent book *Making Noise*, rather than performing for no one, 'the tree resounds' and then 'far away, someone catches wind of something unidentifiable, a very quiet noise, or feels a tremor underfoot'.[6] The performance of sound is apprehended in its wake at varying proximities, from the very close to the far distant, to the furthest limits of imagination. This long (and longing) listening is Schwartz's project, as he listens back to 'the intensity of sound as the intensity of relationships: between deep past, past and present'.[7] As such, his book begins in the very deepest past, in the myths of creation and re-creation stories and our 'newest versions of creation', where science explodes matter into vital new forms. He writes:

> Before thunder, before planets and suns, before light itself, we have the astrophysicists' Big Bang. A figure of speech meant sixty years ago in mockery, the Big Bang has become the popular emblem of a prevailing cosmology, putting a loud exploding at the start of time and the heart of matter.[8]

'It is not possible to begin quietly'[9] Schwartz argues and yet this demands listening back on an epic scale, an imaginative listening to the time before 'the start of time', dreaming up the noisy beginnings of our universe and putting faith in listening not only to a sound of the very deep past, but to a sound with no body present to perceive it. However, the fact that traces of the early universe can be heard in the white noise of a detuned radio is extraordinary evidence that sound does 'reappear', returning through deep time. Whether or not we 'apprehend' this sound in actuality or in imagination, does it matter if we cannot fully comprehend what this material (white noise static) is or means? Rather than obscuring some vital communicative information, what if the material of sound *is* the vital communicative information.

This provocation is most vital when it comes to listening to the unintelligible voice, distorted or distanced from its ability to communicate language. How do we 'read' difficult-to-decipher voices on a badly tuned radio or a degraded cassette tape? Here we most often listen to the medium as material, for example in appreciating the clicks and cracks of an old vinyl record. When the voice isn't mediated through technology, though, and we work to hear an unintelligible voice through live geographical distance, we are actively listening to time, to the material of time travel, as frequencies in the sound strip away the farther it moves through space. Proximity affects the sonic material we eventually hear, and also *how* we hear.

But what if the sound is so distant and/or so affected by the medium it has travelled through that we hear a version so removed from any 'original'. What if we might not hear the sound at all? Here I would like to introduce and listen back to a sound event, which, for most of its intended audience, never happened.

In March 2013 I was invited to make a piece of work for an art fair at Kensington Olympia, specifically to make a pre-recorded composition for the loudspeaker

PA system. Kensington Olympia is a large exhibition hall in London, which for over more than a hundred years has played host to public shows and exhibitions from horses to 'ideal homes', from allergy conventions to computer sales. I was told when I went to record in the space that once the grand hall had been transformed into a Venetian city scape for a spectacular performance at the end of the nineteenth century billed as 'illuminated aquatic festivities'.

The hall has seen many transformations, and these scene changes happen quickly, often without visible trace. The work I made was a three-part composition, played at the beginning, middle and end of each day at the fair over the PA system and intended to reflect this constantly changing space and the very different publics it has housed and 'addressed' before.

I had always wanted to refer to the particular medium through which the work was played, so that in my compositions the expected loudspeaker broadcasts of 'address' and 'announcement' would be reconfigured in order to test what we might assume to be the traditional subject matter, volume or intelligibility of the PA system's transmission.

But the mediums, both the technology of the speaker system and the landscape and architecture of the great echoic hall, through which the sound was broadcast, reconfigured my composition in ways beyond my own or anyone's control.

Please play the recording on the web companion.[10] You will hear the sound as heard over the PA system in Olympia's grand hall. The original recording will follow this.

Played over the PA system at Olympia, the medium performed the materiality of its existence, as the performers voices became unintelligible once played over the huge booming speakers into the vastness of the hall. And the background sounds [of workmen dismantling and building walls in the interval day between two shows] reintegrated into the acoustic atmosphere of the hall and were all but lost, save a few loud bangs.

What caught the ears of the people attending the fair was the very material texture of the loudspeaker sound. We become alert to the sonic quality of PA systems and listen even if we are not sure what we are listening to, or for. In this instance people listened, but to such a vastly altered sound from the original recording. The composition played over the PA system transformed dramatically in its style, form, volume and thus its meaning and intention. Small sonic details were stripped out of the original recording by the speakers and the hall it played into. The sound work was composed anew by the speakers and the space so that by the time it reached the ears of those on Olympia's floor it was a completely changed work.

This is an example of the way sound *keeps happening*, continuing through times, spaces and the mediums of its transmission, while continually composing and recomposing its sonic properties to be heard differently at distinct distances and locations.

In a strange turn of events I was asked to lower the volume of the work at Olympia. The reason? That people were stopping what they were doing to listen. While this might seem absurd, in the context of an art fair the loudspeaker sound work was interrupting sales. While attempting to make a loudspeaker nearly inaudible is a strange contrary task, the resulting effect of this practice was to witness my work playing out to a host of auditors who were not even aware they were listening. Not aware that sound kept happening even if for them now, still, it remains unhappened.

Notes

1 Cascella (2015: 48).
2 Toop (2010: 35).
3 Connor (2007a).
4 Connor (2007b).
5 Connor (2007b).
6 Schwartz (2011: 29).
7 Schwartz (2011: 20).
8 Schwartz (2011: 20).
9 Schwartz (2011: 20).
10 http://www.creativecritic.co.uk.

References

Cascella, Daniela. 2015. *F.M.R.L.: Footnotes, Mirages, Refrains and Leftovers of Writing Sound*. Alresford: Zero Books.

Connor, Steven. 2007a. *Sound and the Pathos of the Air*. Available online: stevenconnor.com/pathos [accessed 27 April 2016].

Connor, Steven. 2007b. *Next to Nothing: The Arts of Air*. Available online: stevenconnor.com/airart/airart.pdf [accessed 27 April 2016].

Finer, Ella. 2013. *Public Address System*, a sound work for loudspeaker, Art13 Art Fair, Olympia, London.

Schwartz, Hillel. 2011. *Making Noise: From Babel to the Big Bang and Beyond*. New York: Zone Books.

Toop, David. 2010. *Sinister Resonance: The Mediumship of the Listener*. New York: Continuum.

17

INSTRUCTIONS FOR LITERATURE AND LIFE

Writing-with landscape performances of joy

Hélène Frichot

Writing is an activity that is practised, much as art or architecture is practised, and in being practised it is also embroiled in an ethical universe of value. Transversal writing is an explorative methodology that aims to acknowledge complex encounters and relations between subjectivities, socialities and environmentalities. Writing of this kind becomes a practical and ethical performance, and with this performance there are attendant risks.

Instructions: Reconstitute the urgent and astonishing essay 'Literature and Life' by Gilles Deleuze as a series of 'instructions for use' that might be delivered to a writer.[1] Cut a transversal line across these instructions to demonstrate how a writer's ambitions might be explored where that writer is concerned with addressing creative practice. Take a writer who seeks to adequately 'write-up' or rather 'write-with' her landscape encounters. Writing and its means of construction are always at stake when it comes to 'writing-with' creative projects and experiments. For the purposes of this transversal writing experiment the writer-practitioner will be Margit Brünner, whose aim it is to achieve, in a Spinozist sense, the greatest proportion of active joys and the least proportion of sad passions.[2] Her creative projects ache to come to terms with a land that is utterly foreign to her, and one outcome is the near-mystic abnegation of the self who utters 'I' as it dissolves, stuttering, shaking, dancing, squatting and *becoming-with* landscape. She admits that she writes as a foreigner (her mother tongue is German, and she writes in English), so her language is apt to become agrammatical. In addition, she will invent neologisms for things and encounters formerly unnamed.

1. To write is not to impose a form (of expression) on the matter of lived experience. Literature moves in the direction of the ill-formed or the incomplete, because writing is non-representational. Writing *with*, not *about* or *for* or *afterwards* . . .

Margit does not want to write *about* what happens to her when she ventures out to the pastoral property of Oratunga in the Flinders Ranges, South Australia. The problem of experimenting with what she calls atmospheres is that they remain incommunicable. You had to be there. Nevertheless, she keeps field notes and she undertakes acts of documentation. For instance, when watched on Vimeo Margit's *Zwischen Büschel* [Among Tufts] renders the landscape distant. The video documentation is of poor quality as though passed through a series of veils and filters.[3] There is a great deal of interference that gets in the way between my act of viewing and the landscape, out there, somewhere. This constituted distance is necessary, as this is not meant to be a window onto a world, instead what is produced are oblique visions of an elsewhere. The video stills are highly pixellated for a reason. We must trust that Margit is a reliable witness, and rely on this documentation as a form of testimony to the fleeting landscape event that has passed.

2. Forms of content and forms of expression while distinct should never be hewn apart. *How* an argument/poem/essay is delivered maintains a large impact on *what* the argument/poem/essay forwards. *How* a creative work is expressed is relevant to the content it is attempting to communicate (*style* is not merely an ornamental flourish, but a mode of expression particular to a work).

> Margit's writing voice stutters and quavers, as she attempts to escape the habit of 'I', or else to refigure the 'I' as a continuously varying sphere of human thought and feeling.[4] Her atmospheres, without which the provisionally secured 'I' of human expression would have no air to breathe, are described as vibrating realities, as an animate medium that sustains and pervades everything. Atmospheres are varied and have temperaments, they move with different speeds and slownesses, taking up bodies and things, sometimes even fully engulfing these things, which subsequently become 'atmospheric'.[5] It is a Spinozist story of Multiplicities sheltered under the umbrella of Univocity. We could say of all things that they are atmospheric or apt to produce atmospheres, but this is not to say that everything is the same or expressed in the same way. There is a structure of atmospheres, Margit insists, and the structuration of distinct occasions of atmospheric expression produce differing effects. Sometimes these environments prove hospitable, becoming facilitative environments, and at other times there is the risk that they will turn bad, rendering life unliveable.

3. Writing's task is not merely to make a report, as though language could be so tamed and expected to communicate clearly and distinctly.

> To manage the extreme difficulty of speaking a foreign language, and of inventing a language for atmospheric effects that have been given

no adequate name, Margit composes a glossary.[6] She has inspired me to reengage Donna Haraway's brief remark about the employment of heteroglossia as a means of escaping the conceit of a presumed common knowledge or the ideal of a common language.[7] This is not only about feminist practitioners 'speaking in tongues', but about building and destroying machines, breaking down identities and categories (in order to rebuild them differently). All of which is to resist persistent attempts at deciding upon a universal theory of everything. Of her glossary, and her neologisms, Margit explains: 'the atmospheric vocabulary as it appears in this thesis builds on terms I have slowly invented throughout a long history of spatial experiments'.[8]

4. Writing is a question of becoming, always incomplete, always in the midst of being formed. It goes beyond the matter of any livable or lived experience (thus thwarting the presumed finality of a report).

> Margit undertakes a processual adventure where everything is about partaking in atmospheres that arouse the greatest joys. No clear line marks the division between literature and life, between creative practice and *a life*. She has to make it up as she goes along, and it is crucial to stress that the practice precedes the writing-up in order to maintain a 'writing-with'. It can be an exhausting activity. In eddies and swirls of reciprocity the concept-tools she constructs affect the practice, and the practice makes possible the construction of concept-tools.

5. Writing is a process, a passage of Life that traverses both the livable and the lived. Writing flies off the page and into (real) space, becoming an expanded and critical practice, a matter of aesthetics and ethics: an ethico-aesthetics.

> I imagine Margit as a mystic, someone capable of seeing things that remain invisible to others, in this way she is like the mystic philosopher Simone Weil. Her acts of becoming landscape, or entering into near indiscernible relations with landscape are also ways of abnegating the constructions of a self. She departs the landscape in a subjective state that is other than the one with which she arrived. In *Gravity and Grace* Simone Weil writes: 'If only I could see a landscape as it is when I am not there. But when I am in any place I disturb the silence of heaven with the beating of my heart'.[9]

6. Writing is inseparable from becoming: in writing, one becomes-woman, becomes-animal or vegetable, becomes molecule to the point of becoming-imperceptible.

> 'All of a sudden my knee plus an idea – responding to sounds transported with the wind from the South . . . Abruptly the left leg, colliding

with a keen marine scent, rushes to a leap.'[10] The body (this body, any body) arrives into its practical situation, the 'I' follows well after, and then sometime later, some words emerge, here and there. Margit insists that for the practitioner the philosophy must never come first.[11] Likewise, her point of view is not pre-determined, but dynamically formed as she comes into her landscape encounter.

7. Writing expresses a multiplicity of transformative becomings, and each becoming is linked to another by a singular line. These lines coexist at every level, following the doorways, thresholds and zones that make up the entire universe (a diagrammatics).

> The line is important to Margit, as is the inflection of the line that is drawn out between her and the landscape; lines meet at the mobile point of view that captures her as though in an embrace, because the landscape enfolds her: 'It is not exactly a point but a place, a position, a site, a "linear focus", a line emanating from lines. To the degree it represents variation or inflection, it can be called *point of view*. Such is the basis of perspectivism, which does not mean a dependence in respect to a pregiven or defined subject; to the contrary, a subject will be what comes to the point of view, or rather what remains in the point of view.'[12] Margit arrives and then she departs again, as she relocates her practice experiments between Oratunga and Adelaide, the capital city of South Australia. She follows what she calls joylines, which could be cautiously conflated with songlines and used as a means of orientation amidst atmospheres, enabling landscape becomings. A line becomes a drawing, and Margit 'walks her drawings'. She drags a drawing ensemble through the mallee brush, she constructs a skirt to capture traces. She manufactures the potentials of indeterminacy.[13]

8. To become is not to attain an identifiable form, but to find the zone of proximity wherein one can no longer be distinguished from *a* woman, *an* animal or *a* molecule. The process of becoming is neither imprecise nor general, but unforeseen and non-pre-existent. One can institute a zone of proximity with anything, on condition that one creates the literary means of doing so.

> Margit constructs zones of proximity between herself and the landscapes she encounters. Sometimes she succeeds, sometimes she fails: that is the nature of the experimental approach to producing the greatest proportion of joys. Margit constructs atmospheres of joy by engaging in what she calls 'test-sites'. Rather than drawing landscape, or shaping it, her attempts are toward a collaboration or co-production with landscape. She does not use the term 'landscape' as for her this is still too exclusive, but instead the term 'atmosphere', a concept she redefines for her own purposes. What is atmosphere for Margit? It pertains to immediate

zones of becoming, what could be called 'blocs of sensation', fleeting, precarious, as likely to be carried away, in fact lacking the durability of a bloc of sensation – if what is required is some minimal durability. Still, she co-produces enough of an event to 'confide to the ear of the future'.[14]

9. To write is not to recount one's memories and travels, one's loves and griefs, one's dreams and fantasies. Writing always carries the risk of becoming too 'personological': be wary of writing merely with memories, with snap-shots of childhood, with dreams, for autobiographies can reproduce the most dull refrains.

Margit makes reference to her Oratunga-diaries. These constitute her field-notes. But a reader, such as myself, has only limited access to their content, for they are only mentioned in passing. One field note reads: 'What now?' the rabbit asks the learned Sir, 'possibly we are in reach of experts'. Here Margit expresses concern about dealing with both the public and experts alike: this concerns the near impossibility of communicating atmosphere.[15] Or else, 'the morning walk can't be bothered with producing an outcome',[16] which suggests a moment when a slump into sadder passions cannot be averted.

10. Literature exists only when it discovers beneath apparent persons the power of an impersonal – which is not a generality, but a singularity at the highest point: a man, a woman, a beast, a stomach, a child … It is not the first person singular that functions as the condition for literary enunciation; literature begins only when a third person is born in us that strips us of the power to say 'I'.

'I consider all experiments as having emerged from cooperation, involving at least Oratunga and myself.'[17] Even though she writes with this 'I' and this 'myself', it becomes evident on reading her work, that she sets this position in place only provisionally. While her subject-position requires sufficient stability so that her work can be done, the important point is the 'cooperation' with Oratunga, and the collaboration with nonhuman forces and things.

11. Writing is a world-historical delirium, which passes through peoples, places and things. It is a delirium that imagines a new people, a new earth.

I confess that I have come to think of Margit as something of a seer, an oracle who can whisper near indecipherable clues that begin to suggest the outlines of a *yet to come*.

A final acknowledgement: I would like to acknowledge the Adnyamathanha people who are the traditional custodians of the land around the Flinders Ranges, South

Australia. I pay respect to their elders past and present and extend that respect to other Aboriginal people who might encounter these words. Well before the colonisers arrived the traditional custodians of the land were already *writing-with* landscape encounters.

Notes

1 Deleuze (1998).
2 Brünner (2011, 2015).
3 Brünner (2005).
4 Brünner (2015: fn. 16, 12).
5 Brünner (2015: 14).
6 Brünner (2015: 219; 2011: 10).
7 Haraway (1990).
8 Brünner (2015: 49).
9 Weil (1999: 42).
10 Brünner (2015: 21).
11 Brünner (2015: 49).
12 Deleuze (1993: 19).
13 Brünner (2015: 185).
14 Deleuze and Guattari (1994: 176). The 'bloc of sensation' for Deleuze and Guattari produces a minimal durability in a work of art, or architecture, a fusing of materials. And what the bloc of sensation must do is 'confide to the ear of the future' (1994: 176).
15 Brünner (2015: 3).
16 Brünner (2011: 164).
17 Brünner (2011: n. 674, 164).

References

Brünner, Margit. 2015. *Constructing Atmospheres: Test Sites for an Aesthetics of Joy*. Baunach, Germany: AADR, Spurbuchverlag.

Brünner, Margit. 2011. *Becoming Joy: Experimental Construction of Atmospheres*. PhD thesis by Major Studio Project. Adelaide, Australia: School of Art, Architecture, and Design, University of South Australia.

Brünner, Margit. 2005. *Zwischen Bushel*. Available online: https://vimeo.com/36272677 [accessed 12 November 2016].

Deleuze, Gilles. 1998. 'Literature and Life' in *Essays Critical and Clinical*. London: Verso.

Deleuze, Gilles. 1993. *The Fold: Leibniz and the Baroque*. London: Athlone Press.

Deleuze, Gilles and Felix Guattari. 1994. *What is Philosophy?* New York: Columbia University Press.

Haraway, Donna. 1990. *Simians, Cyborgs, and Women: The Reinvention of Nature*. London: Free Association Books.

Weil, Simone. 1999. *Gravity and Grace*. London: Routledge.

18

THIRTEEN POINTS, EXPANDED (EXCERPT)

Kristen Kreider and James O'Leary

The 'Peace Wall' clusters have existed and developed as markers of sectarian division in Belfast, Northern Ireland, for the past forty-five years. Here, thirteen points – fragments of image, object, action; slices of matter, memory, history, mediation – are identified: one for each of the 'Peace Wall' clusters situated in and around the city. Each of these becomes the starting point for a piece of writing that seeks to magnify it, hyperbolically; narrate it, fictitiously; study it, obsessively; arrange it, haphazardly. You might call this kind of writing poetry, or site-writing, or art-writing – you might describe it as a form of 'field poetics' or an essay in the most expanded sense of the term. But whatever you call it, the aim of this writing is to explore the physical, psychological, emotional and imaginative effects of the Peace Walls on this city, and the form is intended to embody it.

1. Carson
4. CONCLUSIONS OF A MEETING OF THE JOINT SECURITY COMMITTEE HELD ON MONDAY, 28 SEPTEMBER 1970, IN STORMONT CASTLE AT 11.30AM
6. BBC One, 21.05, Friday, 15th August, 1969 (Miss United Kingdom)
9. A Parliament of Things
13. Underground Wall in Belfast City Cemetery, Constructed 1866

1

A droplet falls and swerves, marking the birth of a political event. A confusing turbulence follows, becoming civil war. Elements, now polarised, congeal and crystallise into bodies seen marching or fleeing from a street on fire. Families are displaced. Decay and decline. A burnt-out bus between the Falls and the Shankill Road severs connection through vernacular divide.

All of this, or something similar, will happen again. The vortical logic will hold. The pattern will repeat, each time with a slight variation, each time leaving behind a wall.

Meanwhile, on the hill overlooking the City, a figure stands with feet spread and arm raised. An oratory gesture in apparent stasis that solicits illusive unity. A bird flies overhead. Emissions rise from his fingertips like the wisps of a fog.

.

SOURCES

Foucault, Michel. 1977. 'Theatricum Philosophicum' in *Language, Counter-Memory, Practice: Selected Essays and Interviews*, 165–196, edited by Bouchard, translated by Bouchard and Simon. New York: Cornell University Press.

Serres, Michel. 2001. *The Birth of Physics*, translated by Hawkes. Manchester: Clinamen Press.

4

In response to the persistence of violence, communities strengthened their borders with ad hoc assemblages of timber pallets, old furniture, burnt-out vehicles and other rubble. When these exclamatory interjections into the social order began to impact the mobility of state force, bureaucracy intervened. A document dated 9th September 1969 outlines a set of conditions to be announced by the Prime Minister on TV.

(ii) A peace line was to be established to separate physically the Falls and the Shankill communities. Initially this would take the form of a temporary barbed wire fence which would be manned by the Army and the Police. The actual line of fence would be decided in consultation with the Belfast Corporation. It was agreed that there should be no question of the peace line becoming permanent although it was acknowledged that the barriers might have to be strengthened in some locations.

Years later, after the antiglobalisation demonstrations at the G8 Summit, a high-ranking Italian police officer will say this to the newspaper *La Republica*: 'Look, I'm now going to tell you something that's not easy for me and that I have never told anyone . . . The police aren't there to put things in order, but to govern disorder.'

.

SOURCES

Public Record Office of Northern Ireland — © PRONI HA/32/2/55_1969
Tiqqun and Alexander R. Galloway. 2010. *Introduction to Civil War*. Semiotext(e).

6

The wall in Alexandra Park is comprised of segments that, tack-welded together, form a single, unified plane that cuts across the whole of the park, drawing distinction. In 2011 a gate was inserted into the wall, onto which was painted a photorealistic depiction of the parkland beyond. On 16th September the gate was opened and, for the first time in seventeen years, members of the local community crossed the park without digging holes underneath the wall or using ladders to climb over the top. Today the gate is open from 9.00am until 4.00pm and, when walking through, it is difficult to say if one is inside or outside.

But let us return to the violence that is just under the skin and the pathology of atmosphere from which symptoms arise. Stomach ulcers. Nephritic colic. Menstruation trouble in women. Sleeplessness. Hair turning white. Accelerated cardiac rhythm and intense sweating. Generalised contraction with muscular stiffness. Skin disorders.

From all of this we know that, by its very nature, power is separatist and regionalist, that its aim is to divide what it seeks to control and that, consciously or not, our aim is to resist.

.

SOURCES

Fanon, Frantz and Constance Farrington. 1969. *The Wretched of the Earth*, translated by Farrington. (Reprinted.) Penguin Books.

9

Circular forts made out of limestone blocks were common in Ireland throughout the Dark Ages. Castles were introduced after the Norman invasion of Ireland in the late 1160s. Hundreds of these castles – varying in shape, size and the exact configuration of fortification – can be found throughout Ulster, their figures in plan revealing a long history of defensive architecture.

Consider this: that the history of thought since the Enlightenment has been a confrontation with the loss of a cosmological centre. That, since the start of the Modern Age, the human world has had to learn to accept and to integrate new truths about an outside that bears no relation to the human. That, according to one philosopher, these are 'shelless times' for which we compensate by creating a dimension where humans can be contained, like the concept of 'globalisation' or the image of a ball-shaped Earth surrounded by an orbit of space junk.

At the interface, things stripped of human cause gather. Formations with the potential to become political. One segment of a broken gate. A plastic bottle. A glass bottle. A litter of tree branches. Bits of algae and plants. The edges of a concrete wall. A leather ball, still floating.

.

SOURCES

Salter, Mike. 2004. *The Castles of Ulster*. Malvern: Folly Publications.
Sloterdijk, Peter. 2011 *Spheres*. Semiotext(e).

13

A popular legend speaks to the origin of the Red Hand of Ulster. The kingdom of Ulster has no heir, so rival chieftans hold a boat race to decide who will rule: whoever's hand touches the Irish shore first will be made king. And when it becomes apparent to one of the chieftans that he is losing the race, he cuts off his hand and throws it to shore where it lands, first – a bloody sign of sovereignty.

Another origin. The Belfast City Cemetery is built in 1869 between the Falls Road and the Springfield Road. Serving as a burial ground for the city's growing population, the plots are divided into Catholic and Protestant areas. These areas are separated by a wall sunk into the ground, nine feet deep. And every day and every year and every decade since, the soil around the wall has been moving and shifting, its particles tilled and sifted by countless little mouths.

.

SOURCES

Darwin, Charles. 1881. *The Formation of Vegetable Mould, through the Action of Worms, with Observations on Their Habits.* London: John Murray. (Relevant discussion in Bennett, *Vibrant Matter.*)

Maume, Patrick. 2010. 'The Red Hand of Ulster' in *History Ireland.* 2:18 (March/April). Available online www.historyireland.com/20th-century-contemporary-history/red-hand-of-ulster [accessed 10 April 2016].

19

RETURNING IN THE HOUSE OF DEMOCRACY

Brigid McLeer

There is a room, an oval room, in a house on the east coast of Ireland. The room frames an ellipse and a floor of ash. It is perforated by four apertures, all of which, when I first encounter the house, are bricked up. The stories I will tell about this room are speculations on transformation and potential informed and infused with the speculations and stories of others. Each time I return the stories begin anew. They too are elliptical, as they do not 'come back full circle to the same'.[1]

1.

I first saw the room through a photograph.[2] A scene of symmetry and damage, in portrait format, it is a strange photograph in which the ceiling predominates. Like a mottled heaven, soaring above the ruins of a neoclassical ideal, it declares the room's ellipse and is resplendent even in its ruined, discoloured and charred condition. Below, a sea of burnt and broken planks of wood flood the ground and the wall's surface disintegrates. Despite its portrait format no person is captured in the photograph, instead it is the outside light burning through the open front door, reeking of substance, that seems to occupy the interior. That, and the effects of fire; a force of so-called 'outsiders' who are visible only by the aftermath of their actions. But their absence does not lessen the event of the photograph nor its quality of encounter. Rather it betrays their exclusion and turns the room in all its devastation into a civil demand. One to which the photograph might respond. It reveals the *means* of the room and of the image, a turning, if not a revolution.

I am returning to the house to partake in this means, through photographs, writings and other records that are trying to resist capture and admit a form of political appearance in which equality reigns. I am returning to the house to partake in a radical figuring of the democratic, a 'promise of politics' that the house and its oval room prefigure. And I am not the only one . . .

2.

Architecturally the ellipse is a Baroque form, enjoyed for its dynamism and its sense of excess. As such it is audacious, normally employed in public spaces or rooms for assembling. As a geometric or architectural figure, the ellipse is a figure of decentring or de-origination as it is drawn via *two* centres, *two* foci. The circle, to which it is estranged, is really only a special form of ellipse, in which the two foci overlap. Understood this way the ellipse is a dynamic and irregular 'circle' adrift from origin, yet recurrent. But it is also a figure of equidistance, an anarchic figure described by the shared-separation of equalities. In astronomical terms, Johannes Kepler's discovery in the seventeenth century of the elliptical orbit of the planets was devastating as it disrupted the ideal order of the universe, a harmonious vision of concentricity and order within which a singular mastery reigned. And while the planets do not orbit *two* suns, the centrifugal and centripetal forces at play between sun and planet require that another *eccentric* point be posited to mathematically prove their irregular motion. In Kepler's 1st law of planetary motion this point remains empty but sits in exact equidistance to the sun relative to a planet's elliptical orbit. Kepler arrived at these conclusions, in part, by giving renewed attention to a similarly eccentric focal point in the ancient Roman astronomer Ptolemy's model of planetary motion. Ptolemy called this point the 'equant' and although it served a very different purpose in his geocentric and circular model of the universe, it nonetheless redistributed a centre, just as the two foci of Kepler's elliptical orbits also did. One might think of the 'equant' then as an equalising origin, a 'second sun', abstract perhaps but no less bright for that. And when these equals meet it is a return. But not a return of the same to the same, this would be to close the circle and to delimit stasis. A return of the same to the other is the perfect unbalancing that returns the other to the same and undoes sameness: a wobble, a fall, a *retombée*, an elliptical return. It only takes one, stepping out and up to the rule, to upset the motion of an entire universe, to revolutionise the spheres and make temporal millennia of firmament. The stateless perhaps, a 'non-citizen', a refugee, a traveller resisting crude forms of interior in a house, a State, a nation, a world, from a distance not a division – a shared-separation – that throws the centre off and demands to be equalised and inhabited as a singular and universal refuge. As with the sun's equant each time the stateless return it is a profound decentring, which here in the house is drawn into the room as a figure and potentially the *figural*, appearing.

The ellipse therefore is the outer figuring of the place or appearance, not of duality but of equality. It is a powerful figure because prior to the equality there was no place, no appearance, just an origin asserting its closure. Etymologically both ellipse and ellipsis are a falling short of closure, of the end. They are gestures to the outside and its infinite potential, from within. When built as a room then the ellipse is a kind of contradiction, an interiority that moves towards the outside and doesn't settle. It is a space built for encounter, with an outside or an equal, in a forum that pertains to the public realm.

3.

Belcamp House is situated in the east of Ireland near the sea on private land bordered by low-income housing estates, travellers' halting sites and the airport further inland to the west. It is now on the edges of Dublin city in an area called Darndale once considered to be a place of poverty, gangs, drug crime and hopelessness: an oblivion, set for redevelopment. When Belcamp house was being built in the late eighteenth century, on the east coast of the New World of America a revolution was starting. It declared itself a revolution on behalf of 'the people' when in fact it was a move to replace sovereignty with governance in a form no less exclusive. Fuelled by an idea of freedom and equality set tightly within limits it was forming a new government in fear of the democratic and unpractised at equality, yet around it democracy was surfacing in defiance. For the people whose land it occupied, equality was a perfected means, struggling to remain at large. Over time this new form of governance would come to embrace the language of democracy and align it with (its) national independence but despite its many achievements it would remain a nation of the interior, powered by domestic and private values and fear of the outside; a 'house' that would rule the world through a promise it could not keep.

From the house he was building in Ireland, the parliamentarian Sir Edward Newenham was also practising a form of limited radicalism, fighting for his own version of freedom from sovereignty. His was to be a Protestant revolution, a break from the same king and country, a new constitution for the same 'men of property'. When the American colonists in 1776 first declared their break from British sovereignty, they did so in the name of republicanism. Theirs was a constitution premised on representation by men of property 'elected' because they had the time and reason, by virtue of their class, to stand for 'the people'. Yet 'the people' were not to be consulted extensively, lest their own reason appear. Newenham was inspired by the colonists' declared independence and grew fervent, ambitious, idealistic, and powerful. Yet he too would admit no 'outsiders' to his forum of power. Then at some point between 1775 and 1785, before he emigrated to America, a young up-and-coming architect and builder named James Hoban was admitted to Newenham's estate to make plans for a house. Hoban was a Catholic from County Kilkenny, son of a tenant farmer and talented, ambitious and lucky. At some point, though it is unclear how this came about, the two met and began to design the house that would be built. In the years following Hoban's arrival in the new federal 'United States' plans were being drawn for a distinct national capital, a 'district', strategically located between Northern and Southern States. It would provide a locus and protection for the institutions of government and would contain the 'City of Washington' named after the States' first president and by 1792 it became clear that the president too would need a house there, a *house*, not a palace. James Hoban had met with Washington in Philadelphia shortly before submitting his proposed designs for the new presidential 'house'. It is possible that he was influenced in his design by Washington's fondness for a bow window, set into a curved wall, which he had had specially built into his house in Philadelphia. Washington hosted weekly levées (meetings with male citizens who had applied in advance for

an audience with the president) in this space every Tuesday at three o'clock. With such an enveloping and theatrical backdrop to the scene, the president could stage himself before the citizens, as a priest to his flock or a king to his subjects. It is possible that Hoban was influenced by this window and recognised its significance to Washington, however Hoban's room had a bow at both ends, one 'stage' mirrored by another, just as it did in the house in Ireland. It was an ellipse, copied and perfected from the designs he had drawn for Belcamp. Who knows what Edward Newenham made of this when Hoban first introduced the oval room – this space of public encounter – to his private house but at some point they may have stood, face to face across the distance of the two foci, in that room with its three bay windows opposite a door, both alit from behind, the Catholic boy and the Protestant peer, temporary equals in a room on the move; in a room that stands for the motion of a promise that one centre cannot hold.

4.

As it stands now the house is liminal, caught in a caesura between redevelopment and redevelopment. As a debt, it stood unused and unprotected for more than a decade. And while its toxicity was absorbed by the State (its) privations grew public. The interior was ransacked, and set alight many times. As it stood, and still stands, waiting, 'outside' continues to incur. After each incursion, security is stepped up and after each securing, so too 'the outsiders' step-up their game. The house is under siege. Or at least that is one way of putting it. It is also that the *outside* is beginning to appear *inside* the house. One could say it is the potential of *oblivion* acting. Coming from the nearby margins, in droves.

The last time I went to Belcamp House an enormous concrete ram had been shoved up against the steel security door at the front of the house. Dents from bullets pockmarked the steel, *real* bullets according to the security guards who patrol the site. The night before, firemen and police had been called to the scene of yet another blaze, this time resulting in the collapse of some of the upper floors. The interior was now so unsafe I was not allowed to enter the house at all. But the security guards opened the front door so I could look inside, first dragging the concrete ram away with a mechanical digger. Two of them entered, crossed the front hall and shone torches round the oval room. I could see nothing except their high-visibility jackets glinting beyond in the distance. On the way out one of the guards told me how he had been to school at Belcamp, when the house was owned by the Oblate Fathers and was part of a larger school complex. He had never been in the oval room before. He called it 'the strong room'. "It was where the money was kept," he said, "and none of the boys were ever allowed to enter it." For him, the house was full of ghosts. Men were still watching him from the empty windows even as their blackened frames smouldered in the late summer air. Now, 'the boys' are back, figments from the edge, from the limits of State and estate. Traveller boys placed beyond the reach of redevelopments, the children of families who move and move again and against the delimits of a house that cannot admit them. They are back. And each time they return the fortress house is weakened further.

Somehow they always get in and gradually the house is being turned inside-out. Soon they will find a way to breach the bricked-up windows on the ground floor, and the oval room will once again flood with light. And maybe people. Sometimes I imagine being there, waiting at one end of the room, while they storm through with picks and crowbars, pulling out the bricks and climbing through the apertures into the ash-filled room. I would be there to meet them as they pile in, the emigrant meeting the travellers in the president's empty place. Perhaps we might become *denizens* there and then, for a moment in that moment of encounter, before the house would collapse in on top of us.

5.

And what if, in that moment, before the once beautiful ceiling with its elaborate oval plaster ceiling rose came crashing down, what if right then, we partook in a photograph? Could it be a partaking rather than a taking, a capture? A special form of non-sovereign encounter, an image that no one *one* can own? Could there be such a photograph, an encounter with dissent and affect, with arbitrary sedition taking place in an old abandoned house that would be a special form of appearing? Could the room, photographed momentarily, as that is all it would take – an instant in and out of time – restage the civil contact it first drew, the promise of politics that was slipped in before the doors closed? Of course it would be two photographs, at least, facing each curved end of the room, we facing each other,

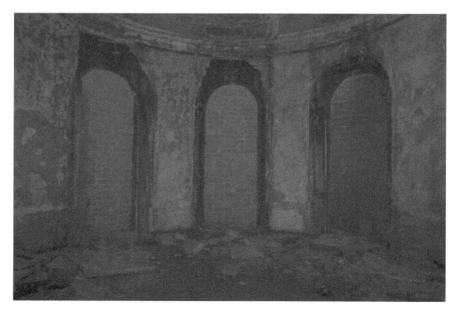

FIGURE 19.1 Belcamp House (interior ground floor oval room facing east) © Brigid McLeer.

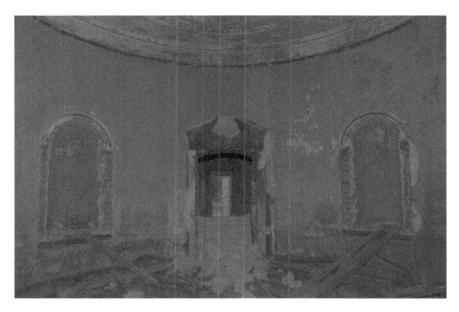

FIGURE 19.2 Belcamp House (interior ground floor oval room facing west) © Brigid McLeer.

and every other 'other' that the photograph includes. It would be figures, appearing in a figural *enunciation*. But that is another story, of other photographs, and people in place of a president, on the edges, waiting . . .

Notes

1 Nancy (1988).
2 The photograph was posted on the blogsite 'Comeheretome' and was itself a link to the original photograph © leonotron.com (https://comeheretome.com/2011/04/15/belcamp-college-today-a-depressing-sight/).

References

Agamben, G. (2008) *Means Without End, Notes on Politics*, 1st edn. Minneapolis: University of Minnesota Press.
Arendt, H. (1958) *The Human Condition*, 2nd edn. Chicago: University of Chicago Press.
Azoulay, A. (2008) *The Civil Contract of Photography*, 1st paperback edn. New York: Zone Books.
Azoulay, A. (2008) *Civil Imagination: A Political Ontology of Photography*. London: Verso.
Donahue, W.H. (2004/8) *Selections from Kepler's Astronomia Nova*. New Mexico: Green Lion Press.
Graeber, D. (2013) *The Democracy Project: A History, a Crisis, a Movement*. London: Penguin.
Lomax, Y. (2015) *Pure Means*. London: Copy Press.
Lyotard, J.-F. (1971) *Discourse, Figure*, 2nd edn. Minneapolis: University of Minnesota Press.
Nancy, J.L. (1988) Elliptical Sense. *Research in Phenomenology*, 18, 175–191.
Robertson, L. (2013) *Thinking Space*. Brooklyn: OPR Editions.

20

DANCING ARCHITECTURE; ARCHITECT-WALKING

Cathy Turner

As a member of Wrights & Sites, my art practice emerges from a tradition of flâneurie, Situationist drift and psychogeographic writing. In this instance, I am informed by Jane Rendell's idea of 'writing architecture' rather than writing 'about' architecture.[1] However, I do not so much attempt to 'write architecture', as to write the movement between architecture and performance that we found at Nrityagram – in particular, the inference of dance from stillness, and capture of movement in design. Since my subject matter is, in all senses, remote from my experience, I make frequent reference to more authoritative sources; this pulls the text back towards more conventional academic writing, but seems essential.

There were no dancers there at the time of our visit. They were away on tour. Nrityagram (literally 'dance village') was quiet. We were invited to walk around it.

This was not a case of losing ourselves in a drift: We took a path that travelled through various nodes to the far end of the site, at which we more or less had to retrace our steps. Nevertheless, Prescott–Steed describes urban psychogeography as a quest for the unknown, '*as if each walk were a dance*, the appeal of which rests in its capacity to reach out into unfamiliarity'.[2] This was a walk that required us to imagine dance with every step, reaching out for the absent dancers, placing them amid the built gestures of the architecture.

Nrityagram is in South India, about 30 km from Bengaluru, near Hesaraghatta Lake. The village was the vision and project of the late Odissi dancer Protima Gauri (also known as Protima Gauri Bedi), who established it in the 1990s. Her dream, as articulated on the Nrityagram website, refers to the Indian tradition of the *guru-kul*, where the dancers live and train with the *guru* (teacher), almost as extended family:

I dream of building a community of dancers in a forsaken place amidst nature. A place where nothing exists, except dance. A place where you breathe, eat, sleep, dream, talk, imagine – dance. A place where all the five senses can be refined to perfection.[3]

FIGURE 20.1 Walking through Nrityagram. Photograph © Jerri Daboo.

The institution now teaches only Odissi dance, but in the past has taught other dance forms: Bharatanatyam, Kathakali, Mohiniattam, Manipuri, Kuchipudi and Kathak. While there is only a small number of students undertaking the full five years of training, the school also runs a large number of workshop activities, including classes for the village children. There are several *gurus* (Surupa Sen is the Artistic Director), but it is made clear that the institution itself represents the *guru* who should be served through the practical work of all those present, tending the land, preparing food, cleaning and earning money through dance performances.

I was there to experience the architecture, although always inferred in my interest was Odissi, the classical dance genre for which the village was built. Interested in the performative qualities of architecture and in performance as a way of re-imagining space, I was drawn to Nrityagram as a place where the architecture was built in the service of performance, not just as event, but as the basis of shared training and living. How does one dance a place into being?

I am not a dancer, unless you consider walking as dance. I am not an architect, unless we all are.

1. Dancing architecture

In the history of Odissi dance, architecture and bodies stand in for one another, exchange between one and another, in a movement that might itself be conceived as dance. While I have written elsewhere about the performativity of architecture, the relationship in this case is one in which illustrative façades directly inform us about historical bodies.

The stone reliefs in the Ranigumpha caves and the carved dancers on the Orissan temples are reference points that both unreliably record and equally unreliably authenticate Odissi as a regional, 'classical' Indian form, with its roots in ritual dances of antiquity, supposedly a development of the *Odra-Magadhi* dance mentioned in the *Natya Shastra* and thus dating from the 2nd century BCE. While both the caves and the temples undoubtedly record Orissan dancers (the former possibly secular, the latter sacred), the connections between contemporary Odissi and the dances of antiquity are tangled and, at times, dubious.

Odissi dance is supposed to be a reconstruction of the ritual of the female temple dancers, *maharis* (or *devadasis*); young women dancing in the service of the god. Initially, this seems to have been a form of Shakti worship, later incorporated into Tantric Buddhism, giving way to worship of Shiva (or Nataraj, the 'cosmic dancer') then subsequently Vishnu (sometimes in the form of Jagannath and with Shakti represented as Subhadra).[4] However, the ritual use of *devadasis* later deteriorated due to poverty, prostitution and corruption, ceasing finally in the mid-20th century.[5] In fact, the form as we now know it was (re)invented in the 1940s and 1950s by male *gurus*, often former *gotipuas*, Vishnaivite street dancers, whose tradition echoed and partly paralleled that of the *maharis*, involving a more public and acrobatic presentation, taking on female roles. As for the *maharis* themselves, there was little left of their erotic ritual practice, which would have been less theatrical, less gymnastic and performed in smaller spaces; indeed, their input was largely

missing from this revival. Instead, the *gurus* based their movements on a range of sources including local dance practices; the aesthetics of the already established Bharatanatyam; the physical training and entertainments of the *akhadas* (gymnasia) in Puri where young men trained in martial arts; and a loose version of the *maharis'* dance, filtered through the vestiges of tradition and memory, re-imagined through the *gotipua* tradition and systematised with reference to Sanskrit manuals.

They also looked to architecture, referencing the postures depicted in Orissan temple carvings.

The ancient Sanskrit text of the *Silpa Prakasa*, which lays down the strict principles for temple architecture, considers the temple figures 'indispensible in architecture . . . without (the figure of) woman the monument will be of inferior quality and bear no fruit'.[6] The sculptures, *alasa-kanyas,* were 'decorative charms to attract the soul of the created towards the creator'.[7] Thus the erotic lure of these figures is supposed to attract the devotee. Sixteen types are laid down in this text, and all sixteen appear in the Jagannath Temple at Puri, for instance. Nrityagram makes reference to these and contains a number of similar sculptures.

The poses found in the sculptures were drawn on by all the gurus and typically embedded in a dance sequence with linking footwork and hand gestures created by the Jayantika group. Indeed, Guru Surendranath Jena went further, developing a form of Odissi explicitly derived from the dance sculptures of Konarak, which Lopez de Royo describes as providing him with 'a dance vocabulary in stone' of 'twenty-four dance movement units, all originating from the Konarak temple',

FIGURE 20.2 The Odissi Gurukul: Surupa Sen stands centre; well-known Odissi dancer Sujata Mohapatra is on the left, circa 1995. Photograph © Bharath Ramamruthan.

divided into sub-units through segmenting the body into movements of the upper, lower, left and right body.[8]

The Nrityagram website refers to these carvings when it suggests that: 'Odissi creates an illusion of sculpture coming to life. Isolated torso movements, typical to the Odissi style only, help create these curves and therefore an eternal "S" pattern is formed in the body and space.'[9]

FIGURE 20.3 Sculpture, Odissi Gurukul. Photograph © Cathy Turner.

Sabina Sweta Sen tells us that these sculptures are referenced as part of the training at Nrityagram through exercises which explore them as 'a source of movement and . . . to learn how emotions are generated through movement'. She describes teacher Bijayini Satpathy leading such exercises, finding them 'a vital source for activating and evoking the emotions "frozen" within those sculpturesque *alasa kanyas*'.[10]

In this sense, Odissi dance is a form mis-remembered from architecture.

2. Architectural dancing

According to an article in *The Sunday Tribune*, the layout of the village was partly determined by Gauri's instinctive feeling for space and movement. Managing Trustee Lynne Fernandez is cited as the source for this anecdote:

> Gerard D'Cunha, the architect was inspecting the land with Protima. She walked with a stereo player and wherever she felt a strong desire to dance, she struck a pose and dropped a stone to mark the place. Trees were then planted there.[11]

This use of dance towards the design is reiterated in a report which paraphrases Gauri as remembering that 'During the design stage, [she] would dance each evening to show the basics of her dance and to express what she wanted'.[12] In his own account of the project, Da Cunha does not mention this, but he does mention his own embodied research at site, staying there for an extended period before anything was built, learning about local crafts. Is this embodied pursuit of knowledge – this conscious pursuit of the performance of place – analogous to dance?

Da Cunha began his process by living on site in a tent 'for over a year'.[13] Gauri, herself camping on site, recalls his activity:

> And Gerard da Cunha, the architect. What would my one year in the tent have been without his energies? He was as driven as I was. Life was doing to him what it was doing to me. He too was restless, on the move at all times, feverishly working, working.[14]

Gauri, who goes on to mention the hot sun, paints a picture of bodily immersion as Da Cunha learned about local materials and practices and drew up rough initial plans to be scaled up later, allowing design decisions to be made through observation and phenomenological response. While the site had few landmarks, the siting of a phone line and a grove of trees provided some starting point for the entrance and the very featurelessness of the site provoked the design. In an interview for *AIDEC World*, he describes it as follows:

> 'When I was starting work there, I had a site that was flat. No trees, no view, nothing. I had to create vistas. It was an isolated area, so I had to bring a sense

of security. For the few students living in isolation with the teacher, it had to be compact.' He grouped his buildings around the three courtyards that he built. 'When you got into the building you felt secure'.[15]

Da Cunha's 'Evolutionist' approach involves the integration of design and building processes. Recognising that local building practices worked with rectilinear forms based on posts made from local granite, and timber beams, with stone slab roofing, Da Cunha incorporated these in his design for residences. However, preferring an architecture that incorporated curves, he included domes in, for example, the Kathak *gurukul*, while arches in several locations also reference local practices.[16] The roof over the dance floor of the Odissi *gurukul*, on the other hand, is more reminiscent of the slightly curving pyramidal shapes of the *Vimana* (tower over the sanctum) in Orissan temple architecture, here more humbly articulated in corrugated metal and timber.

The spaces are not laid down according to *shastric* principles, which Da Cunha rejects as simplistic and encouraging superstition, although we were told that local builders, called on to do repairs, commented that the architecture[17] perhaps reflects them instinctively. However, though it might be fortuitous, the combination of curves, squares and triangular roof beams in the Odissi *gurukul* seems to echo the movements of the dance.

The Odissi dance form is built on the relationship between the *chowka* (square, masculine, the god) and *tribanghi* (triangle, feminine, goddess) postures where the

FIGURE 20.4 The now ruined Mohiniattam Gurukul, c 1995. Photograph © Bharath Ramamruthan

FIGURE 20.5 Kathak Gurukul. Photograph © Cathy Turner.

FIGURE 20.6 AND 20.7 L. Roof of Odissi Gurukul. Photograph © Cathy Turner. R. Entrance to the village. Photograph © Sabina Sen.

latter are characterised by an 'S' shape bending at head, torso and knees. The rectilinear stone walls, regular pillars and square floor echo the *chowka* movements, while the triangular and pyramid shapes of the roof (an undulating square-based pyramid) echo the *tribanghi* movements. The curves in the doorways and roof echo the curving and circling motions that are also found in Odissi. There is also counterpoint: the rough stone walls of the Odissi *gurukul* are described on the village website as offering strength that 'counters the giving gestures of the dance it houses'.

Meanwhile, the half-moon shapes in the pattern of arches in the Mohiniattam *guru-kul* (now sadly in ruins) is explicitly mentioned as echoing the circling movements of that style. Indeed, the repeated use of mortarless stone arches provides rhythm across the site, and, as acknowledged, a sense of suspended movement.[18]

Thus, at least in some respects, the buildings at Nrityagram comprise an architectural vocabulary renewed through dance.

3. Dancing and architecture

After stopping at the office to be introduced, we looped around the yoga centre, then back past the office and Odissi ('Raymond's') *gurukul*, strolling past dormitory buildings, the Kathak *gurukul* and exhibition hall to the red clay of the amphitheatre at the far end of the site. The village calls out to all senses, through its generous vegetable gardens, the heat of red earth underfoot, the bird sounds like the *ghatam*'s hollow ring, and the scent of the snake-headed shivalinga flowers.

The gardens were being tended, since gardening can't be postponed. The site continued its own life.

In my own work, with Wrights & Sites, we've suggested that everyone is an architect, in the sense that we produce spaces through our adaptation of materials, our insistence on specific routes, our *ad hoc* building and our occupation of existing

FIGURE 20.8 Sabina Sen on the stage of the amphitheatre, Nrityagram, April 2013. Photograph © Cathy Turner.

places.[19] Here, however, it became clear that the very shapes of our gestures can also find synergy with architecture, sharing bodily rhythms with the rhythm of pillar or arch.

In our party, Sen was the only dancer trained in classical Indian forms, and was indeed to return, to undertake the Summer School in 2014. Periodically, Sen would pose for us to photograph the spaces with a dancer in them. She stood in a *tribhangi* pose on the cool floor of the Odissi *gurukul*, then posed again on the hot red floor of the amphitheatre, holding her body still to obtain the best picture.

Once again, dance was frozen as image, as documentation, as architectural element, amid the sensory abundance and rhythmic stillness of the built space.

Notes

1 Rendell (2010: 7).
2 Prescott-Steed (2013: 131), my italics.
3 Gauri cited on Nrityagram.org (n.d., n.p.).
4 Sangwan (2015).
5 Patra (2004: 169).
6 Kaulacara (1966: 46, l.392).
7 Hejmadi and Patnaik (2007: 13).
8 Lopez de Royo (2006: n.p.).
9 Nrityagram.org.
10 Sen (2016: 169–170).
11 Pandey (2001).
12 Kumar (1997: 97).
13 Da Cunha (2010: 266).
14 Bedi (2000: 241).
15 *AIDEC World* (2012).
16 Da Cunha (2010: 267).
17 Da Cunha (1997: 38).
18 Nrityagram.org.
19 Wrights & Sites (2017).

References

AIDEC World. 2012. 'Gerard d'Cunha: Architecture Returns to Nature', available online: www.aidecworld.com/people/gerard-dcunha-architecture-returns-to-nature/ [accessed 17 April 2013].

Bedi, Protima Gauri. 2000. *Timepass*. Gurgaon, Haryana: Penguin Books.

Da Cunha, Gerard. 2010. 'Evolving a Vocabulary of Architecture' in *New Architecture and Urbanism: Development of Indian Traditions*, 266–274, edited by Prashad and Chetia. Newcastle: Cambridge Scholars.

Da Cunha, Gerard. 1997. 'Experiments with Truth in Vernacular', *Architecture + Design* 14(1): 38–39.

Hejmadi, Priyambada Mohanty and Ahalya Hejmadi Patnaik. 2007. *Odissi: An Indian Classical Dance Form*. New Delhi: Aryan Books International.

Kaulacara, Ramachandra. 1966. *Silpa Prakasa*, translated by Boner and Sarma. Leiden: Brill.

Kumar, Santosh. 1997. 'Young Architects Festival, Session 1: Synthesis of Art and Architecture', *Journal of the Indian Institute of Architects* 62: 96–97.

Lopez de Royo, Alessandra. 2006. *ReConstructing and RePresenting Dance: Exploring the Dance/Archaeology Conjunction*. Available online: http://humanitieslab.stanford.edu/117/Home [accessed 22 July 2016].

Nrityagram.org website. www.nrityagram.org/ [accessed 22 July 2016].

Pandey, Priya. 2001. 'Keeping Protima's Dream Alive', *The Sunday Tribune*, 22 July. Available online: www.tribuneindia.com/2001/20010722/spectrum/main4.htm [accessed 17 April 2013].

Patra, Benudhar. 2004. 'Devadasi System in Orissa: A Case Study of the Jagannatha Temple of Puri', *Annals of the Bhandarkar Oriental Research Institute* 85: 159–172.

Prescott-Steed, David. 2013. *The Psychogeography of Urban Architecture*. Boca Raton: Brown-Walker Press.

Rendell, Jane. 2010. *Site-Writing: The Architecture of Art Criticism*. London: I.B. Tauris.

Sangwan, Monica Singh. 2015. 'History and Ritualistic Significance of Odissi Dance Today', *Narthaki*, 10 September. Available online: www.narthaki.com/info/articles/art390.html [accessed 22 July 2016].

Sen, Sabina Sweta. 2016. 'When Our Senses Dance: Sensory-Somatic Awareness in Contemporary Approaches to Odissi Dance in India'. Unpublished PhD thesis, University of Exeter.

Wrights & Sites (Stephen Hodge & Phil Smith & Simon Persighetti & Cathy Turner). 2017. *The Architect-Walker: A Mis-Guide*. Devon: Triarchy, forthcoming.

21

DOLPHIN SQUARE TO MI6 WALK – PRODUCED BY DISAPPEARING, ALMOST

Phil Smith

I struggle to identify the kind of writing here. It is a participant observation of an event I failed to turn up to; it rubs away at the auto in ethnographic, partly replacing it with self-indulgent reflections. It runs together both sources and references in the manner of various literary psychogeographies; in its evangelism for the 'drift' and the performance walk it dimly echoes Protestant rhetoric's nagging at things, bodies and itself.

Mytho

On the day of the walk in question I worried when I didn't hear anything. I had missed the calls somehow and had not thought to check for messages. Long after I knew the walk would be over, there had been no posts on social media. Late in the evening, I finally read that it had 'gone well given the circumstances', and then heard that 'it was far better that you weren't there . . . you should always not come'.

For four years on Facebook I posted as Myth O'Geography; I wrote all the posts as 'we'. I was often msg'd as 'all of you there' or 'the Mytho team'. My manifesto book of 2010 was presented as an assemblage of documents from post-situationist organisations and individuals. In 2012 I published two books on Counter-Tourism under the pseudonym 'Crab Man'. I never seriously hid my authorship of any of these publications from anyone willing to look closely enough. Then Facebook removed my anonymity and I published three books on walking, in 2014 and 2015, as 'Phil Smith'.

The result was not public exposure (not of any significance), but loss of public absence, of a virtual, atmospherically effective open space of potential in which, and as which, to speak, write and perform. Operating across a 'plane of consistency' does not consist of a single voice advocating a space of 'heterogeneity-preserving emergent structures', but requires 'exchanges between multiplicities . . . overcoming habitual

patterns of hierarchizing agents'.[1] A short-term concentration of ideas around a name soon coagulates the ideas.

One of the photographs taken on the walk by Max Reeves shows the walkers standing with their backs to a wall, close to signs that forbid sleeping. On the pathway, spread at their feet, are the seventeen imaginary sensory organs they have made from clay. It could almost be a crime scene; or strangers gathered around the

FIGURE 21.1 Photograph © Max Reeves.

afterbirth of a miracle. A dismembering of a walker, or the invention of a new one: the kind of spectre for which travellers absentmindedly set an extra place.

My suggestion, one of eight written hurriedly on finally accepting that I was too ill to go, had partly read: 'Look across to Shanghai in London on the other side of the river, and then at the sundial behind you . . . an idea of Charles Fourier's, that humans will evolve new senses and the organs for them. He suggested a tail with fingers and an eye. Use the modeling clay, as you go, to mold new sensory organs for yourselves, necessary for when the waters come.'

The scatter of soft, vulnerable soft organs constituting an eighteenth walker, the spatial hybrid – critical surgery and messy workplace – and the ambiguity of the walkers, their hands covering mouths, deep in thought, gazing far away or eyes closed. This was a 'plane of consistency', laid across the near-anonymity of multiple identities, accountable only in the last resort, and always spilling beyond singular human frames, with options to be a movement, a document or a flag of convenience. Something I might re-find and even, partially, be.

Tutors at the Royal College of Art had been running a mini-fest of walking and talking called 'Walkative' with people like the artist Laura Oldfield Ford and the geographer Steve Pile organising walks. They asked me to make a walk in London and write an account of it for a book; I met one of the organisers from the Royal College, Simon King, at Paddington Station. After initially becoming cornered inside the station, we looped out around side streets and then across Kensington Gardens. On our way we visited an altar, debated the gender of the Holy Spirit with the priest, and ate egg on toast in a cafe–laundrette hybrid. When Simon asked me if I would lead a public walk I initially intended to re-walk this route, but he had been following Facebook posts about a Dolphin Square walk and asked if we could re-walk that, backwards?

The Dolphin Square walk began as some general thoughts about space, responding to a spatial turn among activists '[U]ninterested in an endless conversation about reflexivity' and committed to a 'form of analysis [that] brings the action of its process and the site of profound power into relationship with each other'.[2] In my *Walking's New Movement* (2015) I had identified such a 'profound power' in what I called 'Savilian spaces': places of abuse located somewhere between private and public space, usually known to and even administered by the institutions, families and communities the abusers operate within. By their non-action, powerful official bodies legitimated the outrages committed against vulnerable people in spaces made invisible and unquestionable.

After new revelations/allegations about establishment rings of abusers using flats in the Dolphin Square complex in London, I commented on Facebook that this was the kind of space that psychogeographers should be exploring and interrogating and intervening in, and was immediately challenged/invited by the poet Edmund Hardy to jointly organise a walk there. Which we did; using Facebook to invite others to join us. We chose to meet outside the MI6 building and find our way to the flats. En route we engaged with a morbidly excited pink balloon caught in the vortex of an ornamental fountain and with a faded information board

depicting 'prehistoric people' in silhouette 'honouring the river gods' by hurling swords and pots into the Thames, with fragments of a rusted engine labelled in permanent marker CAMELFORD outside MI6, with the MI6 building's garden of weeds and floodlights, with the outlets of Effra and Tyburn rivers and discomforting ornaments on private houses, with swastika and vagina graffiti.

In 1997 I was one of four people who jointly set up Wrights & Sites for making experiments in site-specific performance. By 2001 we had mostly switched our focus to walking as performance. I was wholly ignorant, but other members were aware of related practitioners, mainstream like Richard Long and Hamish Fulton, or more in the margins like Tim Brennan, Simon Ford, even (then) Iain Sinclair. The model seemed to be: male and solo. Our one model for collective or sociable radical walking was the *dérive* of the International Lettristes/Situationist International (dissolved 1972); though the small psychogeography-revivalist groups of the 1990s in London, Manchester, Washington and elsewhere had either disappeared or were unappealingly cantankerous and sect-like. By the time I came to write *Mythogeography*, published in 2010, I had spent a few years looking out for 'fellow travellers'; the book's portrayal of a wide but fractious network of walking groups and individuals was a fiction, however. A wishful thinking. And, although I had no word for it at the time, a *ludibrium*: a fiction about an organisation that brings a real organisation into being (the Rosicrucian Order being a good example: an 'historical' account of which appeared in print some years before the Order was formed with readymade past).[3] Since 2010, coincidentally, a meshwork of organisations *has* appeared (Walking Artists Network, web-based groups like Global Performance Walks, and so on) and the model has changed; less literary and more performance oriented, female, sociable.

At the same time, this emergent meshwork is so mutable and dispersed it is like a fiction; there is little in the way of structure, accountability rests on the consciences of a few individuals and the autonomy of hundreds (thousands?) who only participate in what they wish to. There is and there is not the 'new movement' I identified; there is and is not 'the new psychogeography' proposed by Tina Richardson.[4] And yet, it is exactly that uneasy territory, bogus and sincere, that seems to be what makes the affordance and (to take a phrase from mysticism) the groundless ground where others can make and sustain their own models.

Such a space finds a dark reflection within Dolphin Square; a complex of over a thousand apartments which have accommodated 'in such a concentrated space'[5] a thick and strange assemblage of fascist leaders, security service chiefs, parliamentary politicians of far left and far right, and stars of light entertainment, entangled, occasionally in scenes of interrogation, arrest and scandal. It is hard to find a popular cultural myth – from Donald Campbell's death, via the Satanic Abuse trials to the Profumo Scandal – that does not have a scene or two played out in these flats. In the enclosed garden, within the 'castle' of apartment blocks that rise like a New York canyon, there are dark poetries: a warning about 'the Unequal Step', flesh coloured roses, a vortex of mammals.

FIGURE 21.2 Shanghai in London. Photograph © Phil Smith.

When Simon asked me to re-walk MI6 to Dolphin Square, I invited all the original walkers to jointly lead the walk: 'I would love it if you fancied coming along and if you wanted to plan a rant, an action, anything for any point along the way. I'll prepare some moments, but I would also hope and plan for the walk to be as open to whatever is found as before.' In the event, the episodes of weariness, which I had been resisting-by-ignoring for some time, began to run into a whole box series of exhaustion. I was 'diagnosed' as having Pyrexia Of Unknown Origin, which is no diagnosis at all, and as I write this, ten weeks later, after biopsies and regular blood tests, X-ray and CT scans, I am still coughing phlegm from bleeding lungs and no one is any the wiser about me. There is something exemplary about the anonymity of my malady; possibly spectral, possibly an auto-immune response to an infection that is not there.

I was disappointed to miss the walk. I was hugely relieved. I could give in now, admit defeat. Resolve myself into 'unwell'; legitimated by avuncular consultants who, at one point, were calling me in almost daily for monitoring and tests. I was a 'proper' patient; pushed to the head of queues. A pinball bounced down the corridors of clinical hierarchy; sedated, injected with colour, cannulated. Though samples of me swirled about the labs, and occasionally findings were briefly lost and found again, I was fixed in my role as 'medical mystery', repeatedly negative to ever more exotic conditions.

When I look at Max's photos of the walk I am struck by the performance elements; Niall speaking a poem before a portal gated with thick square iron bars and unfolding a collage of James Bond images on soft card. I recognise Anoushka's fingers displaying an exploded fragment of plastic bottle flecked with sand maybe from the Thames beach, Liberty and Julie geometricising the famous Dolphin Square corridors on their phones. Among my offered tactics I had invited the walkers, in small groups, and 'without forcing an entry, [to] charm your way or otherwise gain entry . . . XXXXXX spoke on Facebook of . . . the corridors as like a hotel lobby or an airport lounge . . . Get inside as quickly as you can and use your time to find out what the elsewheres of this place are . . . Where are its interconnecting flights bound for?' I was surprised when they did get in. A line of walkers, their hands at work on clay, as if in prayer. Simon peeping through theatrical curtains inside the Square, Edmund producing poetry from his cape.

Outnumbering the humans though, by far, are the images of things: signs forbidding residents from 'visiting' the roof, the revenant of a conflagration, leaves in congress with symbols, stages for action, statues juxtaposed, a list torn into a poem, and the heads of a line of porcelain pigs lacerated for the insertion of coins.

It is far better that I 'should always' fail to turn up. The tactics are enough; they bring the walkers to the space not to the person. Everyone and everything performs, sociably enabling 'a re/connection with a material space that is always potentially under threat of being renegotiated into private or prohibited space . . . Offer[ing] a material and archaeological critique that excavates the signs contained in the terrain that might be contrary to the dominant discourse . . . [by] the necessary physical enactment of placing one's body in the terrain in order to read the signs therein.'[6] Not in order to construct a future situation, and in the time gap allowing hierarchy back in, but in the moment of the walk itself to confront binaries of 'inside/outside, mind/matter and natural/manmade' (and indeed, public/private, open/hierarchical, exploitative/sensual) so they 'are overridden through one's very movement through the space itself'.[7]

Ending (almost) with a long quote is good.

Everyone is running with their own spectral viruses; withdrawal is both a strategy and a symptom that enables tactics to be molded, like soft clay, in many hands. And I can lose myself, not just in spaces that are critical and sharp, but also in the parts of that eighteenth walker sprawled softly on the pavement tiles, close beside a drain.

Notes

1 Bonta and Protevi (2004: 124).
2 Thompson (2015: 158–159).
3 Thompsett (1995: 83).
4 Richardson (2015: 241–253).
5 Gourvish (2014: xix).
6 Richardson (2015: 247).
7 Richardson (2015: 247).

References

Bonta, Mark and John Protevi. 2004. *Deleuze and Geophilosophy*. Edinburgh: Edinburgh University Press.

Gourvish, Terry. 2014. *Dolphin Square*. London: Bloomsbury.

Richardson, Tina. 2015. 'Conclusion: The New Psychogeography', 241–253, in *Walking Inside Out: Contemporary British Psychogeography*, edited by Richardson. London and New York: Rowman & Littlefield.

Smith, Phil. 2015. *Walking's New Movement*. Axminster: Triarchy Press.

Smith, Phil. 2010. *Mythogeography: A Guide to Walking Sideways*. Axminster: Triarchy Press.

Thompson, Nato. 2015. *Seeing Power*. Brooklyn: Melville House.

Thompsett, Fabian. 1995. 'Society of the Spectacle', *Transgressions* 1: 81–85.

22

IT MOVES

Reflections on walking as a practice of writing

Mary Paterson

This is a lie.

This flow of words, from top to bottom, left to right – this ordering of things. I didn't discover these sentences but built them deliberately. They do not represent my thoughts, but direct them. Language does not reflect experience, but acts on it.[1]

This, at least, is how I like to start a lecture.

The words are useful, not only because they're true, but also because they're funny. Funny enough, at least, to earn approximately 45 minutes of goodwill from the strangers I am talking to. I am quoting myself, from an article I wrote for a Finnish magazine in 2010. The magazine no longer exists – neither online nor in print – and I have lost my copy. My only document of the text is a screen grab I took of the first few paragraphs.

It's funny because it's impossible. It's impossible because it's true. It's written down but it's no longer there. It's made of words but it persists as an image. This is not just a lie, but a whirlwind of its own duplicity, complete with the duplicity of my own attempts to distract you from what might come next. This lie matters to me because I translate things into language. Things – experiences, objects, performances, memories – summoned onto the page, the PC, the tablet, the tongue, as if the words matter. I mean, as if the words have matter: as if they have weight, meaning and exchange value. I mean, as if they have meaning that can be mined like jewels and swapped for money.

And all of this, of course, is a lie.

Words are not discoveries. They arrive, warm and shabby and dog-eared, wet with other people's saliva, rubbery with other people's mistakes, full of holes where the light gets in. Every single one of the words I am using right now, for example, has had more than one careful owner. Sometimes the words arrive polished by the handkerchiefs of the alibis of famous names: Deleuze, Barthes, Guattari, Arendt, Sontag. These names construct these words [note the continuous present, as if

writing and reading happen in the same shiny seconds of time] in these orders [note the request to suspend your disbelief, for a shine of a second, about the fact that you read these words, so often, in translation], and so they must matter. And so they must have matter. And so they mean. And so mean matter; so matter with meaning. I mean, they are ripe with meaning, so full of means.

'And [so] the meaning of Earth completely changes' [these words were set in ink by Deleuze and Guattari, polished by me, and countless others], 'with the legal model, one is constantly reterritorializing around a point of view, on a domain, according to a set of constant relations, but with the ambulant model, the process of deterritorialization constitutes and extends the territory itself'.[2]

But I am walking ahead of myself.

I write [] performance. The [] stands for a relationship I don't have a word for, as well as the gaps in language where the foreign objects get in. I'm interested in the ways that language – particularly language that is recorded and distributed over time and distance – laces its fingers with performance – particularly performance that is temporary, borderless or incomplete – until you can't tell which is the word and which is the action. I am interested in how this happens with the performance of art [and when I say interested, of course I mean I feel it, silently, with the back of my tongue], as well as, increasingly, with the performance of daily life [and when I say increasingly of course, I mean I roll it] and the performance of words through the bodies of the people who use them [this gelatinous ball, across my gums].

Clever. It is clever, isn't it, to spit your second-hand sounds into the air and suck them back in again with a grin? Clever to roam through the city with Sellotape, sticking recycled words to your eyelids and reproducing them for people who have read all the same books as you, albeit in different translations. Clever and free and so clever, I mean, most of all it's so [], like someone who is not just in possession of an education but also the means to pay off its debt.

An aside: I recently met up with some old colleagues in Berlin. We were there with our families. I have a joke with my son that my old colleague Henrik, who is tall and wide and from Denmark, is a Viking. My son, who is two and a half, is used to being told impossible things. We met in Friedrichshain Park and Henrik suggested taking a walk up its hill. Off he went, with his family, in a straight line. Henrik did not take the path that wound around the hill. He did not walk on cobbles or near steps or with hands trailing on low, protective walls. Instead, he walked through trees and puddles and mounds of dirt, over fences and across benches and through the sharp snappy fingers of defenceless trees. He travelled, you might say, 'as the crow flies'. Or, as my son might say, 'as the Viking goes'.

This means. It means, 'Henrik is a Viking'.

But I am walking ahead.

To be a writer implies a facility with language. To say, in company, that you're a writer, or to smile when someone says it about you, or to type it into your Twitter profile or your funding applications, assumes you hold some type of language in your possession, and possession, we all know, is nine-tenths of the law. But this

is a lie. Language, in words used by the writer Tim Etchells, 'is always a suit of someone else's clothes you try on – the fit is not good but there's power in it'.[3]

Indeed [in its own deed, in its doing of itself], the power of the suit lies precisely in its potential for re-use: in its sags and creases and the fact that other people are going to stitch it up. That's another part of my joke. I quote myself sometimes, not because I am pleased about anything I have said, but because I want to emphasise my distance from the words I have written down. 'We don't want to write the last word', my colleague Rachel Lois Clapham and I used to say when we were running writing workshops for art festivals. We self-published printed fanzines with groups of writers we had only just met. We handed them out to people waiting in queues. Then we scribbled over them, screwed them up and tore them into tiny pieces.

An aside: perhaps you are listening for the soft, high whine of a child that has started to stir. Perhaps you are watching for signs of movement beneath a pastel coloured shroud.[4]

But I am walking.

It wasn't until a couple of years ago that I realised this duplicity of language [and when I say realised, I mean burned in the hot fire of long-scented disappointment] is not just to do with the appearance and disappearance of words and bodies, but also the appearance and disappearance of bodies even when they're silent, silenced or busy doing other things. I moved to the suburbs, gained a baby, lost financial independence and was drawn into a private sphere of home times, bed times, shopping lists, cleaning schedules, date nights, laundry mornings, bodily functions – in other words, family life – that I had last slammed the door on when I left home to buy an education.

An aside: one foggy day last year I walked along the medieval battlements that line the coast outside the French town of Calais, and watched a ferry glide into port. The ship was the size of a tower-block. Its edges were smudged into the sky, its horn shrieked through the cloud. I looked down to write some notes and when I looked up again the ferry had disappeared – swallowed by fog or sailed out to sea. In the same pocket of time, two boys arrived next to me. I discovered them, standing still, staring at the imperceptible horizon, just as I realised the boat had gone. They spoke to me in English and, later, when we walked back into town, shopkeepers spat at their feet. From this, I could tell they were migrants,[5] young men from North Africa or the Middle East, waiting in Calais for an opportunity to cross to the UK.[6]

I could no longer walk. I could no longer write. I no longer had surplus words that could be torn up with the promise of more tomorrow. I no longer had time for experiments at dawn in other countries. I no longer had meetings with strangers – albeit strangers who look like me, have read all the same books as me, and give me at least 45 minutes of goodwill for the price of a bad joke. I mean, I could do all those things. But no longer on my terms. And I realised the terms had never been my own in the first place. Having a child was simply the most socially acceptable way of saying, 'my words and my tongue and my body are not always ripe for exchange'.

Boring. Boring, isn't it, to go on about money, as if money matters, as if any of us are in this for the money? I mean, I make so little money it's a joke. I mean, it's funny. I mean, I can laugh about it because someone else is paying the mortgage. I mean, what's funny is that when I quote myself I am making a mockery of the peer review system and the REF and the closed economy of the academy, at the same time as I'm making a profit from it; at least I think I am. I've heard the term CULTURALCAPITAL. It's my pension plan. It's my holiday fund. It's my place to (put my offshore) trust. And that's got to mean something.

In 2015 Theresa May, Home Secretary, a woman in possession of an education similar to mine, a woman, in other words, who has read many of the same books as me, expressed her deepest concern for the migrants trying to get to the UK. This country, with its borders made of sea and racial profiling, has a moral duty to help refugees, she said, as long as they are not 'those who are young enough, fit enough, and have the resources to get to Britain'.[7]

But I am –

'By estranging objects and complicating forms' [inked the writer Victor Shklovsky, translated by Benjamin Sher, modified by Anthony Iles], 'the device of art makes perception long and "laborious". The perceptual process in art has a purpose all of its own and ought to be extended to the fullest'.[8]

And so I made a mistake; or, as those of us in possession of not one but two degrees from UK institutions, along with pale skin and the same name as the late Queen Mother are allowed to write, with some kind of self-deprecating authority, as if we are tossing small change into a well that has already granted us our wishes, 'a pun'. I watched a video made by the neuropsychologist R.L. Gregory which describes the movement of images from the retina to the brain. This movement is slow, he says, unusually so, at least in relation to the movement of the rest of the body's nervous system. The speed of visual perception, says R.L. Gregory, in a booming, old-fashioned, upper-class voice that stirs in me a sense of benign authority and good intentions, is 'about walking pace'.[9]

I went to Copenhagen [note the casual place-dropping of foreign cities, as if my presence is a matter of international demand, my conditions spun from invisible material], and spent three months walking in silence with strangers through a city I did not know. The ten-week workshop had been advertised for writers and artists, but I did not ask anyone to share what they wrote. Instead, I wanted to make public our movement, and make private our words. I wanted to slow the process of perception to walking pace, shape language with our feet, negotiate the public as foreign objects, fling quicksand over the flags of documentation; in short, to wander, unterritorially, with no power, status or small change changing hands.

I wanted [note the use of the authoritative subject, as if what I want matters, as if my ideas are a value of production and a currency of culture] to expand the gap between language and meaning. It was as an intervention (in the lexicon of performance art), a disruption (in the lexicon of digital start-ups), a Viking (in the lexicon of a two-and-a-half-year-old).

But I –

At the end of one of these walks, someone I had been walking next to for a couple of months or so told me that the oldest word in Danish was a Viking word for 'longing'. It's an onomatopoeic word that sounds like the rustling of leaves, she said. We imagined ancient men huddled round fires on unfamiliar coastlines, thumbs resting on their daggers like eighth-century iPhones, listening to the leaves caress each other in the trees and longing for home.

But.

In 2014 Theresa May, in possession of a degree from a UK institution as well as, famously, a collection of the kinds of shoes that are designed for the wearer to be transported rather than to walk, stepped off the kind of Eurostar train that migrants have been clinging to in failed and fatal attempts to move beneath the sea, and arrived in Brussels to argue that the European Union should stop rescuing boats in peril on their way to Europe.

Marauders. Rapists. Imperialists. Freedom fighters. Violent psychopaths with distinctive head gear. Brainwashed thugs. People with no respect for borders. Killers for hire. Men without a choice. Murderers. Depraved agents of terror. Vikings. We still utter the words they brought with them across the water. Sky. Dark. Die.

This means. It means, it matters. Words matter. They have emotions and memories and ghost stories. They have passports and travel documents and the scent of a different horizon. Theresa May's argument was, in a manner of speaking, 'successful'. Since then, migrant deaths in the Mediterranean have risen by 5000%.

And so you are the maker of things, so you are allowed to destroy them. So delicate and firm. You can mark so tear the paper, so it helps you look so neat and tidy. You are so polite. So boundless. So it is shocking you think of violence, let alone act on it. So you stay and whisper, 'this is not violence; this is just words'.[10]

But I

Moving, according to words strung together deliberately by Theresa May, in possession of two homes and a budget for travel expenses, is an admission of guilt. Well, let's be clear: she means, sometimes. *I'm* allowed to move. Positively encouraged to, in fact. It's part of my professionalism (this is a lie). It's part of my cultural capital (this is a lie). It's part of my facility with words (this is a lie. And I don't know how to stop telling it).

But. I have 'no'.

She spits across the TV divide and into my living room as if I am the kind of [] in possession of pale skin and long vowels and a certain type of education, like her, like me, like people like us, as if people like us want to catch her words and wear them round our necks like jewels and use them to buy buy-to-let property. Never mind that I am just a few decades from being a migrant who was smuggled across Europe with her eyes shut. Never mind that I am named after that migrant: the name she gave herself in order to appear English, in order to avoid shopkeepers spitting at her.

But I have no words.

My grandmother wrote in perfect, calligraphic English. She preferred to write the language than to speak it. Her accent had a habit of expanding in the gaps where the foreigners get in.

Notes

1 Paterson (2010).
2 Deleuze and Guattari (1988: 372).
3 Etchells (1999: 105).
4 Paterson (2014a: 163).
5 Recently in the UK, there has emerged an important distinction between 'refugees' (people who have no choice but to leave home) and 'migrants' (people who do). While I understand the political necessity for this distinction, I do not have a right to judge other people's reasons for moving through the world. I use the word 'migrant' in order to make a link with global histories of migration and patterns of change: which are, arguably, more consistent human experiences than staying still.
6 Paterson (2016).
7 May (2015).
8 Iles (2016: 8).
9 See www.richardgregory.org/experiments/.
10 Paterson (2014b).

References

Deleuze, Gilles and Felix Guattari. 1988. 'A Treatise on Nomadology' in *A Thousand Plateaus*. London and New York: Continuum.

Etchells, Tim. 1999. *Certain Fragments*. London: Routledge.

Iles, Anthony. 2016. 'Anguish Language' in *Anguish Language*. Berlin: Archive.

May, Theresa. 2015. Speech to the Conservative Party Conference, October 2015, reprinted in the *Independent*, 6 October. Available online: www.independent.co.uk/news/uk/politics/theresa-may-s-speech-to-the-conservative-party-conference-in-full-a6681901.html [accessed 24 April 2017].

Paterson, Mary. 2010. 'This is a Lie'. *Esitys*. Issue 10. No 3. Helsinki: Todellisuuden tutkimuskeskus.

Paterson, Mary. 2014a. 'Denmark Hill' in *Mount London*. London: Penned in the Margins.

Paterson, Mary. 2014b. *So*. London: Lemon Melon.

Paterson, Mary. 2016. 'Parallel Crossings'. Available online: https://parallelcrossings.com/ [accessed 24 April 2017].

23

IN DEPARTURES, NOT DEPARTING

Tim Etchells

Since the late 1980s and early 1990s I've been writing around contemporary performance, beginning from my own practice and that of other artists, moving at times to broader explorations of questions relevant to the field. From the outset in this writing I set myself the task of finding ways to approach my practice using methods and formal strategies that arose from the work itself and which reflected my position as an artist/maker, involved or implicated in artistic endeavour rather than distant from it. To this end I have pursued interweavings of theoretical, autobiographical and sometimes fictional material, as well as experimental formal structures (texts with excessive footnotes, texts in fragments), always with a view to making critical work that could engage vividly and aptly with the kinds of questions that have concerned me. A through-line in my work in this area has been the pursuit of a performative approach to critical writing – one that treats the relation between writer, texts and readers as variously and emphatically active, imaginative and subversive. The text here, 'In departures, not departing', is one of a number of pieces from recent years in which I'm playfully embedding conversations/thoughts/observations about the cultural field and artistic production into structures that employ both fictional and highly performative dynamics.

The plane's delayed for whatever reason, at first a little, then for longer, and later, longer still. As time passes the calculated wait for your boarding is no more counted in minutes, but rather in hours. Then, with a subsequent shift from numbers to language – 'please wait for an announcement' – all your plans for day and night are sealed abruptly, sent into abeyance. You're trapped here, a human animal penned in departures, not departing, bags in the hold of a plane that will not fly, the prospect of replacement still uncertain, in the lap of the gods.

Only there are no gods in your life, and the ones on offer suck. You wait, enjoying as best you can, what they call the gifts of capital; the mirrored noise of

duty free, where staff with precision faces keep track of your movements, smiling, the escalators' ordered versions of perambulation, the people (passengers, members of a club you no longer belong to) going here and there, travellers for business or pleasure, most of them anyway on phones, smart phones or laptops, checking screens and devices, eyes elsewhere and nowhere, and later in a café by the window, you eat slowly the best food that your poker fist of compensatory airline issue vouchers can buy.

After eating you read the brochure of the festival you were meant to attend. Shows. Ambitions. Claims. Descriptions of shows. You read the newspaper. Claims. Ambitions. Wars. And counterclaims, and crises. And lies. Depressing. You're tired. And not thinking straight. The festival blurs with the one you previously attended and the newspaper blurs with the one you read yesterday in Helsinki, or perhaps it was Melbourne. You start reading the brochure again, forcing yourself to engage. Shows. Ambitions. Claims. And questions; the world and possibilities of change. They announce that your departure is now predicted for an eight-hour delay and you stand to go squint at the flat screen, struggling to focus on the number, checking you've read it correctly. Eight hours. Yes. Yes, you have; a tedium of waiting awaits. Later, in a corner, near some broken terminal, cleaning station or decommissioned vending device you find a seat from which your laptop charger can just reach to prong the welcome eyes of an electrical socket and minutes afterwards you're downloading email, reading the paper again and starting to write.

Night falls in the airport. The human traffic slows, thins, then almost disappears. The handful of your fellow stranded have long been recognisable to you, the mad eyed and restless, the shuffling, the walking from spot to spot; persistent figures of the airport's unconscious, feeding on distractions which are themselves slowly closing; the designer shops, the juice stands, the bookshops with their infinities of magazines on racks, all closing, all closing down. Outside (if runway counts as outside) it gets fully dark and though you try to sleep, you end up only lying down, eyes wide open, watching blankly the blackness through the window from your horizontal place, the world shifted through 90 degrees. There, from your off-kilter vantage, not far from Gate 35, you catch occasional reflected and refracted glimpses of your flightless comrades; skimming the blackness of the night as they shimmer through the terminal on irregular orbits, the old guy, the tired woman and her son, the sisters, the beautiful boy, all, one by one, also dropping from unheavenly circuits to find rest or electrical power. Soon it is more or less stillness back there, in the airport now become its own backstage, and the nightcleaners descend, uniformed in navy blue and green jackets, sweeping the floors with their custom machines, picking trash from the benches, tables and window ledges with gloved hands, emptying the bin-like structures of their numerous recyclables. Later they too, for the most part, are gone, passed through the city of the airport like a wave, leaving you with only the nothingness hum of electrics, the shimmer of lights, the darkness outside. You sleep. Deep, thick and angular sleep, with dreams the colour of the terminal benches.

When you wake, without looking you sense a presence/figure not far away, someone watching, close to you. Slowly blinking yourself back to peripheral vision, squinting the reflected striplights, you see that it's still dark outside, though the airport holds resolute its perpetual day. An elevator closes somewhere in the distance, the sound a punctuation. Peering in the brightness you see there really is someone at the bench nearby and with your eyes getting slowly adjusted, though still without moving, you glance around a little – a castaway in a story, lain on sand – looking out to find that one of the nightcleaners, a woman whose plasticised name badge reads 'Gargaaro', and whose ID shows her smiling, is standing right opposite you, removing latex gloves from heavy hands just as she sighs, sits and drops exhausted to a neighbouring bench, intent to rest and read a long-abandoned newspaper.

You look up, your eyes a question meeting hers, connecting from your prone position.

'Long day,' she says and laughs. 'Long day, Long day,' and shakes her head. And you say, 'Yes, yes, long day, long night . . . And now?'

'Almost finished,' she says, 'Just baggage and the furthest gates to go.'

'What then. Freedom?'

At this the nightcleaner looks at you sideways, then almost sighs:

'Freedom. You really believe in that?'

You're rising to vertical, rubbing sleep, brushing clothes with hands. The night-cleaner continues:

'Well, they do say we have it here – the freedom . . .' She puts down the newspaper, gestures, stands and walks back to her cleaning cart. 'They do say it . . .' then she starts cleaning the floor, mopping thoroughly, switching her gaze between you and the ground. 'I don't mean here in the airport. I am talking about Western Democracies, you know the so-called Developed World. We have some freedom here . . .'

You nod, sitting now and blinking in the light, your brain going slowly. Then she speaks again, with urgency, the mop marking double-time near your feet.

'The freedoms we have are in any case always less than they seem, subject to compromise, not so robust as they might be, fragile.'

She throws a wink to the cluster of surveillance-cams nested at the polystyrene tiles. You try to speak but you're still not ready, not quite in the world for the conversation and anyway, there's no stopping her.

'We're watched – electronically speaking – more closely than even the most paranoid dystopians used to suggest. Our social and informational spaces (news, media, communications, discursive, analytic) are massively constructed, curated, constrained. The political arena is framed and heavily influenced, not just by the state but also, with increasing alacrity and even less transparency, by the transnational corporations and their paid lobbyists.'

'What?' you say.

She ceases mopping to deal with a coffee cup kicked and wedged beneath a bench not far from where you're sitting.

'Look,' she says, gesturing with the cup, 'Even the spaces we inhabit – in physical world as well as online – are in truth less public than they are pseudo-public; the mall or

private road rather than the street, the moderated and in any case owned social media stream or bulletin board rather than the real space of social meeting and exchange.'

She gets rid of the cup, throwing it underarm to the trash cart she's been wheeling. Back-lit by the vending machines, she says:

'Maybe my news you already know; the situation is crisis, global, worse than global, harder now than ever to make sense of. Just look out there . . .'

She nods towards the city invisible, far beyond the airport.

'. . . it's winding up, or crashing; a world in downturn and supposedly consequent austerity. Plus, on top of that, everywhere, the coming home to roost of colonial adventurism; in the Middle East, in Central Europe, the former Eastern Bloc . . . those traps you laid.'

'Yes,' you say, *'But . . .'*

She waves her ungloved hand, touches the name badge on her overalls, as if placing hand on heart. *'Somali name,'* she says, by way of unsought explanation. *'It means "the one who helps".'*

You smile, *'That's nice.'*

'Doesn't matter.' She continues:

'The things I've spoken of are braiding themselves around slow motion social and political "realisations" about the finite nature of Earth's resources and the reality of global warming, adding extreme weather catastrophes and a slew of resource scarcities to our woes. You talk about freedom but in this context it's more of a . . .'

'Wait . . .,' you say. *'I can hear something.'*

It's a shout, in fact a terrible yell, a scream that cuts the air, a voice bouncing like trapped light on the tiles and the glass down past the fluorescent mirage of Gate 55. Rising you set off with the nightcleaner, the two of you pounding footsteps in bad sync on the otherwise empty travellator, dragged from its own slumber to carry you onwards and along, forwards, forwards, towards the source of the sound.

When you get there it's effectively too late. One of the other stranded, an elderly guy of uncertain provenance, has collapsed by a closed-down currency exchange. He's shaking, moaning, foaming slightly. You take his hand and the nightcleaner calls from the wall-phone for paramedics, returning to cradle the old guy's head as he pietas there, all forlorn and broken under the strip lights. He lets out another cry and then, either as a part of dying, or as prelude to it, you can't really tell, he drags his voice from panic abstracts back to speech. He speaks not as a whisper, but as a kind of voice you never heard before. He says:

'Free thought. Free thought. Free thinking. Free speech. Free. Freedom. Free. Freedom of thought. Free speech. Freedom of speech. Free. Freedom. Freedom to speak. Freedom to shout. Free. Freedom.'

You think he's finished, but of course he's hardly started.

'The freedom of shouting. The freedom . . . The freedom of whispering. Freedom to whisper. Free. The freedom. The freedom of hesitation. The freedom of the pause. The freedom of the crossroads. The freedom of silence. The freedom to remain. The freedom to move. The freedom of the silent. The freedom of those that refuse to speak. The freedom of those that cannot speak. The freedom of the visible. The freedom of visibility. The freedom of invisibility and the freedom of the invisible. Freedom of assembly. The freedom of disassembly.

The freedom of the rich. The freedom of the poor. The freedom of men. The freedom of women. Freedom from gender. The freedom of children. The freedom of human animals and the freedom of non-human animals. The freedom of the police. Freedom from the police. The freedom of the people. The freedom of black people. The freedom of white people. The freedom of the jailed. The freedom of the sleeping. The freedom of the dead. The freedom of the unborn. The freedom of the speechless.

'The freedom of the unspeakable. The freedom of the powerful. The freedom of the powerless. The freedom of the page. The freedom of the city. The freedom of the countryside. The freedom of the ocean. The freedom of the wilderness. The freedom of the skies. The freedom of the ozone layer. The freedom of surrender. The freedom of hope. The freedom of secrecy. Secret freedom. Public freedom. Private freedom. Temporary freedom. Eternal freedom. Freedom by permission. Freedom by statute. Freedom by decree. The freedom of the privileged. The freedom of the lost. The freedom of approaching death . . .'

His eyes seem to focus slightly, as if he heeds the words that spill from out of him, body shivering its alphabet of shakes.

'The freedom of the vanquished. The freedom of the captured. The freedom of the weak. The freedom of the unconscious. The freedom of those who act following orders. The freedom of those who take orders from god, or from gods, or from a god or from those representing, interpreting or channelling a god. The freedom of those who dream. The freedom of those without dreams. The freedom of those that speak. The freedom of those that listen. The freedom of those that throw stones. The freedom of the road. The freedom of the open road. The freedom of the stage. The freedom of the auditorium. The freedom of the network. The freedom of the gun. Freedom from the gun. The freedom of laughter. The freedom of hate. The freedom of sex. The freedom of love. Freedom from love. Freedom from desire. Freedom from speech. Freedom from language. The freedom of language. The freedom of darkness. The freedom afforded by darkness. The freedom of the eye. The freedom of the heart. The freedom of the spirit. The freedom of desire. The freedom of those, who finding that they cannot speak, decide to speak anyway. The freedom of those speaking in constraint. The freedom of those whose voices are yet to be heard. The freedom of those whose voices are habitually silenced. The freedom of the voice. The freedom of the song. The freedom of those having no desire to be heard. The freedom of those having no need to be heard and no desire to be heard. Freedom to act. Freedom to act badly. The freedom of bad actors. Freedom from freedom. The freedom of freedom. Freedom from other people's freedom. Freedom of expression. Freedom of inexpression. Freedom of rage. The freedom of the cage. The freedom of money. The freedom of gold. The freedom of the beautiful. The freedom to vote. The freedom not to vote. Freedom won with bullets. Freedom won with struggle. Freedom bought with bloodshed. Freedom bought without bloodshed. The freedom afforded by shelter. Freedom without price. Freedom bought with gold. Freedom bought with influence. Freedom as a birthright. Freedom as a hiding place. Freedom arising from a promise. The freedom of people in different classes. The freedom of the conspirator. The freedom of the murderer. Freedom from the past. Freedom from the present. Freedom from the future. Freedom from the demands of the past. Freedom from all expectation. Freedom from all explanation. Freedom from the need to explain. Freedom from censorship. Freedom from self-censure. Freedom from economic

pressure. Freedom from doubt. The freedom of doubt. The freedom of optimism. Nihilistic freedom. Structured freedom. Free association. Free thought. Free love. Free thinking. Free food. Free lunch. The freedom of privacy. The Free Press. The freedom afforded by friendship. The freedom afforded by change. The freedom afforded by anonymity. The freedom afforded by strength. The freedom afforded by weakness. The strength of the weak. Freedom from care. Freedom from responsibility. Freedom from work. The freedom of work. The myth of freedom. The scent of freedom. The guiding narrative of freedom. The erosion of freedom. The slow erosion and encroachment of freedom. The appropriation of freedom. The bastardi- sation of freedom. The monetisation of freedom. The instrumentalisation of freedom. Fake freedom. Simulated freedom. Supposed freedom. Apparent freedom. Freedom on the terms of others. False freedom. Promised freedom. Forbidden freedom. Dreams of freedom. Beautiful freedom. Freedom taken for granted. Freedom that is not freedom. The space of freedom. The scent of freedom. The stench of freedom. The joy of freedom. The performance of freedom. The hope of freedom. The taste of freedom. The trap of freedom. The lie of freedom. The slippery slope of freedom. The drug of freedom. The manufacture of freedom. The demand for freedom. Freedom from demands . . .'

He falls silent. Staring eyes. Soft breath. Legs no longer kicking.

'Yes,' says the nightcleaner, affirming. *'And on and on – with the knowledge, or intuition, that each freedom might also be a constraint, and that each constraint might also be, contain, give rise to or have potential for, its own kind of freedom.'*

But the old guy won't be summarised. He won't be gamed.

He *says*, *'Snowden. The State. Surveillance. Transnationals. Scarcity politics. Borders and the stateless. The cops, the army, the private armies and all the corporations.'*

You can feel his hand clenching and unclenching in yours, like the dire fucking beating of his heart, collapsing.

'The resurgence of the right, the resurgence of the nationalists, the resurgence of the church.'

He looks directly at you.

He says, *'Nothing is free. Nothing is for free. And no one is free. But, the good news . . .'*

You're puzzled, *'Good news?'*

He says, *'The good news, is that nothing is forever. Think of Rome. The Empire. This,'* he gestures, weakly, looking around. *'All this won't last forever. There's nothing solid here.'*

He's smiling as he gasps and in the distance you can see the paramedics, coming down the gangway between the gates as fast as their faintly ridiculous electrical cart buggy thing will carry them. But it's too late already, already too late, just like it was too late already when you arrived. Nothing to do here, nothing to see, move along.

The nightcleaner shuts the old guy's eyes with her fingers and holds them that way, closed, pressing down for a moment. You exchange a glance, she's smiling too, just like the old guy. You both stand. The tide of urine spreading from the old guy's body has pooled its way to the underside edges of the closed-down currency counter, collecting there. It's four in the morning.

As the impotent medics arrive, the nightcleaner heads off with a nod and a shake of her head – *'I'll go do the other gates.'*

You watch her leaving, your eyes drawn through the shutters at the currency counter's LED. The yen, it says, is 0.01 to the dollar. Sterling is 0.8 to the euro. The Chinese yuan is 0.16 to the rouble.

And, stability is holding, if only for the moment, in departures, but not departing.

24

A STRANGER HERE

Reflections from within *Strange Pearls*

Chris Goode

In January 2015 I spent a week in a rehearsal space at the University of Roehampton with the performance maker Karen Christopher, as part of a series of research duets being undertaken by Karen in a range of contexts and with a variety of collaborators. Our duet work eventually acquired the name **Strange Pearls**. *In this working space, documentary and reflective texts and other self-observing gestures do not sit at a remove from the constructed material itself. Events and enactions become jumbled with their own critical considerations; work written 'about' the work becomes part of the work, and the condition of 'about'-ness becomes very evenly dispersed across the whole field of activity. The texts below were written in a reflective mode on the last day of the residency, in the knowledge that they might in turn also become performance texts, or non-performance texts that could not in the end sustain not being performed. The central source for the week's making had been the film* **Cool Hand Luke**, *which we screened (with inadequate audio) on the first afternoon; this gave rise to obliquely adjacent exercises such as re-enacting scenes with silent puppets, or raiding the web for painted images of Jesus smiling. From the second day onwards, at my urging, we allowed spectators into the room, with the aim of disrupting the often unhelpful paradigm of the sup- posedly culminatory 'public showing'.*

1

It is as if. No I said that wrong.
It *is* as if.
It is as if we.
Yes it is as if we.
Yes it is as if we are.
Yes it is as if we are making.

Yes it is as if we are making together.
Yes it is as if we are making together together.

2

We have slowed time to a third of its default self. I find it easy to trust the elegance of the slow dancing. I have slowed down to be alongside it, to abide with it. We have our entrances and exits. Only my hand-puppet is a little embarrassed. Naked and a little shy.

I like that we have smiled at each other through the medium of other smiles. I am listening for my own smile, which is not up on the screen. Smile as go-between.

I like that we have welcomed twenty Jesuses into the room. This makes the mean average of us slightly less than Jesus, the median average Jesus, and the mode average Jesus. So the pressure is off.

I have been wrong in my own estimation more than I usually am in my own estimation. This feels like a luxurious subroutine. I have followed the wrong instincts, or followed the right instincts in the wrong way. I can't find a way to let this matter. I realise I have felt a little drunk all week. I have not been driving. I have been fiddling with the AM radio and listening to the rain, or to the sound of the rain. It doesn't mean I don't care. I think I have found a new – to me, a different – register of care.

I am noticing how much the tone was set by not being able to follow the dialogue in the movie. Instead, a musical relationship with the needs and fears of trapped men. What gets leaned on. What happens at an angle. Watching how an unintelligible phrase translates into the bouncing and jerking of a cigarette between the lips. Like marking a mystery with iodine.

Visting hours feel unmanageable. The exposure is excruciating. We just ate fifty eggs and now we are in a posture of salvation that does not tell the truth about who we are. I want to learn how to laugh like laughing Jesus with his head thrown back and his teeth delighting in visibility.

The cake was sweet and a little dry for me.

I'm listening for the matter beneath the matter. But my relationship perhaps has shifted a little with the elaborate. The unadorned elaborate. The almost devotional unadorned elaborate. The indicative flicker beyond as if. Here is *here* and here is *is*. Slightly over there.

#mayhem

3

This isn't often true, but it's true here: the most ambiguous moment of the week is also the loudest.

In a week characterised by rolling conversation, quiet laughter, periods of near-silence as writing and reading unfold, there has not been much that is loud.

The movie dialogue on Monday afternoon is fairly loud, partly because when we find the acoustics are muddy in here and the drawled and muttered and heavily accented speech is consequently incomprehensible for whole passages at a time, we turn up the volume, which does nothing to solve the problem but at least makes it louder, makes a feature of it.

On Tuesday afternoon I surprise myself by performing a short text at the top of my voice. There are some students with us and I've just done a longer text and now we've gone straight into this other text and I feel sorry for them so I shout this text, unconsciously I suppose hoping some rudimentary versatility will help hold their attention. Karen is dancing on the table. The students start to leave. I keep shouting. They keep leaving.

All week, the door out of the studio into the corridor slams. This is something I discover on Monday but don't really learn until Friday. Time after time I remember how loudly the door slams at exactly the moment that it slams, though I feel that I remember it just before it slams, in the way that every morning I feel that I wake up just in time to hear my alarm go off. The slam of the door is ugly. It shakes my bones somehow. It makes me feel inadvertently aggressive, as if I had left the room shouting curse words. I feel aggressive not because it is loud and therefore I am loud, but because it is loud because I am thoughtless. Because I am a slow learner. And this is a room in which thoughtfulness and quick learning are survival skills, albeit in an only minimally perilous context.

But this moment, the moment I want to think about, is shockingly loud, and startlingly ambiguous, and it makes everything else feel softer by comparison.

Karen, standing on a low table, is balancing large stones on her ear, the upward facing ear on her tilted head. It has something to do with labyrinthitis. Or, rather, it has everything to do with labyrinthitis, but only partly. When, after a few seconds, for the first time a rock falls off Karen's head and onto the table, it makes a surprisingly loud noise, loud enough to make me jump. Something in the room is punctured that I didn't even know was there. That noise in this room has a kind of obscenity to it.

The ambiguity that starts to blush outwards from this moment has to do, I think, not with how loud that moment is but how disproportionate it seems. Something is out of alignment in its scale. And what I feel after the instant shock of the sound is the longer tremulation of that ambiguity and the problem it represents. Simply: I don't know whether Karen meant the rock to fall. I don't know whether this is a moment of failure. And if it is, I don't know whether that failure is real or simulated. Karen's task is anyway about balance, about precariousness, and in that sense any failure would be recuperated in the moment of its happening, or in the moment just before that moment. The falling confirms the risk and the risk underpins the task. Perhaps it is possible to balance the stones and for none of them to fall. But as soon as one falls, its falling includes the risk of its falling being softened, or hardened, into the inevitability of it falling. It was always going to fall, now that it has. And so Karen's intention, which I can't precisely discern, is

anyway redrafted as a position of total accommodation. The question of whether she meant the stone to fall, whether she wanted it to fall, becomes blurry; instead there's a glimpse of a new question about whether she liked it falling now that it has. I didn't like it falling but I immediately perceive the falling as necessary, so that whether I like it or want it is a secondary concern.

This is a different register of risk to performances such as tightrope walking or Russian roulette or even being in a play. I can hurt a play by forgetting my lines or skipping a couple of pages. Nobody dies of it, but that's not the only standard by which to measure risk. In this room, and in the work I've seen Karen do before, the risk is not a kind of jeopardy, not in any meaningful sense. The work is strengthened, not weakened, by the risk it fosters. A performance of the otolith material in which all the stones fall is not worse than one in which none of them fall; the risk shows up simply as a pivot, a moment of narrative crisis which immediately resolves: it's going to be *this* version of the performance, the one in which that stone falls then. Even performed above a safety net, a trapeze act feels dramatic. A stone falling off Karen's head onto the table top is probably postdramatic. And yet the loud noise it makes causes me to jump, makes my heart race for a moment or two, possibly more than someone falling from a trapeze into a net might do.

I have a friend, a performer I collaborate with a lot, who likes to remind me in moments of crisis or distress or confusion within the process: 'Well, you invited it all in.' And this is always true. We press play on the remote. We let in the risk. We go out into the grounds and bring back the small rocks. But more than this, what I learned from Karen and her colleagues in Goat Island right at the start of my making practice was the radical hospitality of the polysemous, the oblique, the reverberant, the ambiguous, the unresolved; translation, cipher, noise, contradiction, the private myth, the hidden impulse. Holding the definitive in perpetual abeyance. Nobody, on paper, is an expert in watching this work. In this sense, its strategies are extraordinarily kind in their disorienting permissiveness. There is something about the ordering of the work that disdains and often destroys hierarchies. It is profoundly equalising in here. As Adrian Howells used to say: It's all allowed.

And yet not all equalities are equal. At my urging, the default position from Tuesday onwards is that the doors are open to all-comers, whoever may wish to visit us, whenever they like. Rather than concentrate that influx of curious attention on a particular instance of showtime, I prefer a quiet flow in and out, constant and peripheral and unremarkable. This, of course, is a fantasy, triggered partly by experience – other projects, elsewhere – and partly by wishful, or even wilful, thinking. What we get instead – and why not, in this institutional base? – are multiple instances of showtime, to which neither available time nor available show feel adequate. We become presentational. Karen welcomes, guides, narrates, cajoles. I hide. I have very important sound editing work to do. If I could go out to the

shed, I probably would. With our visitors I seem invariably to find an uneasy jocu-
larity. The scalene triangulation leaves me wisecracking strangely, when I engage
at all. I think I sell us out. The hospitality I've envisaged is a kind of effortless
porosity. What we end up performing is a strenuous curdling mixture of justifica-
tion, apology, vamping-til-ready, and house-fire. How in this room, through these
gestures, can we best take care of strangers? How can we help them to be here
with us, in a way that is truthful about here and about us and about the condition
of being with?

John Hall mentioned it in conversation a couple of years ago: the idea, the fact,
that 'host' and 'guest' have the same etymological root. It points first to a historic
(and perhaps not only historic) cultural situation in which reciprocity is the basic
syntax of exchange: the guest will certainly become the host, in time, and the host
the guest, and this circle is a social dynamo through the security of which we all get
to set out from home sometimes. But in the collaborative process, and especially
a collaboration situated in the provisional social space of theatre, the commonality
of host and guest, the rubric of promised reciprocity, registers most in the idea of
making. We make together, and some of what we make together is our together-
ness. We want to make it actual, not just circumstantial. How can these incom-
ers possibly help to hold the space open in which the work is done, the work of
togetherness? How can our guests know that they're also hosting us?

For Derrida, it seems, true hospitality was practically impossible. Any sense
of preparation, any warning in advance, any limit or house rule, any moderation
or restraint, any hope of reciprocity, kills hospitality, opens up instead a kind of
economic space, a relative space that has to do with a kind of commerce. Uncon-
ditional hospitality is vanishingly unlikely. But might it be something that, like one
of those chemical elements that can only exist for a fraction of a second under the
right laboratory conditions, can be flickeringly experienced in the making studio?
It is not our hospitality towards our guests – or theirs towards us, *their* guests – that
renders this possibility, but rather our shared attention, in so far as it can ever be
claimed, on the fundamentally disinterested hospitality of the acts of our making.
At this stage – or on this stage – we have no way of knowing yet. Risk is not at the
crux of a drama here; it is something more like an ethical stance. And so everything
is invited in, and in establishing relations with that everything, in coming to terms
with its movement, we are trying always to stop it becoming clarified within the
operations of our hospitality, in the way that we have sometimes preferred not to
look our visitors in the eye. We cherish what evades evaluation. I don't know what
to make of what I'm making: and in this room, I trust what I don't know more
readily than what I do.

Hidden deeply below hospitality, in the etymological stem cell that produces
both 'guest' and 'host', is a word whose literal meaning is 'lord of strangers'. For
a moment I want to get business cards printed. But I know, or I hope to know,
that in this room, we are the strangers, not the lord. By the way: I apparently can't

read 'guest' and 'host' together without my mind producing out of them the word 'ghost'. Strictly it's a red herring, but in a space of making, there's no such thing as 'no such thing as ghosts'. They flow in and out, constant and peripheral and unremarkable. We find each other in our usual haunt, all welcome. Strangeness is almost the medium of our art, I think. It's how we measure the distances from which the geometries of making are induced. Perhaps it's how we are able to bear the implications of the subjunctivities through which we pass while we're here. We are already over there, not making eye contact.

I can feel this getting away from me.

25

ELFIE UND ELEONORE (FÜR HEIDI)

Hayley Newman

An artist and performer, I am interested in slippages between documentary and fictional forms and write for live situations where a text might be sung, read or performed. My writing finds companionship with activist, feminist and ecological discourses as well as literature, art and performance and includes writing lyrics for girl bands, making fictional image/text works and generating performances to write about in a novel.

Elfie und Eleonore (für Heidi) was originally written over the summer of 2013 when I was artist-in-residence on the off-grid boat Eleonore, moored in Linz, Austria. Commissioned to be read on Austrian radio, the text began its life as a description of the boat's off-grid water system, which was eventually transformed into fiction through the eyes of the coming-of-age teenager Elfie. Elfie, inspired by the character of Zazie from Raymond Queneau's book Zazie and the Metro, *was written as a teenager who is transitioning from child to adult who also finds herself situated on the edge of comprehension between two languages: German and English. In a wider context of climate change, Elfie and her exploration of the boat's water system is a metaphor which enables me to speak in an imaginative way about the changes we are undergoing as a society and to propose a transition to a low-carbon future in which communities reclaim power from corporations and generate their own electricity, preserve water and live more cheaply and with less impact.*

Elfie steps off the train into the sultry *Sommer Abend* air. She has travelled *mit der Bahn* from London, via Brussels *und* Frankfurt, and *ist* tired *nach* her fourteen-hour journey. Her mother has sent her to Linz to spend *ein bissler zeit mit* her *Onkel* Zav *auf* the off-grid, permaculture boat Eleonore – home to a *Kollektiv* of alternative, grassroots, *Wasser*-loving, *Öko*-enthusiasts living their dream in the centre of Linz.

Her uncle, who was to return *von* his *Urlaub am nächsten Tag*, sent his friend, Suzanne, to pick her up. It takes time for Elfie *und* Suzanne *sich zu erkennan, aber,*

eventually the *Zwei* make eye contact and say *hallo*. Suzanne has *lange braune haare* and wears an all-in-one patterned jumpsuit, a little more *exötische* than Elfie's own *gewöhnlich* striped top and denim trousers. Elfie wishes that *sie* could *auch* look *so toll aus*. Like many twelve-year-olds, she is interested in female role *Modellen*, women she can imagine herself becoming *als ein* grownup. Elfie was not the name she had been born with. She had chosen it *fünf Jahren* earlier, and it had stuck, *wie Klebestoff*. To Austrian ears it sounds slightly *altmödisch*, but she loves the name and insists on being called by it.

In the car, travelling to the boat, the young girl tells Suzanne about her journey *von* London: how the *Deutsche* farmhouse roofs were covered with solar panels, how she had finished reading her book and had bought a hot *Schokolade* in Brussels. The woman tells Elfie about her *Arbeit als documentary filmmakerin*, how she makes anthropological films, and that she had recently screened her work in London. This is Elfie's *erste* time in Linz. Well, actually, she thought she had been here *einmal vorher, aber hat falsch erinnert*, mixing up Linz *mit* Krems. She *hat nie* lived on a boat before. Would she feel *seekrank*?

On arrival, Elfie carries her bag over the slatted *Holz* bridge onto Eleonore. In the *halb*-darkness she can see *Pflänzchen, Sonnenblumen,* a giant umbrella-shaped radio antenna and the outline of a huddled group of people. She is greeted by *die Donauten*, who are seated on the deck, drinking *bier* and enjoying the evening breeze. Introduced one by one, she shakes each by *der Hand*. *Die Donauten* are members of the *Kollektiv* who oversee the boat and meet here every Monday night. Their name comes from *Donau*, the Austrian name for the Danube. It seems *auf ersten Blick* that *die Donauten* not only like being on water, but drinking it too, in the form of *bier, most und Schnaps*. She asks for a *bier* and is given one.

Wasser. Es gibt viel hier. In a harbour on the Danube in Linz, *Österreich*. The houseboat offers the possibility of a different kind of life: off-grid and *auf's Wasser*. Although gently moved by swelling tides and passing boats, she is ostensibly static *und nicht* for travel. Since she is engineless, moving would require *ein ganz andere* boat to tug her. Her *schwarz* iron hull sits *aufs Wasser, und* soft undulations connect her *Einwohner* to the river's volume below; *ein konstant* lilting-sway, accompanied by the *Geräusch von* lapping water. *Sie geht unter*, we go down; *sie kommt wieder nach oben*, so do we.

Around her hull, Eleonore wears a skirt of decking that makes it possible to dock canoes, motorboats and kayaks *neben an*. These moored boats, tied with expressive sailor knots, float next to a white ladder *das hilft* swimmers *steigen in und aus* of the water. The craft has been renovated with donated and found materials, and it is these wires, bolts, slats and boards that hold her firmly *zusammen*. Elfie feels *zuhause*.

Suzanne shows her how to fill the toilet cistern, one of the *wichtigste* jobs on the boat. The *selbst-gebastlete* cistern is a bright-blue plastic container that has been screwed to the external wall, its bottom removed and spout facing *nach untern*, so that water feeds through a tube into the main toilet cistern, *innerhalb des Schiffes*.

Next is a demonstration of how to gather river water. This is done by standing on deck and throwing a bucket on a rope into the Danube, and then pulling it out again once *voll*. Using *Flusswasser* to flush the toilet means precious *regen wasser* is saved for other purposes. Elfie wonders *wo* the poo *und* pee *geht*, but *ist zu müde* to ask. She will find out tomorrow, but for now she heads to her cabin and lets herself be lulled to sleep by the boat's gentle sway.

The next morning *Onkel* Zav appears just in time for *Frühstuck*. Looking *kool* in aviator sunglasses, flying jacket, chinos and greased-back *Haare*, he shares *Brot und Käse mit* Elfie at the houseboat dining table. There is only one plate, from which they both eat, to save on washing-up. She cannot think of what to say and an awkward silence follows, which she eventually fills with her big question. 'Where does all the poo and pee *gehen*?'

'*In der grosse Tank dass sitzt direkt unter* the toilet', he answers enthusiastically.

'But *wo* does it go then?' she persists.

'A guy comes to take it away', he answers, adding, 'we'd like a floating compost toilet, *damit* poo can be used for growing *Gemüse*, but the authorities won't let us'.

He has to leave, to go to *Arbeit*, which her mother had told her *hat irgendwas mit computers zu tun*. Leaving the key to the boat, *etwas zu essen und* important telephone numbers, he says he will return that afternoon to see how she is. The prospect of having the *ganze* boat to herself for the day excites Elfie and she decides to become a detective. She will explore the boat and find out how *Wasser* is distributed throughout. There are clues to the logic of the boat's *Wasser system* in diagrams she discovers in the logbook, *und obwohl sie* finds it hard to *verstehen* all the Austrian words, the drawings are *kristall klar*. She can see that the main source is rainwater, which is collected on the newly built plastic roof that covers the deck, before being directed onto the boat's original, smaller iron rooftop, where it is channeled through *grüne Schlänge* to the back of the vessel and stored in *zwei Plastik* tanks.

The diagrams show how the rainwater from the *riesen gross* storage tanks *fliesst* into the lower-level kitchen, *wo* it is used to cook and wash dishes. There is also a *wasser* filter here that cleans the rainwater, *damit es ist fertig zu trinken*. The bathroom is at a higher level than the storage tanks, and so an *elektrisch* pump *ist benützt zu* force the rainwater up, into the insulated tank high above the boat. This airborne tank is connected to the radiator on the boat's *Dach*, which in turn heats the *Wasser*. Unlike household radiators, where the *wasser* heats the room, this radiator absorbs sunlight to heat the liquid inside. It is exactly the same size, *Farbe, Dimensionen und* sun-facing angle as the nearby solar panels, which it can be easily mistaken for. Heat from the *Sonne* during the day means the *Wasser ist warm* in the evening *und kool* in the morning. Elfie is currently on a shower *Urlaub* and has no intention of washing during her stay. In fact, she *und Onkel Zav* have already made a pact not to wash for three weeks. They say that they want to save *wasser, aber wirklich* the *Onkel und* niece just want to enjoy their own *stink* for as long as possible.

There is *nicht genug Regenwasser* for the whole boat, *und* river *Wasser* is used for most activities not related to food preparation. *Zum Beispiel*, the toilet is

flushed with river W*asser*, which is also used to quench the thirst of the lettuces, *Tomaten, Erdbeeren*, herbs and *sonneblüme* that share the deck with the boat's human inhabitants.

Having studied the plans, Elfie *geht auf* deck to observe the pipe system winding its way across the boat's *Oberfläche*; green, *gelb*, grey, *weiss, schwarz und rot* pipes, which dangle, hang and stretch across the boat's metal shell. *Wasser und* pipes run internally and externally, around *ecken, unter* decking and *über köpfe, durch* ad-libbed elbows, taps, reducers, valves, tubing, Ts, crosses, caps, plugs, barbs *und* fasteners. The *Schläuche* are joined in near-infinite combinations that enable *Wasser*-flow into, through and out of Eleonore.

Having made herself a *Tasse von Tee*, Elfie sits looking out to the harbour and eats a couple of handfuls of red tomatoes and strawberries from the deck in a spontaneous *Mittagessen. Lecker.* Lots of *Leute* zip back and forth on motorboats and canoes. She waves at them, and they wave back. Their boats make waves too. *Wellen, quellen und winken.* The *Hitze*, breeze and gentle rocking of the boat make her tired and, lying down to rest, she falls asleep to the sound of water. In her pipe-dreams she dreams of pipes, although *jedes Stück* is made from a different material: a wilderness of infinite and uncontrollable *Schläuche*, channelling liquid around, over, *unter* and across each other. In an attempt to tame these unruly thickets she hacks them back with her pencil. *Mit Bleistift und Papier*, she uses perspective and shading to conquer their boisterous forms and creates a series of drawings of pipes transforming into botanical plants. *Aber* soon their organic forms become orgasmic and the phallic pipes, no longer contained by the page, begin to twist, turn and curl off the paper, moving into three-dimensional *Raum. Wasser* begins to flow through them, dripping, splashing and spurting. She wakes up. That was an odd dream. Not unpleasant, just strange and full of new *unbekannt* feelings. *Durstig* from her experience, she *holt ein Glass Wasser* and drinks it down in gulps.

A boat is gendered: Eleonore *ist ein* vessel. *Sie* is *weiblich.* Technical descriptions of pipes often refer to *männlich* or *weiblich Teilen*, a vocabulary that evokes the human body. The masculine pipes and feminine vessel that is Eleonore have *wahrscheinlich* lodged themselves in Elfie's teenage psyche, prompting her outburst of unconscious desire. *Sehnsücht.* This *war nicht ihre erste erotish* dream, but is still the most graphic evocation of sexuality she has experienced.

Re-invigorated, Elfie continues her exploration, this time swimming around the boat, and looking for ways that drains *kommt ins Wasser.* Putting on her new, bright-red swimsuit she jumps into the *grünes* harbour. Swimming around the boat, she sees *ein Loch* directly *unter* the kitchen sink. It must be a drain. Continuing, she observes two hosepipes running from the *Badezimmer* into the river; these are the pipe concoctions that drain *Wasser von* the *sink und* shower. It begins to *regnen.* She floats, like Eleonore, her body flat. Facing a clouded sky she feels rain falling onto her face and hears *Wasser tröpfeln* as they hit the river's surface near her ears.

Onkel Zav ist zurück. Greeting him from the *wasser*, the niece asks *ob ihr Onkel* could do the washing-up, *damit sie* can see the *Abfluss* flowing from the boat's drain into the harbour. He agrees, and rinses the single plate and two mugs left from their

Frühstuck. Treading water, she observes the bubbling liquid as it dribbles from the *Loch* in the boat's hull into the water below.

While climbing back onto the boat Elfie *denkt* about how water appears and disappears at home, thinking that it happens without much thought or imagination. She likes the colourful pipes that cover the boat and wonders if her mother might let her do something similar *zuhause*.

In the evening, *die Donauten* reappear, beckoned by the call of water *und Bier*, and resume the moistening of themselves from the inside. As darkness surrounds them, water sounds can be heard more *deutlich*: a dripping tap, lapping edges, gurgling stomachs, burbling voices, the drone of water being pumped into a tank.

It begins to rain. *Elfie ist müde*. Warm and dry, she lies down on her bed in the boat's hull. There are distant voices above, and as raindrops unite with the boat's hull to make metallic music she allows Eleonore to seep into her dreams *noch mal* – for one more time. Once asleep, she drops vertically into a *lange, dunkel* smelly pipe, barely touching its damp *und schleimig* sides in her freefall. It is pitch-*schwarz* as she hurtles downwards, her limbs bumping and scraping against the pipe's innards. On slowing, she uses her hands to feel her position at the junction of a metal pipe *und plastik* tube. Thud. She lands on a ginormous blade of grass and immediately sees that the *traum* has transported her to her home in London. Looking-up, she notices solar panels *auf* the roof of the four-storey block, and a rainbow of pipes that cascade water down into all the kitchens and bathrooms. Instead of a car park, there are raised beds where people are growing *gemüse und blumen*.

To her surprise, *alle* the buildings have been similarly refurbished. Like *Onkel* Zav, her post-consumer neighbours have used DIY *Energie* to reclaim common resources from the stranglehold of reeking corporate polluters, so that they might live more economically and with less impact. Stunned, she looks inside the pipe that delivered her, *und* is immediately sucked up into its back-draft. The reverse journey takes seconds, and on her expulsion from the top of the pipe Elfie *wacht-auf in ein pool von ihr eigene* sweat.

26

MARKING A LIFE

Mitch Rose

The problem that motivates both this and other creative projects of mine concerns the purpose of stories. The normal use of stories in the academy is to present them as evidence. Here the meaning of a story is tethered to a particular framework that has been decided before the story is written. Thus, we know what the story will tell us before it is actually told. By attempting to bring the world and our words about the world into a relation of correspondence, the value of a story is measured by its mimetic qualities. This is very far from the traditional work of stories. While all stories work to capture something real, historically that reality is measured through their capacity to affect, move or incite rather than transparently represent. Indeed, as Blanchot suggests, stories work by an act of estrangement: 'I recognise very well', he states, 'that there is speech only because what "is" has disappeared in what names it'.[1] Stories make the world real by both condensing and effacing the reality that they purport to reflect.

But if stories are not empirics then of what use are they to the academy? My work approaches stories as agents of thought. Stories are catalysts. They present situations, events and circumstance that solicit our attention and our consideration. While much of my work is ethnographic, the following story is autobiographical. But similar to my other work, this story is used to situate a problem for thought. It is precisely the story's impenetrability – its reluctance to reveal – that demands a thoughtful response. This is the role of stories in my work – not the evidence of our ideas but their progenitor.[2]

יִתְגַּדַּל וְיִתְקַדַּשׁ שְׁמֵהּ רַבָּא

In August 2005, I went to Beth Abraham cemetery in Ferndale, Michigan, with my partner and grandmother to put stones on my father's grave. I looked around

the grass and found a rock, something noticeable, and set it on the left-hand side of the tomb. I am here. I came. And here is a mark of my presence. My partner and grandmother did the same. This is the way of landscape. A stone, marking a tomb, marking a life, the thread of posts leading to other posts. The scene reminds me of Poussin's painting *The Bergers of Arcadia*, where shepherds, enjoying a timeless bucolic existence, contemplate a stark unadorned tomb. Death here is marked by the headstone at the painting's centre, jutting into the tranquil pastoral scene, as well as by the shadow cast over the shepherd's hand, light coming over his fingers and arm in the shape of a scythe, framing the words on the tomb, 'even in Arcadia there is death'. Here Poussin tells us that death cannot be seen or properly brought to light, but rather, must be grasped through the shadows it casts. Even as light demarcates the visible by illuminating the surface of a tomb, it simultaneously reveals the invisible as an absence of surface, a projected darkness without texture or quality. The same relation can be seen in Heidegger's (1971) concept of the clearing; that portion of the world illuminated by a specific subject's way of being-in-the-world, like a cosy fire illuminating a forest floor. While the warmth and light of the clearing makes the site inhabitable, it simultaneously demarcates the opacity of the surrounding woods. Here is a darkness revealed not as something not-yet-present but as something secret and mysterious. An inscrutability appearing as an inscrutability, too dark for comprehension or engagement, and yet sensed in its oppressive encirclement. While the sunshine off the granite face of my father's grave sparkled, it did not light a path. It simply glistened, reflecting sunlight over a lightless depth.

When the phone rang 18 months previous it was 6 a.m. on Boxing Day in Swansea (where I was staying with my partner's family) and 1 a.m. in Miami where my family spend their winter holiday:

- 'Grandpa?' I asked my brother
- 'No, it's Harvey'

A car accident, I presumed. My dad lost his licence a year ago. He had black-outs and had already been in a crash but I knew he was still driving. 'No', my brother said, 'it's bad'. When people talk about shock, they talk about a world closing in on them or the disappearance of an outside. For me this was not so. I heard my sister-in-law crying, I felt my partner's arm, a cup of tea mysteriously entered my hands. But they took place in a light where depths and textures became effaced and smoothed. There was light, but I was not seeing. What I sensed was a voice, a speaker that was resolutely me, and yet, other and distant. A fold of interiority, a creasing of consciousness, dividing and speaking from afar. I heard an arising from the problem; the demand, posed at that moment by my brother, my father and the legacy that this event presupposed; a questioning whose questions precipitated fractals of interior space, interrogators and pushy problems forcing themselves into a facing, a sounding, a beating, whose comportment worked to initiate a range of determinations – I, him, us, ours, then, today, I am, I can't, how did . . .? I took a sip of tea. For some reason it was sweet.

In 5th grade my father entered the classroom in the middle of the afternoon to take me out of school. I had not seen him since the divorce. He had been living in California for the last four years and that wild place had insinuated itself in his cropped salted brown beard, his Ray-Ban glasses and the small leather purse he walked with. It was Detroit and he was driving a foreign car. Everyone in the classroom looked at him, his rough non-dad-like presence enthralling their imagination. While we hadn't seen each other, we talked on the phone most Sunday evenings.

- 'Come during Christmas' he told me
- 'What about mom?'
- 'She can take you to the plane and I will pick you up'

The idea of going on a plane by ourselves was fantastical and yet tossed over his shoulder like shells from a nut. California had roller coasters drilled into mountains. It was the landscape of dead trees and strangely named dogs and where he, in his mystery, lived. About a month before we were supposed to leave my father's girlfriend called to tell me that he was in hospital. Downstairs my mom sat drinking a cup of coffee. 'Is he sick?' I asked. 'I think so', she said.

I saw the sunrise for the first time when I was 16 and I was resolutely underwhelmed. The sky moved from an inky blue to a light coral feathering above the muddy grey water. The day was overcast and the sea was choppy. I was not happy about getting on a boat. My brother and I had fished for blue gills and bass

FIGURE 26.1 Fishing.

on crude poles from dry land but we were not hardy sons. Using bread instead of worms, the pleasure of catching fish was matched by our displeasure with having to grab them and throw them back. Dad was indulging us in grown-up fishing. Four poles lined up at the back of a small trawler, lurching unsteadily in the windy wake. After two hours of nausea and boredom one of the poles sprung. My dad jumped up and handed it to me. I watched the line shoot out from the reel and my dad reached over my shoulders and gave the pole tension. 'Pull back slowly,' he said. I was caught off-guard by the pull and weight in my arms. 'Swizzle your feet back', he said, 'and shift your hips'. By the end of the day we had a king salmon, and two cohos. We took them to the station, got them cleaned and filleted, and then to a local park where my dad coated them in butter, wrapped them in foil and put them on coals. By the time we started home it was 9 p.m. I slept in the car, the sky a milky rooibos orange and just beginning to darken.

A year after my grandfather's funeral, the family met at the cemetery where my dad was supposed to read prayers. He would have done it well, his calming doctor-patient voice was meditative and comforting. We waited for him. But my grandmother said we should begin. Afterwards at the house my sister and I sat in the kitchen eating coffee cake when my dad and his third wife arrived. Sitting down with a cup of coffee his eyes were blank and distant, the lids drooping. 'I am on a morphine patch' he told us matter of factly, 'the doctor prescribed them for migraines'. The next day his wife called to see if I wanted to meet them for dinner. 'I can't see him. Not now. He's not good.' I heard my dad mumble something in the background. 'Your father says he understands.'

While walking along the Gower cliffs at Easter, my chest began beating and for no apparent reason I became anxious and breathless. I called out to my wife walking ahead: 'Have we walked here since December?' After I first received the news about my dad we had done this exact walk; seen this same scene; stared out blankly through the same cold mixture of rock, sea and mist. Walking back my wife suggested I had been repressing. 'I haven't been repressing', I said, 'I just don't think about it because it makes me feel bad'. She looked at me as if I gave her the clinical definition of repression – but I still disagree. Repression suggests displacement, as if I had taken all my thoughts and feelings and put them somewhere else, hidden from consciousness or contemplation. But it is possible that my response did not precede the scene. Like Poussin's tomb, the landscape marked an impenetrable surface – a darkness that could only be recognised as a darkness by illuminating the space around me. In this sense, the view was not a symbol resonating with an already interiorised space. Rather, it was a surface whose appearance demanded, like ancient sorcery, an interior space to arise. The landscape was a solicitation. Its presence a dark invitation to feel, to hear the beating of one's heart, to sense the quivering of one's lip. In its alchemy of earth, light, shadow, fear and dread, the landscape summoned consciousness and sensation.

The following December I drove out to the Oakland County Coroner's office to talk to Dr Dragovitch about the autopsy. The story my grandmother wrote in the obituary was that my dad died after a long struggle with Parkinson's. He

suffered from shakes, black-outs, loss of balance and other maladies but I doubted my grandma's story: 'your dad's death is a shanda', my mom said, 'the funeral will be a white-wash'. 'In order to properly test for Parkinson's disease', Dr Dragovitch told me, 'one would have to sample particular tissues. We did not go into those details under the circumstances since it's obvious that for a self-inflicted gun shot wound, no such assessment was in order. On the basis of a gross examination of the tissues, I didn't see anything that would qualify as a departure from normal to pursue anything along those lines or even document it.' I moved onto the toxicology report: 'Was he high when he died?' 'No', Dr Drogovitch said, 'he wasn't high. There is a whole account at the scene and that includes various boxes and professional samples: Zolof, boxes of duragesic, professional samples of Phander, a bottle of Trazodone, vials of Depakote, painkillers, anti-depressants and mood enhancers, but these things clear the system very quickly.' As I walked out of the clinic I called his wife and told her I was going to be late for lunch. I had a message from my dad's second wife confirming an appointment tomorrow morning and I had a return call from an attorney to discuss how to attain my dad's files from Maple-Grove Hospital, an addiction clinic nearby. It was one in the afternoon and the sky was a grey milky tea colour and letting go of a weak and listless snow.

For Levinas (1987), the singularity of each individual being is guaranteed by a secret, that aspect of another person that eludes all knowing, all understanding; that which withstands all attempts to discipline, colonise or oppress; that which withdraws from the finitude of death, the expansiveness of love and the exactitude of

FIGURE 26.2 Placing a stone.

science. Subjectivity, here, evades immediate presence. But it can be viewed from a distance. Marked by a name, stories, photos and stones, our being appears to us and others in surface and light: faces that solicit but do not reveal. In this sense, the stories and vignettes I have been telling about my dad can be understood as further incarnations of the rock I set on his tomb. I could keep listing stories – each branch and tangent supplementing his character into further directions and folds, each periscopic angle illuminating a single surface of an infinite geodesic form – but they would provide no clear way, nothing that Heidegger would call *a path* (1998). Or if it is a path it is one of integers; a horizon that stretches out infinitely, ready to be filled by more lists of stuttering, half spoken words – questions, problems, forms of guilt and bewilderment. Unless we understand the dark imperatives that give rise to such compulsions, we will not understand how the obscure surfaces that litter our lives silently call and compel us to think. And why, when we answer it is only occasionally with narrative and text, and more often with stones, marking a way without architecture, meaning or promise.

עֹשֶׂה שָׁלוֹם בִּמְרוֹמָיו, הוּא יַעֲשֶׂה שָׁלוֹם עָלֵינוּ וְעַל כָּל יִשְׂרָאֵל, וְאִמְרוּ: אָמֵן.

Notes

1 Blanchot (1993: 36).
2 I have written more fully about this approach to stories in Rose (2016).

References

Blanchot, M. 1993. *The Infinite Conversation*. Minneapolis: University of Minnesota Press.
Heidegger, M. 1971. 'The Origin of the Work of Art', 15–88, in *Poetry, Language, Thought*. New York: Harper & Row.
Heidegger, M. 1998. *Pathmarks*. Cambridge: Cambridge University Press.
Levinas, E. 1987. *Time and the Other and Additional Essays*. Pittsburgh: Duquesne University Press.
Rose, Mitch. 2016. 'A Place for Other Stories: Authorship and Evidence in Experimental Times', *GeoHumanities* 2 (1): 132–148.

MIDDLEWORD TWO

The Critic as Gesture or John Malkovich's middle name is Gavin

Maria Fusco

The critic as gesture is a frustration with exhausted modes of critical engagement within our elite, cultural world, expressed in writerly form.[1]

Gesture here is defined as an act that is *motivated*.[2] What is loitering behind the invocation of an act that is motivated are the subjects who are acted upon and the direct causes impelling such subjects (ourselves) to experience a desire sufficiently pressing enough to affect scriptural change through our belief in simple marks on a page.[3] The obvious question this motivation elicits, therefore, from the mouths of first world textbooks is: What's so wrong with the way I write anyway?

An answer to this, understandable enough, question would be: I don't like it. Another answer: The way you write is not precise enough. Another answer: Your job is to dismantle, not to build. Another answer: I don't want to be colonised by you *again*. Another answer: You don't own that, put it back where you found it. Another answer: The language of history is contagion, not antidote.[4] Another answer: The way you write hides the way you write.

Language-games must be accosted in each dark alley in which they are lurking.[5] It is not sufficient to be able to simply *voice* a proficient echo of an historical form, (however hilarious this might be), because this demonstrates only proficiency. Whilst it is the wish of all of us who are self-conscious and precocious enough to want to be witnessed publicly as being proficient, finally we cannot place trust in, nor shit from the great arse of this vainglorious instinct.

As with the physical action of employing a lever, it is essential to depress when we wish to elevate.[6] Accurate navigation is a perilous, yet patent responsibility of the analytic enterprise. This invocation of navigation does not agree that legislative plans are always fit for purpose. Rather, navigation here describes precision of intent, exposing the ethical responsibility of the deeds of the writer to our reader, or if we are very lucky, to our readers, plural.[7] It's grand to live alone on a small

island, tending our inky crops, as long as it's possible for other folk to locate, and perhaps even visit, the island when we want them to.[8]

This is duty as mandate; this is duty as tax.

Thrift is the apt schematic here. Thrift trades sparse and tactful forms, not mass-reproducible mementos. Thrift is good example but not *an* example. Thrift is sensible. Thrift carves-up.

The critic as gesture is as diligent as a miser.

When constriction is applied to the wordage permitted by thrift, transubstantiation occurs: we are no longer shuffling marks on a page, on a screen, we are creating new beings.[9] The role constriction plays is that of the joyful enforcer, (not of the tyrannical polemic), acting with contextual knowledge and candour.[10]

Consistency shares a little more than half of its letters with constriction. This is clearly an alphabetic coincidence but an apt one for consistency and constriction cannot be disaggregated. The two are mutually dependent at a technical level because insistent application and physical manipulation of both is required for new limber analytical topologies.[11] Together, constriction and consistency make a pair of muscular thighs: our heads are happy clenched between these very thighs.

This desire for anonymity is a useful proviso against solely interpretive reading. Reading is essential to both the actual act of producing critical writing and the intellectual world in which it bounces. There is much we must try *not* to remember. There is much we must attempt to dis-author. In wishing anonymity in reading, we are also wishing it in writing. Resistance through anonymity is not a relegation of responsibility, rather anonymity creates commodious possibilities for others' works and, in this way, anonymity permits our writing to exceed us, to exceed our own, limited, often class-based ambitions: to *assemble*.[12]

It is entirely possible that multiple voices chance on the same formal solution, this is agreeable if it occurs through happenstance because then it demonstrates the right to assemble at one's own will, the right to party.[13]

However, there is no prize for the best fancy-dress costume. We must not, on *any* account, hide behind those syntactic masks others want to rent us. Not masks. Forget masks. Great big fucking gilt mirrors. Understanding our teeming methodologies as stroboscopic, we may apprehend only small moments, only our own small moments, not a linear historical discursive.[14]

We are always the stranger.

Notes

1 Lorde (1984: 10).
2 Flusser (2014: 56).
3 Agamben (2009: 10).
4 Hegel (1977: 116).
5 Wittgenstein (1963: 167).
6 Weil (2002: 84).
7 hooks (1999: 42).
8 O'Connor (2014: 53).
9 Sister Corita (1967: 44–45).

10 Bergson (1999: 29).
11 Robertson (2012: 12).
12 Butler (2015: 68).
13 Goldman (1934: 56).
14 Deleuze (1972).

References

Agamben, Giorgio. 2009. *What is an Apparatus?* Stanford: Stanford University Press.
Bergson, Henri. 1999. *Laughter: An Essay on the Meaning of the Comic.* Copenhagen and Los Angeles: Green Integer Books.
Butler, Judith. 2015. *Notes Toward a Performative Theory of Assembly.* Cambridge: Harvard University Press.
Deleuze, Giles. 1972. 'Helene Cixous or Stroboscopic Writing', *Le Monde*, 11 August.
Flusser, Vilem. 2014. *Gestures.* Minneapolis: University of Minnesota Press.
Goldman, Emma. 1934. *Living My Life.* New York: Knopf.
Hegel, G.W.L. 1977. *Phenomenology of Spirit.* Oxford: Oxford University Press.
hooks, bell. 1999. *Remembered Rapture: The Writer at Work.* London: The Women's Press.
Lorde, Audre. 1984. *Sister Outsider: Essays and Speeches.* New York: Crossing Press.
O'Connor, Flannery. 2014. *Mystery and Manners.* London: Faber & Faber.
Robertson, Lisa. 2012. *Nilling.* Toronto: Bookthug.
Sister Corita. 1967. *Footnotes and Headlines.* New York: Herder and Herder.
Weil, Simone. 2002. *Gravity and Grace.* Abingdon on Thames: Routledge.
Wittgenstein, Ludwig. 1963. *Philosophical Investigations.* Oxford: Basil Blackwell.

Folding outwards 3

27

ARE THERE ANY PICTURES IN IT?

Creative practice as a serious research vehicle

Simon Piasecki

If there is a stable relationship between my natural work as an artist and its transmogrification into the status of acceptable research, this has to be more than long words; it resides in the discourse and reflects 'the difficulty of proceeding into a space that opens only as you begin to advance'.[1] The question of a stricture between critical writing and practice itself is complex and political, but I certainly do not accept that the only research value emerges in a final written critical analysis of that practice. Therefore, I have attempted with this chapter to conflate playfully the space between writing and practice, since to me they feel very much the same. There is something of a politic in my intention, aimed at a perceptual prejudice of what is regarded as 'serious' research, and it is this idea that I intend to tease. In the research community, the written up object is often regarded *as* the research, when of course it is actually the concluding product of that research. In this sense all research *is* practice in actuality and the performance or art studio does not differ in any great extent to the scientific laboratory.

The real issue, I think, has something more to do with the manner with which arts research will embrace subjective, rather than objective frames; we find it difficult to trust rationally truths that emerge from experience rather than logical fact and place definite measurable objects above indefinite expressions. But consider a poem of the First World War besides the facts of that same event – which one contains more or less truth? There is then the truth born of fact and the more slippery truth born of meaning generated in reception of an object. This is not a new problem; in many respects the fusion of the two was at the heart of Kant's enlightenment project and was certainly a difference between Plato and his student Aristotle (one of my collaboratively performed works dealt with that and is considered later).

This chapter reflects the meeting of practice and writing in the style of my notebooks. As I considered the criticality of my practice, its manifestation in multiple

fields, I realised that my notebooks had always been the central glue between what I created, what I had read and how I reflected or formed questions. Having said so, they have also never been objects of simple efficacy; I dwell in them, I saturate them, sometimes I don't finish things in them, they are fragmented. What follows, then, is a series of illustrations about my practice that also contain writing – whether the chapter exists as an artwork in and of itself (I believe so) or as a body of writing (I believe so too) is really at the nub of how a reader might judge it. Within that too is a question of virtuosity and quality; I play with the distrust of interdisciplinarity in arts practice that bewilders me – it seems to concern benchmarks of skill versus discourse and an accusation of breadth rather than depth. But interdisciplinarity is desirable in research because it forms the very connective tissue that brings multiple contexts to bear on any hypothesis. I have never worked within the context of a single discipline, I don't believe that I could, and the chapter will reflect this. I hope that you like my pictures, but please note that the first concerns Leonardo da Vinci, who wrote backwards in his notebooks; you will need to find a mirror . . .

We find ourselves twice removed from the event by a blotchy image of a leaflet in a book & we are twice removed by an archive of an archive. Once I visited a Da Vinci retrospective of drawings, designs & inventions and was struck by the huge queues to this show. Conversations referred to the delicate beauty of the images and Leonardo's genius. Notebook pages had something of the treasure map about them: ragged edges, browned ink and an impenetrable sense of writing. Many of these qualities had nothing to do with Da Vinci and everything to do with the processes of age. We could no doubt his brilliance, but here scientific drawings were being mythologised romantically as a result of oxidation, handling and nearly 500 years+ genius as an exponential residue of TIME.

There is a presiding image of Carolee Schneeman's 1975 performance of Interior Scroll, wherein she pulled a scroll from here vagina and read manifesto style poetry. The original event was not filmed, but three editions of photographs mounted with the text were produced & staged.

The surviving artefact of Interior Scroll is staged and worn in reproductions, similar in form to Da Vinci's notebooks. The ageing of the paper, the faded text, the artist's marks; these are explorable as qualities of the trace as document ~ it was there. It bears witness. It is the signature of a particular moment in a particular place & by a particular person. Any subsequent discussion, reproduction, critical writing or other visual document only serves to contextualise the trace and reinforce its value in the body of research.

Does this mean that publishing on a critical document. I am in some manner of performance (creating?) a greater impact defending in its memory than in fact? Does the historical perspective of an event have more licence than the event itself?

Is it an act of authentication? Are objects? Does it become the wonder why did something sign this?

I have always kept notebooks ~ generative, romantic would cram them pocketless. As a student my misplaced down. Once I felt like an explorer even in my own exhibited to & it felt strange to view them where the curious. artfenticated 1960. I had no prether they were fact or fiction)

Research posits an archive that implies a self by date that is to say that research is validated by its accessibility & obsoleted by subsequent knowledge or epistemological shifts, after which it falls into the category & context of historical academic archive. The transient beauty of the performance is also what problematises its presentation as research ~ if it exists in the present tense and for Peggy Phelan its documentation (lessens its own ontology). (Phelan, 1993, p.146) the promise of its...

I cannot consider my practice, certainly of the preceding two decades, as separate, despite its containing works in different forms and scales; for me the work flowed from a single moment and discovery that opened up a vast territory of discussion around the nature of identity and belonging. This was rooted of course, in personal experience, and therefore the resulting practice is always at some level a SELF PORTRAIT and as a mirror to the interests of the prac- tioner, perhaps all research is. Whilst that may be true, we need to that this consider artistic presence of through EGO is balanced outward, its turning -ary. The as social comment as a skill of the artist found researcher is both in the ability to and reach an audience questions yet provoke more I have than answers. therefore, always found, practice that artistic lives, the exists in two -essary to first nec- Firstly, the second process of the production, primary the exists investigation, the artist very much for speculative as an intense, a journey full of & reflexive experience, turnings. The end 'failures' and wrong has a ~ finality in product of that not necessarily its own iteration, but a whole ~ more within the discourse as However, in work will be produced. audience, the its sharing with an exists in its second life of an artwork since, as Barthes reception (in its impact?), Author (1977) pointed out in 'The Death of the over that. the artist has no further control

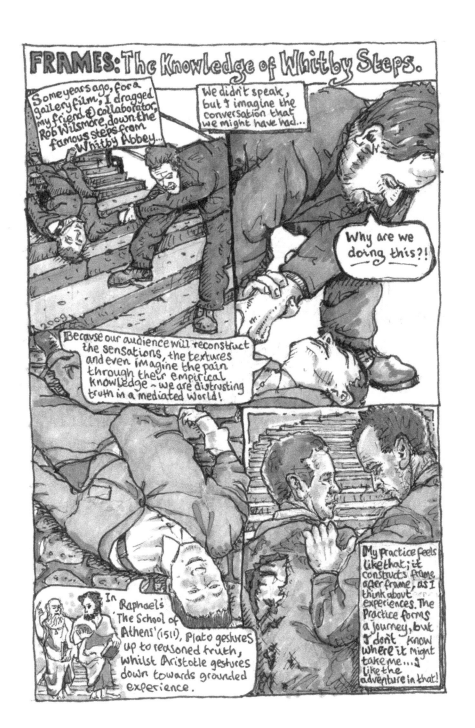

LOCIS. Over many years of producing artworks, I have come to consider practice, both as a performer and a visual artist, as cartographic in nature. I find myself seeking to understand connections between ideas, events, cultures, histories, theories & objects far more than observing the singularity of those things in and of themselves; the process of discourse, of research, is concerned with not only reaching an understanding of the nature of things but also with an understanding of how they locate relatively. Thus, research is essentially a mapping exercise, when we consider that it oper- -ates on the basis of asking questions that relate to the gaps in our understanding. Simon Garfield describes Erat- osphenes' world map of 194 bc, the first of any scalar accuracy. As third librarian of the Great Library of Alexandria, he composed his 'Geographica' from the multiple sources that were in his care (2012, pp. 25-31). Over one thousand years later, in 1290, the Mappa Mundi was created in Hereford. It abandoned all geographical accuracy and depicted instead a...

RINGTON

CROCKEN HILLS.

ST PETERS.

THORSBURY CASTLE.

...bizarre world of mythological man & beast, placing these with biblical sites, across three known continents and all subject to God in heaven above. Mappa Mundi does not require a present truth, preferring to connect disparate traditions within the territory of a dominant narrative.

Western academic traditions of training in the Arts follow a notion that subject will follow form; if, for example, one trains as a dancer, then any subject treated by the artists discourse will be produced as a dance (similarly for a photographer, painter and so forth).

1.FORM 2.SUBJECT	TREATMENT	SUBJECT FORM

VIRTUOSIC MODEL

INTERDISCIPLINARY MODEL

This is the virtuosic model and it is reinforced by a notion of skill, draughtsmanship & technique that prove quality. However, for interdisciplinary artists, including myself, this model is quite reversed; form is defined far more by subject. This approach is often distrusted as a 'Jack of all trades', but for me the idea of quality is transferable: I delight in learning the skills of an alternate form. The direction of subject & form remind me of Kant's consideration of the conforming of objects to knowledge in his *Critique of Pure Reason* (1787).

Here, he reverses the accepted view that knowledge conforms to objects, preferring the mobilisation of logic, when objects conform to knowledge. My empirical knowledge is that the logic by which I process & then decide upon its tension of validity in arts of research, is partly founded IMETAXICAL representation depiction; arts readily subjectivity of the symbolic previous reference to the provide a useful example mythological creatures, including the MANDRAKE and the unicorn and all depicted as relative to places both real and imagined - the labyrinth of Crete, the tower of Babel, the Ark and yet also Hereford - rationalised, with no attempt at geographical accuracy, within a Christian world view under heaven above. So what was the value of these depictions of a meta-world when placed beside phenomenal experience? That seems a key question for artistic practice; for myself it feels like a crucial tool in debating human moralities in a universe empty of meaning.

erba mirabi liter uiraio sa

Certainly the pool pursue a creative (object) form. The practice as a vehicle in its deployment of rather than factual engage with the & the imagined. My Mappa Mundi might here. It is replete with

Note

1 Piasecka referring to Derrida (2005: 4).

References

Barber, P. (Ed.) 2005. *The Map Book*, London: Weidenfeld & Nicolson.
Barthes, R. 1977. *Image Music Text*, translated by S Heath, London: Fontana Press.
Garfield, S. 2012. *On the Map*, London: Profile Books Ltd.
Hayward Gallery. 1989. *Leonardo Da Vinci Exhibition Catalogue*, London: South Bank Centre.
Kant, I. 1787. *Kritik der Reinen Vernunft*, 2nd Edition, Riga: Johann Friedrich Hartknoch.
Kant, E. 2007. *Critique of Pure Reason*, 2nd Edition, translated by N Kemp Smith, New York: Palgrave Macmillan.
Phelan, P. 1993. *Unmarked: the Politics of Performance*, London: Routledge.
Piasecka, M. 2005. *Live Art & the Post-Sixteen Curriculum*, master of arts thesis, Manchester: Manchester Metropolitan University.
Schneemann, C. 2015. *Caroleeschneeman.com*, (accessed on 01/02/2016) http://www.carol eeschneemann.com/interiorscroll.html.
The Times. 2016. *The History of the World in Maps*, Glasgow: Times Books.

The author's illustrations of *The Knowledge of Whitby* Steps are based on photographs by Peter Morton of Piasecki's 2009 performance with Robert Wilsmore, also filmed by Richard Molony.

All illustrations in this chapter belong to the original copyright of the artist, Simon Piasecki (2017) and are supplied to the editors with his sole permission for reproduction in this book.

28

AN ACTOR'S ATTEMPT AT SISYPHUS' STONE

Memory, performance and archetype

Göze Saner

Writing research as an actor is a ramble with interlocutors of different walks, a throw of a pebble into a well and a listening in to the echoes. I am tempted to call it 'reverberation', but 'echoing' is just as good and, at the end of the day, what an actor does.

First push: Sisyphus

Sisyphus simply refuses to die. He tricks death once, twice, three times, by sweet-talking his way out, by locking him in a closet, by plain deception, until eventually the inevitable catches up with him. He is to forever push his infamous stone up a hill and watch it roll back down.

Ah Sisyphus, the symbol of absurdity, the futility of being which always meets an abrupt and untimely end. Ah stone, the inescapable self, aliveness, breath.

Yet, the stone is a gift and Sisyphus 'teaches the higher fidelity that negates the gods and raises rocks'.[1]

I invite you, hypothetical readers, to meet Sisyphus. Not to interpret him, fit him into a framework in which he is done, completely analysed, exhausted. Echoing James Hillman, I propose that you try to 'befriend'[2] Sisyphus, get to know him, spend time with him. Grant him as much autonomy as you grant yourselves. Accept that he *is*. He does not just serve by symbolically posing with a stone mid-hill. (Can you imagine saying to a friend, 'you symbolise meaninglessness'?) Admit and *feel* that he is *at this very moment* pushing his stone uphill or watching it roll back down. And watch closely:

Does Sisyphus know that the stone will roll back down? (Or even, will the stone roll back down?)

Does he hope somewhere deep inside that this time, perhaps this once, and for all, the stone will stay?

Does he notice others around him? Does he perform his pushes for them? If so, does he still push? Or (gasp!) does Sisyphus pretend to push?

Does he push out of habit, almost compulsively? Or out of choice, as an act of will?

I have pushed home the resonance between Sisyphus and the actor. There is a convergence between how an actor engages with and repeats an action, score, choreography, blocking, or performance and how Sisyphus performs his action, task, torture or gift. Here is one last question (let's call it the question of truthfulness) which has concerned many an actor (including myself) and inspired a whole genealogy of theatre practitioners:

Does Sisyphus really push his stone?

Detour: Deleuze

In *Difference & Repetition*, Deleuze posits difference as the necessary constituent of repetition rather than an after-the-fact side effect:

> It is always *in one and the same movement that repetition includes difference* (not as an accidental and extrinsic variant but at its heart, as the essential variant of which it is composed, the displacement and disguise which constitute it as a difference that is itself divergent and displaced).[3]

Repetition by definition necessitates difference, theatre attests. Images, as representations, can be viewed side by side and in relation to that which they represent, and thus understood and evaluated according to relative factors and according to how they repeat an original source. Actions, instances, occurrences—theatrical repetitions—require a different approach. They cannot be accumulated and measured against a yardstick, nor is it possible to live them simultaneously. 'This is the apparent paradox of festivals: they repeat an "unrepeatable". They do not add a second and a third time to the first, but carry the first time to the "nth" power.'[4]

Deleuze proposes a logical shift in how the original and the particular interact, moving away from an arboreal understanding to the rhizomatic. In the first approach, the origin is at the beginning and representations branch out, through the play of differentiation, getting more and more singular, differentiated. In the rhizome, singularity is understood as that which repeats itself necessarily as different; the first repeats because it differs. Displacing the original from a presupposed past starting point and relocating it in each and every repetition, Deleuze also reconfigures time: no longer a linear development from the first moment to the next *ad infinitum*, but again, a rhizome of moments, instances with the ability to recreate and become their own origin.

(Aside: When did Sisyphus first push his stone?)

Within this dynamic image, Deleuze differentiates further between two kinds of repetition, the overt and the hidden, the material and the immaterial:

> One is ordinary; the other distinctive and involving singularities . . . One is a repetition of equality and symmetry *in the effect*; the other is a repetition of

inequality as though it were a repetition of asymmetry *in the cause*. One is repetition of mechanism and precision; the other repetition of selection and freedom.[5]

Overt repetition repeats and is experienced as difference; hidden repetition is all difference but is indeed repetition. Overt repetition goes forward, inserting what Deleuze calls 'former presents' into the current present; hidden repetition goes backwards, starting from the current present and reconfiguring the past into a rhizome of other singularities which only now appear as repetitions.

For Deleuze 'Memory is, nevertheless, the first form in which the opposing characteristics of the two repetitions appear'.[6] On the one hand, memory is a willing recollection of the past, a restructuring of a former present in the current present, going forward from then to now and hinting at others to come, like telling that same story, once again. On the other hand, hidden repetition at work in memory, 'constitutes [time] as the *embedding* of presents themselves'.[7] Dare I say sometimes, watching Sisyphus, I see something happen: the current present goes backwards and inserts itself / something happens now and triggers pathways that unearth a sense of having been / the past is reconfigured into memories of now, into instances that were always already repetitions of this moment.

Oh yes, there is the déjà vu or the uncanny. But there is something much simpler: when you don't remember where you left your keys, you cannot force it out of your memory. You can wait, look for memory triggers, re-walk a path, try to remember, positively, overtly repeating. Yet, the exact moment the location of the keys may (or may not) dawn on you is unrepeatable, unforeseeable and incontrollable. That is hidden repetition in action.

The immaterial repetition at work in memory creates ruptures, breaks, shifts in both the current present and the former present. Its pathways are hitherto unknown.

Enter the actor

The question of truthfulness versus mechanical repetition occupies the core of Stanislavski's explication of Emotion. Torstov, the pedagogue of *An Actor's Work*, asks students to repeat an improvisation where the task is to respond to an imaginary madman at the door. The students smugly go through the movements, precisely re-finding the various theatrical tableaux from the previous incarnations of the same improvisation. They are surprised to be criticised at the end for remembering only the effects, the shapes of their actions and the groupings, but not the impulses or the emotions that accompanied and caused them in the first place.

They are told that 'All external production is formal, cold, and pointless if it is not motivated from within'.[8] Memory is proposed as a tool for breathing life into mechanical repetition. It is presented as that other thing that makes everything true, alive, organic, unpredictable, ultimately unknown. Paradoxically, reference to the past is suggested as a way of creating presence, a more committed engagement with

the current given circumstances. The paradox is explicated with another: Torstov tells the students that memory is the means by which they can allow an element of unpredictability or surprise into their work. So emotion memory, often mis-represented as an actor's controlled insertion of a past moment into the character's circumstances, is indeed presented as the activation of a creative process where the purpose is to destabilise the actor, to keep her on her toes, to put her on a web of associations, a path of mnemonic triggers, jumping from one moment in time to another without preconceived, recognisable routes. Both repetitions are at work.

Grotowski takes this observation even further to construct montages that feed specifically on the dynamic interplay of remembering and forgetting at work in memory. The most famous example is Cieślak's work on the *Constant Prince*, an example that is significant not because of how Cieślak repeats the Constant Prince, but rather because of how he forgets and disrupts him. To borrow Deleuze's term, what results is 'one less' Constant Prince.

Grotowski tells us:

> Nothing in [Cieślak's] work was linked to the martyr . . . All the river of life in the actor was linked to a certain memory, which was very far from any darkness, any suffering . . . a time of love from his early youth . . . And on the river of the memory, of its most minute impulses and actions, he put the monologues of the Constant Prince.[9]

The unit that makes this juxtaposition—this rupture—possible is physical action. Grotowski explains the technique of montage as the selection of actions from an organic line of physical actions like strips of film. To be repeated in a score, it is required that the action be isolated *precisely* and that it sustains its relatedness in isolation like 'a frozen waterfall: all the drive of the movement is there, but stopped'.[10]

The specificity of this relatedness bears directly on the temporal and spatial span of the action, on its force, on its expansion and volume, on the way it is rooted inside the body and extends from the body in relation to a multiplicity of external object(ive)s. Its repetition in performance requires the disciplined re-enactment of not just the outer form or the inner content, but the whole web of relations that created the action in the first place.

In Deleuze's terms:

> This action may be anything from an empirical point of view, or at least its occasion may be found in any empirical circumstances (action=x); all that is required is that the circumstances allow its 'isolation' and that it is sufficiently embedded in the moment such that its image extends over time as a whole and becomes, as it were, the *a priori* symbol of the form.[11]

Breaking the dichotomy of inner/outer, or the mind/psyche versus the body thus, Grotowski locates the action in yet another dynamic opposition: between

discipline and spontaneity. As Cieślak explains in his famous analogy, 'the score is like a glass inside which a candle is burning'.[12] On one hand, Cieślak remembers what is originally at work in the memory through precise actions, going forward, positively, he tells a story while reliving it. Yet at the same time the dilation of the action in space in the present moment, given the scenic facts that surround it in the performance, suggest alternate mnemonic possibilities, other roots of remembrances. Perhaps the Constant Prince seeps into the memory and transforms it? Perhaps the engagement with the other actors reveals a long-forgotten element of the memory, something new is lived? This way, Cieślak becomes an actor that exposes himself *sincerely* not (just) because he publicly remembers an intimate moment, but because he allows other less predictable memories in, both in the present moment and in the former present.

Is Cieślak pushing his stone uphill? The memory selected ('first love') resonates archetypally. Yet it is not finished, still alive and still able to displace the actor. The 'actor's work on himself' is indeed the unending engagement with one's own burdens, a reliving of memories not for the sake of what is known about them, but in order to get a glimpse of what is not yet available.

Rolling credits, or Hillman and 'The myths that live us blindly'[13]

When archetypal psychology asks that we meet archetypes on equal terms, the implication is that they can retain their unknowability and power. Every time an actor repeats an archetypal action, they befriend their Sisyphus. This methodology rests on two principles: 'sticking to the image' and 'staying in the unknown'[14] echoing Grotowski's discipline and spontaneity.

Aligning discipline with sticking to the image and the unknown with spontaneity would imply that the actor must stick to all the details of the action, maintain its relatedness in isolation without sacrificing what doesn't fit, as well as to stay in the unknown, to keep asking, to allow spontaneous encounters to take place. This way, archetype can be remembered through overt repetition, going forward.

Another possibility, however, and the more archetypal, is the opposite alignment: to understand discipline as staying in the unknown, and see spontaneity as sticking to the image. In this phrasing it appears that specificity repeats itself in those spontaneous, previously unpredicted moments, the instance when a memory dawns, whereas staying in the unknown requires disciplined precision. A rupture and a flash: Sisyphus repeats Cieślak, I repeat, Sisyphus repeats Cieślak.

Ah Sisyphus, oh Sisyphus. You are tired, you do remember having pushed your stone, but there are moments when you really remember, as if you had never remembered before.

And perhaps it is because of me, due to that sigh I couldn't stifle while watching push number seven-billion-six-hundred-and-forty-three-million-seven-hundred-and-eighty-nine-thousand-fifty-four.

Notes

1 Camus (2000: 111).
2 Hillman (1977: 81).
3 Deleuze (1994: 289).
4 Deleuze (1994: 1).
5 Deleuze (1994: 287).
6 Deleuze (1994: 287).
7 Deleuze (1994: 81).
8 Stanislavski (1995: 164).
9 Grotowski (1995: 122–123).
10 Grotowski (1997: 303).
11 Deleuze (1994: 294).
12 Cieślak quoted in Schechner (1973: 295).
13 Hillman (1996: 192).
14 Hillman (1977: 78).

References

Camus, Albert. 2000. *The Myth of Sisyphus*. London: Penguin.
Deleuze, Gilles. 1994. *Difference & Repetition*. London: Athlone.
Grotowski, Jerzy. 1997. 'Tu es le fils de quelqu'un', 294–305, in *The Grotowski Sourcebook*, edited by Schechner and Wolford. London: Routledge & Kegan Paul.
Grotowski, Jerzy. 1995. 'From the Theatre Company to Art as Vehicle', 115–135, in *At Work with Grotowski on Physical Actions*, edited by Richards. London: Routledge.
Hillman, James. 1996. *Kinds of Power: A Guide to its Intelligent Uses*. New York: Doubleday/ Currency.
Hillman, James. 1977. 'An Inquiry into Image', *Spring* 39: 62–88.
Schechner, Richard. 1973. *Environmental Theater*. New York: Hawthorn.
Stanislavski, Konstantin. 1995. *An Actor Prepares*. London: Methuen.

29

81 SENTENCES FOR SQUAT THEATER CIRCA 1981

Lin Hixson and Matthew Goulish

A philosopher once said that two people come to know one another by mutually regarding a third element. Lin and I have been collaborators for 30 years. Our collaboration began with a conversation about a performance we both saw, independently, in 1981. In this chapter, we tried to write about how that experience formed us – as the third element that first brought us together. We often import creative constraints into critical tasks, so here we wrote 81 sentences (LH 31, MG 50), because of the year 1981. We divided those into nine sections of nine sentences each, because of the reliable, unnatural beauty of the square. [MG]

1

I flew from Los Angeles to New York in Fall, 1982. I crossed the country to stay in a friend's thrown together sleeping area in her apartment on the Lower East Side. In helping to make my bed, I discovered the flyer for Squat Theater's *Mr. Dead & Mrs. Free.* I vaguely remember looking at the woman floating in turquoise, a belly dancer spacewoman with oversized headphones, and deciding to go.

Associations form between the not-fully-absent past and the not-fully-present now. Like an over-sized, I mean gigantic, nude, papier mâché baby with headphones and video monitors for eyes. The baby sat in the corner of a storefront that served as part of the performing area for *Mr. Dead & Mrs. Free.* I looked into those video eyes and they filled with Esther Williams' water ballets. Thirty-four years later, looking at a performer, playing a matador in a performance (I am making) crouching down and standing up on tar paper over and over again, I know that he is performing a water ballet of sorts that springs from the eyes of this monumental baby.

2

The source of the movement comes from a YouTube science video of water dripping from a pipe. With his body he imitates the water falling. He does so within an

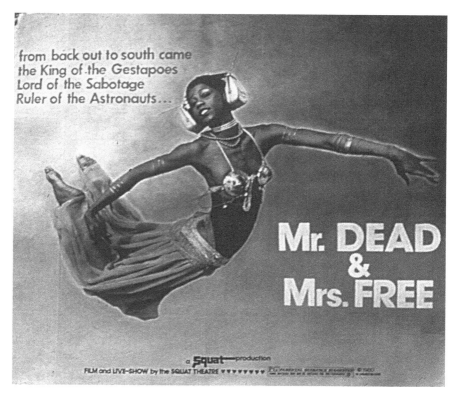

from back out to south came
the King of the Gestapoes
Lord of the Sabotage
Ruler of the Astronauts...

Mr. DEAD
&
Mrs. FREE

a **Squat** production
FILM and LIVE-SHOW by the SQUAT THEATRE ▼ ▼ ▼ ▼ ▼ ▼ ▼ ▼

FIGURE 29.1 Poster. Artwork by Eva Buchmuller, photo Klara Palotai. On the photo Sheryl Sutton (1980).

unseen, colossal bullring, like an eye in a colossal baby. An umbilical cord stretches between the two in an ever so tenuous way. At the time of Squat Theater, modern life and its dramatic effects were surpassing the experience of theater. A crisis occurred among the New York theater makers as they tried to grapple with this situation. Many took Artaud's statement 'Theater must equal life' as a mandate. They removed theater's passive structures with attempts at volatile unpredictability seeking to capture the energy and charge of real life. Squat Theater responded differently.

3

Carefully crafted, rehearsed, and repeatable material was placed next to unrehearsed real life. This prepared material framed and more fully accentuated the lively, action-packed, not-practiced life that *Mr. Dead & Mrs. Free* absorbed into its world, like when a jeep screeched to a halt on 23rd Street which we watched immobile in our raked theater seats. Two performers, dressed as soldiers in fatigues, carried a bloody body from the jeep's backseat into the theater through the storefront's glass door. They placed him in a hammock in front of the bloated baby whose large blinking

video eyes had returned from the water ballet. Thirty-four years later, I watch a performer at a small table recite words based on the poetry of Charles Reznikoff, derived from actual court transcripts from the late 19th- and early 20th-century America. The performer recites a story about a young girl, named Bernadette, who works in a bindery, counting books and stacking them. There are twenty wire-stitching machines on the floor and a shaft that runs under the table works them all.

> The books are piling up fast
> and some slide to the floor
> (Keep your work off the floor! The forelady had said);
> and Bernadette stoops, stoops to pick up the books–
> three or four have fallen under the table
> between the boards that are nailed against the legs.
> She feels her hair caught gently;
> she puts her hand up and feels the shaft going round
> her hair caught on it, wound and winding around,
> until the scalp jerks from her head . . .

4

I hold a necessary piece of ice close to my heart when making performances. The brittle cold gives me a distance and grants me permission to present words I do not want to hear like the horror of Bernadette's injury (immediately after which a rock band, live onstage, blasts into the drumbeat and chords and screaming vocals of a song with no apparent connection to Bernadette). I first saw this ice in *Mr. Dead & Mrs. Free* with Squat Theater's fearlessness in muddling categories; discombobulate meaning; mixing trained and untrained performers; questioning virtuosity; and not making sense. *Mr. Dead & Mrs. Free* was my first experience of what I now call an extreme event – pushing all things to their limit with mastery.

[LH]

In January through April of 1981 I lived in New York City, and on one of those spring evenings I ventured to 256 W. 23rd Street – which seemed a desolate area at the time – to attend a performance by a group called Squat Theater.

They took their name from the abandoned real estate in which they, at some point in their apparently illustrious past, had lived and made theater, after coming to NY from their home country of Hungary.

My friend Dave had described their previous production, *Andy Warhol's Last Love*, and his immensity of detail instilled in me empathic memories not of his telling but of the actual performance.

We walked the windswept streets of the Lower East Side, Dave claiming he was taking me back to the subway, as he delivered an intricate monologue on some subject.

The night he chose *Andy Warhol's Last Love*, I saw a garbage can with a fire in it, three men standing around, and I said: 'We passed that fire ten minutes ago – are you taking me to the subway or not?'

5

Dave was like that – he'd get me to the subway, but only after planting a seed, of which Squat Theater was apparently the most potent, firmly in the garden of my psyche.

So when *Mr. Dead & Mrs. Free* opened, I had no choice.

Fittingly the final image of the production involved a 12-foot-tall papier mâché baby seated in the corner with televisions for eyes.

The televisions showed various videos in duplicate: a swimmer underwater, Nico singing . . . *it's up to you New York New York!* – but the baby could have been standing in for my newborn love of performance, might have been the birth of that love, of macaronic performance, radical in the way its mix of styles fight with one another, betray one another, refuse to cohere into any singular, consumable experience, and in so doing offer up some volcanic uncontainable looping rebellious ecstatic yet oddly humble event.

I remember the performance first as a resolute structure – two parts, separated by a curtain.

The first part, or half, presented several – I cannot say now how many – short events; some live, resembling acts in a strange talent show, some playing out on projected video.

The video I think showed a pregnant woman doing yoga, as well as footage of her giving birth, and taking a shower.

Another video followed a trenchcoated man as he strolled through the (then) seedy pornographic booths of Times Square and used a device involving a plexiglass tube into which he could masturbate in public, ejaculating into clear fluid.

The live parts I remember included a male violinist and a female singer, both dressed in formal black tie as for a recital, performing a deadly serious classical-style duet of James Brown's *Sex Machine*.

6

I also remember a small robot, shaped like a squat cylinder, maybe two feet tall, rolling around haltingly and emitting puffs of incense.

All of this happened in a foreshortened area in front of a black curtain.

Even with the relatively small audience of maybe 50, people had trouble seeing the robot, and I like the others tried to angle for a better view.

I think the robot mutely announced act II: the opening of the curtain and the big reveal.

We may have heard the drummer first, before the curtain opened, as it opened, the live drummer sitting at his drum kit kicking out a simple but textured beat, and once the curtain opened it revealed him as part of a larger tableau, a visual cornucopia not easily registered at once, and the opposite of the austere first act in front of the black curtain, now removed.

The drummer perched in the center near the back wall, which was transparent: windows facing out onto 23rd Street.

In front of the drummer, the room appeared set up as a café with tables and even a few customers.

The giant baby with television eyes towered over the drummer in one corner; in the other corner, an open door.

The disorientation I experienced, unsettling bodily and mentally, resulted in part from the closure of act I within a normalized dark no-place of theatre, that when ruptured made me wonder for a moment how Squat had created the 'realistic street' effect for the backdrop.

7

When a bus zoomed past, bigger and faster than anything I had seen in theater before, like spotting a whale while sitting in a bathtub, I realized the street was real.

The violation felt so complete that as pedestrians hesitated on the sidewalk, considering entering the café, and I could see in their looks that the presence of the small risers full of people (myself included) looking back at them from the opposite end of the café failed to compute, I felt naked, out of place, and complicit in a strange ritual that vaporized in the light of day, or actually the light of evening.

The lack of 'action' for some time seemed designed to allow for the radical recalibration between the two acts.

In fact a vague story did play out, involving customers ordering, paying, departing, and a romance between a male customer and the waitress – entirely ordinary behavior, until the waitress emerged from the kitchen with the man's dinner of a flaming skewer just in time to see him depart with another woman, and clearly distraught, she lifted the skewer, dropped the tray, and impaled herself, dropping 'dead' to the floor as the flames died away, and things were no longer ordinary.

To be clear, this all happened long ago.

Recollections of structures, conflicting styles, and the grimly comic affect remain indelible, but of the events I remember only disconnected fragments.

At some point after night had fallen a jeep loaded with soldiers in camouflage came speeding down 23rd Street, executed a hairpin turn up, jumped the curb and screeched to a halt on the sidewalk.

I know this happened after dark because I remember the blinding headlights through the glass wall.

It was another in a series of jarring episodes, making me wonder again if these were actors or if something had gone wrong.

8

Several soldiers rushed in through the open door, carrying one on a stretcher.

The drums reached a fever pitch, one soldier put his head under the blanket and appeared to fellate the wounded soldier whose body soon lurched up to a seated position as he sprayed blood out of his mouth, then collapsed (Mr. Dead).

Somewhere a man's voice had starting singing, a kind of rap ballad, along with the drums, its words all about the Mr. Dead and Mrs. Free of the title.

I thought he was on a soundtrack until a slight movement caught my eye, and I saw one of the soldiers crouching by the wall with a microphone, then creeping into the light, and finally taking center stage with his song.

The extant documentation of *Mr. Dead & Mrs. Free*, the descriptions and the few online photographs, have filled in some of my memory's substantial blanks.

The very prominent willowy-figured black woman dancer in tropical garb, who joined the singing soldier, completely vanished from my recollection.

I had forgotten both her and the earphones she wore – huge 1981 earphones, like silver boxes with antennae affixed to the sides of her head.

The giant baby in fact wore papier mâché replicas of those giant earphones, and I had forgotten those as well.

I forgot the two adolescent girls who wandered through the performance, conversing about their uneventful plans for the evening, their words amplified through the sound system.

9

My memories are not inaccurate, only incomplete.

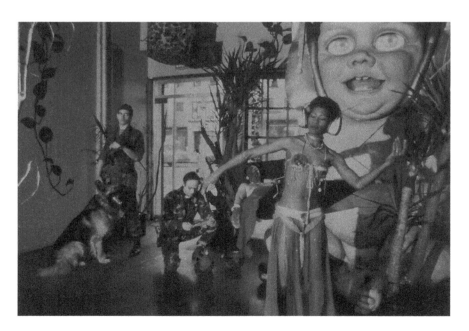

FIGURE 29.2 On the Front: A scene from Squat Theater's *Mr. Dead & Mrs. Free* (left to right) Yogi (the German Shepard), Peter Halasz, Stephan Balint, Peter Berg, Sheryl Sutton 1980. Photo Klara Palotai. 256 West 23rd street, NYC.

At the end, I recall distinctly, a man stood on the sidewalk, leaning up against the glass wall, looking in.

I don't remember how he got there, or how he got his entire arm with the bouquet he held through a hole in the glass, so while he stood outside the café his arm was inside.

The performance ended when, timed with Nico's singing *New York New York* in the baby's TV eyes, this man walked away but his arm remained, suspended on the inside of the glass: an artificial arm, flowers in hand.

That spring night, at the age of 21, I found my way back to my Upper West Side apartment in a kind of disturbed trance, discomforted, like being forced to allow for a new space opening or unfolding inside my body.

35 years later I can readily conjure that entrancement.

The spell the performance cast in me never faded; the door that it opened never closed.

Three years later I met Lin Hixson, and we discovered we had both seen *Mr. Dead & Mrs. Free* – maybe we even attended the same night.

Ours was the first conversation I had on the subject of the performance that I carried with me for three years silently, and I realized only then, listening to Lin, my love for it and that life could after all be like that.

[MG]

30

LANGUAGE, LIPS AND LEGACY

A pedlar's life for me

Tracy Mackenna

My dear Reader,

In 1995, aged 22, I made the daily journey to a largely disused building in the centre of Glasgow. Fleming Tower rises high over the city from the base of the slope at whose peak sits The Glasgow School of Art, my alma mater. In the abandoned and dirty former office spaces that I colonised as a studio, my reflections on being a citizen in post-Thatcher Scotland were channelled into the first of many 'text blankets'. Roughly cut from woven fabric, **I could wreak havoc**, thundered through woollen fibre, keeping to be heard unnoticed in the heart of its urban cradle.

Layer Drawn: I COULD WREAK HAVOC
Layer Endnote: *I could wreak havoc, Winter-Spring 1995*, text blanket, wool, 200 x 180 cms, Tracy Mackenna, 1995.

Bordeaux, 1995. Carrying a light suitcase filled with woollen blankets, threads, needles, scissors, paper and pens, I travelled from Scotland to France to deepen and test the relationship borne between myself and Françoise Valéry during our period at the Centre de Poésie et Traduction, Fondation Royaumont, France, a year earlier. Françoise, along with Franck Pruja founded Éditions de L'Attente in 1992. Taking up Françoise's curatorial proposition while director of Galerie du Triangle, I moved in to the white presentation space, transforming it to public studio, publishing site, exhibition venue, drop-in centre and residence. Opening hours were inverted to reflect and welcome the nocturnal audience, largely made up of the area's prostitutes. A risky strategy, artwork was generated only from conversation, during which I enacted the slide from English to French, and the subsequent full immersion. The city was my subject, its residence my co-respondents. Your words, my writing, our stories. Collectively translated, constructed by me, published through cooperative efforts, great paper sheets adhered to the city's walls, night after night. A tail of occupation, desire and belonging grew incrementally, the scope of its largesse reflected by the rise of the posters' theft by avid collectors.

And this, before we artists adopted the terms socially engaged, participatory, dialogic … and being in advance of the recent acknowledgement of conversation's place in art practice. And is my writing down, setting fast of conversation, really writing? How could it be, when I was the product of art school, where my position in Sculpture was formed, described and named by tangible material and gendered object-led practices. Words, and thinking through text and language resided in a parallel orbit, used to evidence knowledge of another's practice, most often unrelated to the writer's and of little support in building the family of references from which a person and practice could draw strength, get courage and turn to for sustenance.

Layer Drawn: I AM INVISIBLE IN THE CITY
Layer Endnote: Excerpt from *Big Fears and General Anxieties*, text blanket, wool, 200 x 180 cms, Tracy Mackenna, Galerie du Triangle, Bordeaux, France, 1995.

The transient artist occupies and shapes a series of sites, locations and contexts. She meets, works with and draws from fellow artists, curators, old friends and new. The more recent ones have been ascribed new names: participants, contributors, collaborators, respondents. All that and also, audiences and publics. How to enact so many roles simultaneously? How vital is awareness, how necessary unawareness?

Endnote: Not a Shred of Evidence, Tracy Mackenna, (Warwick, UK: Mead Gallery, Warwick Arts Centre, University of Warwick), 1997, 82pp, ISBN 0 902683 36 5.

studity into somelhin

It is linked to **speed** of perception, and not

how long it takes to *grasp* an image or a notion, but how long a is.

If the artist is the embodied catalyst, how can she reveal a subject through the simultaneous production of creative and critical text in the sight of, and during making that takes place in public and that purposefully includes audiences? To do so, I became the Pedlar, inhabiting the character to simultaneously enact and explore through staging and processes of creative encounter, employing and sharing a creative toolkit of self, voice, travel, language and story.

And this of course involves

The Pedlar investigates, researches and produces in the time frame of empathic travel, using the creative product as gift and item of transference to initiate, explore and reveal connections between self, people, place and subject matter.

Performing language is explored in a series of live situations. Considered as transformative experience, the interrelated performances stimulate conversation on specific subject matters: war, conflict, psychological inscription in a place, difference. The Pedlar conversationally investigates a broad range of opinion, fact and theory. My toolkit insists on an art practice as a catalyst that can enfold, investigate and reflect material generated on the spot and

dislocation

folding on in order to cope we are always involved with the technique of replacement

stimulated by methodologies and approaches that include chit chat, storytelling, note taking, drawing, poetic text making and narrative writing. Strategic tools embrace negotiation, critical engagement, taking control, resistance, subversion, failure, self-doubt… developed over long periods where a cumulative research process takes form through research-led projects (this includes everyday activities such as teaching), embedded in and responsive to a locality. At the heart of multi-disciplinary behaviour is a woman's quest - activated through the female body that pronounces female difference in language and text - for the production of text in the habitation of spontaneity: the Pedlar enacts a creative process that nimbly flexes in real time to the shifting and multi-layered conditions of each encounter.

looking to belong?

exaggeration, you begin not to be able to trust to your own memory

Faced with ch
overwhelms n

In the same w
is happening. I

No reason. I

Yes, well. It's
right
connaisance

Let's talk
Yes.
If we are tre
A really creep
believe what y
Murderer's
The prevailing
presumed feeli
trailing bloo

Layer Handwritten text:
Performing Me. Tension. A bilious, softly creeping, tightening secretion pulls stomach to throat. The body prepares for action, delighting in it subversion of the mind's warm up. The advance towards the audience is riven with anxiety: hot body, pink cheeks, cramping organs, loosening bowels. Quicksilver shifts reflect the demands of conversation and writing: oscillation between monologue, dialogue, poetics, reflection, research, production and documentation – relying on the force created by the space that flits between subjective and objective knowledge.

Endnote: The Print Pedlar ... Tracy Mackenna conversing and writing on the move, gifting text cards, in Tracy Mackenna & Edwin Janssen, WAR AS EVER!, Nederlands Fotomuseum in collaboration with the Atlas Van Stolk, Rotterdam, the Netherlands, 2012

But how does the artist's presence get in the way of, or enhance, the criticality inherent in this live exploratory process? Out on the streets, the Pedlar is displaced in time and memory and identity. She is neither here nor there, relevant only to some and simultaneously mostly irrelevant to others, the temperature of her presence dependent on how vocal she is willing to be. The fact of her activation, through her own impetus and experience and others' interpretations, gives her substance, and that bestows life. The swapping of stories creates a temporary mini-circuit, allowing me to concoct in the established gap, itself a chink in the city's time-space pattern where I can explore interests within a fixed, proscribed period of time.

Inhabiting the Pedlar's identity requires quite a bit of effort both emotional and physical. In a series of multiple, linear moments I explore the project's subject, in transition, in the shift in time and space that occurs between my identity and the Pedlar's. I am conscious and controlling, a walking editing table; concurrently generating, mediating and executing. Conversation and place are recorded through writing, later filtered and presented as document, housed in a digital location. Variously extended moments that encapsulate pockets of time enfold multiple locations and points of encounter, while the act of recording, of committing and setting-down, synthesises unique and complex individual and shared experiences into one single artefact – the story.

Layer Print Pedlar gifted card, handwritten:
Images, city sounds, conversation
Resonance and art
Acoustically interesting spaces
Speaking back to
Repeating the words of passersby
Anywhere that echoes regarded as sacred place full of spirits
Unlike sites in history and prehistory, city has
No possibility for reverberation
Resonant surfaces not recognised
To be in dialogue with city
Sites of sonic significance
Communication between people copied, altered, replayed
Chatty informal jokey; form almost as important as content
Melody of exchange is the message - is building up of bond

Endnote: The Print Pedlar ... Tracy Mackenna conversing and writing on the move, gifting text cards, in Tracy Mackenna & Edwin Janssen, WAR AS EVER!, Nederlands Fotomuseum in collaboration with the Atlas Van Stolk, Rotterdam, the Netherlands, 2012

Endnote: The Print Pedlar ... Tracy Mackenna conversing and writing on the move. Shifting text cards, in Tracy Mackenna & Edwin Janssen, WAR AS EVER!, Nederlands Fotomuseum in collaboration with the Atlas Van Stolk, Rotterdam, the Netherlands, 2012

Traces
Sound
Noise
breathe
Silence
vocal chords
Attuning
momentum
Parameters
paradigms
Canons
translation
dialogue
construct
monopolise
interview
positioning
role play
potential
linearity
context
experiential
affinity
space (between)
spatiality
boundaries
spatial
_ artistic
literary
+ visual
transformation
history
territorialism
happening
conversation
mark-
making
immerse
writing
time
uncaptured
rhythmic
repetitive
differences
between

At the heart of the Pedlar's action is a non-hierarchical activation of potential reconsiderations of a place's identity, through what Paul O'Neill describes as 'duration as co-habitational time', "In order to move beyond the ontological notion of a reflexive subject – where moving from passive to active participant in art is equally difficult to quantify – a further contemplation is needed on the issue of time, specifically how public time is framed so that a space of co-production can emerge. This is what Bruno Latour refers to as the need for more 'cohabitational time, the great Complicator,' with democratic space being understood as the time spent together publicly in contradiction to one another. If we are to think of participation as more than a closed, one-off relational or social interaction with art, it must take account of duration as a temporal process of cohabitation, where time can contribute to something that is immeasurable, unquantifiable, and unknowable from the outset. Therefore, participation can only be experienced durationally, as a lived difference."

Layer Ref P.O'N quote above

Layer Handwritten:
The Question of Authorship

When Voice is the Instrument. Dissolving, losing my voice amongst others. The question of authorship when the text is the product of multiple voices, guided by the artist. The tension sparked in the rubbing up of the private (the artist is producing herself through the public revelation of her subjectivity) and the public (the artist is in the site with publics/participants: co-producers of words). The voice is material object. Can you hear me? asks the voice. Unless it leaves a deposit on an archivable support, sound remains merely an event (the discreet afterlife of auditory objects). My aesthetics, whether exposed in word, sound or image is that of the moving; the shifting, slippery, transitional, re-ordered, re-toned, that is later fixed and presented as sequence. This aesthetics, through geographical mobility is transformed in the space between fixity and presentation. The inter-temporal, the personal and general histories, narratives and memories that reference lived experiences sit side by side re-constructing narratives and re-claiming memories, navigating place and dis-placement.

abstraction (meaningful relationship to its appearance)
voices empathetic to each other perception prolonged, recognition arrested
ways of speaking to each other release from reason
nil communication wayfarers – an ocean of multiple meanings
literary traditions exposed seams, raw edges, displacement of components
textual liberation instability of meaning of words and phrases
meaning and value constructing and destroying, making and doing
of local, contemplation, fragmentation, design and anti-design
creating negating the limits of meaning
open-ended, polyphony, reading, mis-reading
beauty and wreckage
remaking
dialectic

patterns, folds, tissue, scarring, states : mental
returning art into craft?
public ——————— discomfort physical
pleasure —— poetic intention ——— searching for private

Writing as a sculptural act

The Fantastic Fragment. Tease out the beauty and worth of the non-linear by looking at the use of the fragment in building towards a larger whole. Reflecting on and emphasising language's performative qualities; revealing the intertwined and inseparable connections between the meanings of words and their performer in the space of the performative moment.

The happening that is every conversation is situated within a makeshift mise-en-scène. Actor (the Pedlar), props and set come together with each fresh staging; each composition a new episode in an unfinished meandering narrative. Frozen in time while the city revolves around, events unfold through conversation, points in a spoken, *pronounced*, dot-to-dot mind-map of opinion. The displacement that generates each tale reflects the journey told, driven by a quest for meaning and a search for sense and order, the shared shaping an on-the-spot concrete poetry in the making.

In the thick of listening and talking the Pedlar is thinking about … Accent Linguistics Inter-text Gaps Slippages Interruptions Linkages Transgressions Draft Re-draft More voices Other voices Authorial voice Editor's privilege Quotation Reference Citation Appropriation Situation (situating language) Language (limitation) Mimesis Comprehension Subjectivity Gender (obsessiveness, revelatory) Beginning – end (incompleteness)

Endnote: The Print Pedlar … Tracy Mackenna conversing and writing on the move gifting text cards, in Tracy Mackenna & Edwin Janssen, WAR AS EVER!, Nederlands Fotomuseum in collaboration with the Atlas Van Stolk, Rotterdam, the Netherlands, 2012

The ways and means of staging can be confrontational, even manipulative. This act, whilst barely sufficient and always temporary, is a means to the possibility of releasing and assembling a heap of ephemeral spoken scraps, to be carefully gathered, recorded and transmitted in the tradition of storytelling, committed later to the written word. Shared conversations co-authored, reordered, appropriated, interpreted and picked apart. The interrelated complexities in seemingly unrelated knowledge streams of how histories and rumours are told are traced and overwritten, erased, reassembled to reveal the very nature of transitional and trans-historical thoughts.

The associative, dynamic and often uncontrolled process of conversation embodies palimsetic patterns and textures of material that explores a wealth of often unspoken cultural resonances, transforming between the space of a sentence and its follower. Simultaneously speaking aloud and thinking out loud, in the liquid and fluid dynamic space and state of language, meaning made in the space between the imagined and the voiced. New dialogues release previously unknown forms emerging as connective mutations across a range of diverse registers.

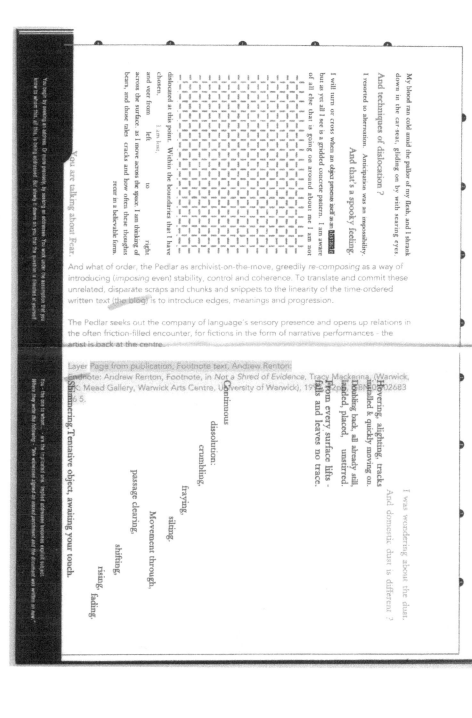

My blood ran cold amid the pallor of my flesh, and I shrank down in the car seat, gliding on by with searing eyes.

And techniques of dislocation ?

I resorted to alternation. Anticipation was an impossibility.

And that's a spooky feeling.

I will turn or cross when an object presents itself as an obstacle but as yet all I see is a gridded concrete pattern. I am aware of all else that is going on around about me I am not

I am lost,

left to right

and veer from

disboated at this point. Within the boundaries that I have chosen.

across the surface, as I move across the space. I am thinking of bears, and those tales cracks and how often these thoughts recur in a believable form.

You are talking about Fear.

And what of order, the Pedlar as archivist-on-the-move, greedily *re-composing* as a way of introducing (*imposing* even) stability, control and coherence. To translate and commit these unrelated, disparate scraps and chunks and snippets to the linearity of the time-ordered written text (the blog) is to introduce edges, meanings and progression.

The Pedlar seeks out the company of language's sensory presence and opens up relations in the often friction-filled encounter, for fictions in the form of narrative performances - the artist is back at the centre.

Layer Page from publication, Footnote text, Andrew Renton:
Endnote: Andrew Renton, Footnote, in *Not a Shred of Evidence*, Tracy Mackenna, (Warwick, UK, Mead Gallery, Warwick Arts Centre, University of Warwick), 199 2pp, ISBN 02683 6 5.

Hovering, alighting, tracks
unveiled & quickly moving on.
Doubling back, all already still,
handled, placed, unstirred.
From every surface lifts -
falls and leaves no trace.

Continuous
dissolution:
crumbling,
fraying,
silting.
Movement through,
passage clearing,
shifting,
rising, fading.

Shimmering. Tentative object, awaiting your touch.

I was wondering about the dust.
And domestic dust is different ?

31

A SERIES OF CONTINUOUS ACCIDENTS

Rajni Shah[1]

> I was attempting to make a bird alighting on a field. And it may have been bound up in some way to the three forms that had gone before, but suddenly the lines that I'd drawn suggested something totally different, and out of this suggestion arose this picture. I had no intention to do this picture; I never thought of it in that way. It was like one continuous accident mounting on top of another.
>
> *Francis Bacon (Sylvester 1988: 11)*

I didn't set out to make a trilogy of large-scale performance works. In retrospect, this feels important for you to know. The first show, *Mr Quiver*, began as a one-hour theatre show, a semi-autobiographical experiment in solo performance. Through a series of adaptations made in response to various technical nightmares, *Mr Quiver* eventually emerged as a four-hour semi-improvised show with three performers, which was mostly performed in galleries and found spaces. Then one day it became clear that *Mr Quiver* was part of a thinking process that was bigger than one show. This is how it became the first in a trilogy of performances, each coming into view as the previous one was being put to bed, the whole unforeseen series reaching completion almost ten years later.

The following three short essays are personal reflections on the process of making and touring each of those three shows. They will not tell you much about the performances themselves, nor about the many other people who made and performed in each show. But I hope that they will give you a glimpse of a certain way of working that I came to hold dear during those years: a questioning of the relationship between performance and knowledge; and a deliberate attentiveness to the creative potential in what otherwise might have been dismissed as accident, irrelevance, or mistake.

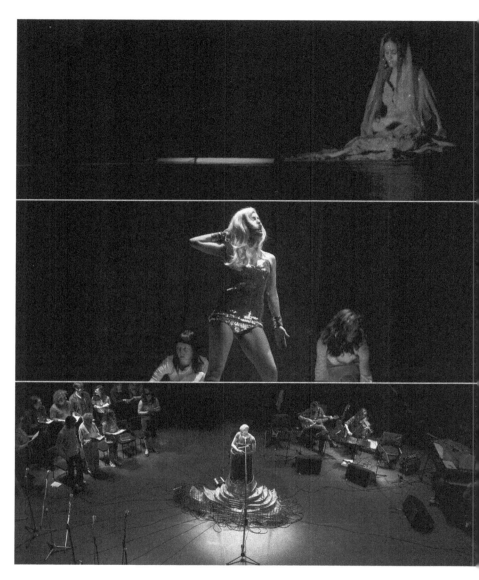

FIGURE 31.1 Top to bottom: Rajni Shah in *Mr Quiver*, Fresh festival (Hastings) 2006, photo by Theron Schmidt; Lucille Acevedo-Jones, Lucy Cash, Rajni Shah in *Dinner with America*, Bluecoat (Liverpool) 2008, photo by Manuel Vason; Lucille Acevedo-Jones, Zohra Boudari, Christophe Canu, Edith Desmette, Nicolas Diricq, Rachelle Lombart, Phil Marichal, Félice Meert, Christiane Nys, Guillaume Sasserath, Anouchka Scaillet, Theron Schmidt, Rajni Shah, Suzie Shrubb in rehearsal for *Glorious*, Un Pas de Trop festival (Mons) 2012, photo by Jonathan Brisson.

1. The accident of naming: *Mr Quiver* (2004–8)

What actually happened is that I mis-heard someone say the name of the film *Mystic River*.

It's incredibly revealing to me that I never told this to anyone when we were working on the show. The mis-hearing happened very early on in the creative process, when I was casually eavesdropping on a conversation between strangers while waiting for a train. I was immediately drawn to it as a show title, and so, without fully understanding why, I called the show I was working on *Mr Quiver*. But I was so ashamed of the randomness of this act of naming that I didn't utter a word to anyone about it for almost ten years.[2] Because of a fear, I suppose, that the truly shambolic nature of my creative decision-making process would be unveiled. Because it seemed somehow unprofessional that it was only in hindsight, having stumbled through the process of making and touring a show, that I could say anything coherent about it using words. Because people often asked me about Mr Quiver: who he was; why I had chosen a male title and a stereotypically feminine gesture to name the show; how the title related to themes of gender and cultural identity that were raised through the performance. And in the backwards way that I work, I slowly found answers to these questions. But it was only with distance that words became my allies.

It is, I think, somewhat unusual to work in this way. Eventually I was able to talk quite coherently about the figure of Mr Quiver and about the ideas embodied in that particular choice of title. But I'm writing this essay as a way of reclaiming that shameful space – the one in which I appear not to be able to speak adequately about my own creative process. I am suggesting that performance can be a kind of knowledge that holds open states of incoherence and inarticulacy that can only be worked through in the realm of performance itself. And I want to recognise how difficult it can be to acknowledge and value this when everything else (including, inevitably, this essay) is measured against another definition of knowledge.

To hold open a space for 'not knowing' within the machine of the cultural industries is to create the possibility for learning; not the kind of learning that comes from acquiring or possessing knowledge, but learning that comes from a place of attentiveness to accident, hesitation, and uncertainty. These kinds of words – not knowing, uncertainty, holding open – are thrown around a lot. I am acutely aware of this. They feel flimsy and over-used. And then, because it has been readily and repeatedly articulated, the idea of learning or understanding that is not grounded in already-knowing can seem easy to grasp. But I don't think it is. To escape the paradigms within which we already 'know' takes a huge amount of work. In performance, it is the work of how bodies and objects encounter each other, affect each other, and mark trajectories through the solidity and oppressions of buildings, personal histories, and social structures. And it is the work that happens even before those encounters are possible: the work of invitation, of carefully considering entry-points and barriers, of making

a deliberate welcome that does not presume a response. It is work that is almost, if not completely, impossible to achieve fully. But it is also work that we, as performance-makers, are poised to do.

In 2008, Cis O'Boyle, Lucille Acevedo-Jones, and I performed *Mr Quiver* for the final time. The get-in was easy, the show was tight, and it felt as if we understood every detail of its timing and rhythm. According to a certain logic, it is at this point that we should have *begun* touring the show rather than putting it to bed. But if we had continued touring past this point, I think that there would have emerged a different division of labour within the performance. On some level, rather than attempting to meet the audience *through* the work, to explore its processes of thinking and meaning *with* them, we would have been presenting them something that we already felt we understood. Instead, in that moment that we came to understand the workings of the show, when it felt most ready, we knew that it was time to move on.

2. Making meaning: *Dinner with America* (2007–9)

Wonder Woman. Black Panther. Madonna. Mickey Mouse. The Twin Towers. The Statue of Liberty. The Wizard of Oz. Buffy. A teenage cheerleader. Glamour Girl. Miss America. Marilyn Monroe. Loretta Lynn. Rita Hayworth.[3]

During the show *Dinner with America*, a series of costumes allowed me to temporarily embody hyper-real western clichéd images of 'beauty' and 'power'. Over two and a half hours, dressed as a busty, blue-eyed blonde, I cycled through a random sequence of improvised poses: fist in the air, arms out wide, thighs open, ankle dropped, hand on hip, head cocked. On stage, in addition to my poses and costumes, were 630 litres of large bark chippings, 34 linkable fluorescent lights, a vertically-rigged video projector casting light down onto the stage, and the two other performers, Lucille Acevedo-Jones and Lucy Cash, who continually arranged and rearranged the other materials. The audience were free to stand, sit, or walk around the performance space, and to leave and come back if they wished to at any point.

There was inevitably a strange tension between the sharp visual presence of my persona and the lack of direction in my performance. Though I moved through bold and provocative poses that clearly evoked a range of historical and cultural references for audience members, the performance never offered to hold any one reading that would stick. After attending a preview of the show, theatre-maker Chris Goode observed that this denial of what an audience-member might be looking for – some kind of story or message – can be incredibly frustrating:

> CG: [I]t's about a desire to embody and to encapsulate and not to comment and not to analyse particularly, and perhaps not to argue. [. . .] At the point immediately before I had my little break—where I went and had some water and some air for a few minutes [. . .] I just began to feel a kind of . . .

grumpiness about being asked to sit with the problems of that embodiment and that encapsulation without . . .

RS: . . . me telling you . . .

CG: Yes.[4]

His 'grumpiness' speaks to a certain desire for revelation – a longing to be given something that finally claims legibility or audibility, or at least something that clearly indicates where and why these are not being granted. Instead, in spite of and in tension with its glamorous opening, what *Dinner with America* offered was a reflection of the complicated navigations of being together: literally and conceptually, the show was about what it means to navigate a performance space with other people, within a set of relations we don't always understand.

Towards the end of the show, I stepped out of the position and costume I had been occupying and that spot was taken over by platters of nuts, fruit, chocolate, and conversation starters, resting on a mound of bark chippings and lights. Everyone in the room was invited to join in food and conversation. This was how we said goodbye. And while it might sound like a feel-good ending, a coming-together, a culmination, it was also an ending that allowed for a kind of unresolvedness. It allowed for the content of the show – the matrix of meanings and readings that were circulating in the space, initially anchored around that central figure – to remain problematic and in motion, maybe even unaddressed, accompanying us all as we left the theatre.

I have always thought about those two parts of the show as reflections of each other: the one in which I am dressed as a busty, blue-eyed blonde, holding centre-stage while bark chippings and lights and people gather and shift around me in various constellations; and the one in which we are a group of people standing and sitting around a pile of props on a stage, tentatively and sometimes awkwardly making conversation until it is time to go home. The same things are happening in both those situations. We are a group of people, holding meaning hesitantly between us for a few hours, allowing a series of accidental meanings to pile up on top of each other.

3. The disappointment of community: *Glorious* (2009–12)

'Let's make no bones about it; this piece could've been a disaster.'[5]

There was something really obvious about *Glorious* that I failed to see until it was too late. I have wondered time and again how I could have failed to notice such a glaring error, right at the heart of the show. But at the same time, I know that it wasn't so much a failure as a refusal. I refused to see the error because it was holding open a problem that I wanted to keep grappling with: the problem of the relationship between artist, stage, and community.

Glorious was like two different shows colliding into one. There was the show that was the third piece in a trilogy of experimental performances concerning cultural identity, in which my (brown, shaven-headed, female) body stood centre-stage

in resistance to traditional representations of power. And then there was the show that had developed from years of conversation-based work in public spaces, in which a team of people, including me, spent several months in a city meeting and working with local residents, building towards a one-off performance in a theatre. The result was a musical based around a repetitive structure of accumulation and dismantlement, with local performers and musicians who moved between different positions to deliver monologues and play music while I stood still and sang from the centre of the stage. My fixity in this show was pronounced; not only was I standing in one spot while everyone else moved around the stage, but I was encased in a column-like costume that was screwed into a heavy podium under my feet. I literally could not move until it was time for me to exit the costume at the end of the show.

Responses to *Glorious* varied greatly, but most reviewers commented on my presence at the centre of the stage. Some wanted to see my body as an image of unequivocal generosity: the artist heroically holding open possibilities for others to 'have a voice'. Others wanted to read it as an image of exploitation: the artist holding cultural capital in unequal distribution with those who are working for her. There were, of course, other readings, but these two extremes felt the most uncomfortable to me. This was the mistake at the heart of the show. It was me. As we began to tour, I wondered: how could it not have occurred to me that it would be problematic to stand centre-stage in a show about community?

I considered many times how I might reconfigure the staging of *Glorious* in order to quell my own discomfort with these readings. But although a part of me wanted nothing more than a sense of resolution, I also knew that to disappear my presence at the centre of that stage would be to disappear a whole set of problems that felt important. In the end, the show in which I stood centre-stage could never fully satisfy those audience members who desired a representation of creativity as a happy democratic leveller; nor was the show singular enough to enthuse those who longed for a more aesthetically clean version of authorship. Instead, standing at the centre of that crowded stage, my body was part of an image that was at once optimistic, disappointing, and wilfully naïve; an image that sometimes failed, sometimes pointed towards the limits of ideals, and sometimes managed to acknowledge the complex, unsettling work of making community.

As Francis Bacon articulates so beautifully in the opening quote, it is in the attempt to do one thing that we have the potential to discover another thing entirely. We might think of this as an accident, or as a stumbling, rather than an artistic choice. My sense, however, is that the work is in how we are able to receive these accidents. It is the subtle work of noticing that an accident has occurred, holding the possibility that it might become something else, and deciding whether to hold on or let go.

As we continued to perform *Glorious* in different locations, the problem of my body at the centre of the stage became manifest again and again. Sometimes it felt like a mistake to keep the staging as it was. It made the show more confronting and complicated than some felt it needed to be. It may even have made the experience less satisfactory for audiences. But it also allowed a sense of unease, darkness and

difficulty into a show that risked being held within an overly simplistic framework. Having made a mistake, though I did not yet fully understand it, somewhere in me I knew that I had to hold on and see it through. It was an accident, a mistake, and a failure – and it was also the opening of possibility.

Notes

1 Katja and Emily asked each of us for one or two sentences about where we situate our own writing as artists. To be honest, I've never been too sure about naming categories for my work. It seems to me that the lines between categories shift according to the position and context of the viewer or the listener, rather than according to anything intrinsic in the work itself. I would say that most of my artistic practice, including this writing, has been about trying to gently dismantle and rearrange those categories of listening and watching that we all inevitably bring into a room with us.
2 This confession originally took the form of a short experimental piece of writing called 'Thinking through salt, thinking through bark, thinking through cables' (Shah 2012).
3 Descriptions all taken from reviews, critical writing and audience comments about *Dinner with America*.
4 Goode (2008).
5 Yates (2011).

References

Goode, Chris. 2008. 'Reason enough for hope': a conversation with Rajni Shah. In *Thompson's Bank of Communicable Desire*. Available online: http://beescope.blogspot.com.au/2008/07/reason-enough-for-hope-conversation.html [accessed 21 September 2016].

Shah, Rajni. 2012. Thinking through salt, thinking through bark, thinking through cables. In *How Performance Thinks*, conference proceedings. London: Kingston University, 161–167. Available online: http://fass.kingston.ac.uk/activities/item.php?updatenum=2136 [accessed 21 September 2016].

Sylvester, David. 1988. *Interviews with Francis Bacon*. Revised. London: Thames & Hudson.

Yates, Daniel B. 2011. Glorious [online]. *Exeunt Magazine*. Available online: http://exeunt magazine.com/reviews/glorious/ [accessed 21 September 2016].

32

THE CONSTRUCTION OF SELF(IES)

Joanne 'Bob' Whalley and Lee Miller

We tend to think of our writing practice as 'collabiographical', which is to say it functions as a collaborative and reflexive approach to our conjoined life and professional practice. This neologism comes from a portmanteau usage of collaborative and biography. Like any biography, the 'collabiographical' is by nature a fiction, but no less true for that. The collabiograpghical allows for an expository relationship with an inward-facing process, forcing us as writers to take account of that which might otherwise go without consideration or critique. Thus, the tonality tends towards the confessional; a strategy that encourages us to consider what is happening in the space in-between, where much of our practice (both performance and writing) lies. As life-partners, collaborative performance-makers, and academics who write together, this approach to writing (hopefully) encourages us to resist the solipsistic, and keeps open Deleuze-Guattarian lines of flight.

One day in the early summer of 2015, a colleague asked Lee how he felt about the term 'identity'. Without really pausing to evaluate what he was saying, he launched into a long rejection of the term, predicated mostly by a blog post he had read the day before in which a liberal-Jewish journalist had spent two weeks posing as a member of a white supremacist messaging group.[1] The story problematised the idea of 'identity' as something which might be identified, even self-identified, in the landscape of a globally extended network of contacts, in which a sense of self is contextual and shifting, even within sentences. On the train home, Lee received the following text message from Bob:

'Are you a rinsta or a finsta?'

FIGURE 32.1 Whalley & Miller, SadFaceEmoticon (2016).

Lee's response was:

'What does this mean?'

Bob offered in reply:

'Look it up'

A quick Google search took Lee to an account of the emerging phenomena of the Rinsta/Finsta within the context of the social networking app Instagram. On the *Elle* website, Justine Harman attempts to unpack the practice, when she observes that:

[a]ccording to Urban Dictionary (yes, we're citing it), a 'finsta' is when 'people, usually girls, get a second Instagram account along with their real Instagrams,

"rinstagrams", to post any pictures or videos they desire. The photos or videos posted', the entry contends, 'are usually funny or embarrassing'.[2]

Harman goes on to observe that the 18-year-old woman who she interviewed for her article 'uses the secondary feed less to dupe her mom than to protect her personal Instabrand',[3] and goes on to reflect that the terms 'real' and 'fake' shift in the context of the Rinsta/Finsta. The 'real' Instagram account is the edited, polished, curated version of her self, the one that would appeal to future employers, future partners. The 'fake' Instagram is where the unruly body is located, this is the domain of the unbounded, the out of control, the ugly. Arguably, the fake Instagram is a form of mediated abjection, where things can hang out and be confusing. As Harman observes, the 'words "real" and "fake" here are curiously inverted', allowing the unedited moments to be displayed and yet disavowed, separated from the exterior branding of identity that the young women of Harman's account use the app for.

On the same day, without intending, we both found ourselves concerned with the different ways that the self can be framed through extended social networks, and how the increased presence of the smartphone affords a complexity and a connectivity hitherto unknown. After 20-plus years of collaboration, it is not particularly surprising that we might find ourselves musing on conjoined territories, but there was no sense that this should become a locus for our research, at least not in any formal way. What we are writing about here started as a series of games played between one another; silly, extended, networked, none of it practice per se, but similarly a doing intended to inform our thinking. So, a practice of a kind, which is why we are considering this here. It is through the accidental, through the unintended that many of our practice as research projects begin. Without meaning to, we were playing with the ubiquity of the smartphone, its role in our relationship,

Bob / Lee

FIGURE 32.2 Whalley & Miller, The Venn of Us (2016).

and the slow realisation that it has offered the potential to shift how the 'self', or in our case 'selves', are represented.

At first the playing was limited to exchanged texts, photos manipulated with FaceTune and MSQRD, messages intended only for one another. However, this gently constructed playing soon moved into a consideration of how we might use our Instagram feeds as a site to interrogate how the conjoined entity of Bob & Lee might be negotiated (which might sound terribly solipsistic and self-involved, for which we apologise, but it does seem in keeping with the territory). Through a consideration of our two distinct and separate accounts, we began to explore the existing tropes of our feeds, and what rhythms and textures asserted themselves there.

By taking a step back from our habitual engagement with the app, and thinking critically about our unthought representations, we became aware of the distinct narratives offered by each feed. In many ways our discovery was merely a realisation of what we already knew, pointing to an understanding akin to the writing of Christopher Bollas who conceptualises those experiences which the individual

FIGURE 32.3 Whalley & Miller, InstaBob (2016).

is aware of, but unable to cognitively process or fully articulate as the 'unthought known'.[4] What became clear was that @preparingforghosts 'curates' colours and objects. She takes pictures which are usually devoid of humans, and rarely contain her own image. She is constantly drawn to the edges of things. She does not have a bio. Her go-to filter is Clarendon. In contrast @dogshelf takes pictures of 'befores' and 'afters', and likes to tell stories through the slow reveal of a series of images. The tag line of his bio states that he is a: 'Big fan of cake. And Ashtanga yoga. And my wife. And my dog. Probably other stuff too.' There are casual pictures of his feet, his dogs, his front room. His favourite filter is Hudson. Without an intentional strategy from either of us, it became clear that Bob is a Rinsta, offering a thoughtfully curated response to the world around her, whereas Lee is a Finsta, happier with confusion, and failure. The overlap is in the tendency of both to photograph cocktails.

From this realisation, we began to explore how a more deliberate engagement with the Rinsta/Finsta approach to our Instagram feeds might be negotiated, so we looked to develop strategies through which our two seemingly unconnected social media presences might be used as a way to curate the messy nature of being collaborative artists / academics and a married couple. Given that we both use iOS devices which share all images taken on our respective phones to the same cloud storage account, we both have access to the images taken by the other. This meant that the more careful, considered images taken by Lee were uploaded by Bob to her @preparingforghosts account, whereas dogs, cooking and failed yoga poses would belong to @dogshelf. In much the same way that we don't make clear which one of us is writing the sentence you are reading, our collaborative playing through Instagram allowed us to interrogate the carefully bounded sense of self that a personal account implies.

The texture and tension of these Rinsta/Finsta-grams drifts somewhere between direct and indirect collaboration. When viewed separately, they nod towards distinct bodies, but this practice, although unannounced to our relatively few 'followers', frays at the edges of our separate identities as we infect each other's images. Sometimes in the real / live world, he will point out a thing for her to frame, and at other times she'll encourage, perhaps via text, another two or three frames of an action to make a narrative (knowing as she does of his love for graphic novels). @preparingforghosts has a different audience for her Instagram account than @dogshelf, where crossovers tend to be those who are aware of the warp and weft of the collaboration that is 'Bob and Lee'. Like cocktails.

The curatorial practices we employ (and we both shudder somewhat at the implicit aggrandisement that the term 'curatorial' imparts – but it's hard to think of a better term) share territory with the Rinsta/Finsta strategies employed by friendship groups and outlined by Harman. Each of us have the opportunity to veto images – of course there is nothing particularly surprising about that. Like most married couples, we defer to one another about 'good' and 'bad' picture, or whether or not something is 'flattering', but the 'project' goes further than that. As an attentive reader, you will doubtless note that there is a good amount of qualification

FIGURE 32.4 Whalley & Miller, InstaLee (2016).

in that previous sentence. 'Good', 'bad', 'flattering', all speak to the subjective. But more significant is 'project', a word that is employed here tentatively. Our Instagram accounts were not initially seen as a means to deliberately construct representations of our 'selves', rather that over time they have shifted towards the collabiographical. Each is a fiction, with a different, perhaps more telling fiction lying in between.

To be clear, what we are offering here is not some claim to be breaking new ground, after all the recognition that the self as a construction is not a new idea. As Judith Butler observes:

> [w]hen Simone de Beauvoir claims 'one is not born, but rather, one becomes a woman' she is appropriating and reinterpreting this doctrine of constituting acts from the phenomenological tradition. In this sense, gender is in no way a stable identity or locus of agency from which various acts proceed; rather, it is an identity tenuously constituted in time – an identity instituted through a stylised repetition of acts.[5]

While there was nothing revelatory in the recognition that on a daily basis we speak our selves into being, more often than not doing so through the ventriloquising of previous iterations of other selves, nor should the emerging practice be dismissed. What is significant is that our understanding of the cultural trope of the Rinsta/Finsta, an action through which the palatable and the unbounded are both given voice, was being played out through an activated enquiry rather than through an abstracted theorisation. In this sense the words Rinsta/Finsta begin to do something in an Austinian sense; they become performative.

Within the discourse of identity politics, the term 'performative' has become a multi-accentuated sign, resisting a fixity of signification, and has developed further to describe the 'nonessentialized constructions of marginalized identities'.[6] While there is undoubtedly a certain amount of slippage surrounding the term 'performative', all uses point to the 'doing' of something that affects a change.

FIGURE 32.5 Whalley & Miller, Lee (with lasers) 2016.

FIGURE 32.6 Whalley & Miller, Bob (smiling) 2016.

When identity becomes a monolith (even an extended and diffuse range of monoliths) to which we conform with more or less success, the internal, contiguous sense of self becomes interrupted by the external conformation to expected versions of the identity with which one identifies. The potential for disconnection and confusion seems to be typified in the playful and resistant strategies employed by the use of Rinsta/Finsta strategies and while there is nothing new in a construction of identity through image,[7] the inversion of 'real' and 'fake' does something to critically interrogate the landscape of the performed self.

Rinsta/Finsta, although presented here as an implied binary is actually nothing of the sort. Instead, it is a dual strategy that allows for a both-and approach to identity construction (rather than either/or), keeping alive all possibilities for those engaged these multi-accented signs. In the case of our own gentle playing with this duality, we began to unsettle the apparent ossification that Bob = Rinsta and Lee = Finsta assumes.

The game of stealing from one another's image archive, choosing those pictures that best represent our 'brand' rather than represent the 'truth' of who took which photograph when and where. The initial game of passing silly snapshots expanded into a curation of assumed identities and the public markers we lay down to own our individual selves. In a landscape of shifting 'ownerships', where the networks we choose to inhabit are granted a range of licences to our images at the point of sign-up, where other users indicate their approval/disapproval by the sharing and repurposing of posts, initial contexts of display are rendered moot, and our images

take on a life of their own; freed of the orginary referent that tied them to the flesh from which they sprang. For us, the Rinsta/Finsta becomes not just a space to resist formal boundaries, but to disavow their existence in the networked space of the Internet.

Notes

1 Available online: www.buzzfeed.com/josephbernstein/white-supremacy-lmfao-lol#. fj1apK055.
2 Harman (2015: unpaginated).
3 Harman (2015: unpaginated).
4 Bollas (1987).
5 Butler (1990: 270).
6 Dolan (1993: 419).
7 Arguably this is something that dates back to the earliest daguerreotypes, with the laborious and time-consuming process of constructing what lies within the frame resulting in a Rinsta-like relationship with the image, which is to say carefully constructed and controlled.

References

Bollas, Christopher. 1987. *The Shadow of the Object: Psychoanalysis of the Unthought Known*. London: Free Association Books.
Butler, Judith. 1990. *Gender Trouble: Feminism and the Subversion of Identity*. London: Routledge.
Dolan, Jill. 1993. 'Geographies of Learning: Theatre Studies, Performance, and the "Performative"', *Theatre Journal* 45(4): 417–443.
Harman, Justine. 2015. 'The Crazy Way Teens Are Hiding Their Imperfections Online: Finstagram', *Elle* magazine online, 9 July. Available online: www.elle.com/culture/tech/a29243/finstagram/ [accessed 21 April 2017].

33

THE PATH ON THE FLOOR AND OTHER USES OF HAND-DRAWING

Karen Christopher

This piece describes an element of my collaborative performance-making process. The performances of my company Haranczak/Navarre use bodies in time and place combined with spoken word, to create evocative visual combinations. Historical, social, philosophical and cultural research and appropriation are considered alongside development of new text and movement. We define performance theatre as a live event for the engagement of ideas, led by the bodily actions which we compose and perform. This piece, the one that follows, describes how one person uses drawing as a mode of thought. Ideas rendered in the form of a drawing or diagram have an increased potential for joining with other human and non-human elements to compose, accept and understand a work of performance.

Sometimes it starts with an image in my head. Sometimes I need to notate an element or section of performance material in order to be able to recuperate it later. Sometimes a finished performance has a form that is unfamiliar to its anticipated audience.

Sometimes an image pops into our minds. It can be complex and present multiple sources of information simultaneously.

What follows are three ways in which I have used drawings to manage development of thought, memory and comprehension in performance work. The first drawing represents an image in my mind that sparked inspiration for generating performance material, the second is an aide-mémoire, and the third is a key to understanding the structure of a cluster of performance material organised in a non-traditional narrative and is intended as a programme note to help position an unfamiliar audience.

The goal: inspiration during the making of
So Below with Gerard Bell

Often a train of thought starts with an image. In this case it was an image of water buckets filled with water and leaking. It was a crowd of buckets on the floor and a few hanging in the air and the sound of water dripping. And we were stood in the middle of this. It was an image that operated much like a dream image which can only be viewed slightly out of focus or out of the corner of your eye—with a kind of indirect gaze—it disappears if you stare at it. As I watched this image in my mind, it changed, it began to develop. My duet partner Gerard held his arms out holding two terracotta plant pots whose water drained out as he held them, feebly blocking the holes in the bottom to slow the loss of water. It was analogous to trying to hold on to life or time as it slips through your fingers. It was a kind of

FIGURE 33.1 In this first attempt at a sketch of the bucket image in my head, the two of us stand among a group of water-filled buckets. Looking at it I sensed motionlessness in our piece and understood I saw myself small in the static image (drawing by the author).

crying machine. I liked it but I didn't know why. I sketched the image. I was still attracted to it. It made something tick over in my head. It did not make sense, the buckets were largely purposeless. Yet nothing we do or show can be completely abstract and these materials—water, plant pots and buckets—are full of meanings. The work then was to figure out how to get there.

What followed became an inquiry into a static state, a moment we were trapped within, a state in which we hovered not knowing how to proceed. We did not hover in the studio. In the studio we got to working with water and buckets and then earth and terracotta plant pots and everything pointed to everything else.

Two slightly tentative human outlines. The position of the shoulders is tentative unlike the lines that identify the figures. One of them is larger than the other. As the drawing is mine I know that I am the smaller figure whereas in reality Gerard and I are the same height. This very static image feels outside of time. It might never move or change. It might indicate an impasse or a stall in forward motion. Whereas the next drawing seems to capture a moment—this one indicates duration. We might be here, like this, for some time.

It is a crowd of buckets filled with water and surrounding two standing figures, one solid and motionless, the other light and possibly transient. Two states of being within the image, one in and one out of focus. Had it been a photo, the one on

FIGURE 33.2 In this second sketch we have traded places within the image and now one of us is standing still and the other seems to be in motion, a bucket has gone sideways. I read a judder in it, a slight progression (drawing by the author).

the right would have been a ghostly motion blur, slightly overexposed or caught in more than one position.

Do the drawings contain unconscious information? Would a written record do the same? Perhaps analysis of word choice and inherent rhythm might lay down involuntary colourisation but most of the written word would be bound to intentional communication. Possibly as a result of having had more practice with words as communication than with visual communication, I find I am more likely to interpret drawings than written notes. Notes are generally taken at face value. The space for interpretation that the sketches allow means space to think into the idea or moment indicated by the drawing. It is not a finalised statement. It is a step toward something becoming.

The process of earning that image informed the early stages of our studio work: investigations into how water marked things—the sound of it, the weight of it; the idea of hovering (getting across the floor without touching it) which became walking on plant pots turned upside down but also invisible footsteps on gravel out

FIGURE 33.3 In this sketch Gerard is holding the plant pots in his wavering arms, everything is leaking out; I begin to see what I am looking at (drawing by the author).

of view. Earth was moist and then sodden, moulded, trodden upon, tended. Fire riding on small candles, tea lights, on the surface of water inside a translucent plastic chest of drawers rocked on waves caused by their opening and shutting. Clothes were pulled from the lower earth-filled drawers. We unpacked an old dance and a discussion of distance and how we experience it. All together it became an hour of moving through the one moment we were caught in. It was not clear who we were mourning for, those lost or simply ourselves in it.

www.karenchristopher.co.uk/performance.1.5.html

The path on the floor: an aide-mémoire in service of composing *Control Signal* with Sophie Grodin

The path on the floor simply describes a shape we are trying to make in space. Another duet partner, Sophie Grodin, and I make our way along a path inscribed on the floor—a path made visible only by our movement through it. As we wanted it to feel as though it were a real path—a rule which we both followed—it had to have a distinct shape. It was drawn on paper and then transferred to the floor, first with chalk until we learned it spatially, and then only in our heads and as described by the movement of our bodies in space. The realness of it was based on our intentionality, in performance there was no visual line drawn on the floor. For this path to remain solid we needed a record of it in the material world. That is what the drawing represents, a concrete plan, a visual manifestation of an idea, a path on the floor as a manifestation of an idea. But importantly, something in the mind made real by its representation in the visual field, something that both of us can look at outside ourselves. It is something we can point to and agree on and return to; it settles the possible argument.

The map indicates a path on the floor. We created a copy of it in the minds of the viewers by following its pattern repeatedly. There are two versions of it, which

FIGURES 33.4 AND 33.5 The first path drawing is the original, idealised version. The second version was more helpful as a mnemonic device. Somehow the symmetry was recalled more readily (drawing by the author).

vary slightly. The second one was altered to simplify it and make it more straight forward. On coming back to the work after a break we both imagined it as more complicated than that. I think this was because in its original, slightly cocked version there is a bit of asymmetry to it and we both internalised that as confusion. In its second version it is a middle looped double-humped line that describes a trajectory horizontally across a space. It is symmetrical and reversible. The two of us used it from both sides to cross back and forth across the space in a sequence which repeated this cross several times. In the long run it was easier to recall as a simple symmetrical line. In practice, the asymmetry worked its way back into the design in the way that our bodies followed the route and with spontaneous breaks in the line during which we perform physical language repeated from other parts of the piece. These breaks from the path are like signal interference or a kind of radio tuning in and out of transmission—the main body of material related to aspects of electricity, in our bodies, in power lines, and through history.

www.karenchristopher.co.uk/performance.1.3.html

The arc or totality: a programme note to coax the unfamiliar viewer

Formal recognition relies on past experience. New forms take some time and development of thought in order to be embraced or understood. If an audience has no familiarity with subject matter or form they may never be reached. Even a group of people who are familiar with being exposed to new forms need to be able to recognise a pattern in the effects in front of them or those effects may not amount to anything. As a rule humans are meaning-making creatures, we are inclined toward pattern recognition. But people have trouble assigning meaning willy-nilly. If the content is not familiar and the form is not visible then blindness sets in—a cognitive breach that can be difficult to mend. Performances are made with this in mind. Usually the performance is made to be comprehensible to its audience. But at times there is a mismatch between a mode of performance language and the familiarity a particular audience has with it. Sometimes this mismatch can be predicted. Sometimes it is desired.

At a university in California I directed a group-devised work whose theme was dictated by a funding scheme. In five weeks, with a group of students stretched for time to devote to the project, we put together a collection of performative responses to the theme of 'air'. As part of this we looked at the metaphysical and aesthetic contributions of air as well as those that are practical and life-sustaining. Some students were interested in aerodynamics, some in air quality, some in sound production and singing, some in the smells carried by the air around us. Material coalesced around their interests. The various parts of the show all related to some aspect of air and there was an underlying message related to protecting the ecology we are dependent on and to celebrating the many ways air supports life on Earth.

Two key organising elements were the course of a day and the subject of air, but otherwise it might have seemed that we were offering a series of unrelated

anecdotal slices of material. In order to hold an audience it was important that they understand the many-faceted nature of our endeavour but equally we wanted to be sensitive to the lightness of it and the group's sense of letting these stories lie equally together without becoming didactic. And we wanted to trust that the

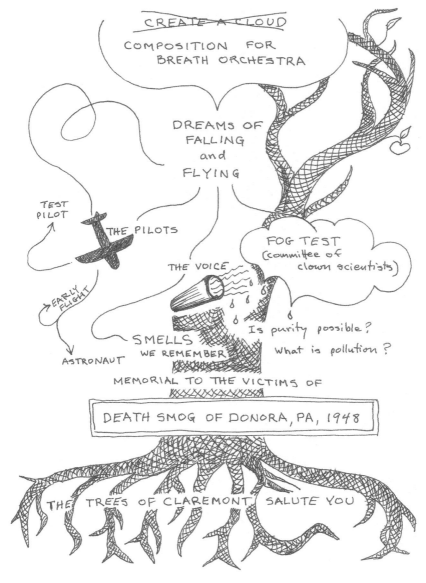

FIGURE 33.6 This drawing of a tree functioned as a director's programme note meant to clarify the content of a performance for audience members unfamiliar with following non-traditional narratives (drawing by the author).

audience would put the pieces together themselves. This kind of work was not usually made or seen much within the community it was to be shown. But rather than assume the audience would not be able to receive the content in a form departing from the traditional well-made play, we contrived a programme message that might help some of those more settled in their ways to read the work.

With this tree drawing I attempted to show that the various areas of material were connected. The tree is familiar as a diagrammatic tool for displaying associations between discrete elements. The tree is pleasantly familiar within the body of content we were engaging and very much in keeping with the theme of air and air quality. It can be absorbed in a glance without reading a long explanation of why we were putting the material together the way that we did. It is akin to a map of an area. In this case an area of thought.

https://youtu.be/_LCpjN89OyM

Drawing is a mode of thought

Thought is a swirl of phenomena both simultaneous and conceptual, a sound, a taste, a cloud conglomeration of idea—these are communicated through language or in diagrams and doing this means a translation from a web of association into a linear linguistic formation or, more sympathetically, through a more simultaneous and relational format in drawing or mapping or other kind of diagram.

In each case, the drawing is a preliminary stage, a step between mind and physical manifestation or between internal dreaminess and external reason and sense-making. It is also a way of connecting minds by bringing them to a single point of focus without overburdening single meanings. The invitation to interpretation drawing affords allows the accommodation of multiple meanings and understandings.

Development occurs as my idea moves from my mind to the page and then back to my mind via my eye as I wrestle with looking at it and reckon with its difference from what I'd imagined. This then alters my internal image and develops the idea/image which reappears on the page. In this way a dialogue between inner and outer is facilitated or contrived and progress is made in thought on its way to becoming performative.

34

SEARCHING FOR 'THE BANDAGED PLACE'[1]

Louise Tondeur

I write novels, short stories, poetry and more recently screenplays. I write academically, some-times about creative practice. At the moment I am finishing a novel. I like the idea of queering a narrative and investigating marginalised positions.

Recently, I found myself considering our contexts. That is, creative practitioners exist within a cultural context crucial to our practice, and in a symbiotic, osmotic relationship with that context. Part of that context is reiterative: it has to do with the way creativity is understood, how those understandings circulate in popular discourses, and how they are internalised. In this short chapter I give two responses. First, I demonstrate one of the practices I use when I write fiction, giving an excerpt from a creative piece. Second, I catalogue the overlapping and, in some cases, contradictory cultural idioms influencing the perception of creative practice in the academy and the values attributed to it. I finish with two disjunctive / alternative possibilities for considering creative practice: the flâneur and the 'frissure'.

Writing

Sometimes idioms about creativity come with reductive cultural force.[2] As a space-claiming exercise, then, I like to tease out what I am practising when I write and ask: *what precisely am I doing?* What I practise (try out) when I write fiction, is a form of method acting. In first or third person, I adopt characters as a mantle. If I thought about it during the process of writing, which I tend not to, I might say that these characters are a way of seeing the world, a paradigmatic 'filter'. This is very different from, say, 'creative problem solving'.[3] I do not attempt to think creatively, or even think about thinking at all. My experience of creative process is better described by Csikszentmihalyi's concept of 'flow'.

Redrafting, too, is about becoming the character to the extent that I am not consciously thinking. It is ironic, then, that on other occasions I do think and write about creativity. I worry that it feels jarring to bring the two (the practice and thinking about practice) together in one essay. Perhaps that is the point, what Barthes famously describes as 'punctum' in *Camera Lucida* (1980): pay attention to the jarring note, the gap or crack, the personally painful, or what Rumi describes as 'the bandaged place'.[4] Perhaps that anxiety is generative. With that in mind, I have provided an example of my own creative practice, an attempt to embody a character, a version of method acting. It is an extract from a longer piece, describing Phyllis Lockhart and her husband Woody, who have inherited her uncle's pig farm.

Phyllis Lockhart

Phyllis Lockhart didn't so much keep things to herself: more like she kept a fleece of silence wrapped around her to keep herself warm and that fleece of silence continued at least an inch below the subcutaneous fat. If you were trying to understand Phyllis, and to her knowledge no-one had ever tried, you could never really get her without this first piece of information. The second thing, which would be much more obvious if only you looked straight in her direction without being distracted by her husband Woody or the smell of pig shit or the freezer of chopped meat at the farm store, was this: finding one's uncle sprawled on a mattress dead from drink and surrounded by a shadow-like stain of leaking bodily fluids was enough to turn anyone's head as well as their stomach. And Phyllis's head had turned.

Phyllis had heard that her uncle had money stashed somewhere safe. More than enough to pay off the debts, to save the farm, to carry on as they were. Under the fleece of silence, Phyllis knew she didn't want things to carry on as they were. She would like to get away from Woody, someday, but habit was a dangerous thing. Anyway she had enquired. Turned out it was a myth. She knew that now. An attorney had told her so. A family legend picked up from repeated telling at the dinner table over pork chops and mashed potatoes: your uncle's got money, you know, kept safe away from the bank.

There was a room at the pig farm that Phyllis had kept locked for a long time. She kept the house clean, but this room, she hadn't touched it, she hadn't even been inside it, since that first day, and that was the room where they found the old man dead: bare floorboards, grey walls, stained mattress. She had locked it, wrapped the fleece of silence around it, and walked away. Trouble was, that room was still there in her nightmares. Some nights in her dream she got as far as the end of the corridor and stood outside the door with her hand resting on the handle. Some nights she heard a noise from inside: banging, like someone wanted letting out of a closet or a chest. She never went in. In daylight she turned her back on the room at the end of the corridor like she had forgotten it was there. Until now.

Phyllis found herself half way along the corridor to her uncle's room with the key in her hand. It would seem odd if he *wasn't* inside: she had imagined him in there for years. She stood outside the door just as she did in her nightmares. In fact she couldn't rightly say if she were awake or asleep. She put the key in the lock. She had convinced herself, the way folk often convince themselves in the middle of the night, that if the money existed it was in that room. She turned the key. She took a breath and moved the handle. She had forgotten the smell. She hadn't expected it to be so overpowering. All the same she went inside. She found herself shocked, no, more than that, *disappointed* that he wasn't there. She had kept him there inside her head all this time but it turned out to be an ordinary room after all. She stood two steps inside and looked around. This wasn't the sort of place for a person to hide or find anything at all. The closet door was already open but she went over to it anyhow. She realised she had taken the longest route possible to avoid the bed. She almost avoided turning her back on it. Almost. She told herself not to be so stupid. She felt the walls of the closet: nothing. She knelt down and felt the walls under the shelves. She found evidence that rodents had gotten inside: old droppings and a gnawed hole in the woodwork, but nothing else.

She went to the chest on the other side of the room, knowing it was useless, because the chest had seemed like the obvious place years ago. She had even opened it with her sweater pressed to her face while the body still lay on the bed. There was nothing inside. Unless someone had stolen the key and filled the chest with gold in the intervening time it would still be empty. She repeated the same small actions now, conscious she was mirroring her previous self: flicked the catch on the top, lifted the lid. Nothing. Of course there was nothing.

She heard Woody's truck pull up outside and cursed herself for acting so foolish. She went quickly to the door. Something made her stop and look one last time. Those damn rodents, she thought, noticing the stuffing from the mattress on the floor. You know what? Let them have the mattress. Let them have all of it because she was going to lock it away again.

She heard Woody slam the truck door. Then next to the mattress stuffing on the floor she saw a single bank note. She walked over to it and picked it up. She saw the rodent hole in the mattress. She knelt down next to it so she had the hole at eyelevel. She put her hand inside and pulled out a handful of bank notes. She got up, ran over to the door, went out, and locked it behind her.

Phyllis kept her secret warm under her fleece of silence as long as she could. When she went back in the middle of the night with her gutting knife, she discovered that the whole mattress was stuffed full of money. The memory of the dead old man had been lying on it all this time. Phyllis was through with Woody. She was through with all of it.

A taxonomy

Taking Rob Pope's work on creativity as inspiration, I have listed some of the cultural idioms that orbit around the term 'creative', in what one might describe

as a contemporary reiterative etymology, or re-etymology; that is, the continual, contingent reinvention of the term:

1. Child's play, playfulness, returning to a child-like creative (or curious, uncon-strained) state.
2. Crafting, honing and refining something, the application and repetition of a skill.
3. Experts in advertising or branding are sometimes called 'Creatives'.
4. Creative industries, an osmotic term for businesses where the arts are foregrounded.
5. Creative learning: an involved, experiential, investigative form of engagement (see Craft and Jeffrey 2004, for instance).
6. Creative practice: engaging in a particular art form for its own sake, emphasis-ing *process*.
7. Creative *thinking* (see Sternberg 2006) is often applied in a business setting, and involves forming unusual connections between concepts.
8. Innovation and problem-solving intersect with 'creative thinking' but refer specifically to new ways of conceiving and actualising a set of processes or ideas.
9. Self-actualisation. Often expressed as 'becoming the person you were meant to be'.
10. Self-expression. This is the popular idea that creative processes help a person to externalise internal sensations and emotions, memories and ideas. Like self-actualisation, it can have therapeutic or humanist aims.

I find it useful to make lists, to catalogue ideas, even those that seem self-evident. The above taxonomy highlights a prevalent dialectic, a 'social constructivist' verses a 'rarified' version of creativity, to which I will now turn.

A social constructivist narrative focuses on self-actualisation and self-expression, and on social betterment; creativity is an important skill for individuals and a tool for bringing about social change. More than ever we have the need for creative thinkers and doers. Learning to be creative is not only possible, it has a powerful social effect and can lead to innovative thinking about local, national and international concerns.

As various commentators have expressed,[5] as far as writing is concerned, there is certainly opposition to the above social constructivist application: a 'rarified' ver-sion of creativity. According to this opposite reading, only a few people have the key to creativity. It is by turns un-teachable, secret, genius, innate or 'drawn out' by training with the 'masters' and involves the inherent paradox of Coleridge's 'vision in a dream'[6] and the perfectly crafted / finished object or product.

Alternatives

Knowing nothing but the 'social constructivist' versus a 'rarified' version of cre-ativity can make a practitioner anxious, and I want to finish with a sense of hope.

Here, therefore, are two alternatives. One is the figure of the flâneur. One might say that wandering, observing and seeing anew set the creative practitioner apart from the other iterations of creativity. In Sally Munt's essay 'The Lesbian Flâneur', she holds that 'arguments concerning . . . the flâneur . . . tend to be articulated within a heterosexual paradigm'. However, with her, I am fascinated by the flâneur as 'observer and a metaphor . . . a symbolic hero and anti-hero, a borderline personality . . . of angst and anomie'.[7]

A second alternative comes from *Frissure*, by Brigid Collins and Kathleen Jamie (2013). [8] *Frissure* is a collection of prose poems and art works recounting the experience of breast cancer surgery and reimagining the line of the mastectomy scar. Attention is given to the transformation of the scar – Rumi calls it 'the bandaged place'[9]– as it becomes part of the survivor's lived experience. *Frissure* offers a radical alternative to more traditional debates about creativity.[10]

The flâneur and the 'frissure': these two disjunctive possibilities offer hope for me as a creative practitioner; that I can practise separately from more formulaic, teleological rendition of process–product–reception, that I will have time and space to take my playful practice seriously.

Notes

1 Rumi (2004: 142).
2 Recent commentators have interrogated both creativity and its meanings, and creative practice and the academy, including Estelle Barrett, Hilary Collins, Anna Craft, Mihaly Csikszentmihalyi, Paul Dawson, Anders Ericsson, Robin Nelson, Robert Sternberg and Hazel Smith.
3 Pope (2005: 1).
4 Barthes (2004: 142).
5 Csikszentmihalyi (2013); Pope (2005); Dawson (2004).
6 Pope (2005: 244).
7 Munt (1998: 35). Recent iterations of the flâneur include Skantze (2013: 4, 10) and Elkin (2016).
8 Images from Frissure, from 'North Sky' to 'What is a Line?', are available on Brigid Collins' website www.brigidcollins.co.uk/gallery.html and images from the book are available online www.brigidcollins.co.uk/gallery_298772.html [accessed 8 May 2017].
9 Rumi (2004: 142).
10 I have written about Rumi, the flâneur and 'frissure' in a longer essay in *TEXT* (Tondeur 2017).

References

Barthes, Roland. 1980. *Camera Lucida: Reflections on Photography*, translated by Howard. London: Fontana.

Collins, Brigid and Kathleen Jamie. 2013. *Frissure: Prose Poems and Artworks*. Edinburgh: Polygon.

Craft, Anna and Bob Jeffrey. 2004. 'Teaching Creatively and Teaching for Creativity: Distinctions and Relationships', *Educational Studies* 301: 77–87.

Csikszentmihalyi, Mihaly. 2013. *Creativity: The Psychology of Discovery and Invention*. New York: Harper.

Dawson, Paul. 2004. *Creative Writing and the New Humanities*. London: Routledge.

Elkin, Lauren. 2016. *Flaneuse: Women Walk the City in Paris, New York, Tokyo, Venice and London*. London: Chatto & Windus.

Munt, Sally. 1998. 'The Lesbian Flâneur', 30–53 in *Heroic Desire: Lesbian Identity and Cultural Space*. London: Cassell.

Pope, Rob. 2005. *Creativity: Theory, History, Practice*. London: Routledge.

Rumi. 2004. 'Childhood Friends', 139–142 in *Selected Poems*, translated by Banks. London: Penguin.

Skantze, P.A. 2013. *Itinerant Spectator / Itinerant Spectacle*. New York: Punctum.

Sternberg, Robert J. 2006. 'The Nature of Creativity', *Creativity Research Journal* 18(1): 87–98.

Tondeur, Louise. 2017. 'Risk, Constraint, Play', *TEXT: Journal of Writing and Writing Courses* 21(1).

35

THE CATALOGUE FOR THE PUBLIC LIBRARY OF PRIVATE ACTS

Johanna Linsley

The (semi-)fictional institution has a long history as an artists' device. It is often deployed to critique existing institutions, such as the art museum, as with Marcel Broodthaers's seminal *Musée d'Art Moderne, Département d'Aigles* (*Museum of Modern Art, Department of Eagles*, 1968–72) for which the Belgian artist appropriated museum practices – including an attempted sale of the 'museum' itself – drawing attention to the administrative and other processes which create and sustain an institution. Artists' institutions may also perform at the limits of disciplines such as historiography, like Walid Raad's *Atlas Group* project (1999–2004), a series of fictional documents about the Lebanese Civil Wars which gesture as much to the difficulty of telling traumatic histories as to the historical events themselves. Fictional institutions may draw attention to gaps and borders in dominant narratives, as Meschac Gaba does with his *Museum of Contemporary African Art* (1997–2002), or may offer alternatives, as the vacuum cleaner and Hannah Hull do with *Madlove: a Designer Asylum* (2014–present), which brings people together to design their own mental health asylum where 'madness can be experienced in a less painful way' (http://madlove.org.uk/). The 'fiction' of these institutions is often slippery – see, for example, *The Institute of the Art and Practice of Dissent at Home*, a 'real' institution set up in 2007 in a council flat in Liverpool, whose members include the adults and children who occupy this flat and who might, under other circumstances, be called a 'family'.

The methods for establishing institutions (or 'institutions') such as these are often highly performative, from manufacturing photographic or administrative 'records', to adopting a character or persona, to simply declaring that a particular group or formation *is* an institution. Writing is implied in each of these tactics, though it is curiously underexplored critically in this context, perhaps because writing may seem to deliver the work too firmly into the category of fiction, unsettling the already uneasy balance of ambiguity. Below, I consider

how text performs in my own (semi-)fictional institution, *The Catalogue for the Public Library of Private Acts*.

Artists who work in performance will often find themselves part of the 'public programme', an event series that accompanies an exhibit or is part of a wider educational programme. What makes these programmes more 'public' than other programmes? I suspect one answer is that they serve and have a responsibility to *the public*, which is a slightly different figure from *the audience*. *The public* can just wander in off the street, though it must also be courted or wooed. Museums especially need to worry about *the public* when public funds are at play, but even private institutions with charitable remits are concerned. There is a risk with public programmes that they function as a sort of buffer or sound-proofing, making other, perhaps more anti-social, work acceptable to the institution and dampening the shock of radical gestures or voices. On the other hand, I am interested in finding out what institutions mean by *the public* and casting this figure in my work.

In April of 2015, I was asked to create a piece of participatory work for the public programme of the *Institute of Sexology* exhibit at the Wellcome Collection in London. The exhibit looked at the history of the study of human sexuality, crucially focusing not on experiences of sex per se, but on the development of sex as an object of analysis, and thus its entry into public discourse. The structures of thought informing the exhibit were sometimes visionary, sometimes dubious or troubling, and ranged from Krafft-Ebbing's case studies, to Freud's analytic couch, to Kinsey's data collection (and later the National Survey of Sexual Attitudes and Lifestyles' mass data collection), to Margaret Mead's anthropology, to Marie Stopes' birth-control-as-eugenics, to Masters and Johnson's laboratory research. Artists' projects by Carolee Schneemann, Sharon Hayes, Neil Bartlett and others were useful counterpoints offering subjective or satirical modes to the set of frameworks for studying sex.

The Catalogue for the Public Library of Private Acts, which I created for the *Institute of Sexology*, is based, in part, on the question of how a cultural institution establishes what and who constitute *the public*. Increasingly, this question is answered through structures of feedback – the public is asked to tell the institution about itself. In *The Catalogue*, this consultation becomes the foundation of the work. The project is structured around a series of questions about experiences, sensations and thoughts that the participant might consider to be private (not necessarily sexual – *The Catalogue* uses the prompt of the *Sexology* exhibit to reflect broadly on processes that structure how we think about the public and the private – though not necessarily non-sexual). The written responses to these questions are entered into a physical filing cabinet and made available for others to read, so that the catalogue grows over the course of the exhibit (there were approximately 400 entries by the end of the project). Thus while the 'library' itself – all of the immaterial *stuff* to which the catalogue refers – may be understood to be fictional, or at least intangible, the 'catalogue' is stubbornly inscribed, and if not reliably 'true', still its status as fiction is unstable.

Intervening in this process is another mode of writing, a series of recorded texts titled 'Learning Tapes' made in collaboration with sound designer Jan Mertens.

These tapes ('not guaranteed to result in learning') take listeners through three steps in the process of conducting research, and transforming it into a public resource: knowledge. The contents of these tapes, however, are mysterious. They are fragmentary. They seem to be dispatches from another world to which the listener has only partial access. In other words, they frustrate the making-public of a particular private logic.

There is a textual interplay in the project, then, between speech, sound and writing, between the multi- and the solo-authored, between fiction and documentation, and between the improvised and the recorded, with each of these modes in some kind of tension with ideas about the public and the private. This tension never resolves, but rather signals back routes and detours when approaching these ideas.

Introduction

This is a *Catalogue*, or it will be.

This is the *Catalogue for* The Public Library of Private Acts, which makes available for the first time the entire array of private experience. As sexology developed, the private experience of sex entered the public realm of ideas and study. Inspired by this movement from private to public, we go a step further. This Library specialises in everything that is unspoken, only imagined and secretly shared. It champions autonomy and tolerates lies, then betrays its own subject by throwing its doors wide, wide open.

Or that's what we hope.

Right now this *Catalogue* is blank and the Library is hypothetical, but straining to exist.

To help us create the *Catalogue*:

1) Take INSTRUCTIONS and a CATALOGUE CARD.
2) Pick an INSTRUCTION and use the CATALOGUE CARD to record your response.
3) Submit your CATALOGUE CARD to the PUBLIC REPOSITORY.

Your card will be left in the *Catalogue* itself, which is a permanent and growing record of all that is private. (If you need help, please use the Learning Tapes provided.)[1]

Instructions

a. Draw a picture of someone who knows your secrets.
b. Write a brief history of an object that embarrasses you. You don't need to tell us what the object is (though you can); we like mysteries.
c. Describe a body part (your own or someone else's) that has surprised you, betrayed you, or let you down. We want the details: size, temperature, texture, etc.

d. Some experiences remain private simply because we forget them. Invent a forgotten memory.

e. Make a mental list of things that nobody knows about you. Assign a colour to each item on the list. Write down the colours.

f. Describe the ideal location for eavesdropping, real or imagined. Use illustrations.

g. Tell us a private joke. Omit the context.

h. Make a list of everything you would want to have if you were going to be entirely alone for a month. Make a second list describing how you would behave if you were surrounded by other people all day, every day.

i. Open call: tell us what else we should include in our catalogue. About sex? About food? About family? About private interest and privatisation? About other unexpected moments of privacy?

Learning Tape 1: How to Design a Research Methodology

Thrilling gossip circuits made of pulsing gossip veins and pumping, pumping gossip blood, and I love it, I love it sooooooooooo much. I love hearing secrets and I love telling them, seriously never tell me anything, except *now* you've started you have to tell me *nooooooooooowwwwwwwwww*.

I love to say, no, that's not on, and she is this way, and he is this way, all the time, always. Collaborative emotional portraits of my friends, my 'friends', my *friends*. My gossip voice on my gossip tongue, better than alcohol. Alcohol helps, tho. My gossip face my gossip eyes my gossip lean my gossip breath. I love my gossip alliances, everyone is interesting to me if we can talk about them. My gossip nose, because gossip is better when you've smelled who you're whispering about.

I want to know who everybody has fucked, every single time, and I want to know what you think about it. Tell me everyone who ever offended you, tell me verbatim, take your time, tell me twice, or more. Talk to me about your family, or better MUCH BETTER talk to me about someone else's family. I won't judge, of course that's not true, but who cares what I *think* I just want to KNOW.

Learning Tape 2: How to Conduct an Interview

FIRST VOICE:
Good. What else?

SECOND VOICE:
Molly, from when she was sixteen, had a mental list of all the local blood donation centres, and she could be very cruel if you went to the wrong one.

FIRST VOICE:
Interesting. Anything else?

SECOND VOICE:
The best parents allow their children to see that they – the parents – actually have a life. The best childhood is conducted in a room full of wandering rays of adult attention, a room full enough of these rays so that at least one beams on the child at all times, but it really shouldn't be the same attention ray all the time.

FIRST VOICE:
Yes. And?

SECOND VOICE:
I don't need recognition – really, I don't. It's not failure to me if I walk into a room and nobody turns around. What I want is time to myself – uninterrupted and unscheduled time. I could literally disappear and I wouldn't mind. Not from existence, I don't mean that. I could literally vanish from sight. I mean that.

FIRST VOICE:
I see. Go on.

SECOND VOICE:
The difference between a heretic and a witch is mostly to down to the voice, I'd have thought. The vocal range is different, you can't write for heretic what you can for witch, that's obvious. But more than the material limitations, from what I understand, there are also questions of . . . of . . . of . . . subjective judgment, which is something you have to develop over time and in context. You need great focus, concentration and dedication. That's what I believe, anyway.

FIRST VOICE:
You're doing great. Just keep going.

SECOND VOICE:
To convert an invert may subvert the pervert – oh, how does the end of that go? *[shouting as if to another room]* Molly?

FIRST VOICE:
Please continue.

SECOND VOICE:
[still shouting] Molly? Molly always knows where I keep my feelings. She was always the tidy one, and I'm the messy one.

FIRST VOICE:
More, please.

SECOND VOICE:

Nowadays Molly is kept under strict watch, of course – she is what she is. She is what she is, but it's under control. Life in the data tower, you know – everyone knows, and nobody cares. Mind you, that doesn't mean you should stop telling people, because you never know, right? Did you know that 'gossip' used to just refer to a very close friend?

FIRST VOICE
Answer the question.
Just answer the question.

SECOND VOICE:

There's a reluctance that sets in, I find, which is somehow in direct proportion to how much I think I want to do something. It's such a shame, that dip in motivation that follows any period of anticipation, and precedes action. It's fear I suppose, hiding as sloth, or maybe it's the other way around.

FIRST VOICE:
Show us the real you.
Pull back the curtain so we can really see you.

Learning Tape 3: How to Observe a Subject

The thing is –

The thing is stable, for now. The thing is whistling tunelessly on the inhale. The thing is an agent. From many angles, the thing is –

Here's the thing –

Walking, female, inventing crowds. The thing walks in anger.

The thing is –

A language –

Well, that's the thing.

Note

1 Please note, Learning Tapes are not guaranteed to result in learning.

36

FIELD NOTES FROM A CHOREOGRAPHIC PRACTICE

Lucy Cash

A BEGINNING (a gathering)

☾

My ~~practice~~ work roots itself in the ~~crevices~~ borders between different disciplines - performance, moving image, installation and choreography.[1]

Is my body sometimes the bridge? Or does the writing form the flyover? Writing re-directed; away from setting things apart ~~claiming territory~~ and towards connection. *(NB. Connection doesn't mean a loss of distinction.)*

Is here the unfamiliar? And over there, the familiar?

♋

There's always so much that I know that I don't know, that to ask questions seems like the most important thing to do. The questions form an anchor – to other people things and places. The people can be dead or alive, real or fictional.

☎

The filmmaker Margaret Tait once said, "Yes that's what I like, everything treated equally – the woman standing there, and the leaf on the wall. It's all got equal significance" (Todd & Cook 2004, p.33).

In *Notes on the Cinematographer* Robert Bresson proposes a film as a, "Visible parlance of bodies, objects, houses, roads, trees, fields" (Bresson 1997, p.24).

≥a≤

A *parlance* is an exchange is a dialogue is a speaking and a not-speaking is a listening and a forgetting is a remembering and a mistaking is a losing and a translating is a naming and a building is a blurring of the boundary between here and there and you and me.

↙

When I started digging at the origins of words, I felt more certain that the wrestling of words from one shape or form into another might at its most enjoyable feel like movement composition.

A kind of

dance.

At some subterranean level writing for me *is* movement – the finding and shaping of the movement of thought.

⊔

How can I invite you in? That's another question.

You are in my future (thank you for turning up). This writing needs you – only you can complete its pattern. I tried dancing it out earlier and all I got was this lousy ~~t-shirt~~.

A MIDDLING (research)

Notebooks // Michael Taussig // (*lessons in observations, provocations, wonderings*)

Thus I felt it was time to think a lot more about the first phase of enquiry – that of the imaginative logic of discovery – which in the case of anthropologists and many writers and other creative types, such as architects, painters and filmmakers, to name the obvious, lies in notebooks that mix raw material of observation with reverie and, in my own case at least with drawings, watercolours and cuttings from newspapers and other media (Taussig 2011, p.xi).

Questions // Virginia Woolf // (*lessons in interruptions, hesitations*)

I should explain that like so many people nowadays I am pestered with questions. I find it impossible to walk down the street without stopping, it may be in the middle of the road, to ask: Why? Churches, public houses, parliaments, shops, loud speakers, motor cars, the drone of an aeroplane in the clouds, and men and women all inspire questions. Yet what is the point of asking questions of oneself? They should be asked openly in public. But the great obstacle to asking questions openly in public is, of course, wealth. The little twisted sign that comes at the end of the question has a way of making the rich writhe [....] being sensitive, impulsive and often foolish, [questions] have a way of picking their asking place with care. They shrivel up in an atmosphere of power (Woolf 2009, p.160).

Answers // Kathy Acker // (*lessons in the politics of power, of subversion*)

The problem with expression is that it is too narrow a basis for writing, for it is pinned to knowledge, knowledge which is mainly rational. I trust neither my ability to know nor what I think I know. Moreover, the excitement of writing, for me, is that of a journey into strangeness: to write down what one thinks one knows is to destroy possibilities for joy (Acker 1997, p. viii).

A MIDDLING (practice)

or, A Demonstration of Time Fading (paradiddle version)

(*amplify a detail, change context*)

It starts like this: folded inside the word, 'consider', is an invitation to 'see with the stars',
con sidere (Cash, 2016).

(*open a window*)

During a research residency at the Foundling Museum[2] in London, I carried out a sequence of performative actions that were organised around encounters with the museum's visitors.

Like any institution, the museum arranges and shapes our way of viewing its architecture and contents. In the most visually demanding of its rooms, I sat at its periphery behind a small desk, re-learning how to write cursively. The words I practised writing were those I gleaned from overheard conversations – from people who passed me by. This gesture was part of a response to a child's rough book displayed in a cabinet in another of the museum's rooms. Opened at a double page, the rough book showed neat pencil guidelines and the repetition of a single word - 'banishment'. I was caught by the repetition of this particular word since the child who wrote it was herself removed – if not banished – from polite society. At the same time, I had recently read several newspaper articles about the fact that cursive, (running, flowing) handwriting would no longer be taught to primary school children.

Having subtly amplified (via microphone and speaker) the sound of my pen on the paper, I was a minimal, yet audible element in the sonic landscape of the room. The meditative gesture of forming and reforming letters supplied an appropriately restrained presence and yet given the age of my body served as a transplanted gesture – one that had migrated to another form.

(*A mistake, a falling*)

And it starts like this: with a finch falling to the ground from the beak of a crow (Cash, 2016).

A DISPOSITION (*open another window*)

Choreography in its expanded form is a field in which politics and aesthetics meet and intermingle. Not least because the abstract forms of pattern and rhythm that are aspects of its language, offer a way of understanding other kinds of systems (both human and non-human). Equally, the inescapable fact that the medium that makes possible the play of signification – the body – is vulnerable to a whole range of questions about embodiment, representation, mimesis and performativity, provokes me to continue exploring the limits of what might be considered choreographic.

I'm always drawn to looking at the deliberate patterning and arrangement of bodies in space – their disposition (Cash, 2014a).

An observation made in my (then) current notebook which became part of a talk I gave at the end of my residency at the Foundling Museum:

I enjoy noticing how a deliberately uniform movement, such as this gesture performed by the girls in the image below exhibits tiny discrete variations as it plays out over their individual bodies. Some girls touch their ears, some their hair – others' hands seem to meet behind their neck. Different girls, differently direct their gaze to the camera (or not) and have contrasting ways of balancing their weight between their turned-out feet. The girl at the apex of the triangle with the dark dress and hands touching her neck – was she picked for her ability to gaze unflinchingly? (Cash, 2014a)

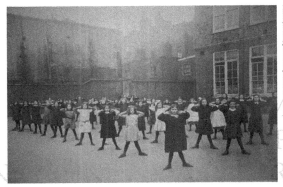

Another image – this one from the Foundling Museum archive. Girls arranged in a similar but different pattern, their feet also turned out, but this time closed in a kind of ballet first position and their arms held up and in front of them.

Their bodies are more rigid than those of the girls on my wall. They already look like they might be maids or nurses.

But what are they doing? Firstly, I think I see invisible cymbals which the girls hold apart - ready to crash together on a given signal; next I see that they might be holding up a piece of laundry – perhaps a sheet – waiting to fold it with another person; then I imagine that perhaps in fact they are wielding invisible batons and that each girl is charged with conducting an invisible orchestra… The more I look at the girls, and see their subtle variations, I begin to see other possibilities – a stretch arrested mid-movement; a gesture of surrender… Movement designed to train and regulate bodies in a particular direction, becomes unruly and multiple in my imagination.

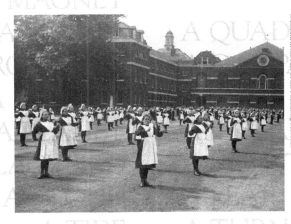

(A new question: *how do we know what we see? What moves us between seeing and understanding?*)

(wave emphatically) CUT TO A DIGRESSION, (Cash, 2014b):

The physicist David Bohm remarks:

'Creativity is, in my view, something that it is impossible to define in words. How then can we talk about it?' (Bohm 2004, p.1)

Bohm answers his own provocation by considering why scientists, as well as artists, engage in their chosen field of activity. He suggests that both disciplines are linked by seeking to, "learn something new that has a certain fundamental kind of significance" (Bohm 2004, p.3). He admits that this significance is most commonly linked to originality and in an unexpected (conceptual) sleight of hand suggests that in order to be original, a person needs to refrain from imposing what he *thinks* he knows on what he *appears* to be experiencing. Since we have all experienced this ability to see 'newly' as children, he reminds us that the reason that this ability withers away is because of the way we are trained to acquire and use knowledge as adults. This occurs in order to prevent us from making mistakes – which we fear – and because we become trained to use knowledge within a particular context and for specific purposes.

The example Bohm uses to describe originality is that of a child learning to walk. A child who is so engaged, so fully absorbed in the act of two-legged motion that she allows her mind the, "energy needed to see what is new and different, especially when the latter seems to threaten what is familiar, precious, secure or otherwise dear to us" (Bohm 2004, p.6).

Through this example Bohm suggests that in any field where creative research is whole-heartedly sustained, it may be possible for new knowledge to emerge which is, "of potential significance to a broad and rich field" (Bohm 2004, p.8).

This kind of engaged exploration is not the same as an occasional moment of insight. Instead it is an activity that needs to take place over a sustained period of time in a situation that is free of the fear of making mistakes, and free of being able to account for the outcomes it might or might not result in.

It may be that this kind of research begins with a question, which propels the research into a flow. But it also might require freedom from trying to describe what it is that is being looked for. The child learning to walk doesn't know that she doesn't know how to walk and she doesn't articulate what she is doing as walking. Instead she *discovers* through the motion that becomes her walk, and she comes to realise that it has re-orientated her world-view – literally.

AN ENDING (falling apart, beginning again)

What is the difference between dancing that is thought and then felt, and dancing that has no separation between thinking and feeling and moving?

The filmmaker Sally Potter once said, "only people who know how to move very, very slowly can move very, very fast. It's where you discover what technique you have." (Fowler 2008, p.111).

(She doesn't mention thinking. But I know that when you are moving very, very fast if your technique involves thinking before you move, then you will discover how very slow and heavy a thought can be.)

There came a moment when I realised that most writing is a description of thinking that is done before the writing and not a realisation of thinking that goes on at the moment of the writing.

What does this change?

↧

What changes is this: words became material that can be torn, hinged, wrestled, burnt, stretched, collapsed, layered, arranged, spilt, knotted, folded, held…

(*recapitulate*)

It ends like this: with the known and the unknown; with silence and with darkness.

And with the boy in the photograph looking out towards us as if he can see through time and space.
As if he can, 'see with the stars', his perspective large enough to accept what falls apart, all around us. (Cash, 2016)

(Thank you for your contribution to this demonstration of time fading…)

Notes

[1] Author's own works cited include: notebooks; extracts from a research residency; an installation sited in a library (*Some Patterns of Current*); a sound installation (*VOICED*) and a 'provocation' for the Jerwood Foundation.

[2] The Foundling Museum commemorates the Foundling Hospital which was established in 1739 by a businessman - Thomas Coram - as the first purpose-built home for children (foundlings) whose mothers were unable to care for them due to poverty, or social exclusion.

References

Acker, K. (1997) *Bodies of Work: Essays*, London: Serpent's Tail.

Bohm, D. (2004) *On Creativity*, London: Routledge Classics.

Bresson, R. (1997) *Notes on the Cinematographer*, Copenhagen: Green Integer Books.

Cash, L. (2016) *To the Land*, VOICED, Nomad Projects, London.

Cash, L. (2014a) Residency talk for the Foundling Museum, London.

Cash, L. (2014b) *What is Choreographic Research? Or, if I don't grow lettuces I can't make dances.* Invited provocation for the Jerwood Choreographic research project.

Fowler, C. (2009) *Sally Potter*, Chicago: University of Illinois Press.

Taussig, M. (2011). *I Swear I Saw This, Drawings in Fieldwork Notebooks, Namely My Own*, Chicago: University of Chicago Press.

Todd, P. and Cook, B. (eds) 2005, *Subjects and Sequences: A Margaret Tait Reader*, London: LUX

Woolf, V. (2009) *Selected Essays* (Oxford World's Classics) Oxford: OUP.

Background text: Cash, L. with Ghelani, S. *Some Patterns of Current*, a commission from Dance in Libraries, 2014

Acknowledgements

Thank you to the Foundling Museum for permission to use *Foundling Girls Exercising in London* and to Michael Taussig for the use of his author image. Layout by David Caines.

37

K.BAE.TRÉ

Douglas Kearney

This essay triptych contains "recordings" of me watching Kendrick Lamar's "Alright" (2015) and Beyoncé's "Formation" (2016) music videos, as well as their live performance of "Freedom" at the 2016 BET[1] Music Awards.

What drives the triptych is the recent reinvigoration of interest in Black popular music as a site of overt sociopolitical discourse in the wake of highly publicized cases of police officers murdering Black people. Lamar's *To Pimp a Butterfly* (2016) and Beyoncé's *Lemonade* (2016) (particularly the latter's lead single "Formation" and its live performances) are, for many, flagship art/pop objects in this resurgence. "Freedom," their duet, as performed live,[2] acknowledges and perhaps, simultaneously, makes a bid for the artists' position at the head of this trajectory.

Processually, these texts combine aspects of ekphrastic poetry, cultural criticism, and performative typography as part of what author and critic Tisa Bryant calls a "*jive* signification system."[3] The texts—". . . Alright! Alright! Huh?", "Re:Formation," and "Freedom! Where—"—are an experiment in "dintelligibility,"[4] a brier-patch of signal and "noise" that synthesizes Lamar and Beyoncé's lyrics, the accompanying musical/video productions, and each clip's visual grammar.

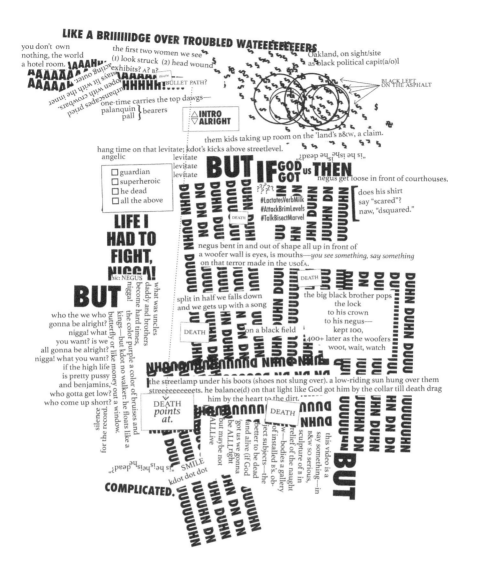

LIKE A BRIIIIIDGE OVER TROUBLED WATEEEEEEEERS

you don't own nothing, the world a hotel room.

the first two women we see (1) look struck (2) head wound exhibits? A? B?

Oakland, on sight/site as black political capit(a/o)l

AAAAHH... AAAAAAA AAAAAA HHHHH!....

actate lit with the inner
urban scapes with crowbars.
pried open lit with crowbars.
stays outer.

BULLET PATH?

DEATH

one-time carries the top dawgs—
palanquin } bearers
pall }

△ INTRO
▽ ALRIGHT

BLACK LEFT ON THE ASPHALT

them kids taking up room on the 'land's B&W, a claim.

hang time on that levitate; kdot's kicks above streetlevel.
angelic

levitate
levitate
levitate

"is he ishe he dead?"

□ guardian
□ superheroic
□ he dead
□ all the above

BUT IF GOD GOT us THEN

negus get loose in front of courthouses.

??? NN NN NN
#LactatesVerbMilk
#AttackBrimLevels
#TalkBisectMarvel

does his shirt say "scared"? naw, "dsquared."

DUHN DN DN DUHN DUUU DUHN DUUU DN DUHN NHUUN DUHN

LIFE I HAD TO FIGHT, NIGGA!

[sic: NEGUS]

negus bent in and out of shape all up in front of
a woofer wall is eyes, is mouths—you see something, say something
on that terror made in the USofA.

DEATH

BUT

what was uncles daddy and brothers become hard times. niggal niggal

who the we who gonna be alright?
nigga! what you want? is we all gonna be alright?
nigga! what you want?
if the high life is pretty pussy and benjamins, who gotta get low? who come up short?

kings—but kdot no walker: he floats like a
the color purple a color of bruises and
butterfly or like money out a window.
'record or the rare or the
silence

split in half we falls down
and we gets up with a song

DEATH

on a black field

the big black brother pops
the lock
to his crown
to his negus—
kept 100,
400+ later as the woofers
woot, wait, watch

DEATH
DUHN DUHN DUUU DUHN DN DN DUHN DUHN DUUU DUHN DN

the streetlamp under his boots (shoes not slung over). a low-riding sun hung over them
streeeeeeeeets. he balance(d) on that light like God got him by the collar till death drag
him by the heart to the dirt.

DEATH
points
at.

DEATH

DUUU DUHN HN DN DUHN JUUUUHN DN DN DUHN

BUT

this video is a
say something—in
B&w so serious,
sculpture of B in
w—bodies a gallery
ject subjects—the
of installed B's, ob-
relief of the naught
better to be dead
and alive (if God
got us we gonna
be ALLright
but maybe not
ALLLive

"is he, he is, he dead?"

SMILE
kdot dot dot

COMPLICATED.

JUUUUHN JHN DN DN JUUUUHN JHN DUHN JUUUUHN JHN DN DN JUUUUHN

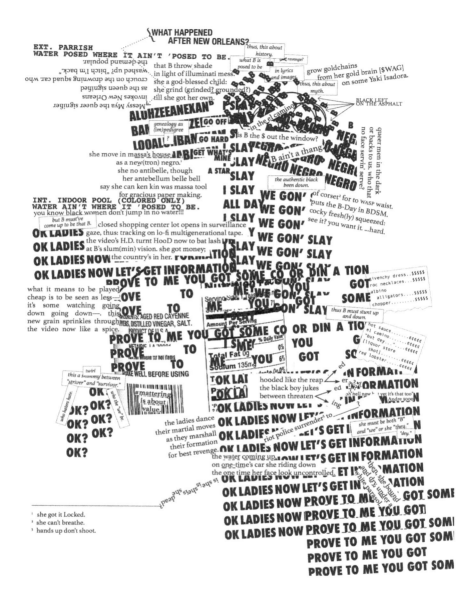

EXT. PARRISH
WATER POSED WHERE IT AIN'T 'POSED TO BE.
the demand popular.
washed up? "bitch I'm back."
crouch on the drowning squad car, who
as the queen signified
invokes New Orleans
Messy Mya the queer signifier

that B throw shade
in light of illuminati mess.
she a god-blessed child:
she grind (grinded? grounded?)
till she got her own.

thus, this about history.
what B is posed to be
in lyrics and images
thus, this about myth.
revenge?

grow goldchains
from her gold brain [$WAG]
on some Yaki Isadora.

BLACK LEFT
ON THE ASPHALT

ALUHZEEANEXAN
BA ZE GO OFF
LOOAL IBAN GO HARD
IAB GET WHAT'S

she move in massa's house
as a new(tron) negro.'
she no antibelle, though
her antebellum belle bell
say she can ken kin was massa tool
for gracious paper making.

genealogy as (im)pedigree

Is B the $ out the window?
B ain't a thang

queer men in the dark
or backs to us, who that
no face servin' serve?

*the authentic black
been down.*

of corset² for to WASP waist.
'puts the B-Day in BDSM.
cocky fresh(ly) squeezed:
see it? you want it. ...hard.

INT. INDOOR POOL (COLORED ONLY)
WATER AIN'T WHERE IT 'POSED TO BE.
you know black women don't jump in no water!!!

*but B must've
come up to be that B.*

closed shopping center lot opens in surveillance
gaze, thus: tracking on lo-fi multigenerational tape.
the video's H.D. turnt HooD now to bat lash
at B's slum(min) vision. she got money;
the country's in her.

OK LADIES
OK LADIES
OK LADIES NOW
OK LADIES NOW LET'S GET INFORMATION
PROVE TO ME YOU GOT SOME CO OR DIN A TION

I SLAY
ALL DAY
I SLAY
WE GON'
WE GON'
WE GON'
Y
WE GON' SLAY
WE GON' SLAY
WE GON' SLAY

NEGRO
NEGRO NEGRO
NEGRO

what it means to be played
cheap is to be seen as less—
it's some watching going
down going down—. this
new grain sprinkles through
the video now like a spice.

OVE TO
ME!
YOU
PROVE TO ME YOU GOT SOME CO OR DIN A TIO
SME!
YOU
GOT
YOU SLAY
GOT
SO

givenchy dress.....$$$$$
roc necklaces.....$$$$$
albino alligators.....$$$$$
chopper....

*thus B must stunt up
and down.*

hot sauce.......€€€€€
el camino.......€€€€€
"but dey.......€€€€€
[liquor store shot].......€€€€€
red lobster.......€€€€€

PROVE TO ME YOU
PROVE TO
ME YOU
PROVE TO
ME YOU GOT
ARE WELL BEFORE USING

*this a $tummy between
"striver" and "survivor."*

twirl

OK? OK?
OK? OK?
OK? OK?
OK?

who leaders lack.

mattering
is about
value

the ladies dance
their martial moves
as they marshall
their formation
for best revenge.

hooded like the reap
the black boy jukes
between threaten
ing

ed N FORMAT
er ORMATION
ed INF
oh hell naw I yet it's that too
Andre 3000

OK LADIES NOW LET'
OK LADIES NOW LET
OK LADIES NOW LET'S GET I
OK LADIES NOW LET'S GET INFORMATION

riot police surrender to
INFORMATION

*she must be both "B"
and "we" or she "they."*
"dey."

the water coming up
on one-time's car she riding down
the one time her face look uncontrolled.

OK LADIES NOW LET'S GET IN FORMATION
...ET I MATION
...N ATION
OK LADIES NOW LET'S GET IN GOT SOM
OK LADIES NOW PROVE TO ME YOU GOT
OK LADIES NOW PROVE TO ME YOU GOT SOM
OK LADIES NOW PROVE TO ME YOU GOT SOM
PROVE TO ME YOU GOT
PROVE TO ME YOU GOT
PROVE TO ME YOU GOT SOM

*then she bound
in white person*
and dry under

is she, she's she dead?

¹ she got it Locked.
² she can't breathe.
³ hands up don't shoot.

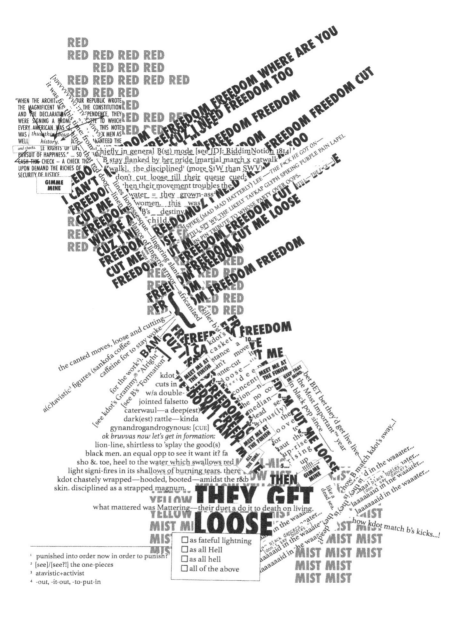

RED
RED RED RED RED
RED RED RED RED
RED RED RED RED RED
RED RED RED
RED RED RED

FREEDOM WHERE ARE YOU
FREEDOM TOO
CUZ I NEED FREEDOM
FREEDOM FREEDOM
FREEDOM FREEDOM CUT
FREEDOM TOO
FREEDOM FREEDOM CUT
FREEDOM CUT ME LOOSE

"WHEN THE ARCHITECTS OF OUR REPUBLIC WROTE THE MAGNIFICENT WORDS OF THE CONSTITUTION AND THE DECLARATION OF INDEPENDENCE, THEY WERE SIGNING A PROMISSORY NOTE TO WHICH EVERY AMERICAN WAS *thus...about* SIX MEN AS WELL *history...* WANTEED THE *and checks* LIFE, LIBERTY OR THE RIGHTS OF LIFE... PURSUIT OF HAPPINESS." ... SO *it was* ... CASH THIS CHECK – A CHECK THAT... UPON DEMAND THE RICHES OF SECURITY OF JUSTICE

GIMME MINE

I CAN'T FREEDOM CUT ME FREEDOM WHERE A CUZ I N FREEDOM CUT ME FREEDOM

chiefly in general B(st) mode [see JD]: RiddimNotion 1814] B stay flanked by her pride [martial march x catwalk walk]. the disciplined¹ (more SIW than SWV) don't cut loose till their queue cued; hen their movement troubles the water = they grown-ass women. this was B's destiny child...

FREEDOM CUT FREEDOM CUT ME LOOSE
FREEDOM FREEDOM
FREE DOM FREEDOM FREEDOM

the canted moves, loose and cutting
alc)tavistic³ figures (sankofa coffee
caffeine for to stay woke
for the work).
[see kdot's Grammy® 'Alright']
[see B's 'Formation'] kdot
 cuts in
 w/a double-
 jointed falsetto
 caterwaul—a deep(est)
 dark(est) rattle—kinda
 gynandrogandrogynous: [CUE]
 ok bruvvas now let's get in formation:
 lion-line, shirtless to 'splay the good(s)
 black men. an equal opp to see it want it? fa
 sho &. toe, heel to the water which swallows red
 light signi-fires in its shallows of burning tears. there
 kdot chastely wrapped—hooded, booted—amidst the r&b
 skin. disciplined as a strapped magnum.

 what mattered was Mattering—their duet a do it to death on living.

MEET ME AT THE FINISH

FREEDOM FREEDOM
CUT ME
MEET ME AT THE FINISH
CUT ME LOOSE

I'M CUT ME LOOSE

GIMME MINE

THEN THEY GET
LOOSE

YELLOW
YELLOW
MIST MIST
MIST MIST MIST
MIST MIST MIST
MIST MIST
MIST MIST

□ as fateful lightning
□ as all Hell
□ as all hell
□ all of the above

¹ punished into order now in order to punish?
² [see]/[see?!] the one-one-pieces
³ atavistic+activist
⁴ -out, -it-out, -to-put-in

Notes

1 Black Entertainment Television.
2 Lamar does not appear on *Lemonade*'s visual album version.
3 In her jacket copy for my collection, *Mess and Mess and* (Kearney, 2015), Bryant explicates *jive* as: "Some mess, some movements, some secrets glyphed behind the hand, continually decoding and decoying the code."
4 A concept I discuss more closely in the book.

Reference

Kearney, Douglas. 2015. *Mess and Mess and*. Blacksburg: Noemi Press.

MIDDLEWORD THREE

When

Timothy Mathews[1]

When William Kentridge writes tear and repair over the pages of an encyclo-
paedia
When Pablo Picasso finds the intimacy of sex in the fantasies of form
When to learn love is to understand hate
When Jonathan Glazer shows two men holding hands in the dim darkness of
their sexual pain
When Paul Gauguin sees in Jacob wrestling with the Angel the bright red of
entangled belief
When telescopic vision is the viewer's viewing writ large; or small, back to
front
When Alberto Giacometti sees in Thor stepping forward his own people
stepping into their hell and past
When you wish that the unspoken will be heard
When tear and repair voices both nationhood and grief
When through playing with hundreds of people Daniel Barenboim hears in
each other the tones of Bruckner and Bach
When the language of love is learnt and never reached
When the sound of my tears and repairs is more than I can imagine
When to foreswear is to foretell
When an anamorphosis is a mirror image
When the philology of projection clings and films
When Rembrandt sees undisclosed generosity in Jacob and the Angel wres-
tling to embrace
When we burn with what we miss and are not
When the hand is ahead of what opens under it, but follows
When the gift of an image is aphasia

When walking to the side you can look along her view, and see the enigma
 only hers to know in the mirror of Diego Velasquez's Venus
When in Damaris Athene's paintings the word trauma aligns body and psyche
When in saying 'we' we know it's broken, and still we speak
When interpretation glides on paranoia
When aphasia trails its legacies
When Cornelia Parker honours the bombed in the loveliness of a coffee spill
When projection is structured like a rhizome
When a glossary forms a ballet, and catalogues creek
When I vanish in plain sight
When repetition is rehearsal and rehearsal ingrained discovery
When the wounds of Sisyphus slowly close, leaving only breath
When what's between us is a photo that I can see with your eyes
When to desire the impossible is to speak as one
When description is the poetry of thought
When perceptions shock enough to remain perceptions
When a face on a face has unconscious depth
When looking to belong is looking without belonging
When we don't know what we're seeing in the trails of resemblance
When unscripted relation turns to welcome as much as violence
When to hit the beat releases the beat
When to assume a self is to accept an offering
When giving seeps through the fissures
We know without telling how to know
And each of us tells the stories that let us begin and reach.

Note

1 In my writing and translating I try to explore what relating to art
 can tell us about relating to people, and I'm now writing a book
 of I'm calling short critical chronicles. *When* is another way of
 writing the living relations of a writer and a reader, and the
 generosity they can find together in artworks.

 Love is naked
 Like everything is
 But not humanity.

 And there it is
 Stood up again
 Along your way
 [Guillaume Apollinaire, translated by Timothy Mathews]

AFTERWORD

L'après-coup

Jane Rendell

A paratext?

> More than a boundary or a sealed border the paratext is, rather, a *threshold*, or –
> a word Borges used apropos of a preface – a 'vestibule' that offers the world
> at large the possibility of either stepping inside or turning back. It is an
> 'undefined zone' between the inside and the outside, a zone without any
> hard or fast boundary on either the inward side (turned toward the text)
> or the outward side (turned toward the world's discourse about the text),
> an edge.[1]

In the early pages of *Palimpsests*, in 1982, Gérard Genette redefines transtextuality
as the subject of poetics,[2] and extends his system of transtextualities into a five-part
schema: intertextuality – a relation of co-presence between two or more texts (or in
Genette more literally than in Julia Kristeva the actual presence of one text within
another, through for example quotes, plagiarism, allusion); paratextuality compris-
ing those liminal devices and conventions, both within the book (peritext) and
outside it (epitext) that mediate the book to the reader, for example, its title, subti-
tle, prefaces, postfaces, forewords, notes, blurbs, book covers, dust jackets . . . allo-
graphic or autographic signals; metatextuality – the transtextual relationship that
links a commentary to 'the text it comments upon (without necessarily citing it)',
this for Genette is the critical relationship par excellence; hypertextuality – the litera-
ture in the second degree or the superimposition of a later text on an earlier one, in
other words, a relationship relating text b (hypertext) to an earlier text a (hypotext);
and architextuality (or architexture).[3] According to Richard Macksey, the 'topol-
ogy' explored by Genette in *Paratexts* is one of the 'borderland', between the text
and the 'outside' to which it relates.[4] For Macksey, Genette's notion of the paratext
is neither on the interior nor on the exterior, neither container or contained, but as

an undecideable space: 'it is on the threshold; and it is on this very site that we must study it, because essentially, *perhaps its being depends upon its site*'.[5]

I

It is a hot day, the hottest day so far this July. And it is a London kind of heat, an air sticky with pollution drifts in off the Euston Road.

All that day we sit in G02. The backs of our legs cling to the grey plastic chairs. And dark patches spread out under our arms.

Periodically images are projected onto a rough and white(ish) wall. Traces of yellowing masking tape peek through. The feverish weeks of final crits have just passed. Except for us, the building is now empty; the summer show has come and gone. Exhaustion hangs over the place.

Steve moves to the window, and tries to let in some air, but that window has been stuck shut for as long as I can remember, and most likely a lot further back than that.

Sophie has, in that typically understated and elegant way of hers, brought a fan. It is lacy and black, and rather large (possibly flamenco?). She wafts it gently, we breathe in relief. It is our only breeze today.

There is hope. Apparently there is air conditioning.

We turn it on. A loud background buzzing begins.

We turn off again. Better to be hot than deaf to the beautiful words being read aloud.

Maria talks of the potential of the amateur, Tony in languages of the street. At one point James is in the corner, canary yellow features somehow, maybe in the form of a hat?

<p style="text-align:center">*</p>

We weren't just architects, but artists and geographers in the room that day. I remember now that it had been my ambition to bring together writers from across disciplines to see what we could perform together in what I thought of as a working of writing's hyphen:

-writing.

L'après coup

The psychoanalytic setting is a spatial construction, but it is also a temporal process. The French psychoanalyst Jean-Luc Donnet has described his interest in the setting as a construction of a site, which can be connected with both space and time, with 'structure (geography) and history'.[6] But in order to focus on the setting's temporality and to draw attention to 'the primacy of the dynamic point of view',

Donnet chooses not to discuss the setting as a site, but to use the term 'analyzing situation'.[7] An understanding of the setting as a situation rather than a site focuses attention on time, and this is something that another French psychoanalyst, André Green, has examined in great detail:

> I have tried to describe how time functions in the session. I think that an analyst at work listens and suddenly realizes that such an element belonging to one chain of association has indirect connections with an earlier element that he had heard and I call this *retrospective reverberation*. On the other hand, the analyst listens and listens to something, which he foresees as announcing that the patient is going to talk about this and that, and this is a prospective association, which I called *heralding anticipation*. What one has to understand is that the linearity of association is of no importance. What is important is the connection that you can make backwards and forwards and I call this *associative irradiation*. You have to pay attention to the movement, to the irradiation of the signifiers and to the way you connect the signifiers either with traumas or earlier memories or affects. The important thing is that there are degrees of tensions in each part of the material which are always threatening to break the thread of the discourse either by an overwhelming affect or by the tendency to act out. All this movement is a movement of breaking apart, coming together, getting closer to the analyst, turning away from him, and this is what I call the movement. We also see the struggle between constructing something and destroying something. Winnicott gave us a very interesting observation on time tolerance, on the quantity of time during which the child can tolerate the absence of the object or its unavailability. But what Winnicott says is that after a certain amount of time the object as such disappears, and it then makes no difference in the future if the object is present or absent, because the only real thing is the absence of the object.[8]

Through his interest in the movement of time in the session, and the tensions between processes of anticipation and retrospection, Green discusses the bidirectionality of language and how this can involve movements both forward and backward.[9] 'Poetry', for example, and according to Green, 'goes *vers l'arriere* (backwards) (*vers*, which in French means "towards", and "verse"), whereas prose goes forwards'.[10] Green also considers how the *après-coup* might relate to an *avant-coup* – so a before as well as an after: 'the anticipatory event (*l'avant-coup*) and the retroactive attribution of new meaning (*l'après-coup*)'.[11] These temporal concepts of anticipation and retrospection or retroaction Green relates to how trauma makes itself felt not only 'in its original occurrence (the earliest scene), but in its retrospective recollection (the latest scene)',[12] and also to the ways in which anticipation and retrospection might be experienced through language, through another back and forth process which Green calls 'associative irradiation':

By this means, free association is liberated from its tie both to the hierarchical categorization of the discourse and to progression (or to its opposite, retrogression) and gives birth to a multi-directional temporality, producing a reticulated aborescence which stands in contrast to the order of words of the sentence interpreted in terms of the logic of consciousness. It is thus possible to speak of 'associative irradiation', the elements of the discourse, following this double trajectory, retroactive and anticipatory, resonate or link up with each other more or less directly, depending on the sound or the meaning, now prey to the activation of the unconscious.[13]

Notes

1 Genette (1997a [1987]: 1–2).
2 Genette (1997b: 1).
3 Genette (1997b: 1–7).
4 Macksey (1997a [1987]: xiv–xv).
5 Macksey (1997a [1987]: xvii).
6 Donnet (2009: 8).
7 Donnet (2009: 8).
8 Green (2008: 1038).
9 Green (2011: 18).
10 Green (2011: 18).
11 Green (2002: 36).
12 Green (2005: 175).
13 Green (2002: 53).

References

Donnet, Jean-Luc. 2009. *The Analyzing Situation*. Translated by Weller. London: Karnac Books.
Genette, Gerald. 1997a [1987]. *Paratexts: Thresholds of Interpretation*. Translated by Lewin. Cambridge: Cambridge University Press.
Genette, Gerald. 1997b. *Palimpsests: Literature in the Second Degree*. Translated by Newman and Doubinsky. Lincoln: University of Nebraska Press.
Green, André. 2011. *Illusions and Disillusions of Psychoanalytic Work*. Translated by Weller. London: Karnac.
Green, André. 2008. 'Freud's Concept of Temporality: Differences with Current Ideas', *International Journal of Psycho-Analysis*, 89: 1029–1039.
Green, André. 2005. *Key Ideas for Contemporary Psychoanalysis: Misrecognition and Recognition of the Unconscious*. London: Routledge.
Green, André. 2002. *Time in Psychoanalysis: Some Contradictory Aspects*. Translated by Weller. London and New York: Free Association Books.
Macksey, Richard. 1997 [1987]. 'Foreword', xi–xxii in Gerald Genette. *Paratexts: Thresholds of Interpretation*. Translated by Lewin. Cambridge: Cambridge University Press.

INDEX

.